Feminist Fathering/ Fathering Feminists

New Definitions and Directions

Edited by Nicole L. Willey and Dan Friedman

DEMETER

Feminist Fathering/
Fathering Feminists
New Definitions and Directions
Edited by Nicole L. Willey and Dan Friedman

Demeter Press
140 Holland Street West
P. O. Box 13022
Bradford, ON L3Z 2Y5
Tel: (905) 775-9089
Email: info@demeterpress.org
Website: www.demeterpress.org

Demeter Press logo based on the sculpture "Demeter" by Maria-Luise Bodirsky www.keramik-atelier.bodirsky.de

Printed and Bound in Canada

Front cover photography: Nicole L. Willey
Front cover artwork: Michelle Pirovich
Typesetting: Michelle Pirovich

Library and Archives Canada Cataloguing in Publication
Title: Feminist fathering/fathering feminists: new definitions and directions/edited by Nicole Willey and Dan Friedman.
Names: Willey, Nicole L., editor. | Friedman, Dan, 1974- editor.
Description: Includes bibliographical references.
Identifiers: Canadiana 20200153889 | ISBN 9781772582185 (softcover)
Subjects: LCSH: Fatherhood. | LCSH: Fathers. | LCSH: Male feminists. | LCSH: Fatherhood—Psychological aspects. | LCSH: Fatherhood—Social aspects. | LCSH: Feminism.
Classification: LCC HQ756.F46 2020 | DDC 306.874/2—dc23

For Christopher, my feminist co-parent;
Walter, my father, who taught me to be a feminist;
Cheryl, my mother, who showed me how to be an equal partner;
and to Jacob and Isaac, who are and will be fantastic.
NW

For May: you are always on my mind.
DF

Acknowledgments

This collection would not be possible without Andrea O'Reilly and Demeter Press. Her commitment to mothering studies and women's voices has enabled my writing and, in many ways, my scholarly career. Kent State University (KSU) Tuscarawas has given me an academic home, and Dean Bradley Bielski has been generous with reallocation of time to support my work on this book. The University Research Council of KSU has also provided important subvention for this work. Every contributor has been through the long gestation of this book with us; each one of them has written this book into being. Dan has talked me down and lifted me up when necessary, providing the editorial and fatherly eye we needed at many turns. Christopher offered his editorial acumen, his ear, and, most importantly, the lived work of his fathering before and through the writing of this book—creating space for my writing and a model of caring masculinity. My boys no longer crawl around me as I write, but their noises and bodies and conversations give shape and urgency to this project; it is in and for them that the hope of a new way of being in family together has taken shape. *NW*

First, Nicole: I could not have completed this project alone. Thank you so much for the significant heavy lifting you have done to keep us moving and get us to where we needed to be. Thanks to Andrea O'Reilly for thinking of me for this project and to my partner, May, for the reassurance, advice, and everyday labour, seen and unseen, that I needed to get to the finish line. Thanks to my parents and grandparents for all that they gave and had to go through and thanks to my four kids, Noah, Molly, Izzy and Sasha, for teaching me every day that progressive fathering work is important, possible, and worth doing. *DF*

Contents

Foreword
Feminist Fathering/Fathering Feminists:
New Definitions and Directions
Andrea Doucet
11

Introduction
Fathering and Feminism:
Notes toward Understanding
Nicole L. Willey
19

Your Father
Donna J. Gelagotis Lee
39

Section I
Fathers in Popular Culture and Literature
41

Chapter One
Dads Can Cuddle, Too: Feminism, 1960s Sitcoms,
and the Making of Modern Fatherhood
Debra Michals
43

Chapter Two
Why Are Stay-at-Home Fathers Viewed as Feminist Progress?
Steven D. Farough
79

Chapter Three
Feminist Fathering in the Shadow of 9/11:
The Lessons of Laila Halaby's *Once in a Promised Land*
Jeff Karem
103

Chapter Four
"I'm the Backup Parent, The Understudy":
Postfeminist Fatherhood in *The Descendants*
Katie Barnett
131

Chapter Five
"We Raise Our Children to Believe that They Can Be Anything":
Analyzing the Feminist Fathering Possibilities on *Black-ish*
Nancy Bressler
155

Chapter Six
Choose Your Own Fathering Style:
Neil Patrick Harris and Feminist Fathering
Nicole L. Willey
181

Chapter Seven
Caring Masculinities and Feminist Fathering
in Contemporary Spain
Marina Bettaglio
195

Section II
Fathering in Personal Contexts
217

Chapter Eight
Co-Parents Who Share Family Work:
Feminism, Co-responsibility and "Mother Knows Best"
in Spanish Heterosexual Couples
Bruna Alvarez
219

Chapter Nine
From Air Base to Home Base
Ginger Bihn-Coss
239

Chapter Ten
Father Figure
Lee Kahrs
265

Chapter Eleven
Observations and Ramblings of a Feminist Father
Stuart Leeks
273

Chapter Twelve
To My Son
Jed Scott
277

Afterword
Dan Friedman
289

Notes on Contributors
299

Feminist Fathering/ Fathering Feminists: New Definitions and Directions

We all read and write from somewhere. And those places are particular and historically and conceptually located; they are also wrapped up with what Donna Haraway and many other feminist epistemologists have called "situated knowledges" and what Bruno Latour refers to as "matters of fact and matters of concern" (233) in writing and knowledge making practices.

Let me begin with a few select matters that inform my writing of the foreword to this wonderful and important book, *Feminist Fathering/ Fathering Feminists: New Definitions and Directions*. I write it as someone who has also attempted to weave fathering and feminism into my research and writing. Yet, for me, the pairing of fathering and feminism has played out in varied ways across nearly three decades; they have been shaped by shifting social landscapes, changing conditions of possibility for parenting practices and identities, and the particular theoretical, conceptual, and methodological tools available to make sense of these changes. From my own experiences on this terrain, I can identify moments when the mingling of these two F words as theory was a creative fit, but there were also times when the fit between theory and practice was awkward and imperfect. I lay some of these moments out, here, as a way of locating my approach to reading this book and my appreciation

for where it fits into and extends a longer historical trajectory of feminism and fathering scholarship.

The Fit between Fathering and Feminism: A Revolutionary Idea

Beginning in the late 1970s and early 1980s, Sara Ruddick, the late feminist philosopher and author of the 1995 bestseller *Maternal Thinking,* succinctly summarized the fit between feminism and fathering:

> It is argued that the most revolutionary change we can make in the institution of motherhood is to include men in every aspect of childcare.... Again and again, family power dramas are repeated in psychic, interpersonal, and professional dramas, while they are institutionalized in economic, political and international life. Radically *recasting the power-gender roles in these dramas might just revolutionize social conscience ... and economic, political and international life.* (my emphasis, "Maternal Thinking" 226)

Feminist Fathering/Fathering Feminists shares Ruddick's view of the fit between fathering and feminism and its revolutionary potential. It, thus, comes as no surprise that she is mentioned generously throughout this book, which was produced by Demeter Press, a mothering-focused publishing house that Ruddick strongly supported. In the community that houses Demeter Press and the Motherhood Initiative for Research and Community Involvement (MIRCI), she was known fondly as Sally.

Ruddick was also one of the most important influences that first moved me towards believing that fathering was an incredibly important focus for feminist scholarship. Her view, radical at that time, that "men are mothers" and that "men can and do mother" (Ruddick, *Maternal Thinking* 40) led me directly into my research on men and mothering and my book, *Do Men Mother?*—which built on and engaged directly with the parameters and possibilities of its title question. I was especially interested in how fathers' caregiving engendered personal and political shifts in families and communities, in ideologies and discourses, and in what feminist sociologist Dorothy Smith called the "relations of ruling" (3). As part of my intellectual training was in political philosophy, I was interested in the philosophical tenets of Ruddick's work and how she drew, for example, on Jurgen Habermas and Ludwig Wittgenstein to

make her argument that the primary care of children is neither an identity nor a set of tasks but rather a "social practice" (Ruddick, "Maternal Thinking" 214) that can and does lead to new ways of thinking and being. As Ruddick states, "All thinking ... arises from and is shaped by the practices in which people engage" (*Maternal Thinking* 9). In the case of primary caring for children, it is a "deeply rewarding, life-structuring activity that tends to create ... distinctive capacities for responsibility, attentive care, and non-violence" (Ruddick, "Thinking about Fathers" 225).

Inspired by Ruddick's work and guided by questions about men and mothering and feminism and fathering, I took up issues of everyday parenting practices in several studies with fathers who identified as primary or shared primary caregivers of children (first, a study of shared caregiving fathers in the U.K. in the mid-1990s, then single and stay-at-home fathers in Canada in the early 2000s, and then Canadian fathers who took parental leave in multiple studies beginning in 2006). Across these studies, I have often made the case that when men spend time caring for children, especially when they can do so without relying on women to take primary responsibility, the everyday trials and tribulations of their caring practices teach them the depth of what it means to be *responsible* for the care of children. As this book demonstrates so well, having such responsibilities for others can profoundly affect men's lives and how masculinities are enacted and experienced. Fathers start to recognize the values and skills involved in caring work, and they join mothers in advocating for more care-centred values, ideologies, and structural changes.

Although my research confirmed many of Ruddick's arguments, it also raised issues that she, as a philosopher, could not have foreseen. Indeed, I was fortunate to have the opportunity to discuss these issues with her at a 2007 MIRCI conference and then later, through several email exchanges, until she passed away in 2011 (Doucet, "Taking off the Maternal Lens").

Feminism and Fathering:
(Past) Challenges in Playgroups and Playgrounds

As is the case with many of the chapters in this book, for me, the links between feminism and fathering emerge from everyday parenting practices, in kitchens, in bedtime routines, or in managing the family calendar. Yet they also emerge on the wider social landscapes of parenting, in the play groups, schools, schoolyards, and parks where parents and children mingle. What I have learned is this: it is in these wider social landscapes that feminist optimism (including mine) about engaged fathering has faced challenges. In *Do Men Mother?* I described how my recognition of the uncomfortable fit between feminist ideals and fathering practices began partly because of one significant experience I had as a mother who shared parenting with a man who was harshly judged when he tried, in 1991, to join a local parenting group in England. His recounting of the excruciating details of being sidelined in a moms-and-tots group in Cambridge over several cold winter months highlighted how even the most ardent aspirations for engaged fathering can be tempered by a community's painfully hesitant acceptance of it.

I observed this resistance to primary caregiving by fathers again and again in my research throughout the 1990s and 2000s. One of the first stay-at-home fathers I interviewed, Sean, appears in several of my earlier published pieces. I carried his voice in my head for many years because the stories he told me demonstrated his stunning isolation and loneliness; the image that stuck with me was his description of feeling like he was drowning in a sea of mothers. He told me how every morning when he dropped his son off at school and every afternoon when he went to pick him up, he noticed that "all the mothers immediately sort of relate to one another," whereas the men "don't even talk to each other." As he moved through the community with his two young sons, he felt watched by other men, who looked at him like he was a "sissy." He told me that "being a male trying to make networks is difficult" (Doucet, "There's a Huge Gulf" 164).

A decade later, in the 2000s, in Canada, many fathers told me how they were still struggling with the mother-dominated culture of playgroups and schoolyards. They spoke to me about feeling surveilled and judged within the social landscapes of parenting, which one father referred to as "estrogen-filled worlds" (Doucet, *Do Men Mother?* 41).

Fathers who challenged heteronormative assumptions about families and parenting or who spent their days caring and not working for pay outside the home were entrenched in social judgments that viewed them as a "failed male" (Thorne 116), as incompetent or secondary caregivers, and, in some cases, as "potential pedophiles because of [their] interest in children" (Doucet, *Do Men Mother?* x).

Although sociocultural change is slow, it is also the case today, as this book illuminates so powerfully, that fathers of all kinds are facing greater social acceptance within communities. And arguments about essential or proscribed fathering identities or practices are now superseded by a burgeoning of attention in scholarship, in public discourses, as well as in everyday sites that attest to the greater diversity, complexity and nonbinary possibilities for fathering, gender, and parenting. In this sense, the chapters in this book tug at and reweave the threads of a reconfigured relationship between fathering and feminism.

Feminism and Fathering in the Third Decade of this Second Millennium: New Stories...

As you will learn in this book, there are, especially in the Global North, more examples of fathering models that centre caregiving, multiple parenting forms and reconfigurations, and new masculinities, including "caring masculinities" (Elliott). The chapters describe changing media images, cultural representations, and varied positive depictions of fatherhood and fathering in films, television shows, and memoirs. They also highlight several distinct cultural variations of fathering. Through its essays, research-inspired pieces, analyses of popular culture, personal stories, poetry, and even a letter from a father to his son, this book explores rich cross-disciplinary terrain and crafts new stories that open up fresh possibilities for families and for all genders.

Feminist Fathering/Fathering Feminists underlines how, in the past few decades, there has been a considerable widening of who fathers are and who is socially accepted as a father. The authors in this book highlight how, as Nicole Willey states in the introduction, "Transgender fathers, lesbian fathers, noncishet fathers (or men who are not straight and/or do not present as masculine), nonbiological fathers, and fathers who fulfill the role without legally adopting their children are all at play in real families today." This is a far cry from the restrictive models that

fathers, including my research participants and my partner, faced some twenty to thirty years ago.

This book combines feminism and fathering in creative and inspiring ways. It looks towards emergent possibilities for fathering and feminism and rightly encourages new conversations and receptiveness to different and more complex understandings. The book's aim is not to establish "a concrete, proscriptive set of feminist fathering dos and don'ts," as Dan Friedman mentions in the afterword; rather, it issues an invitation to readers to take up "the challenge of listening and engaging with the project of feminist fathering," as Willey states in the introduction. Highlighting heterogeneous and constantly changing entanglements between feminism and fathering with the radical goal of "uncovering, analyzing, and transforming oppressions where we find them," Willey further notes that "feminists, and feminist fathers in particular, commit to undoing patriarchy in not only their own homes, but in our shared communities and world."

These chapters embody what Anna Tsing calls a "kind of storytelling," in which "stories should never end, but rather lead to further stories" (287). This book does even more than that. It is about the kind of revolutionary change that Sally Ruddick dreamed about and hoped for. Reading this book, you can feel her smiling. Sally would have loved it.

Andrea Doucet

Works Cited

Doucet, Andrea. *Do Men Mother? Fathering, Care, and Domestic Responsibility.* University of Toronto Press, 2006/2018 Second edition.

Doucet, Andrea. "Taking Off the Maternal Lens: Engaging with Sara Ruddick on Men and Mothering." *21st Century Motherhood: Experience, Identity, Policy, Agency,* edited by Andrea O'Reilly, Columbia University Press, 2010, pp. 170-80.

Doucet, Andrea. "'There's a Huge Gulf between Me as a Male Carer and Women': Gender, Domestic Responsibility, and the Community as an Institutional Arena." *Community Work and Family,* vol. 3, no. 2, 2000, pp. 163-84.

Elliott, Karla. "Caring Masculinities: Theorizing an Emerging Concept." *Men and Masculinities,* vol. 19, no. 3, 2015, pp. 240-59.

Habermas, Jurgen. *Knowledge and Human Interests.* Beacon Press, 1971.

Haraway, Donna "Situated Knowledges: The Science Question in Feminism and the Privilege of Partial Perspective." *Feminist Studies,* vol. 14, no. 3, 1988, pp. 575-99.

Latour, Bruno. "Why Has Critique Run out of Steam? From Matters of Fact to Matters of Concern." *Critical Inquiry,* vol. 30, no. 2, 2004, pp. 225-48.

Ruddick, Sara. "Maternal Thinking." *Mothering: Essays in Feminist Theory,* edited by Joyce Treblicot, Rowman and Littlefield, 1984, pp. 213-30.

Ruddick, Sara. "Thinking About Fathers." *Conflicts in Feminism,* edited by Marian Hirsch and Evelyn Fox Keller, Routledge, 1990, pp. 222-33.

Ruddick, Sara. *Maternal Thinking: Towards a Politics of Peace.* 2nd ed. Beacon, 1995.

Smith, Dorothy. *The Everyday World as Problematic: A Feminist Sociology.* Northeastern University Press, 1987.

Thorne, B. *Gender Play: Girls and Boys in School.* Open University Press, 1993.

Tsing, Anna Lowenhaupt. *The Mushroom at the End of the World: On the Possibility of Life in Capitalist Ruins.* Princeton University Press, 2015.

Wittgenstein, Ludwig. *Philosophical Investigations.* New York Macmillan, 1953.

Introduction

Fathering and Feminism: Notes toward Understanding

Nicole L. Willey

"The power of fathers has been difficult to grasp because it permeates everything, even the language in which we try to describe it."—Adrienne Rich, *Of Woman Born*, 57-58.

Fathering is having its day. As a topic, it has arrived a little later to the forefront of parenting studies than mothering; part of the reason for this is that the male-public vs. female-private split has seemed natural since the industrial age. When men write about their experiences, it is often about their public lives; domesticity, family life, and the hearth have all been seen as the domain of women. And as Adrienne Rich astutely notes, the institution of fatherhood is hard to analyze, as it permeates everything. Fathers have often been experienced as a shadowy (though real) presence lurking in the background of women's and children's lives and stories. For instance, in the American literary tradition, if fathers are not absent altogether, they are often authoritarian or repressive; Josep M. Armengol-Carerra goes so far as to say that one theme in American literature is "fatherhood as absence" (211). Writing about and studying private fathering practices may have seemed secondary to the importance of men's public lives— the providing work of fathers—especially since the home was the domain of women. Furthermore, studying fathers seemed almost

counterproductive to the feminist goal of hearing, publishing, and analyzing motherlines, in which "mothers and children can develop a life-cycle perspective and worldview of interconnectivity with each other, with others, and with the world that offer[s] them opportunities and ways to create inspiring mothering perspectives and practices" (Green 10). Men's public stories have been the default for so long that celebrating fathers, perhaps, seemed beside the point.

Rich was likely my first access to sustained thoughts on fathers and fathering, her work being central to my own scholarship on mothers and mothering. So I came to fathering studies as a scholar of mothering. Thanks to MIRC, JMI and Demeter Press, through the efforts of Andrea O'Reilly and her staff, mothering studies is a force in academe. Motherlines are created and analyzed. Academics who are primarily literary critics, or creative writers, or gender studies theorists, or sociologists, or educators (and more) have powerful voices as they shape and transform the possibilities of mothering and family life across the world. This has been important work, and I am grateful to be a part of this burgeoning community of mother scholars.

So: why fathering, why this press, and why now?

Of course, since fatherhood as an institution is part and parcel of reproducing patriarchy, we, as feminists, must study it. In fact, we must study it because making the invisible visible is precisely what will help us fight back against the status quo. As Homi K. Bhabha notes, "masculine identity ... initiates a mobility, a movement of meanings and beings that function powerfully through an uncanny invisibility" (58). If masculine power retains its force through seeming natural due to its invisibility, then we must study it to shine a light on its power and also on its weaknesses. May Friedman notes that foregrounding fatherhood and fathering as a subject of study is important because right now "the relationship between dominant discourses of fatherhood and motherhood simultaneously marginalize fathers and allow fathers to avoid responsibility" (99). Yet, and as the scholarship shows, when fathers become involved with their children's lives in active and nurturing ways, it benefits the entire family unit. For instance, William Pollack writes the following:

If one piece of good news is that active, loving fathers have a lifelong positive impact on their son's development, and that fathers as primary parents seem to raise eminently well-adjusted,

self-confident boys, another is that these loving men themselves seem to derive ample benefits from their endeavors as fathers. Just as nurturing, generative fathering offers a powerful alternative to the limited love and support boys tend to experience in their outside emotional lives, research now shows that being such a father also has substantial positive repercussions for the men themselves. (133)

Although Pollack's study focuses on the parenting of boys and undoing harmful masculinities, these findings also apply to families with daughters in which a type of "nurturing, generative fathering" exists as well. Children benefit from active carework by fathers and the fathers benefit as well. The definition of fathering used to only extend to "an initial sex act and the financial obligation to pay" (Coltrane 4). But Scott Coltrane is just one of many fathering scholars who shows how the transformation of families to have greater involvement by fathers provides for "the potential of richer lives for men, more choices for women, and more gender equality in future generations" (4). All people have a stake in transforming fathering, since as Elizabeth Podnieks argues, "successes of maternal activism are dependent on a more personally and politically engaged fatherhood, and ... feminist motherhood is not possible without equally revised conceptions and practices of fatherhood" (Preface, xiv). For society to move forward with gender equality, fathers, along with their fathering practice, need to get on board. Fortunately, many fathers already see themselves as part of this feminist practice.

Who Are Fathers? What Is Fathering?

Feminist Fathering/Fathering Feminists: New Definitions and Directions is a collection interrogating several things at once. First, there is the question of definitions. What, specifically, is a father? Nancy Dowd says there are three basic "patterns" for fatherhood. From least to most involved, there are men who are "fathering as limited or disengaged nurturers"; "fathering as a secondary parent, supporting mothers in their full-time parenting role"; and "father[ing] like mothers in both substance and style" (4). Although Dowd's study shows that the "men who father like mothers" is the smallest group, other research indicates progress and change in this area. Pollack notes that in just one generation "not only do most fathers today want to be close to their

sons, they *are* close to them" (118). Pollack sees a slightly different role for fathers than mothers: "Fathers provide a flexible surface for their sons to bounce off, a play space with elastic but firm limits, a secure sense of love expressed not just in words but through actions" (121). But this model is not a monolith either, and problems do exist with the binaries Pollack assumes in this description. There are as many ways to father as there are fathers, and Myriam Miedzian notes that fathering need not be "masculine" or "macho," which is a trait her own father equated with the Nazis who overran his town (xx). Instead her father provided "very positive traits of initiative, independence, curiosity, courage, and abstract thinking, which have traditionally been connected with masculinity" (xxi). In her study of masculinity, Miedzian notes that "gentle, sensitive, caring men" are also often men who have "unusual courage, curiosity, [a] sense of adventure, and independence from societal pressures" (xxi).

Beyond noting the many differences among fathers, the research and our contributors' chapters clearly show that fathering in all its guises is in the process of transformation. Podnieks notes that since the 1990s, "fatherhood as an institution, practice, and responsibility has generated unprecedented consideration in cultural, political, economic, legal, and medical arenas" ("Introduction" 1). Her collection, *Pops in Pop Culture*, goes a long way towards rectifying the absence of fathers in considerations of popular culture (as opposed to simply studying men as default characters and progenitors of art and popular culture), and her introduction to the work gives an excellent review of the extant research on fathering from a multiplicity of disciplines. The field is burgeoning, alongside the increased involvement of actual fathers in their families. However, in the study *Fathering: Promoting Positive Fathering Involvement*, the editors show that "new fathers" are now getting a lot of credit as caretakers while, at the same time, they are still assumed to be inferior to mothers (Devault et al. xi). Fathers are making strides, but the politics and reality of gender difference are still holding all of us back.

Fathers are changing their role, and are more involved than ever. Annie Devault, Gilles Forget, and Diane Dubeau define these "new" fathers in the following way:

This new dad works alongside mom or his gay partner to be engaged with and attentive to the kids, takes his share of responsibility for planning activities, and when the opportunity arises,

takes parental leave or becomes a stay-at-home dad so that his partner can take advantage of the higher income that he or she can earn. And, if there is a separation or divorce, there is a growing expectation that men will be granted their fair share of custody. (xi)

Similarly, Pollack notes that "if past research showed that most fathers spent significantly less time with their young sons than mothers did, the trend is now moving towards expanded commitment, with a greater than 20 percent increase in fathers' overall family involvement over the past ten years" (131). And this seems great. These growing expectations and hours of work put in are helping everyone—or are they? Devault and her co-editors show that "studies indicate that men have increased the time they devote to child care—but only incrementally and still disproportionately compared to women" (xi). And Pollack admits that fathers today "spend approximately 30 percent of their time (as opposed to mothers' 70 percent) on family-related activities" (131). Clearly, true parenting equality has not arrived, which leads us back to the question of who, actually, is a father?

Even a couple of decades ago, defining fathers as men would have seemed like common sense, but that is not the case today. Collectively and individually in this collection, we, as intersectional feminist authors and editors, have had to understand that there is no monolithic father and that fathers may not be tied to sex and gender roles in ways that were previously proscribed. How do we understand fathers when they are traditionally attributed with bringing provision, protection, and authority to their children, yet women are now increasingly providing these same functions (Frye 27)? Definitions and roles overlap, and there is no one way to discuss fathers: "The reality of a gay dad in New York City is distinct from a single father raising a child in a rural setting. Fatherhood, like motherhood, is informed by social location. Sexuality, gender, age, race, ethnicity, class, and ability all shift the lens through which dominant discourses of fatherhood may be transgressed" (Friedman 88). In addition to noting the differences present in individual fathers, we also must observe that fathers may not be "biologically or legally related, and fathering doesn't have to be heteronormative or even male" (Podnieks, "Introduction" 11). Transgender fathers, lesbian fathers, noncishet fathers (or men who are not straight and/or do not present as masculine), nonbiological fathers, and fathers who fulfill the

role without legally adopting their children are all at play in real families today. Additionally, "fathers who fall outside dominant constructions of white, able, heterosexual fatherhood face additional barriers to their social inclusion related to their citizenship-immigration-refugee status, language, religion, socio-economic status, ethnicity, ability, and sexual orientation, among other factors" (Devault et al. 15). Underlining the importance of studying all fathers, we agree with the following statement:

> even white, middle-class fathers tend to be excluded from parenting policy, research, and programming. Unless challenged, their social exclusion in the domain of fatherhood will serve to maintain polarizing gender norms and the status quo that structures men's roles as being "outside the home," or men as "absent parents" ... maintain[ing] the construction of women as "natural" primary caregivers. (Devault et al. 17)

If we want to undo harmful gender roles, defining fathers is both more critical and harder to do than it seems at first glance, so we have made efforts to include essays from as many perspectives as possible. Admittedly, this collection cannot include all voices and vantage points, but we hope it will be just the first of many more explorations of feminist fathering.

Fathering Benefits and Limitations

The expansion of definitions of fathers and fathering, when it includes more involvement and nurturance, can help families and individuals, as well as society as a whole, with the seemingly intractable problem of gender role inequality. Over forty years ago, Rich's hope that our sons and daughters would "grow up unmutilated by gender-roles, sensitized to misogyny in all its forms" (207), has still not come to fruition. To realize Rich's dream, the current and next generation of fathers must parent outside of current gender roles, enabling a future of equality. Girls must be trained not to accept misogyny and be shown positive partnership models free from sexism. The parenting of sons is also a feminist concern, as boys and men reap the most rewards from propagating the gender status quo. Pollack writes that "the best parenting of sons will be achieved when mothers and fathers transcend gender straitjackets in actions as well as words" (104). Undoing familial

gender roles is desired, yet Pollack highlights the following problem: "In real life, couples tend to split up roles, with each partner doing whatever he or she feels most comfortable with. This can lead to a pernicious pattern where mothers do more nurturing and daily care and fathers do more disciplining. The real problem with such a pattern is that it perpetuates the rigid stereotypes we hope to teach boys to overcome" (Pollack 104). Unfortunately, many families do fall back on learned familial patterns from their own childhoods, unless they are consciously engaged in change. Gentle, loving, and nurturing fathers, of all types, who model nonviolent parenting, have the best shot at moulding nonviolent sons, and by extension, daughters who refuse to tolerate violence. Miedzian further points out that "families in which child-rearing is shared by the parents or in which the father is the primary caretaker reveal that the sons in these families are more empathic than boys raised in the traditional way" (82). In fact, "paternal involvement in child care" is the "single factor most highly linked to empathic concern" in children (Miedzian 82). Fostering empathy among their children is a goal all thoughtful parents should have and nurturing carework by fathers plays a huge role in that development.

One mother raises her largest concern about parenting a son, which is that she raise a boy "who does not think of women as lesser beings" (O'Donnell 173). To raise feminist fathers, we, as intersectional feminist parents, must focus on undoing sexism and misogyny in our sons and must teach our daughters, many of whom will become mothers, to recognize and reject sexism and misogyny. Breaking down rigid gender roles in the home is one way to ensure that such patterns do not replicate in the next generation. As Gary Lee Pelletier and Fiona Green write, "to foster a greater societal ethic of care, specifically a feminist one ... gender-essentialized norms should be contested" (2). Furthermore, if we can break down these gender-based straitjackets in our homes, and if our society can begin to see that "men can and do care, it should be accordingly disproven that women have some natural affinity for care work" (Pelletier and Green 2). The realization that fathers can, do, and should provide carework in their families will help free everyone from forced gender roles and will prevent the reproduction of traditional gender roles.

The problem many feminist individuals have with recognizing fathers' parenting abilities is explored by Andrea Doucet when she

discusses different types of feminism and how these play out in terms of our lives and policy. In *Do Men Mother?*, Doucet explores the limitations of both feminisms of difference and feminisms of equality in regards to fathering. She notes that a feminism of difference keeps mothers and fathers in their own roles, reproduces gender roles and stereotypes, and extolls mothers but does not recognize (or hold responsible) fathers in their parenting. Conversely, equality feminisms may recognize that fathers can do carework, but this only continues the privatization of carework within the home, dividing the labour that keeps mothering underappreciated and underpaid (21-24). So how do we resolve this conundrum? If we wish to note and encourage the benefits of nurturing and active fathering for all involved, how do we ensure this involvement does not simply become a tool of patriarchy in keeping carework invisible and devalued? Doucet explores this as well: "What is needed for greater parity in mothering and fathering: Such measures would include income equity for women, greater acceptance by employers of fathers' use of parental leave, and work flexibility options for both men and women. It would also mean recognizing the possibility that men can nurture and care for children" (50). Although active fathering should help spread the burden of parenting more evenly, it does run the risk of reifying carework as feminized and private. If parenting is seen as solely an individual responsibility, then it will always be undervalued instead of being given appropriate societal supports for the important work that it is.

As Sara Ruddick notes, because women are the primary ones doing maternal work, it looks feminine and is often undervalued. In her ground-breaking work *Maternal Thinking: Toward a Politics of Peace*, she defines mothers in the following way: "Briefly, a mother is a person who takes on responsibility for children's lives and for whom providing child care is a significant part of her or his working life. I *mean* 'her or his.' Although most mothers have been and are women, mothering is potentially work for men and women" (40). Ruddick's famous definition of mothering helps us understand both the importance of fathers' potential as nurturers as well as the possibility of furthering the damaging feminization of nurturing through seeing all parenting work as maternal. Ruddick is absolutely correct in noting that "we don't know what our biological 'differences' would look like outside of social constructions of gender," which leads her to suggest the following:

There is no reason to believe that one sex rather than the other is more capable of doing maternal work. A woman is no more, a man no less "naturally" a mother, no more or less obligated to maternal work, than a man or woman is "naturally" a scientist or firefighter or is obligated to become one. All these kinds of work should be open to capable and interested women and men. (41)

Reinforcing gender roles is contrary to the project of raising whole children and of remaking society in a more egalitarian way; thus, Ruddick's work is instrumental in emphasizing that nurturing parenting can be done by anyone.

Michael J. Diamond notes that undoing harmful stereotypes should be part of our efforts as feminist parents: "In Western societies, despite efforts to reduce ... gender splitting, the underlying cultural images for masculinity generally continue to mean being rational, protective, aggressive, and dominating, while those for femininity mean being emotional, nurturing, receptive, and submissive" (5). Nurturing the carework and parenting done by all kinds of fathers will ultimately undermine gender stereotypes and set the stage for a new gender equality. This collection is part of that effort, but we recognize that analyzing feminist fathering is only a part of the work; together with our contributors we are making visible what is possible. We need to continue to move toward policies that will give everyone, and every family, greater chances at reaching equality.

Which Feminism(s)?

This book is dedicated to undoing patriarchy, defined by Rich in the following way: "Patriarchy is the power of the fathers: a familial-social, ideological, political system in which men—by force, direct pressure, or through ritual, tradition, law, and language, customs, etiquette, education, and the division of labor, determine what part women shall or shall not play, and in which the female is everywhere subsumed under the male" (57). Feminist fathers should therefore be concerned with not perpetrating or perpetuating patriarchy; they should be aware of their own privileges and actively work to undo the gender binaries that lead to such privileges. As scholars working on the problems of the patriarchy, we have collectively brought feminist theory and thinking

to our methodologies and lenses to find, develop, and define feminist fathering where we see it (and where we wish to see it). Of course, in the same way that fathers and fathering cannot be easily defined, feminism, and the fight against the patriarchy, is not a singular monolithic effort or unified theory either. As editors, we have pushed our contributors to think through their feminist theories and methodologies, which has resulted in the multiplicity of feminisms found in these pages. The contributions use an intersectional feminist framework—which takes into account the spirit of Kimberle Crenshaw's work—to understand and dismantle the many and overlapping points of oppression that an individual can face related not only to sex and gender but also to race, class, ability, age, nationality, and any number of other identity positions. As intersectional feminists know, white middle-class women's feminism is not real feminism at all, as it does not do enough to take into account multiple forms of oppression. And following O'Reilly, we use as a starting point a holistic definition of feminism:

> I rely on a very open-ended definition of feminism: the recognition that most if not all cultures are patriarchal and that they give prominence, power, and privilege to men and the masculine; they depend on the oppression, if not disparagement, of women and the feminine. Feminists are committed to challenging and transforming this gender inequity in all of its manifestations: cultural, economic, political, philosophical, social, ideological, sexual and so forth. As well, most feminisms (including my own) seek to dismantle other hierarchical binary systems, such as race (racism), sexuality (heterosexism), economics (classism), and ability (ableism). (48)

In this collection, we are committed to uncovering, analyzing, and transforming oppressions where we find them; we are also interested in the ways in which feminists, and feminist fathers in particular, undo patriarchy not only in their own homes but also in their communities and in the world. This is a tough job for all parents, and one in which perfection is not possible. But in imperfect ways, we, and the fathers we *are, study,* and *emulate,* are working toward gender equality in and through our parenting practice.

Elizabeth Bartlett and Joanne Frye both highlight the importance of

feminist parenting that takes place not only in the private sphere but in the public world as well. Bartlett writes that "we should be working for social justice more broadly, to give support for 'self-determination' in marginalized groups" (34). Frye agrees and pushes all feminist parents toward more social activist work: "And we must continue to work for the institutional changes that support parenting: paid parental leave that also takes into account the distinctive requirements of pregnancy, childbirth, and breastfeeding; universal free early childcare; and affordable after-school care for older children" (28). Social pressure toward these types of changes would support all parents and children. In the meantime, transforming our homes will help nurture the next generation and will get them ready to fight for continued social equality. Although the difficulties for parenting/fathering outside of the mainstream are real, this practice can also allow for productive transgression of the status quo. Jake Pyne notes that "Trans parents in [his] study preserved gender options for their children, expanded notions of biological possibilities, negotiated new identities, and role modeled authenticity and embodiment" (127). If trans parents can help their individual children experience more gender equality, their very being also changes ideas of parenting and helps to "unsex mothering as the primary parental relationship and ... unsex fathering as breadwinner" (Lowik 212). Neither fathers nor feminism are monolithic. *Feminist Fathering/Fathering Feminists* is interested in the complex ways fathers, fathering, and feminism are defined, and the approach of our collection is as intersectional and inclusive as possible.

Feminist Fathering Is Feminist Parenting: Exploring New Models

By definition, there is a power differential in the parenting relationship. Lynn Comerford, Heather Jackson, and Kandee Kosier write: "Feminist parenting affects the political, economic, emotional, symbolic, and physical conditions of women's and men's lives. To be a feminist parent is to confront and correct systemic gender inequalities and injustices associated with parenting children" (1). And therein lies the paradox: how do we parent against oppression or parent "applying the values of non-oppression and non-domination" (Bartlett 23) in our relationships, when parents by default have a dominant role in their

relationships with their children? Bartlett applies an "honourable relationship," using Rich's term, in which she commits "to raising and nurturing this child in [her] care with honesty and respect, with validation of his perceptions, and with honouring of his truths" (26). Feminist parents have to "consciously parent from a feminist perspective, by which [they are] respecting individual rights and opposing acts of domination and oppression" (Comerford et al. 2), including the need to "own up to instances when they acted unjustly" with their children (Bartlett 35). Needless to say, feminist parents of any identity will have a hard time living up to these ideals one hundred per cent of the time, but we must nevertheless try.

Is it fair to ask the same thing of feminist fathers that we do of feminist mothers? O'Reilly defines feminist mothering in the following way:

> A feminist mother challenges male privilege and power in her own life and the life of her children. In her own life, then, a feminist mother insists on gender equality in the home and on a life and identity outside of motherhood. As well, feminist mothering would ensure that the important work of mothering would be culturally valued and supported and that mothers, likewise, would perform this motherwork from a place of agency in authority. In the context of children, feminist mothering means dismantling traditional gender socialization practices that privilege boys as preferable and superior to girls and socialize boys to be masculine and girls feminine. Feminist mother, thus, seeks to transform both the patriarchal role of motherhood and that of childrearing. (48-49)

According to this definition, it is clear that certain parts of feminist parenting will at once be easier and more challenging for men; this is not just a flipped script. For a father, especially those who are men, to challenge male privilege and power is to confront and undermine his own privilege, a privilege that can be both comforting and invisible. Insisting on gender equality in the home is more difficult than it sounds for any parent, but feminist fathers should try to do this for their partners and for their children. A feminist father should insist that mothering be culturally valued and supported and help mothers parent from a place of agency in authority, to follow O'Reilly's thinking. But fathers often

simply act as the disciplinarian, which is a stereotypical gender role, while the problems of reifying the feminization of mothering work have already been discussed. Feminist parenting—whether from a mother or father—is a tall order, and its difficulties are easily apparent to any parent who has made good faith efforts to be a feminist parent.

Continuing with O'Reilly's line of thinking, feminist fathers, of course, should value daughters and sons equally, and not socialize boys and girls along gender-appropriate lines. The problem here becomes a conflict of social acceptability, particularly for those children who form identities that can and will be attacked (O'Reilly 55). As Bartlett notes, "the harsh reality is that no matter how much a parent raises a child without oppression and domination, forces of domination, nevertheless, exist outside the home in the form of other adults ... as well as older and bigger children" (31). The stakes are higher for some children. Bartlett asks the following question: "Is it fair, prudent, or simply privileged of me to suggest such an approach when the consequences for transgressing cultural norms or questioning authority for my white middle-class heterosexual son are likely to be far less severe than if he were black or queer or working class?" (Bartlett 33). Indeed, the real world will raise its ugly head—seemingly more now than ever in the context of Trump's mark on America—in opposition to the efforts of feminist parents, but that does not mean we should give up. Investing in feminist parenting is an investment in our children and in the future because it will allow all parents "to invest in the wellbeing of their children" (Frye 25). Joanne Frye uses the lenses of maternal thinking, fatherhood, and parenting to "consider the idea of 'parental thinking' as a practice deriving from the ongoing and active commitment to caring for children, shaped by current constructions of gender but available to both men and women" (15). Feminist parenting will hopefully enable a future free of sexism, racism, ableism, classism, hetereosexism, and xenophobia. Feminist parents of all stripes, including feminist fathers, are making a better future possible right now. As Bartlett writes, "If we, as parents, do not perpetuate the power dynamics of patriarchy and our children do not perpetuate them as well, then we engage in the work of disrupting and subverting their very foundations" (24). This should be the goal of every feminist parent.

But even self-proclaimed feminist fathers question the project of feminist fathering and its boundaries. Wesley Buerkle suggests that it is

difficult for a feminist man to be a partner when there are no clear models or firm roles. Consequently, Buerkle has struggled with his role of caring for his partner instead of taking control: "Whether it stems from my deep concern for those I love or my inability to resist taking over—what can be called a feminine desire to care and tend for another or the masculine propensity to control others—I began to take charge" (183). Teasing out these difficulties and providing role models and, ultimately, definitions for feminist fathering is what this book attempts to do. As our contributors show, we are not yet individually or as a society fully clear about what feminist fathering is or should look like, but we are getting there. We are hopeful our book will begin to help provide some of the discussions and visibility necessary for fathers like Buerkle.

My Story[1]

I am an academic who has been at work on mothering issues since before I was a mother. My undergraduate senior thesis was on the mothers in the works of Margaret Atwood and Toni Morrison. My master's thesis was on motherlines in the works of Jamaica Kincaid and Buchi Emecheta. During my doctoral program, I started to realize that studying masculinity would help with both my public (scholarship and teaching) and personal (family and relationship) projects of feminism. And then I became a mother. I left masculinities behind and dug into the motherline and published individual articles on mothering as well as co-edited an edition about motherhood memoirs for Demeter Press in 2013.

My interest in fathering has arrived gradually. As a feminist, honouring women and mothers took precedence for me, but as I have lived my own experience, I have realized the importance of fathers in my life. Both of my grandfathers were loving men to their families and to me. My maternal grandfather, Elmer Rice, taught me how to play checkers (by never going easy on me), taught me the dangers of smoking (by letting me take a puff of his pipe when I was about four—oh the coughing fit that ensued), and seemed to always have time to be with me—whether it was watching morning television game shows, trying to get me to crochet, or just talking. My paternal grandfather, Gordon Willey, was the person my sisters, cousins, and I most wanted to sit by

at dinner. He worked a swing shift for the federal government while I was a child, so when we visited him, we would defer to his schedule and would eat a first breakfast and then a second breakfast with him around 1:00 p.m., always vying for his attention and the seat next to him. He would make us laugh by taking out his dental bridge and eating every part of the orange or apple, except the seeds, and by telling the same jokes over and over again.

And it is my father, Walter Willey, to whom I attribute my early feminism. He was not (and maybe is not) a feminist per se, but having three daughters, he refused to let us be reliant on anyone else, most especially a man, for money, car help, or anything else. We knew how to check our fluids, change a tire, shovel snow, and bring in wood. We also knew that we could be anything we wanted and that we should consider making a living along with having a vocation. My parents never shied away from discussing our family finances or how we should budget. They gave guidance but not (usually) demands. When I asked my mother—a long-time business owner and tax preparer—to be on a panel of feminist women I was putting together in college, she surprised me by asking if I was sure I wanted her to. I asked what she meant, and she said the following: "I'm afraid I won't say what you want. I'll explain that it is really your father who made me see owning my own business as a possibility, and he has supported me every step of the way." And he did, even working on her business late into the night with her after his own job as a chaplain was done for the day. I definitely witnessed loving relationships through my grandparents' my parents' marriages. In my parents' relationship, I additionally saw an egalitarian partnership, in which two parents decided everything together, took care of their kids together, and worked side by side to build the life and family they had.

Not surprisingly, I also married a man who would be a true partner. A self-avowed feminist and medieval scholar, we met in our master's degree program. Unlike previous boyfriends, he wooed me by becoming my best friend before anything else. One memorable day, he sealed my burgeoning romantic interest in him by telling me not only that he wanted to be a father but that he knew he would be a good one, as his primary example showed him what not to do. We have been together for over twenty years, and we now have two boys. These boys are our most challenging and important feminist project. I want to raise boys who will never expect someone else, especially a woman, to do household

work for them. I want to raise boys who understand the dangers of toxic masculinity and male privilege. This is particularly important as my sons are also middle-class, white, American citizens. So in becoming a mother to boys, I redoubled my efforts on studying masculinity, and I eventually found my way to examining fathering. My hope is that this collection will continue to inform both my own parenting practices and my partnership and that it will also positively affect my sons.

The Chapters

Through memoir or more traditional academic pieces, each contributor defines feminist fathering and provides examples of fathers who meet, exceed, or fall short of certain expectations. Transgression has emerged as a major theme of this collection. If we look outside of the mainstream, to people bucking the status quo, we will often have a better chance of finding models of feminist fathering. The experiences of single fathers, queer fathers, people of colour, and people in the process of defining, redefining, and questioning assumptions about fathering in their lives will help us to understand the possibilities of feminist fathering.

Our book starts with the personal—a poem by Donna Gelagotis Lee ruminating on the role fathers and father figures can play in our lives. Our first section, "Fathers in Popular Culture and Literature" includes essays exploring the possibilities for feminist fathering as seen in fictional and creative works. The first chapter by Debra Michals explores images of a new fatherhood in several 1960s television sitcoms, in which the fathers are pushed into the primary parenting role through widowhood. Her analysis convincingly shows that these television widowers provided models of a nurturing masculinity, which was perhaps more palatable to a wide audience because they were free from the spectres of divorce and women's liberation. In chapter two, through a wide-ranging survey of stay-at-home fathers, Steven D. Farough argues that a father staying home to raise children is not in itself a feminist act. Using a variety of popular press and pop culture referents, he problematizes the notion that men who stay home are helping the feminist cause. Jeff Karem's analysis of Laila Halaby's *Once in a Promised Land* in chapter three discusses fathering challenges and successes in both the novel and in his own experiences. He sheds light on the additional complexities of finding community as a descendent of Lebanese immigrants and explores his

own and the novel's feminist fathering examples.

Chapter four by Katie Barnett focuses on feminist fathering in the film *The Descendants*, which is about a father pushed to the primary parenting role through the death of his partner. Through George Clooney's character Matt King, the viewer follows a grieving husband and father struggling to relate to his daughters after their mother's death. Both his masculinity and paternity are discussed, which highlights a father learning a new path. Nancy Bressler discusses the television show *Black-ish* in chapter five and shows the character Dre to be a father who excels in feminist fathering in some cases while falling short in others. With her intersectional feminist lens, she showcases a self-aware and progressive father, who still reifies patriarchy at times in his differential parenting of his son and daughter and his uncritical consumerism. Moving away from visual depictions but staying with a television and film star, in chapter six, I interrogate Neil Patrick Harris' model of queer feminist fathering as put forth in his memoir. Fathering, and his joy at being a father, suffuses the entire book, and although he does not claim to be a feminist father, I use his memoir as a case study in the possibilities of feminism for queer fathering. In chapter seven, Marina Bettaglio studies Spanish paternal memoirs and the advent of a new fathering model in Spain; she questions whether the new Spanish father is a sign of non-normative gender roles or is simply a tool of neoliberalism.

The second section, "Fathering in Personal Contexts," moves away from cultural representations and into the lived experience of fathers and families. Bruna Alvarez in chapter eight explores egalitarian parents in Spain and points out some of the benefits and pitfalls in feminist fathering there. Alvarez's study of real couples in which fathers provide much of the carework, shows that feminist women are less likely than their nonfeminist counterparts to accept the greater involvement of their partners as fathers as good enough when it still falls short of mothering carework. Ginger Bihn-Coss's chapter nine is an autoethnographic work about the decision her family made for her partner to be a stay-at-home father. Bihn-Coss discusses the challenges and successes they both face in their non-normative roles. In chapter ten, Lee Kahrs shows us what it means to be a lesbian father to her child and explores her own father as a role model as well as the difficulty of parenting an adult who is going through divorce, and in chapter eleven, Stuart Leeks explores his growth

as a feminist and feminist father and how he models to his own children and his students what it means to be the primary parent as well as an egalitarian partner. Finally, Jed Scott's letter to his oldest child, chapter twelve, rounds out our collection, as he gives his son specific rules for being a male feminist and shares personal stories of his family of origin and the family he created with his wife. Scott's essay is an appropriate place to end, since it asks which rules to follow to get where we want to go. This collection presents challenges for all of us, and we hope that the reader is up to the challenge of listening to and engaging with the project of feminist fathering.

Endnotes

1. I use here the divide between the institution of motherhood and the act of mothering and extend the same terminology to fatherhood and fathering (Podnieks, "Introduction" 10). The institution is always seen as more monolithic than the messiness and play of actual parenting.

2. Dan Friedman's story is present in the Afterword of this collection.

Works Cited

Armengol-Carrera, Joseph M. "Where Are Fathers in American Literature? Re-visiting Fatherhood in U.S. Literary History." *The Journal of Men's Studies,* vol. 16, no. 2, 2008, pp. 211-26.

Bartlett, Elizabeth Ann. "Feminist Parenting as the Practice of Non-Domination: Lessons from Adrienne Rich, Audre Lorde, Sara Ruddick, and Iris Marion Young." *Feminist Parenting,* edited by Lynn Comerford et al., Demeter Press, 2016, pp. 23-37.

Bhaba, Homi K. "Are You a Man or a Mouse?" *Constructing Masculinity,* edited by Maurice Berger et al., Routledge, 1995, pp. 57-65.

Buerkle, C. Wesley. "Just Along for the Ride?: A Father-to-Be Searching for His Role." *Essential Breakthroughs: Conversations about Men, Mothers, and Mothering,* edited by Fiona Joy Green and Gary Lee Pelletier, Demeter Press, 2015, pp. 179-91.

Coltrane, Scott, *Family Man: Fatherhood, Housework, and Gender Equity.* Oxford University Press, 1996.

Comerford, Lynn, et al. "Introduction." *Feminist Parenting*, edited by Lynn Comerford et al., Demeter Press, 2016, pp. 1-20.

Devault, Annie, et al. "Introduction." *Fathering: Promoting Positive Fathering Involvement*, edited by Annie Devault, Gilles Forget, and Diane Dubeau, University of Toronto Press, 2015, pp. 3-13.

Diamond, Michael J. "Evolving Perspectives on Masculinity and its Discontents: Reworking the Internal Phallic and Genital Positions." *Masculinity and Femininity Today*, edited by Ester Palerm Mari and Frances Thomson-Salo, Karnac, 2013, pp. 1-24.Doucet, Andrea, *Do Men Mother? Fathering, Care and Domestic Responsibility*. University of Toronto Press, 2006.

Dowd, Nancy, *Redefining Fatherhood*. New York University Press, 2000. Friedman, May. "Daddyblogs Know Best: Histories of Fatherhood in the Cyber Age." *Pops in Pop Culture: Fatherhood, Masculinity, and the New Man*, edited by Elizabeth Podnieks, Palgrave, 2016, pp. 87-103.

Frye, Joanne S. "Parental Thinking: What Does Gender Have to Do with It?" *Essential Breakthroughs: Conversations about Men, Mothers, and Mothering*, edited by Fiona Joy Green and Gary Lee Pelletier, Demeter Press, 2015, pp. 14-31.

Green, Fiona Joy. "Empowering Mothers and Daughters through Matroreform and Feminist Motherlines." *Journal of the Motherhood Initiative for Research and Community Involvement*, vol. 9, no. 1, Spring/Summer 2018, pp. 9-20.

Green, Fiona Joy, and Gary Lee Pelletier. "Introduction." *Essential Breakthroughs: Conversations about Men, Mothers, and Mothering*, edited by Fiona Joy Green and Gary Lee Pelletier, Demeter Press, 2015, pp. 1-13.

Miedzian, Myriam. *Boys Will Be Boys: Breaking the Link between Masculinity and Violence*. Doubleday, 1988.

O'Donnell, Rachel. ""That's Not What Boys Do": Mothering a Boy Child, Resisting Masculinity, and Coming to Terms with Manhood." *Feminist Parenting*, edited by Lynn Comerford, Heather Jackson, and Kandee Kosior, Demeter Press, 2016, pp. 168-177.

O'Reilly, Andrea. "Feminist Mothering." *Feminist Parenting*, edited by Lynn Comerford et al., Demeter Press, 2016, pp. 38-62.

Podnieks, Elizabeth, ed. *Pops in Pop Culture: Fatherhood, Masculinity, and the New Man.* Palgrave, 2016.

Pollack, William. *Real Boys: Rescuing our Sons from the Myths of Boyhood.* Random House, 1998.

Pyne, Jake. "Complicating the Truth of Gender: Gender Literacy and the Possible Worlds of Trans Parenting." *Chasing Rainbows: Exploring Gender Fluid Parenting Practices,* edited by Fiona Joy Green and May Friedman, Demeter Press, 2013, pp. 127-44.

Rich, Adrienne. *Of Woman Born: Motherhood as Experience and Institution.* Norton, 1976.

Ruddick, Sara. *Maternal Thinking: Toward a Politics of Peace.* Beacon Press, 1989.

Your Father[1]

Donna J. Gelagotis Lee

Content in a boat.
No one has the oars
For this moment.
No one knows that there
Will be few summers
To come where you
Row out together
On that silver lake.

So now, here
You both are,
In this photograph,
Years in sepia,
The past dulled.
But there's no
Mistaking
The arms around
You, the love
That holds.
There's no
Mistaking who
Would be here
If he could.

1. Published with permission from Donna J. Gelagotis Lee's book. *Intersection on Neptune.* The Poetry Press of Press Americana, 2019.

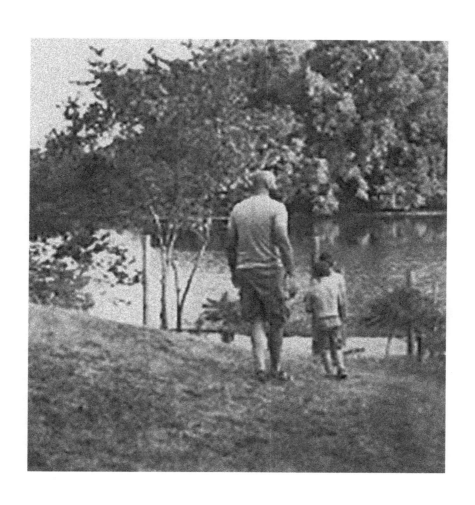

Section I

Fathers in Popular Culture and Literature

Chapter One

Dads Can Cuddle, Too: Feminism, 1960s Sitcoms, and the Making of Modern Fatherhood

Debra Michals

The 1960 pilot episode of the television sitcom *The Andy Griffith Show* opens with the wedding of a young couple, which is performed by Andy Taylor (Griffith's character)—a sheriff and justice of the peace in the fictional, rural town of Mayberry, North Carolina. The ceremony takes place in Taylor's office and in attendance are a small boy—Taylor's five-year-old son Opie—and Deputy Barney Fife, who serves as a witness. Andy Taylor barely completes the line, "Speak now or forever hold your peace," before Opie leaps to his feet to object. The child tries to stop the wedding several times, even jumping up on a desk to loudly make his case, because he knows that once married, the bride Rose will no longer be his hired caretaker, and Opie has clearly become quite attached to her. The rest of the episode is spent setting up what will become the structure of the Taylor family: the arrival of Rose's replacement, Aunt Bee, an aging, never-married relative who had raised Andy (although no one ever mentions why) and will now come to perform the same household tasks necessary for his young son Opie. Even though the child balks at the idea of this woman being a suitable replacement for his beloved Rose, Opie later warms to the idea when he worries that without him, Aunt Bee may be alone without a family ("The New Housekeeper").

Like an increasing number of situation comedies throughout the 1960s and into the 1970s, *The Andy Griffith Show* was the tale of a widowed or single father trying to raise a child. Missing was the standard-issue wife and mother typical of earlier and still more dominant, intact family-based situation comedies. Instead, in this show and many others throughout the 1960s and early 1970s—notably, *My Three Sons, Gidget, Family Affair,* and *Courtship of Eddie's Father*—a single, usually widowed, man was left to play the dual roles of father and mother, assisted by a "surrogate," a male or female relative or hired housekeeper who managed the home and did the housework as a mother would (Liebman 22, 120, 131-32, 135, 183-85). In the case of *My Three Sons*, it was first Bub (the grandfather and father-in-law) and later Uncle Charlie; on *Family Affair*, it was the hired valet-turned-nanny Mr. French; and on *Courtship of Eddie's Father*, it was the paid Japanese American housekeeper Mrs. Livingston (who had lost her own son and husband in a tragic car accident).

What makes these 1960s single father sitcoms significant is that they collectively represent, and contribute to, a transitional moment in the history of masculinity in fatherhood. The representation of fatherhood in single-father sitcoms provided a bridge between older, patriarchal ideas about what it meant to be a father (i.e., a breadwinner as well as an authority figure) and the possibility of feminist or feminist-inspired fatherhood for present and future generations of young men, who increasingly looked to popular culture for reinforcement about acceptable masculinity. At a time when almost all American homes had televisions, single-father sitcoms mainstreamed a newly expansive definition of masculinity in fatherhood that prized and encouraged the expression of emotions, affection, and nurturance of children—all previously pre-scribed as mothering behaviours, which were also (and continue to be) central tenets of feminist ideals about good parenting. These sitcoms increasingly addressed the rigidity of expectations about manliness and, at times, issues of inequality.

Such ideas marked a break with traditional norms of fatherhood depicting men as brave, strong, and unemotional role models, who provided for their families under any circumstances, such as during World War II or the old War climate that followed (Samuels 53). These patriarchal ideals were reinforced by the image of the breadwinning father of 1950s sitcoms, (e.g., *Leave it to Beaver, Ozzie and Harriet,* and

Father Knows Best), who dispensed discipline and worldly wisdom but never provided physical or emotional affection (Liebman 118-23; Pehlke 114-15). But that began to change in the 1960s; influenced by the social climate of the era, single-father sitcoms offered a kinder, gentler model of fatherhood in which men were free to express love for their children and concern for their psychosocial development yet could still be seen as masculine men. Such positive television images and challenges to traditional gender norms, in turn, gave contemporary and future generations permission to broaden their understanding of fatherhood. In this way, these sitcoms helped to mainstream a more flexible and feminist-inspired fatherhood that began in the 1960s and early 1970s and continues to influence parenting ideas in the present (even if often without embracing the term "feminist" or understanding the connections to earlier feminist ideals and movements.) These shows, then, represent the bridge between prefeminist and feminist-influenced fathering norms.[1]

Single-father sitcoms and their white male creators and writers were undoubtedly grappling with the impact of the immense social and cultural changes of the 1960s on family life and, in particular, on what these changes would mean for men's roles within the family (Liebman 22, 31, 52, 63). Specifically of concern were escalating divorce rates, a surge in working mothers, and, importantly, the rise of the women's movement. These shows seemed to ask: if women leave the home for any reason (to pursue education and jobs or to end a bad marriage), what does that mean for men's roles within the home? In some ways, feminism, which helped advocate for several of these changes, also helped smooth what could have been a far more awkward and resistant transition by providing alternative visions not only for social equality writ large but also for gender roles within the family. The feminist movement of the 1960s and 1970s recognized and sought to overturn patriarchal power and privilege, and with it, restrictive notions of gender and the biases that blocked women's advancement and self-determination in all aspects of their lives. Feminist demands for reconfigured gender roles shifted the discourse on parenting and created a space for men to be more emotionally open and for Hollywood to promote this new emotional and psychological nurturance of children as part of masculinity. In effect then, feminist ideas, along with the device of the single father, enabled these 1960s sitcoms to experiment with gender roles by having fathers

engage in the emotional aspects of childrearing typically handled by mothers (Liebman 131-32). At the same time, however, single-father sitcoms preserved traditional gender norms with a strict demarcation of men's and women's domestic work within the family by having surrogates do the housework (Liebman 22, 119-20, 183-84)—thereby allowing men to simultaneously embrace a more feminist model of fathering while maintaining their status as "masculine men."

But what does it mean to be a feminist father? Although writers and scholars have long addressed notions of feminist motherhood, the focus on feminist fatherhood specifically is a more recent endeavour, and certainly this volume attests to that. Feminist fathering in this essay borrows from feminist writers and modern "dad bloggers" alike, and refers to parenting that seeks to enlighten rather than dominate children or otherwise replicate traditional power structures (Bartlett 24; Moniz 10-11). "To be a feminist parent is to confront and correct systemic gender inequalities and injustices associated with parenting children," write scholars Lynn Comerford, Heather Jackson, and Kandee Kosier in their recent book *Feminist Parenting* (1). Thus, feminist parenting means "reducing sexism in the family ... respecting individual rights" of family members as people (Comerford et al. 2), and creating an environment that allows the child to "grow into [their] true self" (Bartlett 23). Feminist fathers acknowledge and attempt to transgress the rigid boundaries of traditional patriarchal power and norms, and they embrace egalitarian practices for themselves and their children, including doing the caregiving (emotional and otherwise) work typically associated with women. Feminist fathers, then, are, as Sara Ruddick and others have noted, men who are "capable of participating fully in the responsibilities and pleasures of mothering" (Ruddick 225)—specifically, loving and nurturing children. It also means being open to who children are or may become on their journeys to adulthood, especially if they challenge expectations or norms. The single fathers in the 1960s sitcoms discussed here embodied many of these traits, and increasingly so as the decade progressed and women's movement ideals mainstreamed.

Still, although they disrupted traditional notions of masculinity in fatherhood, these sitcoms, nonetheless, continued to reify most other aspects of masculinity writ large in the nonfamily lives of the father characters and in the family structures. To be sure, even though feminism helped shape the behaviour of these 1960s sitcom fathers

toward children, the men in these shows were most definitely not feminist—they lacked a consciousness about patriarchal power and privilege and they did not seek to alter men's status and power within the home or beyond it (Liebman 127). Rather, they clearly enjoyed many of the benefits that traditional masculinity bestowed (e.g., good jobs, financial success, and the attention of beautiful women). The men in these sitcoms valued the surrogates and the assistance they received from them, but they also enjoyed and left unchallenged their paternal rank at the zenith of the family hierarchy. In *Family Affair* and *Courtship of Eddie's Father*, household helpmeets Mr. French and Mrs. Livingston, respectively, regularly acknowledged their place on the social hierarchy below that of the patriarch.

Moreover, the changes to masculinity offered by the 1960s single-father sitcoms is complicated by the fact that it was built on the complete elimination (and therefore invalidation) of the mother. However, even while privileging the experience of fathers, these shows, nonetheless, broadened the definition of masculinity in fatherhood toward feminism in important and lasting ways, which continue to influence the practice of fatherhood in the U.S. Significantly, these sitcoms embraced feminism's call for greater flexibility in gender roles, which resulted in a masculinity that 1) incorporated emotional nurturance of children that was traditionally socially ascribed to mothers, 2) inspired children to be tolerant and loving of difference in others, and 3) encouraged children to follow their own paths, regardless of social prescriptions. In this way, the 1960s mark a unique transitional moment in the history and representation of fatherhood.

Scholars began studying the history and evolution of masculinity in fatherhood in the 1980s (Goldberg 159-60) and point to several historical moments when shifts in fatherhood were evident, such as the Industrial Revolution of the nineteenth century (LaRossa, *Modernization*, 5-7, 39-40). Many scholars look to the period from the 1960s to 1980s as the advent of the "new fatherhood," defined as a time in which men became more involved with the care of children. Ralph LaRossa has made a solid case for two moments when the new fatherhood emerged—between the 1910s and 1930s and between the 1960s and 1980s—and has written extensively about these two eras (LaRossa, *Modernization*, 5-16; Goldberg 151). But the definition of "care" in much of this scholarly work seems to point to caretaking, as in sharing the daily tasks that ensure a child's

physical wellbeing (e.g., getting them dressed, fed, and off to school). Some studies have used infant care, and specifically diapering, as a benchmark for measuring men's involvement with children, and argue that these new fathers increasingly shared in childcare work that had previously been done almost exclusively by women (LaRossa, "The Culture...," 7-10). Most research, too, marks the amount of time men spend with children as a sign of more engaged fatherhood (playing, doing homework, talking) (LaRossa, "The Culture" 8-17; Kelly 79; Cabrera 128).

This essay expands the notion of new fatherhood and the definition of care to include the feminist-inspired emphasis on the emotional and psychological development of children and, specifically, the legitimation of male expressions of love (e.g., hugging), compassion, and empathy as a part of masculinity in fatherhood. Social changes affecting home life might have been the engine driving what would become the new fatherhood, but feminist ideals about gender roles and parenting provided the theoretical grounding and validation for it. And television sitcoms mainstreamed this new, feminist-inspired notion of masculinity in fatherhood. Feminism's influence had been so sufficiently mainstreamed in the 1970s that historian Anthony Rotundo described the decade as marked by the rise of "androgynous fatherhood" (7). In fact, a 1970 article in *Parents* points out that "A happy offshoot of women's 'lib' is the increasing demand on the part of new fathers to take on their fair share in active parenting" (LaRossa, "The Culture of Fatherhood" 9).

What Happened to Mom?

Writers of single-father sitcoms made their foray into reshaping notions of masculinity much easier by eliminating the mother character, which is significant for a number of reasons. It is tinged with misogyny and patriarchal assumptions about the centrality of men in general. By eliminating the mother, fathers do not have to compete for children's love and affection—a reference to the nurturing role that typically made mothers the centre of real (actual) children's lives. In effect, it said that fathers could be just as good, if not better, at mothering than women were. And by including surrogates to do the domestic work, these shows similarly minimized the value of women's real work within the home. After all, anyone—older male relatives or paid helpers—

could step in and do these tasks (Liebman 131-32, 183-84). At the same time, surrogates helped single father sitcoms recreate the veneer of a so-called "normal" family life with dad solidly at the helm even in the midst of change, albeit as represented by Hollywood's version of white, middle-class American families (Moore 44, 48, 49).[2] In fact, normalcy and whiteness were often conflated in these sitcoms (Glenn 176; Moore 48-50). Although the representation of family life on these shows was white and middle class, television's strong links to consumerism (Lipsitz 359-62; 367) meant that the message was intended for all viewers, regardless of race or class (Bogle 6). Although people of colour saw only scant and stereotypical, often racist, representations of themselves in sitcoms throughout the 1950s and 1960s, they were, nonetheless, among the growing population who owned and watched television (Bogle 7, 19-23; 26-39, 42, 56; Lipsitz 368, 374-36).[3]

Just as important, killing off the mother simplified the narrative. That is, without a central female character, these shows would not have to directly address any of the real-world social changes that were necessitating a reshaping of gender roles within the family. They could bypass the hardships posed by rising divorce rates or the complicated family tensions around mothers taking jobs, either due to necessity or desire. They could ignore, for example, why women (and men) would seek a divorce in the first place, just as they could avoid addressing the impact of divorce on women's, men's, and children's lives. Instead, without a female familial lead character, the focus was on what these kinds of social changes would mean to *men*—what men would lose and gain and how they would not only rise to the occasion but possibly outshine women in their new roles as loving fathers.

Similarly, by eliminating the mother in these sitcoms, writers could touch on the issues of inequality raised by the women's movement without attributing these storylines to, or directly embracing, feminism. In fact, none of these shows discussed the women's movement or feminist ideals by name, even if they challenged older biases in ways that reflected the ideals of the women's movement. For example, *The Andy Griffith Show* featured a few episodes in which male characters (both Griffith and his son) have to rethink their previously unquestioned assumptions about men's superiority in certain areas (and, therefore, their sense of masculinity). In one episode, the sheriff and his son both struggle with their masculinity when confronted female characters who are better athletes

("Opie's Girlfriend" and "The Perfect Female"). In another, Griffith faces similar inner angst when his girlfriend Helen becomes a writer and it appears that she may out earn him ("Helen, the Authoress"). Although in each case the men come to terms with, and ultimately celebrate, the women's talents in ways that may make some feminists smile, the women's movement's efforts to similarly challenge the gender status quo in the real world are never mentioned. Without a mother character, these shows could avoid the conflicts—even humorously—between couples over roles and rights at home and work that were happening in real life all across the U.S. in the 1960s and 1970s.

Notably, even in the earliest episodes, single-father sitcoms offer scant, if any, details about how the mother came to be absent. The usual reason was a hazy nod to death, but this detail was often slipped into the narrative casually and without further explanation—and not always from the show's outset. The first few episodes of *The Andy Griffith Show*, for example, make no direct reference to his widowed status and do not explain why there is no Mrs. Taylor. When viewers finally learn about the loss of his wife (in episode four), it is only a passing reference. Opie blurts it out as he introduces himself to the new "lady druggist" in town, Ellie Walker, who asks if he is any relation to Sheriff Taylor. Opie's reply is "He's my paw. Ain't got no maw. But I got an Aunt Bee. She takes care of me" ("Ellie Comes to Town."). Although the show would air for more than eight years—remaining a top-rated hit throughout—there were less than a handful of references to Taylor's late wife, whose name and cause of death are never uttered. In all of these sitcoms, too, the mother's absence is typically explained not by the widower but by others. For example, the premier episode of *My Three Sons* (1960) opens with the grandfather, Bub, announcing to a salesman that there are no women in the house. "I'm the nearest thing to a lady around here," he says ("Chip off the Old Block").

Rather than address loss, these single-father sitcoms simply shifted the focus to the family's new normal and to finding the widowed husband a new wife (Liebman 45). Sweeping past the mother's death also enabled the shows to quickly begin to play with traditional masculinity, gradually expanding its borders to reach into the emotional realm of the so-called feminine. Viewers of *My Three Sons* never learned precisely how Mrs. Douglass died, only that her untimely passing left her husband Steven a widower. The same was true as late as 1969's *Courtship of Eddie's Father*;

there, it was clear the mother died of an illness (possibly cancer?), but the disease was never named. Only *Family Affair* in 1966 stated the cause of death as a car accident, likely because the show needed to tell viewers why both parents perished and their children were sent to be raised by their affluent, bachelor uncle, Bill Davis ("Buffy"; "Mrs. Livingston, I Presume").

It is not until the late 1960s that these sitcoms made the loss of the mother a stated aspect of the child's development and relationship with the father, which had as much to do with the maturing of these sitcoms as it did with the evolving social climate and influences of the women's movement. By the time *Family Affair* and *Courtship of Eddie's Father* debut (1966 and 1969, respectively), women's movement ideals about childrearing and being emotionally expressive had begun to reach mainstream audiences. *Family Affair* made the loss of the mother (both parents) a focus of at least the first year's shows and an occasional recurring theme thereafter when topically relevant, such as when teenage Cissy needed motherly advice. Her uncle arranged this by asking one of his girlfriends to step in ("The New Cissy") Unlike shows that first aired in the early part of the decade, in *Family Affair* and especially *Courtship*, the children were shown grieving, and the father figures affectionately comforted and worried about them. By decade's end with *Courtship*, however, it is clear that the son's ability to grieve and show an array of other emotions was due entirely to his father's nurturing. In the first few seconds of the pilot, which introduces the show's format of opening and closing each episode with a father-son outing and conversation, young Eddie says, "Before Mom died, she told me, I'd have to watch over you and take care of you" ("Mrs. Livingston, I Presume"). In several episodes, Eddie's father, Tom Corbett, worries to friends about whether the child is still grieving; in other episodes, Eddie is shown talking to his late mother and seeking advice to a troubling question as he nods off to sleep.

Bittersweet and at times wrenching in its realism, *Family Affair's* Bill Davis and his valet Mr. French struggled to ensure the children coped with the tragic death of their parents (including bad dreams) and become healthy, well-adjusted people. Each of the adult males, however, did this via stereotypically gendered roles, with French increasingly playing the mother and housekeeper role to Davis's nurturing father, even while French grappled with what this role shift from valet—what he refers to

as "a gentleman's gentleman"—to nanny meant for his masculinity. As he became demonstrably loving with the children—cuddling, kissing, and working through their every emotional need as a mother would—Davis's masculinity was constantly reaffirmed through the bevy of beautiful women he dated, the global development he brought to remote areas via his highly successful civil engineering firm, and the sometimes gruff and assertive way in which protected his children from other authority figures (teachers or counsellors), who might not have understood their distinctive emotional needs as orphans.

For French, the task of safeguarding his masculinity was more complex, since it was shaped by the gender and class value assigned to service work ("Buffy"; "Jody and Cissy"; "The Matter of School"). Trained in England and part of a generation of men who worked as valets for elite men, French saw this male profession as noble and more senior than that of women's paid employment in childcare. As he took on more of the work of mothering, French was mocked by the other gentlemen's gentlemen for engaging in the feminine enterprise of nannying. To preserve his masculinity, French initially put distance between himself and the children, refusing any task that smacked of what a nanny might do, such as tucking the younger children in at night or helping the teenage sibling choose an outfit for a date. Ultimately, however, a nanny friend raised French's consciousness about the gift of love inherent in the occupation; from that point on, when he took the younger children to the park, he proudly opted to sit on the bench with the nannies rather than with the male valets enjoying an afternoon break from their duties ("A Nanny for All Seasons"). The episode title was possibly a riff on the 1966 Oscar-winning film, *A Man for All Seasons,* perhaps adopted as yet another attempt to reify French's masculinity.

By the end of the 1960s, much of the tension over the dividing line between the new fatherhood and older ideas of masculinity had all but vanished. *Courtship of Eddie's Father,* which ran from 1969 to 1972, made its centrepiece the strong emotional connection between father and son as they carved out a life for themselves without a wife and mother. Just as important a theme, however, was the freedom for father and son to express their feelings and for the child to become, like his father, an emotionally warm, kind, and loving man who respects all people, including the women in his life. In virtually every episode, the child showed empathy or worked through an emotional issue, while his father

guided him and later expressed pride in the person his son was becoming. In a nod to just what a man should be, the inquisitive and loving Eddie tells his father, "You know what I want to be when I grow up? A sweet, kind, intelligent, good guy just like you" ("Mrs. Livingston, I Presume").

The Changing Social Landscape

What forced this reconsideration of masculinity in fatherhood, as depicted in 1960s single-father sitcoms, were the massive social changes that began with the end of World War II and reached new heights in the 1960s—for example, rising divorce rates, women's increasing employment outside the home, and the growing visibility and force of the women's movement. All of these concerns would provide the subtext for the single-father sitcoms. Though never discussed in any of the single-father sitcoms, women's growing workforce participation was a major factor in women's shift from home to work. Women's, and particularly mothers', increasing participation in the workforce began with World War II, when government and business leaders called them to fill the labour void of male soldiers who went off to war. Even as women were encouraged to leave their jobs as the war wound down, many women both needed and wanted to continue working. Some, too, had developed new skills and enjoyed the independence and higher pay that their wartime jobs offered. Women whose husbands returned from battle too injured to work, or those with husbands who did not return at all, found themselves still in the role of head of household. U.S. World War II casualties numbered over 400,000, with an additional 671,000 returning home wounded (Hartman, *Homefront* 22). Although many of those good-paying war jobs went back to men and women ended up in a pink-collar ghetto of low-paid, service sector jobs (Matthei 226, 235-45; Howe 12-14), they, nonetheless, continued to work. Even though there was a slight decline in women's labour force participation after the war, by 1948, the numbers began to rise and continued to do so uninterrupted up to the present (Matthei 278, 283; Hartmann, *The Homefront* 24). In 1950, about one in three women participated in the labour force. By the 1960s, 37.8 per cent of women over age sixteen worked, rising to 43.4 per cent by 1970 (Berch 5; "Changes in Women's Labor Force;" "Changes in Men's and Women's"). Just as important, however, is that beginning with World War II, the

composition of women in the labour force shifted from primarily single women—most of whom held jobs until marriage—to predominantly married women, a fact that was likely not lost on 1960s sitcom writers and creators (Hartmann, *The Homefront* 92-93).

Just as women's presence in the workforce was changing family life, so, too was the burgeoning consumer culture of the 1950s. The surge in new consumer goods—appliances, apparel, automobiles, and televisions—not only pushed more women into the workforce for the additional income needed to purchase these items but also contributed to growing debates about men's and women's proper gender roles, debates that would begin to play out on the small screen, albeit subtly. While women, especially white middle-class women, were encouraged to be good consumers, there was little societal support for anything resembling careerism, and they faced criticism in popular magazines for desiring more than a little extra "pin money" (Hartman, "Women's Employment" 84-98; Michals 106-7). Women's magazines printed articles encouraging working mothers to return home because children missed and needed them, and male childcare experts, such as the bestselling author Benjamin Spock, reinforced these ideas (Spock 570-72). Although he recognized that some mothers might need to work, Spock was so committed to the idea of mothers staying at home until children reached at least age three that he proposed the following: "The government pay [sic] a comfortable allowance to all mothers of young children who would otherwise be compelled to work. You can think of it this way: useful, well-adjusted citizens are the most valuable possessions a country has, and good mother care during early childhood is the surest way to produce them" (570). Still, women kept marching into the workforce, and, privately, families increasingly addressed new questions about who would care for children while mothers were at work, who would get dinner on the table, and who would be the primary influence on growing children's development. These were the same concerns that would begin to play out in single-father sitcoms as early as the mid-1950s, with *Make Room for Daddy,* and increasingly throughout the 1960s.

Also fuelling the reconfiguration of fatherhood in single-father sitcoms were the rising divorce rates, which contributed both to women's need to work as well as to changes in family structure and roles. In the U.S., divorce rates jumped from a total of 393,000 divorces and annul-

ments in 1960 to 708,000 in 1970, as states adopted no-fault divorce laws that made it easier for unhappy spouses to part ways (Swanson par. 4, 10; Coontz 5). The women's movement's message of independence and empowerment undoubtedly also inspired some women to feel confident about their ability to survive without a husband. Whatever the reason, as divorce rates rose, children were more likely to find themselves in single-parent households for some part of their lives, and even if fathers were not the primary custodians, they were spending time during weekend or other visits as primary caretakers.

Growing awareness about inequality and familial challenges of households with working mothers also undoubtedly entered the consciousness of 1960s single-father sitcom writers. Women's efforts for greater equality in the job market and in society writ large not only prompted questions about the care of children but also had implications for the organization of men's and women's roles within the family. In 1961, President John F. Kennedy assembled a group of women leaders— chaired by former First Lady Eleanor Roosevelt—to study the obstacles women faced economically. Widely publicized and distributed, Kennedy's Commission on the Status of Women's report, issued in 1963, pointed specifically to both job discrimination and the lack of childcare for working women. While not advocating that husbands take on childcare, the report, nonetheless, recognized the need for change in traditional notions about who cared for children (*American Women* 4-5, 21, 29).

The emergence of a host of social movements in the late 1950s and especially the 1960s similarly raised new questions about the status quo and provided spaces to legitimately interrogate and transgress traditional gender roles. The beats and counterculture, for example, offered a range of alternative social visions and constructs, and while both movements would later prove to be tinged with sexism, their existence still challenged existing social and cultural structures. The civil rights and antiwar movements played similar roles. But for notions of masculinity within the family, especially fatherhood, the women's movement would have the greatest impact. It was the openness and flexibility of gender roles suggested by both radical and liberal feminists in the 1960s and early 1970s that single-father sitcoms began to experiment with in limited yet important ways.

Feminism and Family Life

If social changes were posing the "what now" question for family life—in this case, for sitcom writers in the 1960s and early 1970s—women's movement ideology provided the impetus, language, and tools to answer it via gender role experimentation on screen. Moreover, as the movement gained media attention, feminist messages not only spread more widely but increasingly permeated all forms of popular culture, from books to magazines to television sitcoms. However resistant the public might have been to accept feminism, the ideals of the women's movement still offered solutions to the effects of social change on family life. Feminists proposed revisiting gender roles within the family—ultimately, the very meaning of motherhood and fatherhood—which was something that the single father sitcoms seemed to be tapping into, even if in limited and subtle ways. As feminist ideas became more mainstream, writers, thinkers, and everyday people could embrace them without necessarily identifying themselves as feminists or without linking these ideas to the movement that generated them (Rosen 296-314, 320-326).

Both liberal feminists and their younger, more radical counterparts in women's liberation took issue with the family as an institution, particularly with the 1950s celebration of the middle-class, suburban, nuclear family ideal. To liberal feminists such as Betty Friedan, who chronicled women's frustrations in her 1963 bestselling book *The Feminine Mystique*, the home and "happy housewife" myth was confining for women (Friedan 23-30). To radical feminists, the family was a role prison that replicated patriarchal power and women's oppression (Dicker 13-16; Rosen 123, 152; *Feminist Revolution* 115-17, 120-25, 170, 172). In truth, the frustrations Friedan outlined in her book were already finding their way into popular media in the 1950s, including articles Friedan herself authored for women's magazines about her fellow Smith College alums (Friedan xvi-xvii, 47-52; Rosen 4-5). Similarly, the issue of family roles would make its way into the 1966 mission statement of the newly formed National Organization for Women (NOW), founded by Friedan and feminists Aileen Hernandez and Pauli Murray. Established to find concrete solutions to sexual discrimination,[4] NOW's Statement of Purpose made a direct reference to the family. Declaring that "women should not have to choose between family life and participation in industry or the professions," the Statement advocated for the estab-

lishment of daycare centres nationwide. It further argued for a restructuring of men's and women's roles within marriage: "A true partnership between the sexes demands a different concept of marriage, an equitable sharing of the responsibilities of home and children and of the economic burden of their support" (NOW Statement of Purpose par. 18; Rosen 79; Nelson 18-20). What's more, the Statement was widely read, as NOW quickly built a massive membership, garnered media attention, and rose to become the largest women's rights organization of the era.

Not only were NOW's ideas mainstreamed in ways that would influence TV audiences and writers, but so were those of younger, more radical segments of the women's movement that emerged in the second half of the 1960s. These women created a cache of feminist theories and social criticisms touching on every aspect of life, including the family (*Feminist Revolution* 13-45, 66-72, 86-110, 120-22). Most notably, radical feminists argued that gender was socially constructed and, therefore, malleable. This idea not only undergirded their calls for a completely altered society, but it also shaped how they lived and how they thought others should live, too (*Feminist Revolution* 144-51; Rosen 198-208). Through consciousness raising, radical feminists recognized the ways in which gender norms were created and perpetuated, as well as how these norms sought to restrict a range of behaviours and roles, including those that defined acceptable femininity and masculinity (Echols 83-6, 89-90; Nelson 18-20, 79).

Feminists at all points on the political spectrum began to create an array of literature that promoted new visions of gender, producing everything from pamphlets to gain supporters to children's books that shared their visions of healthy, nontraditional childrearing and development. The ideas in feminists' writing mirrored the way they lived and raised their own children: "We tried to offer alternatives to the patriarchal 'norms,'" writes feminist activist Robin Morgan, who noted that giving her son Blake nurturing, so-called girls' toys led to his egalitarian impulses and sensitivity (Morgan 306). She continues: "We construct alternatives to patriarchal holidays like Wiccan sabbats.... He [Blake] plays with—dolls *and* trucks" (Morgan 306). Morgan's son, who was born in 1969 and grew up in the 1970s, also adored baseball and in the fifth grade, of his own accord, he successfully fought to integrate girls on his school's team, just as he ensured gymnastics were open to

boys (Morgan 331). And feminists' ideas were shared in major newspapers and magazines that reached a wide audience and might well have shaped the thinking of 1960s single-father sitcom writers and audiences. Ariel Chesler, the son of the feminist psychologist Phyllis Chesler, recounts his mother's ideals about parenting sons in a 1970s article in the *New York Times*: "She told the *Times* that she thought one of the most important things in raising a male child was to involve fathers in daily child care ... She also reported that I (then 19 months old) was given lots of toys to choose from including 'teddy bears and trucks,' but that I wanted a female doll which I cuddled with and fed and called 'Baby'" (Chesler par. 5).

Radical feminism calls for greater freedom and gender flexibility made their way into everything from children's books to toys and even to celebrity images of masculinity. By the early 1970s, a host of new children's books and toys—many created by feminist businesses and presses—sought to encourage children to develop in non-gender-specific ways. A women's liberation collective, Lollipop Power Press, for example, published several books promoting emotional expression as a gender-neutral, positive attribute. Their first book in 1971, *Martin's Father*, "was about a Black single father who was nurturing to his son – he cooks, tucks him into bed, and takes him to daycare" ("1970s North Carolina Feminisms" par. 2). Sara Evans, a North Carolina feminist activist and later historian, recalls the following: "In simple picture-book stories, we scrambled sex roles–female heroines, moms who study, fathers who nurture–and conveyed a broad sense that girls (and boys) could do anything they choose" (12-13). Similarly, the notion of an emotionally nurturing masculinity had been so mainstreamed that children's toy manufacturer Playskool launched Dapper Dan, a plush doll for boys in 1970 (Mansour 129). Two years later, Harper Collins published the children's book *William's Doll*, the story of a young boy who "repeatedly asks for a doll to care for despite [sic] the taunts of other children and the displeasure of his father (who prefers to buy him sports equipment and other more traditionally 'masculine' toys).... Finally his grandmother supports him on the grounds that he may be practicing for a nurturing fatherhood" (Rotskoff and Lovett 89). As parents debated the merits of such stories and toys, media coverage of it all brought greater attention to the questions of masculinity in fatherhood that they raised—themes that increasingly played out in family-based sitcoms.

Television and the New Fatherhood

The new fatherhood depicted in 1960s single-father sitcoms had been a long time coming and represented a generation's attempt to work through the dramatically changing post-World War II social landscape. Television, as experts have long argued, serves as a kind of mirror, reflecting who we are as a people as well as who we wish we were. As such, it serves as a vehicle for transmitting a vision of an idealized reality, reinforcing social norms and values, mocking our follies, and pushing us forward by representing new ideas or changing constructs (Andreasen 3-27; Dow 24, 59-60; McLuhan, 7-11; Pehlke 115-17). In 1960s single-father sitcoms, television writers struggled to balance it all—particularly the tradition of family with new ideas about gender roles within it.

Despite the absence of the mother, all of the 1960s single-father shows attempted to recreate the image of the nuclear family—complete with successful professional breadwinner fathers. Much as the Internet, smart phones, and social media have altered how the world is processed and understood today, television in the 1950s and 1960s was rapidly becoming a vehicle for teaching and learning about society. In the case of family-based sitcoms, television became a yardstick by which American families could, and often did, measure themselves. The numbers alone make the case for the power and influence of television in this era. Before 1947, few homes had televisions—barely six thousand televisions were owned nationwide. Just four years later, in 1951, 12 million homes had televisions; by 1955, 64 per cent; by 1960, 87 per cent; and by 1970, nearly 96 per cent (Spiegel 32; Steinberg 142; Hess and Grant 372). What's more, people watched at least six hours of television per day by the 1970s (Hess and Grant 372). As such, any messages contained in television content was mainstreamed widely, and in an age of only a few major networks with limited broadcast days, they had immense impact and outreach, especially on younger generations—the prime audience for many of the night-time sitcoms.

Traditional family portraiture was notably part of the promotional materials for each show. In every case, the surrogate (or family helper) was substituted for the mother, which was a nod to how possible it was to keep families intact even when they were not or when they were facing a variety of changing, nontraditional circumstances. The arrangement of the people in the photos reflects traditional family portraiture—

the surrogate is often front and centre with the father, and everyone is seemingly happy with the arrangement. In this way, these sitcoms both accepted the changing social landscape and thwarted any possible incursions into the mythic nuclear family norm.

Family Affair promotional photo. The seating arrangements in this photo reflect those used in nuclear family portraiture, with the children organized around each "parent." (CBS Photo Archive via Getty Images).

This emphasis on recreating the image of an intact, nuclear family may also be why many of the shows focused on children and well-meaning family and friends as matchmakers for their widowed fathers (Liebman 45). If a new wife could be found, the family would be whole again. That theme was built into the title and focus of *Courtship of Eddie's Father*, and the often-told joke was that Eddie, the six-year-old son, was always trying to find his father dates that may result in marriage. In one episode, Eddie is so driven by this quest that he faces his fear of riding the carnival Ferris wheel because, as he tells his father, "there is a nice mother-type lady" in the next row ("And Eddie Makes Three").

The concern about incursions into so-called normalcy may also explain why children raised by widowed fathers were overrepresented in sitcoms of this era. Roughly 88 per cent of children in 1960 in the U.S. lived in families where both parents were present; yet only 58 per cent of television children did (Robinson and Skill 152-53). Moreover, single fathers were just 1 per cent of the population yet 28 per cent of television sitcom dads (Robinson and Skill 153). Interestingly, producers seemed to have more than one widowed father sitcom in their portfolios. Danny Thomas, of *Make Room for Daddy*, an early incarnation of the single-father sitcom, was also the producer of *The Andy Griffith Show*. Don Fedderson, who was a divorced and remarried father, was the producer and creator of several single-father shows, including *My Three Sons* and *Family Affair*. Fedderson consciously sought to depict the comedy of men trying to survive without women in *My Three Sons*, yet as feminist media scholar Nina C. Liebman has pointed out, the sitcom actually showed men doing just fine on their own (Liebman 183).

Statistically, in reality, by 1960, 50 per cent of single-parent households were the result of divorce (not death) (Robinson and Skill 142-43, 149, 152-53). Television, however, sidestepped the issue of divorced single parents until the mid-1970s, or before that, it made the rare divorcee a secondary character and the divorce itself undiscussed. In *The Lucy Show* (which ran from 1962 to 1968), Lucille Ball's main character was a widow, while her co-star Vivian Vance portrayed a divorcee raising a young son on her own. It was not until 1975 when CBS made divorce the focus of its slice-of-life sitcom *One Day at a Time* (Moore 53). That long-running series, however, focused initially on the downward mobility and struggles of the divorced mother, who left her husband for feminist reasons—because he treated her like a child and she wanted her independence (Rabinovitz 7; Lotz 107).[5] Her feminism is alluded to throughout the show, as her employer sarcastically addresses her as "M-S Romano" (spelling out "Ms." rather than using the salutation). A year later, ABC introduced a divorced African American mother in its sitcom *What's Happening* (Robinson and Skill 148-58). Similarly, widowed mother-based sitcoms did not share the success of widowed father shows until much later. Unlike single father-based shows, which spent from five to ten years on the air, the few sitcoms featuring widowed mothers had significantly shorter lifespans in the 1950s—lasting just one year in almost every case (e.g., *The Eve Arden Show, Sally, The Betty*

Hutton Show) (Brooks and Marsh 1166-77). That changed in the 1960s with *The Lucy Show*, its follow-up *Here's Lucy* (which ran from 1968 to 1974,) and *Julia*, the 1968 sitcom about an African American widow of a Vietnam veteran (Brooks and Marsh 602-3; Moore 47).[6]

A Revolution in Fatherhood: Men Can Be Moms

As noted earlier, in single/widowed-father sitcoms, the absence of the mother became the vehicle for prescribing a new form of masculinity in fatherhood, one that said families can survive without full-time mothers but only if fathers fulfill the emotional, psychological, and developmental childrearing duties (while letting the surrogates do the rest of women's work). This dividing line of duties—where men can embrace the traditionally feminine roles and where they cannot—is crucial for understanding the subtle but important transformation of masculinity within fatherhood. What is gradually—and arguably, permanently—legitimated by the 1960s sitcoms is the notion that romance alone is not the only forum in which men can display emotion; childrearing is the other. Men could now be demonstrative; they could hold hands, cuddle, and even well up with tears in 1960s sitcoms in ways that Ward Cleaver would never do. In the show's opening theme for both the *The Andy Griffith Show* in 1960 and *Courtship of Eddie's Father* in 1969, father and son are holding hands. And there are lots of hugs and clear demonstrations of love between parent and child in many different episodes. These sitcoms, however, offered a timeline on the progression, degree, and frequency of legitimate emotional expression between father and son, which increased as the decade advanced. At the beginning of the 1960s, Andy Taylor hugged his son and tucked him in. He also read him fairy tales about compassion and the power of love, such as *Beauty and the Beast*—albeit without the awareness feminist scholars now have about the disturbing gender narrative in that fairy tale. In the context of the early 1960s, and the *The Andy Griffith Show* in particular, this was a father sharing with his son a story typically associated with young girls, all the while emphasizing what it means to love ("Bringing Up Opie").

The Andy Griffith Show. Music and sing-alongs were a common vehicle for father-son bonding in this sitcom, and what is clear in this image is the strong emotional ties between the two as they look warmly at each other (CBS Photo Archive via Getty Images).

During the show's early years, Taylor struggled with the boundaries of discipline and wisdom—the more traditionally acceptable roles for television dads—and affection and nurturance, the roles associated with mothers. But Griffith's character, like many of the widowed sitcom fathers, sought to ensure he raised, first and foremost, a good person, and his affection and lessons were doled out accordingly. That said, it is significant that Taylor was almost never heard saying the words "I love you" to his son. Yes, he modelled the power of love throughout the series, but he never uttered the words directly to his son. Still the love between them was ever present. In one episode, when Aunt Bee worries that young Opie is spending too much time with his father at the courthouse, Andy, in an effort to do what is best for his child, reluctantly agrees to tell his son to stay away and to have fun playing. But the two are miserable, and the audience can feel the yearning of father and son for each other. In the end, Aunt Bee realizes she was wrong; they need time together ("Bringing Up Opie").

As the 1960s progressed, this physical and verbal affection were more pronounced and central to the relationships depicted between fathers and children. Uncle Bill in Family Affair always hugged and kissed the kids, tucked them in, and cuddled with them. He was always conscious of the impact of the loss of their parents, and even in an era that was just beginning to recognize the value of psychological counseling, he sought professional advice to help especially the two younger children adjust emotionally. And like any good mother, he was self-sacrificing, as he ended relationships with women he loved but who did not love his kids the way he did ("Ciao, Uncle Bill"). He even considered, albeit briefly, letting his sister take over guardianship, despite how much it pained him, when she argued that she would be a better parent ("Family Reunion"). Significantly, by the end of the decade, in *Courtship*, Tom Corbett, Eddie's father, was completely free to verbalize his love for his son. Context here matters; this sitcom debuted in the post-summer-of-love, post-Woodstock era. There was no episode of this show where the father and son did not say at least once (and often far more) "I love you." Even the show's famous opening song conveys the notion of a new fatherhood masculinity, in the words of the son in this lyric: "People let me tell you about my best friend; he's a warm-hearted person who loves me to the end." The child, too, underscores this special bond in the pilot episode, telling his father, "Most kids have a father father but I have a father who's my best friend" ("Mrs. Livingston, I Presume").

Courtship of Eddie's Father. Probably the most demonstrative father-son relationship in 1960s sitcoms, *Courtship of Eddie's Father* featured multiple scenes of hugging and other displays of affection between father and son like this one (ABC Photo Archive via Getty Images).

Not only could fathers show emotion with children, by the late 1960s, they could also show emotion about children. Uncle Bill was visibly holding back tears as he explained to his young charges that it was their parents' love that brought the children into the world ("Birds, Bees, and Buffy"). Tom Corbett endlessly fretted over his child with friends and colleagues, and he welled up with tears of pride when he

realized he had helped shape such a loving child. In one episode, Eddie, who had become worried that he might not always be around to take care of his father—perhaps in a nod to his own mother's passing—decides to leave a will. None of the adults are aware of this, and as the child heads out for the day, he tells his father he has left a letter on his desk but not to open it. After struggling with whether to open it or not, Corbett and his best friend—whom Eddie calls "Uncle Norman"—ultimately open it and discover it is a will. When he sees that his sensitive child has bequeathed his father to Mrs. Livingston, Mrs. Livingston to his father, and Uncle Norman to them both, Tom Corbett tears up and says proudly twice, "That's my son." ("Eddie's Will").

The Line in the Sand: The "Surrogates"

This new definition of masculinity, as noted previously, told men that as fathers, they were and should be every bit as capable as mothers of expressing love to children and raising children to do the same. But that was where the revolution stopped: in all other ways, traditional masculinity remained, facilitated in these shows by the surrogates taking on the mother's domestic tasks. *Family Affair's* Uncle Bill still travelled the globe as a civil engineer to afford the upscale Manhattan lifestyle that he, and now his children, enjoyed. It was Giles French who stepped in to manage the domestic realm. It was French who took the children to the doctor, chauffeured them to play dates and daily trips to the park, worried about their manners and clothing, and nursed them back to health when they were sick. French also cooked and cleaned, baked cookies, and oversaw trips to the playground.

All of the widowed fathers feigned ignorance and expressed helplessness about all things domestic and relied on the surrogates to take on these roles. Andy Taylor could cook out in the wild and even barbecue, but when Aunt Bee left town, he burned dinner, dishes piled up, and clothes and papers were strewn about the house. Father and son were rescued when an attractive woman whom Taylor was dating dropped by, saw the mess, and offered to cook and clean until Bee returned ("Andy and Opie, Housekeepers"). Similarly, Tom Corbett badly botched an attempt to make breakfast when his paid domestic, Mrs. Livingston, decided to leave her job, but he ultimately convinced her to return ("Guardian for Eddie").

The symbolic nod to the outsourcing of women's/wives domestic roles in these sitcoms was in the form of an apron. All of the surrogates wore aprons; none of the fathers ever did. Even the gruff Bub in *My Three Sons* had an apron around his waist, and the first thing Mrs. Livingston did when she arrived at the Corbett apartment was put her apron on. She not only cooked, cleaned, and got Eddie to school, she also rushed in to clean up a dropped egg or a spilled glass of milk as the two men look helplessly on. In fact, all aspects of motherhood were reduced to domestic tasks as fathers became emotional nurturers. When Chip Douglas is crying and missing his mother in an early episode of *My Three Sons*, his father comforts him by taking out a box of photos. The audience might have expected images of the boy and his mother, but instead the father shows Chip pictures of Bub making him a cake for his birthday. To console the child, he says, "I think Bub does a pretty good job of mothering all of us" ("Mother Bub"; Liebman 63-64). Chip agrees. Here the message is clear: good fathers—that is, good feminist-inspired fathers—are also willing to do the work of mothering their children. Put simply, then, the surrogates do the domestic work associated with mothering, and the fathers do the emotional work, thereby reifying gender norms in one way and expanding them (at least for men) in the other.

Conclusion

A powerful tool for spreading information and values, television sitcoms helped legitimate a new form of fatherhood that would prove flexible to adapt to changing times. The generation that grew up watching shows like *Griffith* and *Courtship* would become far more engaged parents than any previous generation. And there is plenty of evidence—anecdotal and statistical—to bear this out. Anecdotally, men who came of age in the 1960s and 1970s have fought harder to co-parent their children whether in intact marriages or after divorce, and this generation, as well as their younger counterparts among Generation X and millennials, expect to be as emotionally involved with children as their partners (Goldberg 161). Television alone did not create this transformation, but it helped usher in feminist ideas about gender roles and parenting in a changing social climate. Television shined a positive light on what the new fatherhood could look like.

There is no question that none of the characters in 1960s single-father sitcoms would have labelled themselves "feminist fathers," nor would women's movement activists or theorists then or now have judged them as such. What they might have seen—and what is clearly evident from the distance of more than fifty years—is that feminist-inspired ideals about parenting infused the notion of fatherhood portrayed in these shows. Feminist concepts, widely mainstreamed in the 1960s, added a crucial flexibility to the previously rigid and limited definitions of the type of masculinity allowed in fatherhood in society and as portrayed on the small screen. The new traits of emotional nurturance and involved fatherhood had an impact on subsequent generations of fathers, both the young boys watching these shows and the sons they would someday raise. Today, involved fatherhood is both the norm and the ideal—the yardstick against which families measure their paternal figures and the goal they constantly strive to achieve. It is embraced by both the political right and the left, by conservatives and by feminists. According to a PEW research study on fatherhood, since 1965, fathers have tripled the amount of time spent with children. The study also showed that fathers are as likely as mothers to "see parenting as central to their identity" (Parker, "Modern Parenthood" par. 24). Approximately 46 per cent of fathers and 52 per cent of mothers said they personally spend more time with their children than their own fathers and mothers had spent with them. Yet these fathers also said that they felt that it was not enough— that they wanted more time with them (Parker, "Six Facts" par. 11).

Are these "new fathers" feminists? Some may be; many may not. Given the various political agendas and affiliations that exist around fatherhood today, it is not simply enough to label as feminist any father who embraces the same ideals around parenting that feminists in the 1960s proffered: being emotionally expressive and engaged with their children's psychosocial development, as Ruddick and others have described. It is a first step in breaking down gender roles, but a truly feminist form of fathering would go much further. It would challenge patriarchy in all its forms. It would, as contemporary dad bloggers Tomas Muniz and Jeremy Adam Smith write, fight "the social power that men have over women—and beyond *that*, challeng[e] all of the ways that some people have power over others" (Muniz and Smith 10-11).

Muniz's and Smith's words further feminist visions of fatherhood offered nearly five decades ago—ideas that, consciously or not, were

aided in their mainstreaming by 1960s single father sitcoms. As such, these sitcoms served as a precursor to the potential for truly feminist fathering, in which both parents are free to engage with their children and define their parental role beyond gender prescriptions and according to their own comfort levels as well as their own emotional and psychological abilities. Even so, the picture is not so simple or entirely optimistic: these portrayals of fatherhood existed in a complicated realm that both sought a necessary and desired change while also holding fast to the privileges that traditional masculinity and patriarchy afforded most men. For that reason, truly feminist forms of fathering that embraced equality and decried power structures were impossible in the 1960s and have remained elusive. But the transformative power of the 1960s social experiment has had some important and enduring effects, as evidenced by father bloggers, such as Muniz, and by sitcom fathers who continue to nurture children, such as *Modern Family's* Mitch, Cameron, and Phil. Michael Kimmel has famously argued that women's lives have changed during the last several decades, whereas men's generally have not (TedTalk). In terms of work lives and educational opportunities, that may be true. But in terms of what opportunities for women have meant for men as fathers, men, too, have been transformed and liberated by feminist-inspired fathering.

Endnotes

1. A note about methodology: this essay applies interdisciplinary approaches to the question of feminist fathering. It draws on US women's and gender history and masculinities studies as well as feminist media studies and television and communications studies, which are cited throughout. The work of Nina C. Liebman on representations of family in 1950s films and television has been particularly helpful. The analysis presented here is also based on the author viewing entire series over a period of several years (and many episodes multiple times) of *Courtship of Eddie's Father, Family Affair, The Andy Griffith Show, Gidget,* as well as several seasons of *My Three Sons.*

2. Television shows were not initially as dominated by white, middle-class images and ideals as they would become by the beginning of the 1960s. Whereas early 1950s family comedies included more

ethnic, urban, and mother-focused shows, by the middle of the decade, these groups were virtually erased. Instead, mid-to-late 1950s sitcoms embraced the domestic ideology of the Cold War era and featured white, suburban, and middle- or upper-middle-class nuclear families, with men and women uncritically occupying their prescribed gender roles of breadwinner and housewife, respectively, and happily consuming an array of new products, which was essential for postwar economic growth. This would be the standard as the 1960s began (Lipsitz 356, 361, 366; Moore 44).

3. This would begin to change as the civil rights movement advanced, and by the late 1960s, greater and more diverse representations of African Americans appeared on television (Bogle 6-7; Glenn 177). Even single-father sitcoms would include a race episode from time to time, as in the *Family Affairs'* episode "Albertine," which focused on a fatherless, African American little girl.

4. NOW specifically sought to challenge workplace discrimination and promote enforcement of Title VII of the Civil Rights Act of 1964, which prohibited employers from discriminating on the basis of race, sex, religion, and national origin.

5. According to Lauren Rabinovitz, from 1975 to 1985, at least ten half-hour sitcoms centred on single mothers were introduced on television networks.

6. In the first show, *The Lucy Show*, Lucille Ball reteamed with her *I Love Lucy* co-star Vivian Vance. The two women friends were raising children on their own and helping each other; but where the original book upon which the show was based called for two divorced mothers, producers allowed only Vance to be the divorced mother. They made Lucy's character a widow, concluding that two divorced women were too much for the viewing public and that the audience might not accept a fictional divorce for Lucy (since many fans still grieved over her real-life divorce from husband, business partner, and *I Love Lucy* co-star Desi Arnaz) (Brooks and Marsh 602-3).

Works Cited

"Albertine." *Family Affair*, season 3, episode 9. 2 Dec. 1968. Accessed via Amazon Prime Video.

"And Eddie Makes Three." *The Courtship of Eddie's Father*, season 1, episode 3, ABC, 1 Oct. 1969.

Andreasen, Margaret, "Evolution in the Family's Use of Television: An Overview." *Television and the American Family*, 2nd edition, edited by Jennings Bryant and Alison J. Bryant, Taylor and Francis, 2009, pp. 3-27.

"Andy and Opie, Housekeepers." *The Andy Griffith Show*, season 1, episode 23. 13 Mar. 1961. Accessed via Amazon Prime Video.

Bartlett, Elizabeth Ann. "Feminist Parenting as the Practice of Non-domination: Lessons from Adrienne Rich, Audre Lorde, Sara Ruddick, and Iris Marion Young." *Feminist Parenting*, edited by Lynn Comerford, Heather Jackson, and Kandee Kosior, Demeter Press, 2016, pp. 23-37.

Berch, Bettina. *The Endless Day: The Political Economy of Women and Work*. Harcourt Brace Jovanovich, 1982.

"Birds, Bees, and Buffy." *Family Affair*, season 2, episode 1. 11 Sept. 1967. Accessed via Amazon Prime Video.

Bogle, Donald. *Primetime Blues: African Americans on Network Television*. Farrar, Straus, Giroux, 2002.

"Bringing Up Opie." *The Andy Griffith Show*, season 1, episode 32. CBS. 22 May 1961. Accessed via Amazon Prime Video.

Brooks, Jim and Earl Marsh. *The Complete Directory to Prime Time Network and Cable TV Shows, 1946–Present*. Ballantine Books, 1999.

"Buffy." *Family Affair*, season 1, episode 1. 12 Sept. 1966. Accessed via Amazon Prime Video.

Cabrera, Natasha J., et al. "Fatherhood in the Twenty-First Century." *Child Development*, January/February 2000, Volume 71, Number 1, 127-136.

Chesler, A. *On Fatherhood and Feminism, Writing for the Web*. 2017. nomas.org/fatherhood-feminism-writing-web/. Accessed 3 Aug. 2017.

"Chip Off the Old Block." *My Three Sons,* season 1, episode 1. 29 Sept. 1960. Vimeo. vimeo.com/149495953. Accessed 6 January 2020.

"Ciao, Uncle Bill." *Family Affair,* season 3, episode 11. CBS. 16 Dec. 1966. Accessed via Amazon Prime Video.

Comerford, Lynn, et al. *Feminist Parenting.* Demeter Press, 2016.

Coontz, Stephanie. *The Way We Never Were: American Families and the Nostalgia Trap.* Basic Books, 1992.

Courtship of Eddie's Father, The Complete First Season. Warner Archive Collection, 2014.

Doucet, Andrea, and Robyn Lee. "Fathering, Feminism(s), Gender, and Sexualities: Connections, Tensions, and New Pathways. "*Journal of Family Theory & Review,* vol. 6, issue 4, Dec. 2014, pp. 355–73.

Dow, Bonnie J. *Prime-Time Feminism: Television, Media Culture, and the Women's Movement Since 1970.* University of Pennsylvania Press, 1996.

Echols, Alice. *Daring to Be Bad: Radical Feminism in America, 1967-1975.* University of Minnesota Press, 1989.

"Eddie's Will." *The Courtship of Eddie's Father,* season 2, episode 6, ABC, 28 Oct. 1970.

"Ellie Comes to Town." *The Andy Griffith Show,* season 1, episode 4. 24 Oct. 1960. Accessed via Amazon Prime Video.

Evans, Sara M. *Tidal Wave: How Women Changed America at Century's End.* Free Press, 2004.

Eversoll, Deanna. "A Two Generational View of Parenting." *The Family Coordinator,* vol. 28, no. 4, Oct. 1979. www.jstor.org/stable/583511. Accessed 11 April 2017.

"Family Reunion." *Family Affair,* season 2, episode 16. 1 January 1968. Accessed via Amazon Prime Video.

Fedderson, Don, creator. *My Three Sons.* Don Fedderson Productions, 1960-1972.

Friedan, Betty. *The Feminine Mystique: 50 Years.* Norton, 2001.

Glenn, Cerise. "White Masculinity and the TV Sitcom Dad: Tracing the 'Progression' and Portrayals of Fatherhood." *Communicating Marginalized Masculinities: Identity Politics in TV, Film, and New Media, first edition,* edited by Ronald L. Jackson and James E. Moshin. Routledge, 2012.

"Guardian for Eddie." *The Courtship of Eddie's Father,* season 1, episode 21, ABC, 4 Feb. 1970.

Goldberg, Wendy A, Edwin T. Tan, and Kara L. Thorsen. "Trends in Academic Attention to Fathers, 1930-2006", *Fathering,* vol. 7, no. 2, Spring 2009, pp. 159-179.

Hartmann, Edward and Don Fedderson, creators. *Family Affair.* Don Fedderson Productions, 1966-1971. Accessed via Amazon Prime Video.

Hartmann, Susan. "Women's Employment and the Domestic Ideal in the Early Cold War Years." *Not June Cleaver: Women and Gender in Postwar America, 1945-1960,* edited by Joanne Meyerowitz, Temple University Press, 1994, pp. 84-98.

Hartmann, Susan. *The Homefront and Beyond: American Women in the 1940s.* Twayne, 1982.

"Helen, the Authoress." *Andy Griffith Show,* season 7 episode 24. CBS. 27 February 1967. Accessed via Amazon Prime Video.

Hess, Donald J. and Geoffrey W. Grant. "Prime Time Television and Gender-Role Behavior." *Teaching Sociology,* vol. 10, no. 3, April 1983, pp. 371-388.

Hogan, Judy. "My Small Press and the Public Library." Judy Hogan, *Papers,* Special Collections Department, William R. Perkins Library, Duke University."

Howe, Louise Kapp. *Pink Collar Workers: Inside the World of Women's Work.* Avon, 1977.

Kelly, Janice. "Decoding Comedic Dads: Examining How Media and Real Fathers Measure Up with Young Viewers," *Deconstructing Dads: Changing Images of Fathers in Popular Culture,* edited by Laura Tropp and Janice Kelly, Lexington Books, 2016, pp. 77-95.

Kelly, Janice. "Fathers and the Media: Introduction to the Special Issue." *Fathering,* vol. 7, no. 2, 2009, pp. 107-113.

Kimmel, Michael. "Why Gender Equality Is Good for Everyone, Including Men." *TED.* www.ted.com/talks/michael_kimmel_why_gender_equality_is_good_for_everyone_men_included. Accessed 12 June 2017.

Kohner, Frederick, creator. *Gidget.* Screen Gems, 1965-1966.

Komack, James, creator. *Courtship of Eddie's Father.* MGM Television, 1969-1972.

Kwoleck-Folland. *Incorporating Women: A History of Women and Business in the United States.* Twayne, 1998.

LaRossa, Ralph. "The Culture and Conduct of Fatherhood in America, 1800-1860." *Japanese Journal of Family Sociology,* vol. 19, no. 2, 2007, pp. 87-98.

LaRossa, Ralph. "The Culture of Fatherhood and Late-Twentieth Century New Fatherhood Movement: An Interpretive Perspective." *Deconstructing Dads: Changing Images of Fathers in Popular Culture,* edited by Laura Tropp and Janice Kelly, Lexington Books, 2016, pp. 3-30.

LaRossa, Ralph. *The Modernization of Fatherhood: A Social and Political History.* University of Chicago Press, 1997.

Leonard, Sheldon and Don Weis, Bob Sweeny, and Gene Reynolds, Directors. *Andy Griffith Show.* Danny Thomas Enterprises, 1960-1968. Accessed via Amazon Prime Video.

Liebman, Nina C. *Living Room Lectures: The Fifties Family in Film and Television.* University of Texas Press, 1995.

Lipsitz, George. "The Meaning of Memory: Family, Class, and Ethnicity in Early Network Television Programs." *Cultural Anthropology,* vol. 1, no. 4. November, 1986, pp. 355-387.

Livingston, Gretchin. "A Tale of Two Fathers: More are Active, but More are Absent." Pew Research Center. 15 June 2011, www.pew-socialtrends.org/2011/06/15/ataleoftwofathers/ Accessed 4 Nov. 2017.

Lotz, Amanda D. "Postfeminist Television Criticism: Rehabilitating Critical Terms and Identifying Postfeminist Attributes." *Feminist Media Studies,* vol. 1, no. 1, 2001, pp. 105-121.

Mansour, David. *From Abba to Zoom: A Pop Culture Encyclopedia of the Late 20th Century.* Andrews McMeel Publishing, 2005.

Marlo Thomas and Friends. "Free to Be, You and Me." Bell Records, 1972.

Matthaei, Julie A. *An Economic History of Women in America: Women's Work, the Sexual Division of Labor, and the Development of Capitalism.* Schoken Books, 1982.

McLuhan, Marshall. *Understanding Media: the Extensions of Man.* Signet Books, 1994.

Meyerowitz, Joanne. *Not June Cleaver: Women and Gender in Postwar America, 1945-1960.* Temple, 1994.

Michals, Debra. *Beyond "Pin Money:" The Rise of Women's Small Business Ownership, 1945-1980.* Dissertation, New York University, 2002. UMI, 3048843.

Moore, Marvin L. "The Family as Portrayed on Prime-Time Television, 1947-1990: Structure and Characteristics." *Sex Roles*, vol. 26, nos. 1-2, 1992, pp. 41-61.

Morgan, Robin. *Saturday's Child: A Memoir.* W.W. Norton & Co., 2001.

Munford, Rebecca, and Melanie Waters. *Feminism & Popular Culture: Investigating the Postfeminist Mystique.* Rutgers University Press, 2014.

"Mother Bub." *My Three Sons*, season 3, episode 15, ABC, 27 Dec. 1962, *Dailymotion*, www.dailymotion.com/video/x5h6r6p. Accessed 6 Jan. 2020.

"Mrs. Livingston, I Presume." *The Courtship of Eddie's Father*, season 1, episode 1. ABC. 17 Sept. 1969.

Muniz, Tomas and Jeremy Adam Smith. *Rad Dad: Dispatches from the Frontiers of Fatherhood.* PM Press, 2011.

National Organization for Women. "Statement of Purpose." 29 Oct., 1966, now.org/about/history/statement-of-purpose/. Accessed 2 Feb. 2018.

Nelson, Hilde Lindemann. *Feminism and Families.* Routledge, 1997.

"Opie's Girlfriend." *Andy Griffith Show*, season 7, episode 1, CBS, 12 Sept. 1966. Accessed via Amazon Prime Video.

Parker, Kim. "Six Facts about American Fathers." *Pew Research Center*, 16 June 2016, www.pewresearch.org/facttank/2016/06/16/fathers dayfacts/. Accessed 11 Apr. 2017.

Parker, Kim. "Modern Parenthood." *Pew Research Center*, 14 Mar. 2013, www.pewsocialtrends.org/2013/03/14/modernparenthood rolesofmomsanddadsconvergeastheybalanceworkandfamily/. Accessed 11 April 2017.

Pehlke II, Timothy Allen, et al. "Does Father Still Know Best? An Inductive Thematic Analysis of Popular TV Sitcoms." *Fathering*, vol. 7, no. 2, spring 2009, pp. 114-39.

President's Commission on the Status of Women. *American Women*. U.S. Government, 1963.

Rabinovitz, Lauren. "Sitcoms and Single Moms: Representations of Feminism on American TV." *Cinema Journal*, vol. 29, no. 1, 1989, pp. 3-19.

Robinson, James D. and Thomas Skill. "Five Decades of Families on Television: from the 1950s through the 1990s." *Television and the American Family*, 2nd edition, edited by Jennings Bryant and Alison J. Bryant. Taylor and Francis, 2009, pp. 139-162.

Rosen, Ruth. *The World Split Open: How the Modern Women's Movement Changed America*. Viking, 2000.

Rotskoff, Lori, and Laura L. Lovett. *When We Were Free To Be: Looking Back at a Children's Classic and the Difference it Made*. University of North Carolina Press, 2012.

Rotundo, E. Anthony. "American Fatherhood: A Historical Perspective." *The American Behavioral Scientist*, vol. 29, no. 1, Sep/Oct 1985, p. 7.

Ruddick, Sara. "Thinking about Fathers." *Conflicts in Feminism*, edited by Marianne Hirsch and Evelyn Fox Keller, Routledge, 1990, pp. 222-33.

Samuel, Lawrence R. *American Fatherhood: A Cultural History*. Rowman & Littlefield, 2015. "1970s North Carolina Feminisms: Lollipop Power Press." Duke Uni-versity, sites.duke.edu/docstl10s_01_s2011_bec15/print-culture/lollipop-power-press/. Accessed 3 Sept. 2017.

Spiegel, Lynn. *Make Room for TV: Television and the Family Ideal in Postwar America*. University of Chicago, 1992.

Spock, Benjamin. *The Common Sense Book of Baby and Child Care*. Duell, Sloan and Pearce, 1946.

Steinberg, Cobbett. *TV Facts*. Facts on File, 1980.

Swanson, Anna. "144 Years of Marriage and Divorce in the United States, in One Chart." *Washington Post*. 23 June 2015. www.washingtonpost.com/news/wonk/wp/2015/06/23/144-years-of-marriage-

and-divorce-in-the-united-states-in-one-chart/?utm_term=. 51bf42366a97 Accessed 13 February 2017.

"The New Cissy." *Family Affair,* season 2, episode 25, 5 Mar. 1968.

"The New Housekeeper." *The Andy Griffith Show,* season 1, episode 1, 3 Oct. 1960.

"The Perfect Female." *The Andy Griffith Show,* season 2, episode 8, 27 Nov. 1961. Accessed via Amazon Prime Video.

Tropp, Laura, and Janice Kelly. *Deconstructing Dads: Changing Images of Father in Popular Culture.* Lexington Books, 2016.

"TV Single Dads Hall of Fame." www.TVDads.com. Accessed 3 March 2017.

United States. Bureau of Labor Statistics. "A Century of Change; the US Labor Force, 1950-2050." Toosi, Miltra. *Monthly Labor Review,* May 2002, www.bls.gov/opub/mlr/2002/05/art2full.pdf. Accessed 13 February 2017.

United States. Bureau of Labor Statistics. "Changes in Women's Labor Force Participation in the 20th Century." *TED: The Economics Daily,* 16 Feb. 2000, www.bls.gov/opub/ted/2000/feb/wk3/art03.htm. Accessed 13 February 2017.

United States. Bureau of Labor Statistics. "Changes in Men's and Women's Labor Force Participation Rates." *TED: The Economics Daily,* 10 Jan. 2007, www.bls.gov/opub/ted/2007/jan/wk2/art03.htm. Accessed 13 Feb. 2017.

United States. National Center for Health Statistics. "Fathers' Involvement with Their Children: United States, 2006–2010." *National Health Statistics Report,* no 71, 2013, www.cdc.gov/nchs/data/nhsr/nhsr071.pdf. Accessed 1 April 2017.

"Wedding Bells for Aunt Bee?" *The Andy Griffith Show,* season 2, episode 26, Apr. 1962. Accessed via Amazon Prime Video.

Chapter Two

Why Are Stay-at-Home Fathers Viewed as Feminist Progress?

Steven D. Farough

W hen one thinks of feminist fathering, stay-at-home fathers may come to mind as a worthy example. These are fathers for whom domestic responsibility is their primary mission. They are the ones who take caregiving seriously. Some of us, no doubt, know stay-at-home fathers who embody these characteristics, and others who may fall short, but we have also come to know about stay-at-home fathers as a cultural representation in the public sphere. Stay-at-home fathers are in a sense a vision of the way some families already are, and a portrait of the way things could be at the same time. This chapter explores how stay-at-home fathers are culturally represented in the mass and social media environments since they became notable in the early 1980s. These representations offer us an opportunity to explore society's changing views of primary caregiving fathers during the growth of neoliberal social governance, the period ranging from the 1980s to the present (Fraser 2).[1]

Alongside the evolving trope of the stay-at-home father, caregiving in the early twenty-first century has left parents in the U.S. increasingly on their own in managing the expenses of childcare, education, healthcare, and retirement (Cooper 34-36). These challenges that families face have been greeted with a neoliberal vision of feminist fatherhood in public discourse— namely, that the individual behaviour of men is seen as the answer to the challenges of work-family balance.[2]

The cultural representations of stay-at-home fathers are populated across a media landscape, including comedies, dramas, and personal accounts as well as demographic and social policies. The images of stay-at-home fathers have evolved from domestically incompetent and failed men to a viable solution to the current challenges of work-family balance. It is in these cultural constructs of stay-at-home fathers that we may envision feminist fathering. Do we think of feminist fathering as rooted in the exigencies of family life that will alleviate the disproportionate amount of carework done by mothers? Do we take a more expansive view of feminist fathering to focus on how caregiving and domestic responsibilities can be instituted through state social policy as well as egalitarian domestic responsibilities? It is the latter question that is not adequately addressed.

This chapter adopts a genealogical approach: after discussing the theoretical background on feminism and stay-at-home fathers, this chapter traces the evolution of the stay-at-home father as represented in American pop culture since the 1980s. The analysis will bring us to the "opt-out revolution" and Cheryl Sandberg's "lean in" approach—both are more recent cultural phenomena that have held up stay-at-home fathering and stay-at-home parenting as solutions to a domestic care-giving crisis with unacknowledged roots in social policy. Ultimately, this chapter proposes that although feminist fathers do need to be deeply involved in managing childrearing and other domestic matters, feminists in general also need to realize and advocate for policy solutions that help shift the responsibilities of caregiving back to the state.

The Unit of Analysis: A Brief Review of Scholarship and A Case for Studying Stay-at-Home Fathers as Cultural Constructs

Although it may seem like common sense to view stay-at-home fathers as an important part of a feminist agenda in solving the work-family balance crisis, others have more moderated views. The sociologist and stay-at-home father expert Andrea Doucet argues that stay-at-home fathers should not be automatically equated with feminist praxis; their existence in some ways maintains the breadwinner-caregiver model of work and family that feminists have fought hard to transform (11). Others point out that by mostly focusing on what individuals do to

manage the exigencies of work and family responsibilities, our attention turns away from the real structural constraints that plague the vast majority of families who struggle to find balance between family and work (Rottenberg 151-52; King 68; Farough 147-48). Most families cannot afford to have a stay-at-home parent due to the great expense of childcare in the U.S. (Cooper 34-36). Even when primary caregiving fathers are able to help their families achieve work-family balance, the focus on what stay-at-home fathers can offer working mothers eschews a socialist feminist vision that calls for a redistribution of caregiving and nurturance onto the state to ensure parents have more balanced and meaningful lives (King 68; Fraser 2). And therein lies the debate. On the one hand, the image of stay-at-home fathers becomes a beacon of feminist fathering due to their embrace of the private sphere; on the other hand, this image only offers a privatized solution to what should be addressed through public policy.

This debate about the efficacy of stay-at-home fathers ultimately raises questions about where care work should be located in the social order. If men can mother (read: care), then carework cannot solely reside with the female body. But caregiving (or carework) by women and men is also a cultural symbol that circulates in the public consciousness, and it invariably becomes part of a broader discourse about gender. The association of caregiving with gender becomes a cultural template that offers ways to behave, gives us solutions to pressing problems, and provides a vision of what is desirable and objectionable. These cultural symbols wind up on our Facebook and Twitter feeds, and they are discussed in TED Talks, on television news, and in local and national newspapers.

In a similar vein, the identity called "stay-at-home father" should not, therefore, be reduced only to the lived experiences of primary caregiving fathers or their views of the world. The standpoint of a stay-at-home father is not just a quantifiable demographic category, a psychological experience, or an identity at the micro level. A stay-at-home father could be seen as what the great masculinities scholar R.W. Connell would call a "configuration of practice"—an identity standpoint in the system of gender that links cultural symbols of masculinity in general and the varieties of them in particular to a broader social system in a field of power (72-73). Therefore, the identity stay-at-home-father is also a cultural representation that is located beyond the level of the

individual. The public representation of an identity always provides a vision of what is possible and desirable and what is unattainable and lacking in value; embedded in such an identity are the hopes and fears of the public (Connell 72-73).

It is worthwhile to genealogically trace these images because they reveal something about the efficacy and particular style of (potential) feminist fathering being offered in the public consciousness, and the images provide insight into the substantial transformation of the gender social order in the late twentieth and early twenty-first century. Consider how the term "Mr. Mom" is part of the parlance of American culture. Consider what comes to mind when you think of the term "stay-at-home father." The images of stay-at-home fathers in the media landscape are worthy to explore because not only do they offer what is possible for feminist fathering (or fathering in general), but they also provide insight into the transformation of gender in the twenty-first century. Indeed, representations of stay-at-home fathers have evolved from emblems of domestic incompetence and failure to a legitimate way to handle work-family balance.

Mr. MOM: The Original Stay-at-Home Father

The representation of stay-at-home fathers has become varied in recent years. For some time, however, stay-at-home fathers have been depicted as domestic buffoons and failed men, as the powerful imagery of masculinity and work cast a dark shadow over the possibility of competent, male primary caregivers. In this frame, fathers have failed in one of the primary missions of adult masculinity—breadwinning—and have entered into a sphere where they do not have the requisite skills of nurturance. Stay-at-home fathers have also been cast as a cautionary tale of infidelity in films, such as *Little Children* (2006) and television series, such as *Parenthood* (2010-2015), in which heterosexual couples reverse traditional gender roles in the family. The takeaway is that in popular culture, stay-at-home fathers have been portrayed as unable to manage a household, as likely to engage in an affair, and as suffering from depression—or any combination of these negative characteristics (Roberts 12-13).

It could be said that the commentary about stay-at-home fathers came before there were even sizable numbers of them. In 1983, when

Mr. Mom hit the box office, the number of stay-at-home fathers was relatively miniscule (Kramer et al. 1662)[3]. Nevertheless, *Mr. Mom* left a cultural footprint in the American social order. The film went on to earn $64 million dollars in the box office that year, and the phrase "Mr. Mom" is now a widely recognized idiom used to refer to stay-at-home fathers.[4] Although *Mr. Mom* would hardly be mistaken as one of the more prescient films of our time, it helped usher in a genre of filmmaking about the idea of modern men in domesticity, and as a result, it is a cultural representation of primary caregiving men in the late twentieth and early twenty-first century.

Mr. Mom tells a story of a recently unemployed automobile engineer named Jack Butler (played by Michael Keaton), who becomes the primary caregiver of his three children while his wife returns to the work world as an advertising executive. Much of the film is dedicated to making light of Jack's domestic ability and pokes fun at the chaotic nature of families with young children. The comedy rests largely on the idea of a man becoming a stay-at-home parent. The scene of a busy Jack warming up a poorly executed grilled cheese sandwich with an iron or holding a diaperless baby over a hand dryer in a public bathroom have become well-worn images of a father who is clearly in over his head. However, Jack is eventually able to find a rhythm to primary caregiving and befriends some of the fellow stay-at-home mothers in the neighbourhood. They watch soap operas together and speak critically of their working partners.

But the film also addresses the cultural anxieties of changing gender roles in the family and work arrangements in the latter part of the twentieth century. What happens when women leave the role of the primary caregiver to work or when men move into the domestic sphere? One thing that happens in *Mr. Mom* is that both Jack and his wife Caroline experience unsolicited sexual advances. One of the stay-at-home mothers in the neighbourhood takes a liking to Jack, and Caroline's boss tries to seduce her on a business trip. Jack and Caroline do ward off the advances, but each of them experiences worry that the other is involved in an affair. Jack also becomes jealous of Caroline's success, which suggests he longs for the work world and feels that he has failed as a man. Caroline also finds herself missing her time with her children. At the end of the movie, Jack returns to work, and his time in the at-home world ends. *Mr. Mom* left a cultural imprint of men in the domestic

world as largely incompetent, domestic buffoons. The trope of the male domestic buffoon has continued on in TV shows and movies, such as *3 Men and a Baby* (1987), *Guys with Kids (2012-2013)*, *Daddy Day Care (2003)*, *Grown Ups (2010)*, and *What to Expect When You're Expecting (2012)*. The idea of stay-at-home fathers has become a recurring comedic plot device in our popular culture landscape.

In the 2006 movie *Little Children*, the depiction of the stay-at-home father is one of loneliness and sadness; worse, he is a sexual threat to traditional marriages with stay-at-home mothers. It highlights the character Brad Adamson, an attractive and smart former high school football player, who has become a stay-at-home father while he studies for the state bar exam to become a lawyer. Brad comes across as a capable and involved caregiver. He goes about his day caring for his infant son Aaron with a rhythm that one would expect from the more competent providers of primary care to children. Brad is an object of desire and curiosity of some of the stay-at-home mothers at the park. At the playground, they watch him from afar, but most of them do not engage him in conversation.

The characterization of Brad Anderson, then, eschews much of the buffoonery of stay-at-home fathers in film and TV. Brad would never cook a grilled cheese sandwich with an iron. He knows how to care for his child in the early twenty-first century. However, in the case of Brad, he is lovelorn. He longs for intimacy with his wife Kathy, who seems too preoccupied with her career as a documentary filmmaker and who mourns lost time with their son, whom she clearly adores. It is not long before he befriends stay-at-home mom Sarah Pierce, one of the stay-at-home mothers who admired him from afar. Although Sarah is part of the at-home community, she was never fully able to embrace domesticity and the forms of femininity that exist there. Her relative outsider status is exacerbated when the other stay-at-home mothers look on with disapproval at Brad and Sarah's interactions. After numerous playdates, their friendship morphs into an affair. Both Brad and Sarah eventually end their relationship and resign themselves to their unhappy marriages. They are ultimately depicted as two fallen souls. The tone of the movie is sombre and filled with remorse. It is a cautionary tale that moves the narrative away from buffoonery but continues the cultural anxiety over fathers entering the domestic sphere.

84

Stay-at-Home Fathers Meet the Opt-Out Revolution

Around the time of the screening of *Little Children,* there was also a flurry of articles about what was perceived to be a new social trend: the opt-out revolution. Pieces written by *The New York Times* journalists Louise Story and Lisa Belkin made the case that higher ranking professional women were willingly leaving the demands of the work world to return to domesticity, and many college women at Ivy League institutions' major life goal was to become an at-home parent. As Lisa Belkin notes in "The Opt-Out Revolution," "As these women look up at the 'top,' they are increasingly deciding that they don't *want* to do what it takes to get there. ...Instead, women are redefining success. And in doing so, they are redefining work" (my emphasis 20). Then Belkin offers this answer to why more women are not in high ranking professional positions: "Why don't women run the world? Maybe it's because they don't want to" (25-26). Belkin does state that some of the mothers returned home because work was unaccommodating to family life, yet the larger takeaway is that educated, professional mothers were returning to domesticity because that was their real desire.

Louise Story makes the case in "Many Women at Elite Colleges Set Career Path to Motherhood" that Ivy League college-aged women had a plan that sounds similar to professional women opting out in Belkin's report: college, a brief stint of professional work, marriage, children, and domesticity. In the article, Story highlights Cynthia Liu, a Yale sophomore student. Her record was excellent; her high school transcript was stellar—1510 SAT score, 4.0 GPA—and her resume included many other extracurricular talents. Story writes, "So will she join the long tradition of famous Ivy League graduates? Not likely. By the time she is 30, this accomplished 19-year-old expects to be a stay-at-home mom" (2). As Cynthia Liu says herself, "My mother's [sic] always told me you can't be the best career woman and the best mother at the same time. You always have to choose one over the other" (3). Story uses this anecdote to propose that college women now see the idea of being able to "have it all" as the failed ideal of older feminists. The demands of the work world are too challenging to raise a family, so women should simply not plan on trying to balance both.

The opt-out revolution narrative suggested that women were leaving the workforce because they just really preferred being an at-home parent. It also gave the sense that neotraditionalism in Generation X

families was on the rise. It was more than acceptable for women to work (a break from the attitudes of older generations), but when they became mothers, it was expected they would be the primary caregiver of their children. That way the children would have the attentiveness of an at-home mother, and the father would continue to work fulltime to provide for the family. Or, as Story's article suggests, Ivy League college women were making a strategic calculation in less than ideal circumstances: because professional employment is often antithetical to family friendly work, women should plan to opt-out once they have children.

The critique of this trend was substantial. Some academics questioned if the trend was happening at all, and others pointed out the choice of opting out was not as simple as mothers just preferring to be with their children (Stone 4-7). Still, the idea that women were choosing to forgo advancement in professional life to become stay-at-home mothers became part of the national conversation about women and work. Although the philosopher Linda Hirshman suggests that opting out was an affront to the feminist struggle to gain access to the public sphere, the rebuke to this claim was that women now have a true choice. They can either work or stay at home—and that is what feminists should be promoting, the idea of choice. Of course, the singular focus on choice ignored the class-based reality that the stay-at-home option assumed one spouse would have a well-paying job. Despite its shortcomings, opting out was offered as a solution to the balance between work and family life in the first decade of the twenty-first century. It should come as no surprise that fathers who opt out of the workforce to care for their children would become a policy solution about one decade later.

Whereas stay-at-home dads were depicted as buffoons and philanderers, the opt-out revolution offered mothers a path back to domesticity as a means of balancing work and family demands. Then came the Great Recession. The women of the opt-out revolution found themselves wanting back into the work world, and fathers found themselves tumbling out of work, as the economy went into the worst tailspin since the Great Depression, with one in six workers having reported losing their job between 2007 and 2009 (Faber 2).

In Judith Warner's 2013 publication "The Opt-Out Generation Wants Back In," she follows up with the stay-at-home mothers highlighted in Lisa Belkin's "The Opt-Out Revolution" ten years later. The story is less than sanguine. Rather than learning of the virtues of stay-at-home

parenting, a more complicated picture is given. The mothers all say they enjoyed their time at home with their children, but opting out did not help them return to the workforce when they wanted to or when they needed to because their marriages ended in divorce. The development of the Great Recession, an economic downturn thought to disproportionately affect men, put pressure on at-home mothers to return to work. Warner writes the following:

> Among the women I spoke with, those who didn't have the highest academic credentials or highest-powered social networks or who hadn't been sufficiently "strategic" in their volunteering (fund-raising for a Manhattan private school could be a nice segue back into banking; running bake sales for the suburban swim team tended not to be a career-enhancer) or who had divorced, often struggled greatly. (25)

Among the many lessons learned from the opt-out revolution was the importance of being able to have some connection to the labour market and to have both spouses able to earn an income. After the economic devastation of the Great Recession, Warner's piece has become a cautionary tale for the choice narrative of the opt-out mothers (they want back in after all). When they leaned back into the work world a good ten years later after divorce or following financial stresses from the Great Recession, many of them found themselves earning markedly lower incomes and wondering how they would make ends meet.

One of the media angles on The Great Recession was its gendered outcomes. At the height of the economic downturn, some journalists made the case that the privileges of masculinity were largely over. Hannah Rosin wrote the now-classic "End of Men" for *Atlantic Magazine* and book with the same title to suggest that the Great Recession has put the final nail in the coffin for male dominance in employment and the polity; she goes on to suggest that the skillsets required to thrive in the aftermath of economic devastation—social intelligence, open comm-unication, focus—were ones largely held by women (25). Reihan Salam offers a similar assessment in "The Death of Macho" in *Foreign Policy* magazine. The sectors of the economy that were most devastated were finance and housing—both areas heavily dominated by men. Thus, the Great Recession represented a veritable "he-cession" (4); Salam continues by arguing that not only did the Great Recession demonstrate the limits

of unfettered financial institutions, but it also made apparent the problem of building a global economic order around the masculine ethic of brash overconfidence. The new economy would be built around skills that women tend to have more than men, notes Salam (13). And as a result, he argues this new economic order will benefit women more than men; it is up to men to adapt or resist. Resistance entails doubling down on an outdated breadwinning, manufacturing paradigm—a path Salam believes will offer little reward. Adaptation means "embracing women as equal partners and assimilating to the new cultural sensibilities, institutions, and egalitarian arrangements that entails" (Salam 17). In the end, Salam suggests that men need to become more flexible when it comes to the new economic order in general and to work-family balance in particular.

The promotion of flexibility opens up the door for stay-at-home fathers to become a solution. As we will see, numerous articles build towards a solution discourse, as men take on domestic roles in the ruins of an outmoded patriarchal economy. They go en masse into the private sphere and care for their children and the myriad responsibilities in the home. There is a palpable sense of malaise and resignation and, at the same time, an underlying opportunity for men to become primary caregivers, as the new economy has been rejigged in favour of skills that benefit women more than men. The fathers in these articles are meeting the call of domestic obligations. They are not cooking grilled cheese sandwiches with an iron. They are even involved in solving problems in the volunteer world of the at-home community. And the fathers have proven they can be more involved with their children—an idea that provides a prototype of stay-at-home fathers as a solution to the work-family balance crisis.

In Sarah Kershaw's *New York Times* piece "Mr. Moms (by way of Fortune 500)," she highlights the challenges of an upper-middle-class suburban community during the Great Recession. One million dollar homes were being placed on the market frequently, as many employees of the financial sector lost their jobs. But there are also numerous examples in the article of fathers who take on caregiving responsibilities of their families and volunteering more in the community. For instance, Mr. Levy, a forty-six-year-old former hedge fund manager, became a member of the PTA (7). There also seems to be a transformation in the fathers. As Kershaw notes, "Like other out-of-work fathers ... [Mr.

Emery] said that unemployment, while wrenching, has also forced him to find opportunity in dramatically altered lives that involve spending long hours with their children" (19) These families are in financial stress to be sure, but Kershaw does point out that the fathers are now better versed in childrearing, and some of them, such as Mr. Emery, "said he is considering careers, including teaching, that would enable him to stay more involved with his children" (24).

From Opting Out to Leaning In: Fatherhood Takes a Domestic Turn

In the gendered anomie of the Great Recession, earlier work-family balance solutions, such as "opting out" for mothers, seem less viable, and the new economy is supposedly more open to employing women. There is also a clarion call for mothers to stay working. Consider Sheryl Sandberg's TED Talk and book *Lean In*, for example. Inspired by Betty Friedan's *The Feminine Mystique*, Sandberg's *Lean In* is a plea for mothers to not opt out of professional work life and instead, as the title suggests, to "lean in" to their professional life. In her 2010 TED Talk, Sandberg offers a variety of strategies that working mothers can use to stay employed in the public sphere. One in particular that she highlights is the importance of having a "real partner," who is as committed to caregiving and household chores as women often are:

> Message number two: Make your partner a real partner. I've become convinced that we've made more progress in the workforce than we have in the home. The data shows this very clearly. If a woman and a man work full-time and have a child, the woman does twice the amount of housework the man does, and the woman does three times the amount of childcare the man does. So she's got three jobs or two jobs, and he's got one. Who do you think drops out when someone needs to be home more?

She also mentions the importance of opening up domesticity for fathers:

> The causes of this are really complicated, and I don't have time to go into them. And I don't think Sunday football-watching and general laziness is the cause. I think the cause is more complicated.

I think, as a society, we put more pressure on our boys to succeed than we do on our girls. I know men that stay home and work in the home to support wives with careers, and it's hard. When I go to the Mommy-and-Me stuff and I see the father there, I notice that the other mommies don't play with him. And that's a problem, because we have to make it as important a job, because it's the hardest job in the world to work inside the home, for people of both genders, if we're going to even things out and let women stay in the workforce.

The implication of Sandberg's advice is clear: women have been opting out because they carry exponentially more domestic responsibility than their husbands. If women are to lean in to the occupational world, fathers need to help their spouses by taking on more of the domestic obligations. She also interestingly infers that the domestic sphere needs to be more welcoming to primary caregiving fathers. In effect, to balance family and work obligations, both domains need a greater degree of gender neutrality to make it all work—especially when it comes to fathers and caregiving. Of course, a "real partner" can have a profession or not, but Sandberg believes this partnership is an essential part of women staying in professional work.

Sandberg's vision has motivated her to social activism: she helped found *Leanin.org,* a feminist nonprofit dedicated to promoting the advancement of women in the workforce. At *Leanin.org,* there is an op-ed by stay-at-home father Bob Wright, who makes the case for the importance of primary caregiving fathers to women achieving successful work lives:

> Having men who are capable, caring stay-at-home-parents is vital to the progress of women—and society.... One of the reasons [mothers] may make [the] choice [to become a stay-at-home parent] is that they have doubts about men's abilities to fill their roles at home. If I, and all the other stay-at-home dads, can involve ourselves in the community of young people and show them that we are at least capable of doing the job, perhaps young women 20 years from now will believe they have a partner capable of taking care of the house. Perhaps 20 years from now, young men will also recognize that they are capable of staying home with the kids. (5)

As fathers become more involved, Wright believes this may help plant the seed for future generation of men to become primary caregivers.

On December 7, 2013, journalists Jodi Kanto and Jessica Silver-Greenberg published "Wall Street Moms, Stay Home Fathers: As Husbands Do Domestic Duty, These Women Are Free to Achieve" on the front page of the Sunday edition of *The New York Times*. The piece realizes Sandberg's message of finding a "real partner," as "Wall Street Moms," often in high-level positions, have a fully committed partner in the domestic sphere. Indeed, Kanto and Silver-Greenberg note the following:

> [The mothers] *rely* on support that growing numbers of women on Wall Street say is enabling them to compete with new intensity: a stay-at-home husband. In an industry still dominated by men with only a smattering of women in its highest ranks, these bankers make up a small but rapidly expanding group, benefiting from what they call a *direct link* between their ability to achieve and their husbands' willingness to handle domestic duties. The number of women in finance with stay-at-home spouses has climbed nearly tenfold since 1980, according to an analysis of census data, and some of the most successful women in the field are among them. (my emphasis 2-3)

What is compelling about this analysis is that the piece makes a "direct link" between stay-at-home fathers and the success of women in the finance industry. Stay-at-home fathers are viewed as a solution to what ails working mothers. The phrase "small but rapidly expanding group" is a common one throughout the articles on stay-at-home fathers. These articles are clearly bringing to attention what is perceived as the beginning of a hopeful trend that follows the individualistic logic of rational economic actors. Consider the de Beur family:

> When they married 13 years ago, some of Ms. Jan de Beur's male colleagues scoffed, suggesting that she would become useless in the workplace. Marriage turned out to be one of her better career moves. By the time she became pregnant, her husband was working extremely long hours for an architecture firm that was pressuring him to relocate, and he made less than half of what she did. *The solution seemed obvious.* (my emphasis, Kantor and Silver-Greenberg 16)

But the decision for the husband to stay at home was not purely based on income generation. The move to make an inverted nuclear family also came about because "Many discovered that even with babysitting and household help, the demands of working in finance made a two-career marriage impossible" (Kantor and Silver-Greenberg 7). What became impossible was meeting the standards of culturally acceptable parenting (which expects family life to be centred on the child) without a hands-on, stay-at-home parent (Hays 9-12). Something had to give. In this case, it was the husband who opted out of the workforce to become the primary caregiver. The message from Sandberg's "lean in" approach to the "Wall Street Moms, Stay Home Fathers" piece is that individuals themselves can achieve that elusive balance—if they make the right choices in their marriage partner.

The Demography of Hope: Stay-at-Home Fathers as Solution

The media has also highlighted the growing number of stay-at-home fathers as a largely positive narrative. However, the demographic estimates of stay-at-home fathers have varied widely. It has been estimated that in 2015, there were between 199,000 and 2.1 million stay-at-home fathers in the U.S. (US Census Bureau 12; Livingston 5). That is not a typo. The estimates range by almost a factor of ten. Such a wide variation may suggest that demographers are not doing their job well or the data are not of high quality. However, the reason for the wide fluctuation is merely the result of how stay-at-home fathers are defined and measured. The U.S. Census Bureau typically designates a stay-at-home father as a man who is living with children under the age of fifteen and who has been home for an entire year in order to care for his home and family; also included in this definition is that he is to be married to a woman who has been in the workforce for the entire last year. Using this measure, the Bureau estimates that stay-at-home fathers have increased from 76,000 in 1994 to 199,000 in 2015.

There are clearly underlying assumptions that accompany this measure. This U.S. Census Bureau definition imagines stay-at-home fathers within a traditional heterosexual family structure and a separate spheres paradigm. The assumption is that the fathers are at home to care for children and household because they choose to do so, and the mothers

are out in the workforce providing financial security because that is their preference. Suggesting that primary caregiving is born out of choice limits the number of stay-at-home fathers to families where one income is enough to maintain a household. It also normalizes a vision of the heterosexual nuclear family structure—a formation that is hardly common today or throughout history (Coontz, *The Way We Never Were* 8).

The Pew Research Center finds the Bureau's definition limiting. For instance, when the Pew Center (2014) uses a more expansive definition of stay-at-home fathers to include fathers who are chronically unemployed, disabled, ill, back at school, or retired, their number increases to 2.1 million. Using this measure, the Pew Center estimates that the number of stay-at-home fathers almost doubled from 1.1 million in 1989 to two million in 2012 (Livingston 5). It offers a more class inclusive definition as well. Regardless of the conceptualization, the number of fathers who are at home with children has increased by a factor of two to three times over the past twenty years or so (U.S. Census Bureau; Livingston). Numerous articles in the media have noted this growth (Livingston; Miller; Cohn et al.). For example, Emily Peck's *Huffington Post* article is titled "Only 6 American Men Identified as Stay-At-Home Dads in the 1970s. Today, It's a Different Story"; she points out the number of stay-at-home fathers in 2015 was approximately 1.9 million (6-7). Although the number of stay-at-home fathers is comparatively small when compared to stay-at-home mothers (only 16 percent of all stay-at-home parents are fathers), the emphasis on the exponential growth of primary caregiving fathers suggests a trend that has caught momentum (Livingston 9). It also shows hope: as fathers continue to become more involved in domesticity, they will help realign the work-family balance, making the lives of working mothers less onerous.

Indeed, despite the fact that the majority of stay-at-home fathers are primary caregivers because of external constraints, a number of articles and news reports have come out emphasizing that the growth of stay-at-home fathers who are in the domestic sphere is because they genuinely want to be with their children. They effectively opted out of the workforce in the same vein as the mothers in *The New York Times* articles did a decade ago—it was their choice to do so. The titles of the pieces are illustrative. For instance, the Pew Research Center released a report on stay-at-home fathers titled "Growing Number of Dads Home with the

Kids, Biggest Increase among Those Caring for Family" (Livingston 1). In 1989, only 5 per cent of stay-at-home fathers were at home voluntarily, whereas by 2012, 21 per cent of fathers were at home out of choice (Livingston 3). Other articles echo the choice narrative. In 2014, *The New York Times* ran a piece titled "More Fathers Who Stay at Home by Choice," and *The Washington Post* published one called "Don't Call Them Mr. Mom: More Dads at Home with Kids Because They Want to Be" (Miller 1; Schulte 1). The National Public Radio also ran a story in 2014 on the voluntary element of stay-at-home dads called "Stay-at-Home Dad by Choice" (Young 1).

The choice narrative builds on the "Wall Street Mothers, Stay-Home Fathers" piece by emphasizing the genuine desire of these primary caregiving fathers to maintain a household. This choice is not made as the result of structural constraints forcing fathers into primary caregiving; it is made out of their own free will. Like the small but rapidly growing number of "Wall Street mothers," choice (as opposed to unemployment, illness, or disability) was consistently noted the reason that had increased the most for fathers becoming the primary caregiver in these articles. *The New York Times* journalist Claire Cain Miller notes the following:

Despite a recent small decline in the number of fathers who take care of children full-time, their numbers have doubled over the last 15 years, according to new data from Pew Research Center. And the main driver for the growth is the increase in men staying home by choice, not because of unemployment or injury. That shift reveals a structural change in gender roles in families and at work in the United States. (3)

This small but rapidly growing demographic is expansive enough to conclude that a structural change in the gender social order is underway.

What is perhaps most striking about these articles is that they emphasize the growth of choice when most stay-at-home fathers still enter domesticity by way of chronic unemployment or being ill or disabled, as Pew demographers, such as Gretchen Livingston, will readily acknowledge. Still, it is the trend of stay-at-home fathers by choice that shows the greatest gain. One lesson to be taken away from these pieces of journalism and research is that the voluntary and noble impulse of fathers to be with their children is trending enough to infer that a new

solution exists for work-life balance. In an age of persistent gender inequality for women in both the professional and domestic realms, such pieces give a sense of hope: men are finally getting their acts together and helping their families better address the complexities of work-family balance. And yet, the data clearly show that the choice option is limited to a small number of middle-to-upper-middle-class fathers.

Stay-at-Home Fathers as a Solution? Stay-at-Home Fathers as Feminist Fathering?

This brief genealogical history of the cultural representations of stay-at-home fathers tells varied stories—stay-at-home fathers as buffoons and philanders, as capable managers of a household, and as a potential solution to work-family balance. They also raise serious questions about the scope of their impact on the gendered social order and how they fit into a broader conversation of feminist fathering. The more recent trend in the representations of stay-at-home fathers is decidedly better than it was decades ago. Though far from being total, this cultural warming to stay-at-home fatherhood is one that highlights the importance of gender role flexibility in meeting family and occupational needs and is to some degree a dedication to feminist fathering. Nevertheless, it is a solution that is also located at the level of the individual. It is a solution that asks what individuals can do to overcome the tensions between work and family life.

Of course, the limitation of individual solutions to work-family balance is not lost on the many who make it their living to study these issues, and it is not missed by many who cannot afford to have a primary caregiver at home. For instance, Catherine Rampell's "Lean In, Dad: How Shared Diaper Duty Could Stimulate the Economy" offers a comparative analysis of paid leave and subsidized daycare policies in Europe, which highlights, among other things, how incentivizing paid paternal leave for fathers helps keep working mothers in the labour force and creates more balance in childrearing obligations (8-9). European nations do better at managing work/family balance because they have sound enough social welfare policy to make it all happen. There are other pieces, such as Marc Tracy's "Rich Stay-at-Home Dads Aren't the Future" that quickly point to the clear limits of the generalizability of the Wall Street Mom/Stay-at-Home Dad formula (1). And as stay-at-

home father Stephen Marche notes in his piece "Home Economics," the "lean in" remedy is ultimately an example of what he calls a "plutocratic wave of feminism," an incendiary phrase designed to illuminate the limits of this solution (2). He continues: "The central conflict of domestic life right now is not men versus women, mothers versus fathers. It is family versus money.... The main narrative tension is: 'How the hell are we going to make this happen?' There are tears and laughs and little intrigues, but in the end, it's just a miracle that the show goes on, that everyone is fed and clothed and out the door each day" (3). The solutions offered are ultimately for the highly paid and provide the vast majority of families nothing viable. The choice of the word "miracle" is telling. One could interpret this as an acknowledgment that in the U.S., work-family balance seems almost impossible to solve through the smart choices of individual families.

Although stay-at-home fathers have experienced a status upgrade in the public sphere, there is also a palpable sense of malaise that primary caregiving fathers' contribution to work-family balance is limited and the structural solutions that could help mitigate the tension are not coming anytime soon. This analysis of stay-at-home fathers in the media ultimately reveals the hope and fears about the state of the U.S. economy, polity, and family life. It should also be illustrative of feminist fathering: the focus of feminist fathering and, for that matter, fathering feminists is often on the consciousness raising of men to become more involved in family life and on the passing of the feminist baton onto their children. Feminist fathering offers reprieve from the second shift. It must succeed if working mothers are to have a chance in our economy.

Still, the sense of malaise in pieces such as Marche's *Atlantic* essay should also encourage the feminist fathering project to not fall into what Nancy Fraser would call neoliberal feminism—the exclusive focus on individual self-improvement and promotion strategies for working mothers with little regard for how globalized capital has diminished the ability for the state to provide stability for families. Fraser argues that neoliberal feminism now has a toehold in the public sphere, which is the result of a shift in feminist thought from "redistribution to recognition" (7), where feminism turned away from socialist influence to cultural politics.

Take for example the "second shift." This concept focuses on the cultural practices of heterosexual families, in which women have not

received the recognition for the unpaid labour they do on top of the paid labour they do. The solution calls for greater involvement by men. The move to opt out or lean in is a cultural practice that leads to individualized strategies for addressing the challenge of family and work life.

Over the past thirty years, American workers have increased their hours in professional occupations, have lost hours in lower-skill forms of employment, have suffered from stagnant wages, and have received fewer workplace benefits, while housing, education, and childcare costs have increased notably (Cooper 34-36). Work and family life are unstable, which has resulted in the vast majority of married couples with children requiring two incomes and needing some kind of policy to help them pay for the high costs of childcare and education. The growth of two-income families could have pushed American society towards social policies designed to create a more public form of raising children with such programs as subsidized daycare, longer school days, federally enforced flex time, and paid parental leave for all working adults (Hays 199). This has not happened.

Meanwhile, as many family scholars now argue, the American public has also embraced a view of raising children that is more labour intensive, child centred, and expensive than in previous generations (Hays; Senior; Warner; Hirshman). Although the neoliberal economy and polity provide relatively little opportunity for making an at-home parent a viable option for the majority of Americans, the belief in the efficacy of the at-home parent has arguably become more prominent. Feminist fathering should be mindful of this reality. Feminist fathering should also be dedicated to social policies that afford better alignment between family and work. The cultural practice of greater father involvement in domesticity is not enough without appropriate government social policy to alleviate the real challenges that most families face.

Endnotes

1. It should be noted, however, that this time frame is by no means the first time that fathers were heavily involved in childrearing in North America or in other societies. Prior to the Industrial Revolution (1600s-1800s), it was common for fathers, mothers, and children to work together farming. At this time, fathers and mothers were deeply involved in their children's lives, albeit with a notable

gendered division of labour, and there was no real cultural separation between economic and family life (Coontz *The Social Origins of Private Life* 123). It is also worthy to note that there are numerous examples of prehistoric and hunter and gatherer societies in which mothers, fathers and children worked together to obtain food and resources; there was no notion of a stay-at-home parent in these social orders either because economic and family life were bound together (Lorber 123-30).

2. This belief that more involved fathers resolve the tensions around work-family balance does not mean that other caregivers, namely stay-at-home mothers, are not left to their own devices. Whether mothers, fathers, or other primary caregivers, families are increasingly expected to manage care on their own.

3. Kramer and her associates estimate the percentage of stay-at-home parents who are stay-at-home fathers went from almost zero in the late 1970s (which was approximately the time of *Mr. Mom*) to 3.5 percent in 2009.

4. A number that was viewed as successful enough at the time to launch the filmmaker John Hughes to a profitable signing with Universal Studios.

Works Cited

Belkin, Lisa "The Opt-Out Revolution." *New York Times Magazine.* 23 Oct. 2003, www.nytimes.com/2013/08/11/magazine/the-opt-out-revolution.html. Accessed 20 Apr. 2014.

Cohn, D'Vera, et al. "After Decades of Decline, a Rise in Stay-at-Home Mothers." *Pew Research Center's Social and Demographic Trends Project*, April 2014, www.pewsocialtrends.org/2014/04/08/after-decades-of-decline-a-rise-in-stay-at-home-mothers/. December 15, 2015.

Connell, R.W. *Masculinities.* University of California Press, 1995.

Coontz, Stephanie. *The Way We Never Were: American Families and the Nostalgia Trap.* Basic Books, 2000.

Coontz, Stephanie. *The Social Origins of Private Life: A History of American Families 1600-1900.* Verso, 1988.

Cooper, Marianne. *Cut Adrift: Families in Insecure Times.* University of California Press, 2014.

Doucet, Andrea. "Is the Stay-At-Home Dad (SAHD) a Feminist Concept? Genealogical, Relational, and Feminist Critique." *Sex Roles*, vol. 75, no. 1, 2016, pp. 4-14.

Faber, Henry "Job Loss in the Great Recession and its Aftermath: U.S. Evidence from the Displaced Workers Survey" NBER Discussion Paper No. 9069, May, 2015. National Bureau of Economic Research.

Farough, Steven. "Stay-at-Home Fathers: Are Domestic Men Bucking Hegemonic Masculinity?" *Letting Go: Feminist and Social Justice Insight and Activism*, edited by Donna King and Catherine Valentine, Vanderbilt University Press, 2015. pp. 139-50.

Fraser, Nancy. *Fortunes of Feminism: From State-Managed Capitalism to Neoliberal Crisis.* Verso, 2013.

Friedan, Betty. *The Feminine Mystique.* W.W. Norton & Company, 1963.

Hays, Sharon. *The Cultural Contradictions of Motherhood.* Yale University Press, 1996.

Hirshman, Linda *Get to Work:... And Get a Life, Before It's Too Late.* Penguin Books, 2007.

Kantor, Jodie, and Silver-Greenberg, Jessica. "Wall Street Mothers, Stay-Home Fathers" New York Times, 7 Dec. 2013, www.nytimes.com/2013/12/08/us/wall-street-mothers-stay-home-fathers.html?pagewanted=all&_r=0. Accessed 7 Dec. 2013.

Kershaw, Sarah. "Mr. Moms (by way of Fortune 500)." *The New York Times*, 22 April 2009, www.nytimes.com/2009/04/23/fashion/23dads.html. Accessed 12 June 2010.

King, Donna. "Toward a Feminist Theory of Letting Go." *Frontiers: A Journal of Women Studies*, vol. 33, no. 3, 2012, pp. 53-78.

Kramer, Karen, Erin Kelly and Jan McColloch. "Stay-at-Home Fathers: Definition and Characteristics Based on 34 Years of CPS Data" *Journal of Family Issues*, vol. 36, no. 12, 2015, pp. 1651–73.

Little Children. Directed by Field, Todd and Tom Perrotta, Bona Fide Productions, 2006.

Livingston, Gretchen. "Growing Number of Dads Home with the Kids: Biggest Increase Among Those Caring for Family." *Pew Research*

Center's Social and Demographic Trends Project, June 2014, www.pewsocialtrends.org/2014/06/05/growing-number-of-dads-home-with-the-kids/. Accessed 10 Aug. 2014.

Lorber, Judith. *Paradoxes of Gender.* Yale University Press, 1994.

Marche, Stephen. "Home Economics: The Link between Work-Family Balance and Income Inequality." *The Atlantic,* July/August 2013, www.theatlantic.com/magazine/archive/2013/07/the-masculine-mystique/309401/. Accessed 15 Oct. 2014.

Miller, Claire Cain "More Fathers Who Stay at Home by Choice" *The New York Times,* 5 June 2014, www.nytimes.com/2014/06/06/upshot/more-fathers-who-stay-at-home-by-choice.html. Accessed 5 June 2014.

Mr. Mom. Directed by Stan Dragoti, Written by John Hughes, 20th Century Fox, 22 July. 1983.

Parker, Kim and Wendy Wang. " Modern Parenthood: Roles of Moms and Dads Converge as They Balance Work and Family." Washington, D.C.: Pew Research Center's Social and Demographic Trends Project, March, 2013.

Peck, Emily. "Only 6 American Men Identified as Stay-At-Home Dads in the 1970s. Today, It's a Different Story." *The Huffington Post.* 8 June 2015, www.huffingtonpost.com/2015/05/08/stay-at-home dad s_n_7234214.html?utm_content=buffer189cc&utm_medium =social&utm_source=facebook.com&utm_campaign=buffer. Accessed 10 August 2015.

Rampell, Catherine. "Lean In, Dad." *New York Times Sunday Magazine,* 7 Apr. 2013, www.nytimes.com/2013/04/07/magazine/how-shared-diaper-duty-could-stimulate-the-economy.html. Accessed 12 Dec. 2014.

Roberts, Soraya. "Mr. Moms: Pop Culture's Househusbands Lag Behind the Reality of American Households." *The Daily Beast,* 18 June 2013, www.thedailybeast.com/articles/2013/06/18/pop-culture-s-house-husbands-lag-behind-the-reality-in-american-homes.html. Accessed 22 June 2015.

Rosen, Hannah. "The End of Men." *The Atlantic,* July/August 2010, www.theatlantic.com/magazine/archive/2010/07/the-end-of-men/308135/. Accessed 3 Sept. 2010.

Rottenberg, Catherine. "The Rise of Neoliberal Feminism." *Cultural Studies,* vol. 28, no. 3, 2014, pp. 418-37.

Salam, Reihan. "The Death of Macho." *Foreign Policy,* 21 June 2010, foreignpolicy.com/2009/06/21/the-death-of-macho/. Accessed 3 Sept. 2010.

Sandberg, Sheryl. *Lean In: Women, Work and the Will to Lead.* Knopf, 2013.

Sandberg, Sheryl. "Why We Have Too Few Women Leaders." *TED Women Talk,* December 2010 www.ted.com/talks/sheryl_sandberg_why_we_have_too_few_women_leaders/transcript?language=en. Accessed 23 May 2012.

Schulte, Brigid. "Don't Call them Mr. Mom: More Dads at Home with Kids Because They Want to Be." *Washington Post,* 5 June 2014, www.washingtonpost.com/news/parenting/wp/2014/06/05/dads-who-stay-home-because-they-want-to-has-increased-four-fold/. Accessed 7 Aug. 2014.

Senior, Jennifer. *All Joy and No Fun: The Paradox of Modern Parenthood.* Harper Collins, 2014.

Steinhauer, Jennifer. "Beth Court: With Dad Laid Off, Finding Ways to Hold On." *The New York Times,* 23 Aug. 2009, www.nytimes.com/2009/08/24/us/24bethtwo.html. Accessed 4 Jan. 2010.

Stone, Pamela. *Opting Out? Why Women Really Quit Careers and Head Home.* University of California Press, 2007.

Story, Louise "Many Women at Elite Colleges Set Path to Motherhood." *The New York Times,* 20 Sept. 2005, www.nytimes.com/2005/09/20/us/many-women-at-elite-colleges-set-career-path-to-motherhood.html?_r=0. Accessed. 13 July 2006.

Thompson, Derek. "How Did Work-Life Balance in the US Get So Awful?" *The Atlantic,* 1 June 2013, www.theatlantic.com/business/archive/2013/06/how-did-work-life-balance-in-the-us-get-so-awful/276336/. Accessed 10 Aug. 2014.

Tracy, Marc. "Rich Stay-at-Home Dads Aren't the Future." *New Republic,* 9 Dec. 2013, newrepublic.com/article/115863/wall-street-moms-and-stay-home-dads-are-not-f ture. Accessed 9 Jan. 2014.

U.S. Census Bureau. "America's Families and Living Arrangements." *U.S. Census Bureau,* 2012, www.census.gov/newsroom/facts-for-features/2016/cb16-ff11.html. Accessed: 22 Feb. 2018.

Warner, Judith. "The Opt-Out Generation Wants Back In." *The New York Times*, 7 Aug. 2013, www.nytimes.com/2013/08/11/magazine/the-opt-out-generation-wants-back-in.html?page wanted=all. Accessed 10, Sept. 2013.

Warner, Judith. *Perfect Madness: Motherhood in the Age of Anxiety.* Riverhead Books, 2006.

Wright, Bob. "Stay at Home Dad Member Stories." *Leanin*, 2015, leanin.org/stories/bob-wright/. Accessed 5 Apr. 2015.

Young, Robin "Stay-at-Home Dads by Choice." *Here & Now*, 22 Dec. 2014, www.wbur.org/hereandnow/2014/12/22/at-home-dad-by-choice. Accessed 9 Jan. 2014.

Chapter Three

Feminist Fathering in the Shadow of 9/11: The Lessons of Laila Halaby's *Once in a Promised Land*

Jeff Karem

"I see artists as translators/interpreters who give us a glimpse at a situation or a person or a feeling in some more accessible medium. They can also offer us an eye into someone else's world and help dispel stereotypes and misconceptions by tugging at that universal spot, the humanity within us all."—Halaby par. 2

Feminist fathering has been practiced across several generations of my family, although my father and grandfather probably would not have used the term. My grandfather, who emigrated from Lebanon to the U.S. in 1917, worked as a salesman while completing law school in the U.S. He became a lawyer and judge, and my grandmother was equally committed to the law. In the 1950s, she enrolled in law school at night at the University of Louisville and completed her JD in four years with the highest bar exam score in the city. Every night that she was studying, my grandfather took full responsibility for their five children. His work was exceptional in his family context, as his Lebanese relatives typically kept strict barriers between so-called men's work and women's work. The Karem women usually did all of the cooking, ate with the family, and then retired to

the kitchen while the men played cards, smoked, or shared *arak* (a Mediterranean anise spirit). Despite these expectations, my grandfather did not view this time with his children as diminishing; he valued it as an opportunity to play and to share art and culture, often bringing them to his nights at the Catholic Theater Guild, where he wrote and directed plays. Once my grandmother completed her degree, she and her husband formed a joint law practice, Karem and Karem Attorneys, which was unique in its era as a husband-wife partnership.

For my part, I was raised in a family that may have seemed traditional from the outside but was much more nuanced in its shared parenting. My mother started her career as a middle-school teacher and then shifted to raising her sons as a stay-at-home mom. At the same time, she worked as a neighbourhood advocate and conducted extensive research as a local historian—commitments that required childcare and support from my father, who was a lawyer, community activist, and state representative. Although he was a public figure, he was deeply committed to family. He helped around the house not just in the traditional male venues of the 1970s and 1980s—such as home repair and yard care—but did much of the grocery shopping, cooked frequently, and shared in the myriad transport duties for two boys: school, sports, and the inevitable emergency room visits. Because my mother was so active and engaged in the community, she was able to support my father's work more substantively than the photo ops expected of spouses in the 1970s. In both generations of the Karem family, the key element to fathering was caregiving rather than lawgiving (which is ironic given my family's work in the field of law). "Wait until your father gets home" was never a threat in either generation, because there was no vision of the father as an enforcer. Both parents shared in discipline, and both parents shared in nurturing.

This background well prepared me for the complex balancing act of a future family that blended art and academe, both of which are fields that demand a great amount of sacrifice from spouses. Just after finishing her master's degree, my wife and I married, and her honeymoon was spent driving a U-Haul with me in the snow to New Haven, Connecticut, over winter break so that I could return to graduate school for classes. It was only fair to reciprocate when my wife won a doctoral fellowship back in Kentucky, so we packed up two years later, and I wrote my dissertation in a commissary house in horse country. Achieving an equitable

domestic-work balance was especially important for us because of the nomadic nature of academe, which often means that couples are on their own and often in unfamiliar settings with no family support. After one hundred job applications, thirteen interviews, and two campus visits, I secured an assistant professor position in Cleveland, a city we grew to love, but which was hundreds of miles away from our families in Kentucky, Vermont, and California. Because I finished my doctorate first, we went where I got a job, meaning my wife's career had to follow mine. We both felt lucky to have landed in a major city with a thriving arts community—a stroke of pure luck. As our marriage developed in Cleveland, the script slightly flipped. Although I had a developing career as an academic, that work was less creative and emotionally draining than my wife's career as an artist, so a crucial goal of our domestic arr-angement was finding a space for her to work. Even before our children arrived, we made sure that my wife had a "room of her own," while my creative space was in the kitchen. Both of my parents had taught me to cook, and I always expressed my love by sharing food, but I decided to gear up to take extra responsibilities to help my family prepare for our first child.

My eldest son's due date was September 11, 2001. He was born prematurely, eight days early, which landed him in the NICU but spared him a lifetime of association between that tragedy and his birthday. As a descendant of Lebanese immigrants, I still breathe a sigh of relief that my son was not born on 9/11. Post-9/11 politics would later reshape my teaching of domestic fiction and lead me to the novel I will discuss in this essay, but nesting and sleeplessness shielded my family from those concerns during the first months of my son's life. In those early days, I quickly learned of the institutional challenges facing fathers in the American workplace. Even in a tenure-track professorship—a position with great flexibility and privilege—there were no contractual provisions for parental leave or course coverage for me. I had to teach the day after my child was born while he was still in the NICU and my wife was recovering in the hospital. Once our son could come home, our house was set up to prioritize both the baby's and the artist's spaces. My study became primarily a nursery so that my wife's studio could remain intact. This arrangement suited our mutual situations. As an artist, my wife needed quiet and room to work. As a new professor, I had my own work space on campus, which meant that I could shift my time at home to be

more domestic in focus. Although our families came for brief visits or offered support and encouragement from a distance, we lacked day-to-day help, so we had to tackle childrearing as a strictly two-person operation. My wife gave up adjunct teaching to take care of the baby because the cost of childcare was higher than what she would make per course. We split the day into shifts. Because our son was colicky, he needed to be held to sleep deeply, so I spent many nights on the couch holding him and watching classic movies on our VHS through the night. I cherished that physical intimacy with our son, and I credit those nights with my deep familiarity with the canon of film noir, as I worked my way through all of the classic film holdings of the Cleveland Heights Library system.

My son's birth, 9/11, and my teaching at Cleveland State University generated a haunting convergence of the personal, political, and pedagogical. Over the summer, I had been preparing a syllabus on "Domesticity and American Literature"—perhaps the professorial version of nesting. Given the rich multicultural history of Cleveland, I aimed for a reading list that echoed the diversity of the city and my students. This goal became an ongoing commitment of mine in the shadow of 9/11, as anti-Arab rhetoric and the drumbeat for invading Iraq dominated the mass media. I found it vital to share literature that provided a humanizing counter-narrative to the xenophobic broadcasts in circulation. In tandem with that literary outreach, my parenting—which was primarily centripetal, if not housebound at first—became much more tied to the community. Because I taught primarily evening classes, I was available in the morning to watch my son, get out of the house, and give my wife a quiet place to work on her dissertation. Without a history or family ties in the region, I looked to help build a village of support in my community. I was fortunate that Cleveland Heights had a centre for parents and children to gather to play, share toys, and plan outings together. I joined an emerging subculture of fathers at the centre, who had free time during the day and used it to bond with children and support their spouses. One of the best aspects of this group was the mutual support across multiple lines of culture and class. Some of us were stay-at-home dads; others worked irregular hours as contractors or pilots; others worked second shifts in local businesses. The virtual village that developed among us gave us a chance to share tips, swap baby gear, and discuss the complexities and challenges of

work-life balance in our own careers or those of our spouses.

The challenges we shared proved diverse, surprising, and sometimes contradictory. Upon first meeting any of us, many community members assumed that we were single parents—as if only the absence of a partner could account for a male caring for his children. Some of us found that doctors or school officials did not regard us as the real parent and shifted focus to the mother in family visits, even when she made clear that these caregiving responsibilities were ours. At the other extreme were those who seemed to view us as super-heroic for taking up these responsibilities—precisely the same domestic work for which most mothers receive little credit. We did not view ourselves as martyrs or saints. In fact, we found this work to be a privilege. Few fathers because of work responsibilities or a lack of parental leave had the opportunity to provide early childhood care and bond as we did. Questions of privilege also revealed the limitations of the power of our group. We all had either flexible schedules or working spouses who could make these arrangements possible. Most fathers did not. Our individual and collective practice supported our children, spouses, and one another, but we could not guarantee that through our efforts that this was an opportunity available to everyone in our community.

Currently, the cohort of parents regularly visiting the centre is now so mixed in gender that there is no longer a need for a specific dad's group. Fathers, feminist or otherwise, are regular and expected participants at the centre. As our children entered elementary school and careers shifted, the group separated, although some of us check in on an annual basis (usually New Year's) to see how our families are doing. One of the key values I learned from fathering practices in the group was the need for readily available, mutual community support for parents and children alike. Ten years after my first child was born, our second son arrived, and I tried to carry forwards the feminist fathering I learned, both in personal practice and in my workplace. Beginning in 2006, I became involved in our faculty union and worked consistently to support the rights of mothers, fathers, and children. My first service to the union was leading a grievance panel that restored pay to a faculty member who was docked salary for completing (with her supervisor's approval) the last two weeks of her course via distance-learning after she delivered her child. As union president and chief negotiator, a key goal of mine was advocating for better policies to support parents and

children. Although I did not find active resistance to these proposals, there was considerable inertia in response, and even with improved contract language recognizing rights to family leave, there are no still no well-developed university policies to support parents at this time—a fact that bedevils me when I aim to support faculty in my current role as department chair. I have had to improvise and essentially ask for volunteers to cover courses because the university has not yet developed a consistent policy. If a relatively progressive institution such as a university still needs systemic advancement to support fulltime faculty, one can only imagine the challenges facing part-time employees and parents in other workplaces.

Within our own domestic sphere, my wife and I had more success in finding balance than at my workplace, and we built upon the practices we shared after the birth of our first child. Because we had moved into a house (as compared to our first apartment), my wife had space of her own, but time became the most important commodity for her work. She took care of our younger son during my work hours, and I cooked dinner and took on transport and extracurricular responsibilities—taking my youngest to daycare in a bike trailer, picking up my older son from school, and shepherding each of them to swim lessons and school clubs. Outside of our immediate family, I aim to preserve the communitarian spirit I learned from the dad's group by fostering on open-door policy with other parents and children in our area. We live in a mixed-income, diverse neighbourhood with parents on complex work and custody schedules, so the vaunted playdate ideal is rarely practicable. Instead, we share in a communitarian spirit; we know that the neighbours down the street can pinch hit for us, and we for them, when the kids need to be watched or parents need some respite. I lead neighbourhood carpools to school and can pick up kids at a moment's notice, as I know my neighbours can for me. My wife is always ready to welcome passersby to her garden to pick fruit and flowers, and I am ready to be a referee, coach, or trainer for kids as needed—setting up the basketball hoop and getting ice water and snacks ready on short notice. This open-door approach has struck some of our suburban acquaintances as odd because it can make it hard to pin down schedules for when children will meet, but it actually reminds me of the free play of my youth, where children could range up and down city blocks, with the expectation that they could go anywhere and be welcome. For me, the commitment to

FEMINIST FATHERING IN THE SHADOW OF 9/11

welcoming all children from our community as part of a virtual family is a key component of feminist fathering. At the same time, I recognize that our approach cannot be the sole response to broader economic injustices, which must be tackled more systemically. Children we have welcomed into our home often have moved away overnight due to foreclosure and parents' unemployment. At one point, every house on our street but ours was in foreclosure. Our neighbourhood began to feel like a sad ghost town, and we saw signs of strain for families everywhere. Although the neighbourhood has since recovered, we saw all too clearly how easily the very concept of a community can fray and mutual support can disappear, illustrating the necessity of Angela Davis's maxim that "we must always attempt to lift as we climb" (12).

The Pros and Cons of Domesticity

Introducing students to a diverse range of families and cultures through American literature became a natural pedagogical correlative to the community-based parenting I had learned to practice as a feminist father. At first glance, courses on family and domesticity would seem the ideal way to foster thoughtful cross-cultural engagement. This subject connects particularly well to Cleveland State University students, who are often commuters with jobs and family obligations well beyond their academic studies. Consequently, they are well-prepared to consider the complex demands of domesticity, work, and parenting. Cleveland is a city of immigrants, so texts with an international dimension resonate well with many of my students, who often can find fruitful parallels between their own families' experiences and those of the families depicted in the course texts.

At the same time, discussions of home and family can take on a darker, more violent tone in times of national anxiety. As I refined my syllabus in the years after 9/11, I noted the abundance of family metaphors that came to characterize our national discourse, such as the "Department of Homeland Security," which sounded to me like a bureaucratic branch on loan from Phillip K. Dick's *The Man in the High Castle*. A neighbour expressed to me her approval for George W. Bush's military buildup with the truism "A father has to do what he has to do to protect his family." *His* family? Was I now, by implication, a scion of the Bush clan? (Could I borrow from the Bush family trust?) If the nation was being remade as

a family, what kind of family would that be? What national legacy would there be for my children? As a father aiming to raise a globally aware child who would respect others, militarism and anti-Muslim discourse were not the family values I wanted to teach. As a father, I have always felt the impulse to protect and value that instinct. As a citizen, however, I saw our nation's protective reaction lead us into dark territory that betrayed our nation's best values: an invasion of Iraq on false intelligence, Abu Ghraib, Guantanamo Bay, illegal surveillance, torture, and killings of immigrants and people of colour—a history of violence that persists nearly two decades after that tragedy.

In the context of debates about the price of protecting the American family, Laila Halaby's *Once in a Promised Land* (2007) emerged as an invaluable work of literature for promoting reflective dialogue in my courses. Halaby's novel threads together thornily intertwined issues that continue to divide the nation, including immigration, security, substance abuse, racism, and toxic masculinity. The novel traces the challenges faced by a Jordanian husband and his Palestinian–American wife after 9/11. As the title suggests, Halaby interweaves the lives of these characters and their pursuit of the American Dream with fairy tales (both Western and Middle Eastern), which typically have some of the most fixed gender and parenting roles in world literature. Readers who begin the novel, however, expecting a Cinderella story or narrative of Prince Charming's rescue find themselves surprised and challenged by Halaby's complex gender permutations. Salwa, the beautiful Palestinian princess in the story, longs for a child to fill her suburban loneliness but resists traditional models of motherhood and domesticity. Her husband, Jassim, plays a role readers are more likely to view as maternal, as he is concerned for the future of children across a wide swath of their adopted city of Tucson, Arizona. Although the novel does reveal the damaging impact of prejudice against Arab Americans after 9/11, Halaby is equally committed to exploring the damage done to all Americans by problems of inequality and diminishing opportunity in the twenty-first century. Since 9/11, a national foreclosure crisis, the Great Recession, and the opioid epidemic have continued to decimate families. Although these problems are internal, if not endemic, to the U.S., these hardships are tempting some Americans to ever greater extremes of xenophobia and hate. In this context, Halaby's exploration of a failing American Dream is hauntingly resonant today. Through

Jassim's travels, Halaby exposes the sordid underbelly of his adopted nation, with children facing absent fathers, broken families, suicidal depression, substance abuse, and declining economic opportunities. The self-styled prince of the novel, the American ex-marine Jack Franks, fancies himself a protector of the homeland but is revealed to be an ineffectual and abusive pretender to that throne. In contrast, the outsider Jassim focuses on the plight of children and the nation's failures towards them. He becomes a model of feminist fathering, as he aims to foster a more collective sense of responsibility—a much needed antidote to the toxic cultures of masculinity raging in America today, from President Trump's abusive demeaning of women, to incels' wishes for female sexual compliance, to self-help texts aimed at empowering men at the expense of women, such as Jordan Peterson's *12 Rules to Life*.

In Halaby's vision, it is vital to develop feminist fathering because feminist mothering cannot uphold a just community on its own. Mothers are constantly under attack from male authority in the novel. Abusive fathers, husbands, and boyfriends pose a direct threat to Halaby's mothers and their children. More indirectly, American religious and cultural narratives, such as right-wing Christian patriarchy or American romance, infantilize young women and confine them to disempowered domestic spaces. Jassim resists the urge to meet violence with violence and instead opts to help people in their recovery. In Halaby's fairy-tale ending, the hero is "an ordinary man ... not a handsome prince" (*Once in a Promised Land*, 335). He helps his wife, along with other families in Tucson, by listening to their grief, binding their wounds, and disentangling the threads of trauma that have tripped them as they aspired to the American Dream.

My understanding of Jassim's feminist fathering is grounded in a number of seminal sources surrounding feminist parenting. bell hooks offers the most thorough model for appreciating Halaby's call to transform fathering practices. hooks observes that "sexist oppression perverts and distorts the positive function of family"; she calls upon us to "affirm the primacy of family life" but to "rid family life of the abusive dimensions created by sexist oppression without devaluing it" (38). Andrea Doucet's *Do Men Mother? Fathering, Care and Domestic Responsibility* provides a valuable framework for understanding the broad range of parental care towards which fathers may contribute. For Doucet, "the essence of mothering is the responsibility for children"

(15), and Halaby's novel effectively functions as a call to action for men to share in that responsibility. For the purpose of this chapter, I will term Jassim's caregiving as "fathering," not in order to answer Doucet's question once and for all but to highlight Halaby's emphasis on the vital need to transform American masculinity. Two decades ago, Judith Kegan Gardiner sounded an alarm call that "a popular consensus has developed around the idea that American fatherhood is in crisis" (264), and Halaby's novel shows that the crisis has deepened in the twenty-first century. In response, Halaby's novel provides an apt illustration of Doucet's insistence upon "reconstructing fathering" (217). My chapter aims to analyze and highlight Halaby's blueprints for this project. Through Jassim's development, Halaby demonstrates the necessity of shifting fathering away from vertical operations of power—such as upholding hierarchy, enforcing authority, and protecting one's family from cultural others—in favour of creating mutual structures of caregiving and support.

This conception of feminist fathering necessarily extends beyond the nuclear family towards an ethics of community-based responsibility for children. If traditional patriarchal fathering focuses on primogeniture and blood relations, feminist fatherhood understands responsibility as horizontal, rhizomic, and extending beyond the immediate family. As Doucet reminds us, there is always an "extra-domestic, community-based quality of the work of being responsible for children" (141). This reminder is particularly apposite Halaby's focus on Arab American culture, which has a much broader sense of community responsibility for child-rearing and extended family relations. Although I chafe at Doucet's language of "Third World settings," her description of the vitality of "community networks and inter-household relations" (142) to support children is an apt description of Jassim's grounding in Jordanian traditions. Taking a broader view of one's responsibilities as a parent in a diverse context—what Doucet terms the "relational and intersectional" (34) components of parenting—is essential for advancing progress towards equity and opportunity in one's community. Without attention to community relationships outside of one's immediate family, fatherhood that simply assists mothers and children in the same subject position runs the risk of reinforcing existing inequalities by maximizing internal competitive advantage rather than lifting up and assisting the community around them. hooks reminds us of the obligation to respect these

intersectional responsibilities: "Individuals who fight for the eradication of sexism without supporting struggles to end racism or classism undermine their own efforts" (40). In this regard, I would suggest that Jassim's work follows in the spirit of hooks's call and, more broadly, fulfils what Sara Ruddick describes as a "maternal politics of care and justice" (xxi). Feminist fathering means a commitment not simply to caregiving within one's nuclear family, but to society more broadly. In the words of Providence House, a Cleveland crisis centre for families, "Every child is your child."

An Unlikely Feminist Father

At first glance, Jassim Haddad would seem an unlikely candidate for a feminist father. Given Western media representations, American readers are likely to expect Middle Eastern men to be patriarchal and women to be subordinate, a stereotype that Halaby plays against. Jassim shows considerable strengths as a feminist husband, encouraging his wife's work at a bank and as a realtor. His support for the latter is especially significant because some of Salwa's more traditional Arab friends, such as her ex-boyfriend Hassan, frown upon real estate work as usurious and deem her a "land pimp" (12) for her efforts. Halaby also shows Jassim's strengths as a feminist in his rejection of the hypersexualized American landscape that caters to the male id. In an ironic reversal of Western expectations of the Eastern harem, Halaby reveals that it is America that is a cornucopia of sexual opportunity, which Salwa briefly embraces (in the form of an adulterous affair) but Jassim steadfastly rejects. When he leaves Jordan to take a job in America, Jassim's friends joke about "the seductive swish of America's broad hips" (65), effectively figuring the nation as a seductive temptress. The narrator suggestively refers to Jassim's discovery of cell phone "Anytime Minutes" (62) in America—a phrase that takes on a very different resonance when a gym attendant at Fitness Bar recurrently flirts with Jassim using the phrase, "Anytime, honey. Anytime" (141). Although Jassim will find himself profoundly attracted to another woman in the novel, who reciprocates in kind, he ultimately rejects that attraction, turning back a "tidal craving" of lust (159).

Perhaps even more challenging to the claim of feminist fatherhood for Jassim is that, at the start of the novel, Jassim is not a biological father

at all. In fact, the subject of children is an ironic source of misreading between the couple. Salwa craves a child to fill a void she feels in her life but fears that Jassim is not interested in children. For his part, Jassim has confused Salwa by letting her know that he does not expect her to have children—a move that he intends to be supportive of her independence but leaves her feeling that he does not want children: "He had made it seem that he was opposed to having children, but in fact he was opposed to women having children simply because they got married ... he just wanted her to have all the opportunity she wished for so that she would not look back on her life with regret" (110). Salwa does eventually become pregnant but suffers a horrendous miscarriage, although they decide towards the end of the novel that "they would try again" (217).

So how can a reader understand Jassim as a father, feminist or otherwise? Halaby offers a range of evidence to suggest that Jassim, while not a literal biological father at the start of the novel, succeeds as a virtual or figurative father for those he encounters, effectively assuming the shared responsibility for community that the novel finds lacking in twenty-first century America. Early in the novel, Halaby sets this pattern in motion by skillfully reframing the father-child "Abu" naming tradition from Arabic cultures in her depiction of Jassim. "Abu" means "father of," and Jassim, thus, refers to his elders back in Jordan as Abu Jalal and Abu Fareed. The use of "Abu" defines the father by the child rather than vice-versa, essentially inverting the pyramid of patriarchal primogeniture. Halaby tweaks this approach to give Jassim a fatherly title in his own right. When the reader first meets Jassim, Salwa playfully calls him "Father of Water Preservation" (3), referring to his vocation as a hydrologist and an engineer. Although this honourific may start as a gentle joke about his zeal for conservation, it assumes a more serious tone as the reader learns of Jassim's concerns that contemporary approaches to water and waste threaten the future of humanity. He is disgusted by how little Americans recycle (58) and takes to heart his uncle's advice to him that "water is what will decide things, not just for us but for every citizen of the world as well. If we humans were smart, if we were truly as evolved as they say we are, we would all work together to figure [this] out" (40). In this hopeful vision, a shared commitment to water access could help bridge cultural gaps and foster peace. At a lecture back in Jordan, Jassim cautions his audience to avoid anthropocentricism in their approach to nature: "Who has the rights to

the rivers and oceans and seas? Is it the person who lives closest to them? Is it the person with the most technology? Here is my answer: no one. At the end of it, water is its own being and is far more powerful than man, a fact that man, with his enormous ego, cannot accept" (245). In these cautionary assessments about humans' hubris, Jassim uncannily echoes key strains of ecofeminist thought, such as Rosemary Ruether's contention that "there can be ... no solution to the ecological crisis within a society whose fundamental model of relationships continues to be one of domination" (204).

A City of Lost Children

As *Once in a Promised Land* develops, Jassim shifts his conservationist focus to the urban environment around him, and he is shocked by the broken ecosystem afflicting children, community, and families throughout Tucson. In his journeys, he sees the poor and wanting children who are shut out of the American Promised Land" and gives comfort to them and their mothers as best he can. His plot enacts Doucet's vision of feminist parenting as accomplishing the "broader work of building bridges and social support between families and households" (142). Jassim's work as a healer begins domestically, as he shifts attention from his work to support his wife in the wake of her miscarriage, "holding her ... offer[ing] her comfort" (104) and prioritizing her wellbeing: "he promis[ed] himself he would ... focus on her instead, would get her through this somehow" (134). It is, of course, not surprising for a husband to support his wife in the wake of such a loss. However, as Jassim becomes more aware of his wife's needs, he develops a broader sense of responsibility for the challenges he sees facing other mothers and children around him in Tucson. Whereas Jassim begins the novel as an introverted engineer living a life of suburban privilege, his awakening to issues of loss in the city compels him to travel away from the suburbs, broaden his perspective on class in America, and become a supportive community partner to the women he meets. This commitment is important for the novel in terms of both its ethical and formal structures, as Jassim's outreach unites the plots and connects the three major women of the novel—Salwa, Penny, and Mary. Although biological fathers are absent and abusive, and families are broken, it is Jassim who reaches out to offer support. His

actions represent an attempt to fulfill communal and collective responsibility that Halaby's novel finds lacking in the materialistic, competitive world of twenty-first-century America.

As the novel develops, Jassims learn that Salwa's miscarried child is only one of many lost children in the novel. In her portrait of children and parents in America, Halaby takes up the Western tropes associated post 9/11 with Arab youths—such as poverty, suicidal tendencies, and self-destructive violence—and reflects them back onto the youth culture of the U.S. Amanda Lloyd has aptly described this aspect of the novel as Halaby's "reverse orientalism," referring to Edward Said's influential account of how the West has projected reductive stereotypes onto Eastern culture. In Halaby's work, the surprising light she casts on American families functions not as a reduction or as condescension but as a call to awaken American readers to their own domestic problems.

If, as Davis observes, "children represent the promises of material and spiritual riches that their mothers and fathers have been unable to attain" (73), Jassim finds an America in which that hopeful trajectory has been inverted. Almost every major character in the novel has experienced literal or virtual loss of a child, whether from domestic abuse, drug use, or separation. The context for these specific losses is a culture of unequal opportunity in which family bonds have frayed and children are neglected. Salwa finds that "there was a raggedness about these American children that unsettled her" (100), and she is troubled to see a homeless man ignored by the community: "In America this gray-tinged man was lost. Invisible. In Jordan he would have had his place, an explanation to go along with him, a family to connect him" (202). When Jassim visits Wal-Mart, which Halaby's narrator describes as "an establishment with rolled-back prices and rolled-up hope," Jassim watches "large bodies bursting out of tight clothes, children stuffed into shopping carts, screamed at, slapped" (276).

Salwa's miscarriage is doubled in the novel by an equally disturbing accident in which a young man named Evan inexplicably crashes his skateboard into Jassim's car, killing himself in the crash. This tragic end is both thematically and literally linked to the problem of an absent father. On the day of the accident, Evan was supposed to be picked up by his father to go to a car show, but his father forgets him and their plan altogether: "His dad had been such a jerk. Why did he still fall for it? All the promises of *we'll do this* and *we'll go there* that his father never

delivered on. Should have known that his father would forget that he had promised to take him to the Auto Mall to look at cars" (74). Angry at this broken promise, Evan decides to try crystal meth for the first time, which sets in motion the final skate that leads to his demise. Halaby's rendering of that event suggests that it is a final act of rebellion against his father. It is not clear why he chooses this particular car, but the act seems deliberate: "he then pushed off and jumped, propelling him straight into the front of Jassim's car" (117). Jassim tells police that he "just came out, but he looked at me first, like he planned to do it, or like he thought he would do something else, like jump over the car, only he ended up going right into it" (121). Although Jassim's car is the accidental instrument of Evan's death, Halaby's portrait suggests that the missing American father is the truly guilty party in this chain of events. That father continues to go missing throughout the novel, and it is Jassim who sees Evan pass out of this world, holding "the boy's hand as he breathed for the last time" (139).

Because Evan's actions are ruled a virtual suicide, confirmed by other witnesses, Jassim is cleared of any wrongdoing, but he nonetheless seeks to make reparations to the family and support them in their time of need: "*I will turn this around, help the boy's family. I cannot undo what I have done, but I can offer to help with the damage*" (144). As he reaches out to the family, he discovers a host of problems that he had never expected to find in America. When he reads Evan's obituary, he is disturbed to find that his family is both broken and broke: "He wondered why Todd Parker was not listed next to Mary, why Bethany had been placed between them, perhaps. Maybe that was why donations were requested to help pay for the funeral. Perhaps the parents were divorced and the father was not working" (177). Jassim's understanding of inequality and poverty in America deepens as he locates Evan's family and travels to their neighbourhood to meet them. He is surprised to find an underworld of deprivation and evidence that contemporary America has been, in Davis's words, "slaying the dream" (73) promised to its citizens:

> Jassim's eyes, for the first time in his life, singled out pickup trucks and pink faces, shaved heads and snotty nosed children, food stamps, tattered smiles, ill-fitting false teeth, tobacco-stained fingers, and fourteen-hour-shift bloodshot eyes. His eyes double-clicked on rusted classic cars with engines next to them, cinder-block walls, and forgotten Christmas decorations. (275)

He is shocked by both the exhausted homes and exhausted bodies. The poorer neighbourhood strikes him as "an exposed wound with skin seared back" (194). Evan's mother is an "older, more tired woman than he had expected" (194); her screen door is bent and "paint hung off the house in geometric slices" (252). Nevertheless, he persists, and although Mary, Evan's mother, is angry to meet Jassim—"Did you think I would feel better seeing the face of the rich prick who ran over my son?"(195) —they fall into reflective conversation, and she welcomes the chance to share with Jassim the burdens she faced as a single mother even before Evan's death. Besides having to bear the economic and domestic responsibilities as a sole provider, Mary laments that Todd was not present for their son after the divorce because he "needed his dad" (198). Jassim obviously cannot fill that role, but he helps bring closure to the family by funding the funeral, visiting Mary regularly, and bringing her small but thoughtful gifts.

While Evan's father left him, other characters, especially young women, take steps to leave fathers who mistreat them. Jack Franks, an alcoholic ex-marine and fellow Fitness Bar denizen with Jassim, has a missing daughter, Cinda, who fled to Jordan with an exchange student to escape problems at home. Whereas Jack tells Jassim that she left because of drug use, the narrator suggests a different story: "Something happened in those three days, chased her into the arms of the Jordanian student, and within two weeks they had both vanished" (165). Whether Cinda leaves for true love or to escape her alcoholic and controlling father, she finds a much better life in Jordan, living "with her extended family, helping to tend the crops and animals, and teaching schoolchildren English" (164). Cinda can find her Promised Land only after she leaves America.

Cinda's success is a rare note of hope amid generally grim prospects for American children in Halaby's novel. Jassim's friend Penny, a waitress he befriends at Denny's, has a permanent loss to face. Her eldest daughter, Josie, fatally overdosed at age thirteen. Both Josie and Penny are subject to domestic abuse by Sky, Penny's boyfriend, and there are also hints that Sky has sexually abused his stepdaughter as well. Penny experiences further loss (which will be discussed later in this chapter), after Sky completes a jail term, becomes a born-again Christian, remarries, and is rewarded by the court with custody of the two other children because his family is now deemed superior to Penny's single-mother household.

As generous as Jassim may be in his contact with Mary and Penny, he is a neither saint nor a martyr. Halaby makes clear the complexity of his motivations with both women. Jassim's first impulse to help Mary is primarily a matter of personal justice and atonement: "*May I save your life to make up for your son's life?*" (197), he asks himself. Jassim quickly discovers the hubris and impossibility of such saviour impulses and instead bears powerful witness to American injustices through his journeys and conversations. Even as he laments what he sees, he has no illusion that his individual contact will singlehandedly overturn the violence inflicted by toxic masculinity and an unjust economy. His final choices at the end of the novel reflect his awareness of the limits of personal agency in the face of systemic problems of injustice and abuse. Halaby also renders these exchanges with Mary and Penny as reciprocal rather than condescending, revealing the benefits Jassim experiences when he leaves his zone of privilege. Jassim begins the novel with a nearly monastic sense of self-discipline, eating sparingly and exercising intensively each morning. As he reaches out to Penny and Mary, he slows down his pace, taking time to eat, talk, and listen. He becomes enamoured of simpler pleasures outside his engineering profession, ranging from a cup of coffee with Mary to regular Grand Slam breakfasts at Denny's restaurant. As he eats and grows more in touch with his bodily desires, he also feels great temptation towards Penny—"Jassim the predictable, Jassim the faithful, had morphed into Jassim the lusting" (159). Although he ultimately resists this temptation, his dedication to spending time with Penny, as well as meeting with Mary, comes at the expense of time with his wife, who turns to a young man named Jake for support when Jassim becomes less present.

Jake's experience in the novel reveals Halaby's insistence that even wealthier children in America can be subject to spirals of loss and dispersal. Jake is a young student who becomes obsessed with Salwa after he meets her at the bank, and his life begins with a fairy-tale, "once upon a time" (50) backstory. He was born to diplomat parents on the eastern seaboard and descended from an Ivy League pedigree. Because of their work and travel, they were often away, which seems to have left him rudderless. In addition, Jack struggles with sense of belatedness— that his family's American Dream has already been lived and done: "When so many things have been done before, and done well, it's hard to reach the goalposts or the top of the mountain, easier just to forge a

new path ... which was why he turned his back on his accounting and worked part-time for almost a year as a valet parking attendant at Flash, a topless bar on the one of the ugliest streets in the city" (50). One of the most complex characters in the novel, Jake struggles to endure the fruits of his own rebellion. He is appalled by the "enhanced tits and asses and high-heeled shoes and empty pockets and loneliness" and "ma[kes] the job tolerable with the help of the occasional pill, an odd line of cocaine, stayed awake with nicotine and speed" (50). In language echoing Evan's accident, Halaby's narrator suggests the dangerous road ahead for Jake:

> The straight and narrow curved and widened. Caution thudded by the wayside.
>
> Parental guidance traipsed down a different path. He was left with his job, his apartment, and his newfound excitement for life.... No way to know when your heart is racing and you are feeling so fine, sped up for days, that your body is being gobbled up by the greedy promise of perfection that it is only a matter of time before the bottom drops out, along with your teeth. *Plink plink.* (82)

Jake's plot rapidly accelerates into a quintessentially bad romance across the novel. He has a brief, torrid affair with Salwa as she seeks comfort after her miscarriage, and he then violently attacks her after she severs ties with him, leading to his arrest. Halaby's image of Jake's crash, foretold in the road image above, is symbolically resonant, as it suggests the obstacles facing American youth when "parental guidance traipse[s] down a different path."

Contrasting Patriarchal and Feminist Fathering

Jake suffers from a lack of parental guidance, but Halaby's novel demonstrates that fatherly guidance, if administered in a dominating fashion, can lead to abuse that is worse than neglect. In this context, Jassim's feminist fathering finds a dramatic contrast in the patriarchal fathering practices of other fathers in the novel, such as Sky and Jack. Halaby's representation of these American-born fathers well illustrates hooks's view that too often men are taught "to conceive of the father's role solely in terms of exercising authority" (139). For Sky and Jack, patriarchy begins at home, and they confirm their status and masculinity

by enforcing their will on their families as lawgivers rather than caregivers, often in overcompensation for their lack of authority or power outside the home. For example, Penny and Josie are subject to greatest abuse when Sky is unemployed, which is in contrast to the busy women around him. Josie, at thirteen, starts to develop a network of friends outside the home, and Sky responds by "fenc[ing] her in with rules and regulations, usually delivered with shouts" (137). When these rules are not followed, Penny and Josie are "beat[en] ... black and blue" (138) by Sky. After Penny eventually leaves him, he exerts violence from a distance by stalking her so much that she develops panic attacks (155). Sky's behaviour exemplifies hooks's concern that for many fathers "love is not as important as having the power to dominate others" (38). Salwa's friend Randa diagnoses these male threats as a national problem with American masculinity: "Randa sat on her couch ready to fight the American Man with his arbitrary borders and sickening sanctions, with his machismo and his rapist's agenda" (286). This formulation potently links domestic abuse to political abuse and suggests that male violence inside American families corresponds with abusive military and political practices by the U.S.

The problematic conjunction of militarized masculinity and domesticity finds its strongest exemplar in the novel in Jack Franks—an angry "ex-Marine," who "resent[s] everyone" (163) after his career as a soldier is cut short by a medical discharge. Cut off from the military, which gave him a sense of discipline and power, Jack lapses into alcoholism and seeks to control his wife and daughter to confirm his authority. Jack is clearly a victim of what Doucet terms "hegemonic masculinity" (37) or, in Randa's terms, the macho expectations of the American man. Jack's sense of paternal power is violated when his daughter, Cinda, flees the family and migrates to Jordan with an ex-change student. In response to this loss, Jack doubles down on his machismo. He develops a plan to rescue her that seems like a preview of Liam Neeson's role in *Taken*: "He searched all over the city. Asked all his old Marine connections for help. *Semper fi*" (164). The fact that Jack's first choice is to consult with the Marines rather than his wife or Cinda's friends suggests his commitment to a militarized vision of paternal masculinity. In Jack's mind, only other men—armed men, no less—can help him find his daughter. His intelligence plot bears no fruit, however.

Jack does eventually find out Cinda's location, not because of his skills or sources but because she calls and tells him the name of the village where she is living. With that knowledge, Jack embarks on a self-styled Rambo rescue mission "to find her, to bring her back" (164). The brief scene of their reunion subverts American expectations of rescuing women from Arab captivity. He "expect[s] her to be smoking dope in some sort of primitive harem," intoning upon arrival the cinematic cliché: "It's time you came home" (164). In contrast to his imagined scene, however, she "look[s] contented and happy" and tells him "this is my home now" (164). In terms of tropes and expectations, Halaby's scene is brilliantly anticlimactic: Cinda was never in peril, does not need rescuing, and calmly refuses her father's pleas for her to return to the U.S. This plot, in miniature, directly refutes vertical, patriarchal fathering. Jack is possessive, views his role as father as a one-man enforcer, and strongly ties his beliefs in paternal rights to a nationalist sense of the homeland. His machismo, however, does not win Cinda back, and upon return to the U.S., he finds his authority further eroded after his wife and son leave him because of his obsessive pursuit of his daughter. His patriarchal fathering literally costs him his family.

After 9/11, Jack finds a temporary rejuvenation of his militarized masculinity as a self-styled investigator, which Halaby renders in a naïve and delusional interior monologue: *These are some scary times we live in ... My number-one duty is to help protect my country. The president said that specifically* (173). Jack's fantasy here is comically grandiose, as he interprets President Bush's general speech about national vigilance as a personal charge to him to serve as a defender of the homeland. His faith that he can be a champion for the nation is not only absurd in scale but flies in the face of his precarious physical and mental health. Jack's self-chosen security mission reveals his deep ignorance about the Middle East. He decides to track Jassim obsessively—a man who is decidedly secular and from a country with literally no connections to 9/11 at all. Jack stalks Jassim throughout the city, and his performance is mocked both by his peers and by the narrative arc Halaby crafts for him. When he asks questions at the Fitness Bar about Jassim's movements, the attendant Diane sarcastically quips, "Don't tell me Mr. FBI is surfacing again" (172). The grand anticlimax of this plot arrives when Jack surveils Jassim in the produce section at the grocery store. He grows frustrated by his fruitless investigations—"what little information he had" (215)—

and promptly has a heart attack, "dead before he hit the floor" (216). Halaby's crafting a bathetic and pathetic end for Jack satirizes the American vigilante tradition, which suggests that American outrage after 9/11 is likely to be misdirected, ineffective, and even self-destructive.

Father Doesn't Know Best: The Failures of the Security State

Jack Frank's quest to save the homeland is paralleled in the novel by a host of other misbegotten vigilante and law enforcement actions. Halaby not only exposes the "relentless, state-imposed scrutiny of Arab Americans after 9/11" (Fadda-Conrey 536) but also underscores the ignorance and bravado underwriting that scrutiny. Halaby, thus, casts this struggle less as an apocalyptic clash of civilizations and more of a grim comedy of errors that one may call "Father Doesn't Know Best." Jassim is, at first, optimistic that Americans will respond to the tragedy with information and restraint: "Why would anyone hurt Randa's kids? People are not so ignorant as to take revenge on a Lebanese family for the act of a few extremist Saudis" (21). He soon learns, however, that a Sikh gas station attendant is killed in Phoenix, and Salwa explains this errant violence as a problem of masculinity, calling Americans "stupid and macho" (21)—problems that haunt Jassim as the novel progresses. After he is confronted by mall security for shopping-while-Arab, Salwa makes an inquiry and learns that the employee who called security had an uncle who "died in the Twin Towers." She explains to Jassim that the American clerk is "avenging his death" (31) by calling the authorities on him. As Halaby depicts it, primitive retaliation and clannish vengeance —practices Americans typically associate with foreigners in regions like the Middle East—are revealed to be a homegrown product of American patriarchy, one that is expanding as errant fathers like Jack and his kin seek to rescue the homeland.

Jassim experiences a more high-stakes investigation from the FBI because of his access to water sources as a hydrological engineer, and their lines of questioning are as misguided and ridiculous as the vigilantes and self-styled homeland defenders in the novel. One of the agents, apparently with little knowledge of geography or population sizes, asks Jassim, "*Did you ever meet any of the hijackers personally?*" (232)—as if the Middle East were simply one large high school or small town where

everyone knows one another. The misbegotten quests of Jack Franks, the security guard, and the FBI reveal the frailties and absurdities of America's macho approach. Halaby's novel suggests that American men have grown smaller and weaker through these misdirected exertions, and their efforts have not brought security. Indeed, the nation was already insecure from a host of factors that had nothing to do with 9/11: inequality, diminishing economic opportunity, broken families, and toxic masculinity. In contrast, Jassim reaches out to others in the novel not to investigate or to exert his male authority but to listen and to support, which helps him grow stronger not only as a feminist father but as a contributing community member, spouse, and friend.

Happily Ever After? A Fairy-Tale Ending Reimagined as a New Beginning

Although Jassim loses his employment to post-9/11 suspicion, he does not finish the novel as a victim or martyr. He is neither deported nor prosecuted but actively chooses to leave America after all he has discovered in the novel. Given what Jassim has brought to the community as an engineer, friend, and class-conscious citizen, his departure will clearly be Tucson's loss and a gain for both Jassim and his native Jordan. After Salwa recovers from Jakes's attack, she and Jassim choose to leave the U.S. and to travel back to Jordan. Halaby renders this transition skillfully in a closing myth of a young girl seeking to escape a *ghula*, a traditional monster from Arabic folklore. This story effectively laces together multiple conceptual threads from the novel, which returns readers to crucial issues surrounding feminist fathering, including the nature of caregiving, masculinity and identity as well as the links between caregiving and a broader community. The ghula story, at first, seems headed in the direction of a fairy-tale rescue plot that would confirm the primacy of male "domination and control" (hooks 84). Such a traditional plot would sustain the heroic masculine models that Jack Franks aimed to uphold, but Halaby's rendering of the folk tale takes a far more complex turn, further interrogating parenting archetypes. Ultimately, this closing tale suggests that a feminist approach to caregiving is not an act of sacrifice, nor does it undermine masculine identities; instead, it is an empowering and transformative force for men and women alike.

The reader learns that the childless ghula is a would-be parent who once saw a beautiful newborn and "wanted the baby for her own" (331). Rather than simply abduct the child, the *ghula* opts to make her a puppet by interlacing invisible red threads into her skin so that she can control the child and draw her to her as she matures: "When the ghula was done, the baby lay asleep with a thousand and one red threads hanging from her" (331). This richly gruesome image offers a powerful explanation for the pull Salwa feels towards the U.S. As a child in Jordan, Salwa longed to migrate to the U.S., and she married Jassim, in part, because he had a job lined up in the U.S. In this scenario the ghula is a kind of monstrously abusive mother figure. She does not take the responsibility of raising the peasant girl but maintains control from a distance and bides her time until she can benefit from the girl's moving to her and doing domestic chores. With this manipulation from a distance, the ghula echoes the operations of neocolonial power, in which America seamlessly projects its influence without direct colonial intervention. The image of Salwa's being drawn to the ghula—and the ghula's expectation to feed off of her labour (and eventually her body)—evokes America's dependence upon immigrants to enrich the country as human capital for national consumption.

The ghula-girl relationship becomes more complex as two other characters enter the frame of the closing fairy tale. The first is a male nightingale whom the ghula invites into her cave so that she can hear his beautiful songs. He is fed and cared for but is ultimately tricked and locked into a cage. Eventually he is even lulled into a sense of complacency: "Over time the nightingale forgot that the kindly old lady was actually a ghula who was going to eat the girl, so he did nothing more than sing his beautiful songs from dawn to dusk" (333). The nightingale's Faustian bargain—material comfort in exchange for freedom—may echo Jassim's service to a country that ultimately seeks to confine or reject him. More complex is the role of the second male in the story, Hassan—whose name evokes a quintessential hero from Arabic folklore, along with the name of Salwa's ex-boyfriend from Jordan. At first glance, the arrival of Hassan seems the ideal solution to the girl's plight. He "trip[s] on several hundred of the threads" entwining the girl and "severed them from her attachment under her skin" (332). The girl falls in love with Hassan, but he leaves for other adventures. When he returns years later to kill the ghula, he succeeds but wounds her in the process: "Hassan's knife

plunged not into the body of the ghula but into that of his beloved" (334). In perhaps the most shocking twist for those accustomed to happy fairy-tale endings, Hassan fails to rescue the girl and leaves her to die: "Filled with shame and agony, he begged for god's forgiveness, kissed the maiden's forehead, and fled from her disfigured body" (335). It is impossible to square Hassan's choice with any models of masculine responsibility—traditional, feminist, or otherwise. With this resolution, Halaby subverts fairy-tale expectations by revealing a colossal failure of masculine responsibility. The handsome and strong hero who is beloved by the girl not only fails to rescue her but mortally wounds her and leaves her to her fate.

This failure creates a space and an opportunity for Halaby to posit a different kind of resolution to the fairy tale and to open up a "plurality of masculinities" (Doucet 36), which links back to the feminist fathering that Jassim has developed across the novel. In the shadow of Hassan's fleeing, the bird escapes his cage and tends to the young girl: "With his beak he began severing the threats from the girl, one by one, until every thread dangled not from the girl but from the dead ghula" (335). Unlike Hassan, the nightingale and Jassim resist traditional masculine approaches to power and choose instead to "renounce violent strategies of control and to resist the violence of others" (Ruddick xix) in favour of caregiving instead. The girl is saved here not by the death blow of a victorious knight but by something closer to the handiwork of a tailor. By privileging this caring and careful work, Halaby foregrounds an alternative model of heroic masculinity: the mutually empowering caregiver, who makes a lasting difference not by a singular stroke of power but by patient and attentive craft. In hooks's terms, this victory offers a model of "reconceptualized power" (88), and it undoubtedly produces better results—both for the peasant girl and the nightingale himself—than Hassan's weapon wielding.

It is vital to appreciate the reciprocal outcome of this resolution. Neither the nightingale nor Jassim closes the novel with abjuration or sacrifice as their final fate. In the dominant plotline, Jassim and Salwa reunite at the end and are prepared to build a new life together in Jordan, whereas Jack is dead, and Jake is headed to prison. Within the ghula story, Hassan loses his true love due to his violence and leaves her alone, while the nightingale becomes the partner to the beautiful girl. Bearing witness to her captivity helps the nightingale recognize his own, and

they both head towards path of mutual liberation. Freed from the ghula's cage, his motivation to help the girl strengthens and enhances his own identity and stature. Indeed, Halaby reveals a fairy-tale transformation for the bird after his labours: "Once the nightingale severed the last thread, he transformed into an ordinary man" (335). Only after tending to this woman can the nightingale truly be a man, much as Jassim develops a new sense of power and responsibility as he reaches out to Salwa, Penny, and Mary across the novel. By reaching out to support the mothers and children in the novel, Jassim returns to Salwa as a stronger man and is prepared to deepen his bond to her and make a second attempt at a family.

It is also significant that he becomes an ordinary man—a detail foregrounded in the novel's conclusion. The implied listener to the story asks the narrator, *"Not a handsome prince?"* and the narrator emphatically responds, "Not a handsome prince" (335). The conclusion to the fairy tale makes an even clearer link between Jassim and the nightingale hero:

> This ordinary man was not so handsome—above average, perhaps, but nothing of the prince-hero type—and had only once before found himself folded over a nearly lifeless body. Years of exercise had left him strong and sound in mind and body, so he lifted up the unconscious and dangling maiden and carried her home across land and sea, hoping that with the proper care she would recover from her wounds. (335)

This closing passage skillfully encapsulates the vital importance of Jassim as a feminist father across the novel. The characters that have most closely conformed or aspired to the prince-hero type in the novel (such as Sky, Jake, or Jack) have succeeded only in spreading violence around them and have harmed themselves in the process. Jassim, in contrast, learns from the violence he witnessed—Evan's suicide—and builds upon his experience of that "lifeless body" to help Salwa after Jake's attack puts her in the hospital. The nightingale hero's closing gesture is an act of healing, patience, self-strengthening, and careful departure, echoing Jassim's plan to leave the U.S. and take Salwa back to Jordan.

By its conclusion, the novel skillfully equivocates on the issue of whether or not Salwa and Jassim have a fairy-tale ending. If one cherishes America as truly the Promised Land, then the protagonists suffer a loss

at the end by their departure, which may be viewed as a tragedy by readers who subscribe to the American Dream. Yet because Halaby has demonstrated the failures of the American Dream for natives and immigrant families alike, leaving America may not be a loss at all but a net gain for her protagonists. In this interpretation, the final rupture becomes an opportunity for Jassim and Salwa to leave the U.S. and start again in a land of more promise back in Jordan. The end of the novel implies that, once healed, Jassim and Salwa will have a second chance to make a family and help it thrive. Jassim's developments, in particular, suggest that he will live up to Judith Kegan Gardiner's call for "a new feminist future for fathering" (271).

Conclusion: The Challenge of Fathering Hope in Contemporary America

Like Jassim, my sense of self has been transformed by my work as a caregiver. Feminist fathering has helped me support my family as I deepen myself, learn new degrees of tenderness and patience, and wonder at my children and their development. I have grown stronger raising my children, and Jassim stands poised to do the same when he and Salwa return to Jordan. I am fortunate to have the family that Jassim hopes for upon his return, but I envy the community awaiting him in his native country. I see around me every day the problems Jassim wants to leave behind: dissolution of neighbourhoods, burgeoning debts, dwindling employment, a deadly opioid crisis, and a general lack of progress towards rights for parents and children to receive the institutional support they need and deserve. The close of the novel suggests that Jassim will foster a productive second chance for his family back in Jordan, and it challenges American fathers to do the same within their own country. By its conclusion, the novel reminds American readers that we are not yet the Promised Land we preach to the world but instead are at a crisis point—riven by inequality, diminished opportunities, and domestic division. If Americans value families and children as much as we say we do, we must work together to promote a common good across ethnic and class lines, and learn to see our children in the faces of others.

Works Cited

Davis, Angela. *Women, Culture, Politics.* Vintage Books, 1990.

Doucet, Andrea. *Do Men Mother? Fathering, Care, and Domestic Responsibility.* University of Toronto Press, 2007.

Fadda-Conrey, Carol. "Arab American Citizenship in Crisis: Destabilizing Representations of Arabs and Muslims in the U.S. after 9/11." *Modern Fiction Studies,* vol. 57, no. 3, 2011, pp. 532-53.

Gardiner Judith Kegan, "Feminism and the Future of Fathering." *Men Doing Feminism,* edited by Tom Digby, Routledge University Press, 1998, pp. 255-73.

Halaby, Laila. *Once in a Promised Land.* Beacon Press, 2008.

Halaby, Laila. *Lailahalaby,* lailahalaby.net/. Accessed 6 Sept. 2018.

Hampton, Barbara J. "Free to be Muslim-Americans: Community, Gender, and Identity in *Once in a Promised Land, The Taqwacores,* and *The Girl in the Tangerine Scarf." Christian Scholars Review,* vol. 40, no. 3, pp. 245-66.

hooks, bell. *Feminist Theory: From Margin to Center.* Pluto Press, 2000.

Lloyd, Amanda. "Reverse Orientalism: Laila Halaby's *Once in a Promised Land."* MA Thesis. Cleveland State University, 2012.

Ruddick, Sara. *Maternal Thinking: Towards a Politics of Peace.* Beacon Press, 1995.

Ruether, Rosemary. *New Woman, New Earth: Sexist Ideologies and Huma Liberation.* Beacon Press, 1995.

Chapter Four

"I'm the Backup Parent, The Understudy": Postfeminist Fatherhood in *The Descendants*

Katie Barnett

Early in *The Descendants* (Alexander Payne, 2011), Matt King (George Clooney) must tell his daughters that their mother—his wife, Elizabeth (Patricia Hastie)—will not wake up from the coma she has been in since her recent boating accident. He brings his troubled older daughter Alex (Shailene Woodley) home from boarding school but flounders when he must break the tragic news. As Alex swims, Matt half-heartedly clears leaves from their neglected pool and they have a tetchy conversation about Matt's inability to control his younger daughter Scottie (Amara Miller). "Maybe if you spent more time with her," Alex snaps, pushing through the leaf-ridden water. Matt wavers before blurting out that Elizabeth will not wake up, startling Alex, who dives underwater to hide her tears.

It is clear that Matt does not have the language to tell Alex that her mother is dying. His sense of timing, propriety, and empathy all fail him. "Why'd you have to tell me in the goddamn pool?" Alex cries. Partly, of course, this is because there is no prescribed way to break such news to his daughter. But within the framework of the film, it is also an indicator of Matt's precarious grasp on his own fatherhood. It is not simply that he forgets how Scottie likes her eggs or the name of Alex's school play. Fundamentally, he has no idea how to talk to his daughters.

"I'm the backup parent," he says in narration, "the understudy." At its heart, *The Descendants* works to usher Matt towards a redemptive vision of postfeminist fatherhood, yet unlike many triumphant paternal narratives of American cinema that have persisted from the 1990s onwards, the film also displays a self-awareness that highlights the limitations of such a model.

In framing *The Descendants* as a postfeminist fatherhood film, the complexities and contradictions of postfeminism must be acknowledged. As terms, "postfeminist" and "postfeminism" bear the weight of multiple meanings and understandings. It is, at once, potentially indicative of a contemporary antifeminist backlash, the economic empowerment of women (Brabon 119), the neoliberal reconfiguration of gender relations as personal rather than political (Gill 154), and the possibility of liberation and the achievement of gender equality. With regards to the latter, postfeminism often relies on the assumption that, as Tania Modleski notes in her seminal work on the subject, "the goals of feminism have been attained" (ix). Now, as in 1991 when Modleski first expounded these doubts regarding postfeminism, this would be a difficult claim to make.

In pointing to the ways in which postfeminism is "shrouded in contradiction," Joel Gwynne and Nadine Muller make a useful distinction between "postfeminism" as a cultural sensibility and "post-feminism" as a temporal marker of a period after second-wave feminism (2). It is my contention here that one must inform the other: postfeminism as a cultural sensibility must arise out of the context of post-second-wave feminism and does not suggest linear progression so much as a branching off into neoliberal territory, whereby the focus turns inwards, to the self. Therefore, although the term "post-feminism" is suggestive of a period *after* feminism, it may be more usefully employed not as a marker of temporality but as a marker of how the political considerations of feminism have often been sidelined, particularly in popular culture, since the 1990s.

In discussing *The Descendants* as an example of postfeminist fatherhood in cinema, I wish to draw attention to the ways in which popular culture—with film and television particularly implicated—has been keen to appropriate feminism while stripping it of much of its political impetus. This approach owes much to Rosalind Gill's work on postfeminism, in which she argues that a "grammar of individualism"

has become central to the "postfeminist sensibility" (153), which is particularly notable in the ways that fatherhood and parenting have been negotiated in film and media since the 1990s. Fatherhood becomes a site of individualized redemption rather than broader political change. *The Descendants* follows this model, as it focuses on Matt's difficulties and triumphs as a father. Furthermore, the film also bears the distinct hallmark of another facet of postfeminism—"knowingness" (Gill 159), which signals its own awareness of the image of fatherhood it constructs and the limitations of this image.

This chapter explores the negotiation of postfeminist fatherhood in *The Descendants*. First, it considers the film within the context of a history of single-father films in American cinema since the 1960s. Second, it discusses the marginalization of the mother as a persistent condition of postfeminist fatherhood on screen as well as the self-reflexivity of *The Descendants* that complicates its construction of a triumphant paternal image. The chapter examines Matt as a father of two daughters and the ways in which, more often than not, he finds himself baffled and scared of raising two young women. Ultimately, Matt is shown to make small but significant steps towards rebuilding a relationship with his daughters and embracing his role as newly widowed father. The heroic cinematic narrative of transformative fatherhood is, however, muted in favour of an image of fatherhood that acknowledges being a father as an ongoing process. Crucially, the film also leaves room for Matt's daughters' stories to be told—a reminder that without his descendants, Matt is not a father at all and that any fatherhood, however feminist (or not), must go beyond the father himself.

Single Fathers in American Cinema

The Descendants, based on Kaui Hart Hemmings' 2007 book of the same name, was a critical success. It won the 2011 Academy Award for Best Adapted Screenplay and was nominated for a further four, including Best Picture and Best Director for Alexander Payne. The film is routinely framed as being about family, tragedy, and loss—as Kyle Killian has it, "a film about loss, grief, and inheritance, in its various forms" (364)— yet all of these elements coalesce around the necessity of Matt facing up to his role as a father. The title points to the central relationship within the film—between Matt and his own descendants,

Scottie and Alex, for whom Matt must be the link between their past and their future.

The Descendants belongs to an established lineage of American cinema that envisages the lone father as a latter day domestic hero, which can be traced back to Gregory Peck's Atticus Finch in *To Kill a Mockingbird* (Robert Mulligan 1962). Stella Bruzzi calls Atticus "the perfect fairytale father," a man of principle, morality, and dedication both to his community and, crucially, to his children (85). Atticus's first place on the American Film Institute's list of cinema's greatest heroes owes as much to Peck's portrayal of a dedicated, principled patriarch as it does his actions as a small town lawyer.

To Kill a Mockingbird offers perhaps the most idealized image of a father parenting alone—as Bruzzi notes, the spectre of remarriage never enters the picture (85)—but it is one of a number of contemporary films focusing on a lone father figure. *To Kill a Mockingbird* was preceded by *Houseboat* (Melville Shavelson 1958); after these came Vincente Minnelli's *The Courtship of Eddie's Father* (1963), *The Sound of Music* (Robert Wise 1965), and *Chitty Chitty Bang Bang* (Ken Hughes 1968). Thus, there is a small but significant number of films that venerate the good single father at their centre (Bruzzi 84). In these films, the lone father is a widower; most often, these films drive towards a conclusion that sees the formerly lonely man—and his children—falling in love with a new woman.

The heroic lone father gains particular traction from the 1970s onwards, coinciding with work within the feminist movement calling for men to take on their fair share of parenting. This rallying call for equal parenting formed one of the tenets of second-wave feminism, as outlined by Gloria Steinem in 1970, when she spoke of a desire for men to "share equal responsibility" for looking after their children. This call was framed, in part, as a desire to "liberate men," which would allow the father to be "relieved of his role as sole breadwinner and stranger to his own children" and would, simultaneously, liberate women from the expectation of sole childcare (Steinem 193). In the same year, the National Organization for Women (NOW) issued a press release that stated the following: "The care and welfare of children is incumbent on society and parents. We reject the idea that mothers have a special child care role that is not to be shared equally by fathers" (qtd. in Griswold 246). In 1979, Betty Friedan, co-founder of NOW, identified the family

as the "new feminist frontier" at the NOW conference. The mainstream feminist movement recognized the benefits of involved fatherhood and championed it during this period. For women to fulfil their potential outside of the house, men would have to recognize the domestic demands of parenthood and be willing to accept equal responsibility.

On screen, a vision of fatherhood materialized that built upon these mainstream, second-wave feminist calls for equal parenting. In this context, the notion of feminist fatherhood owes much to the rhetoric of the women's liberation movement and the work of white, middle-class American feminists, such as Betty Friedan, whose indictment of the patriarchal household structure and the chronic dissatisfaction of (mainly white, middle-class American) women with their primary existence as housewives and mothers manifested in calls to reassess the role and place of the father. This vision imagined a father domestically and emotionally engaged with his children and cognizant of the unpaid labour involved in parenting, albeit with often problematic undertones, as discussed further below. With little exception, these onscreen images retained the same focus on white, economically comfortable, middle-class fatherhood, sidestepping any wider debate about parenting, work, and domestic labour.

One prominent example is *Kramer vs. Kramer* (Robert Benton 1979), in which iconic images of Dustin Hoffman's Ted Kramer making French toast for his young son and teaching him to ride a bike paved the way for a host of films about domestic fatherhood. *Author! Author!* (Arthur Hiller 1982) saw Al Pacino appear as a playwright juggling the production of his new play with the departure of his wife, leaving him in charge of five children. A year later, *Mr. Mom* (Stan Dragoti 1983) trod similar ground, with Michael Keaton's character as the reluctant stay-at-home dad. In all cases, men realize that their formerly career-driven existence can only be bettered by committed, hands-on parenting, no matter how much spaghetti ends up on the floor or how much their pay cheque takes a beating. Frequently, Hollywood's burgeoning project of domesticating fatherhood substitutes token gestures for genuine overtures towards equal parenting. Most commonly, the dads in question will prove hapless at a basic domestic task, such as making a meal or changing a diaper. Their failure to perform these duties—to much comic effect—plays into the belief that the domestic sphere is not a masculine domain; their subsequent mastery of these same tasks is framed as such a triumph that

they are essentially let off the hook. These narratives should be considered as a Hollywood vision of feminist fatherhood, which are predicated upon a simplified interpretation of the politics of women's liberation and may be more fruitfully read as images of power being retained through the appropriation of the domestic rather than considered overtures to change.

Over the next two decades, numerous films would follow in the same vein; they established a vision of domesticated fatherhood as a salve for disrupted masculinity and as a worthy endeavour that benefited both men and their children. In this era of post-second-wave feminism, these persistent paternal images borrow from feminist calls for equal parenting and valorize the floundering man turned committed father, reorienting masculine identity towards the paternal. As Hannah Hamad notes, "ideal masculinity in postfeminism has increasingly tended towards fatherhood" (1). Likewise, Yvonne Tasker highlights the "specificity of male parenting as a prominent feature of postfeminist media culture" (176). Accordingly, cinematic images of rediscovered fatherhood persist throughout the 1990s and into the millennium. Such films include *Three Men and a Baby* (Leonard Nimoy 1987), *Kindergarten Cop* (Ivan Reitman 1991), *Mrs. Doubtfire* (Chris Columbus 1993), *The Santa Clause* (John Pasquin 1994), *Liar Liar* (Tom Shadyac 1997), *Daddy Day Care* (Steve Carr 2004), and *War of the Worlds* (Steven Spielberg 2005), to name just a handful. The box office success of these films suggests that audiences retain a fondness for this now perennial narrative of the plucky dad mastering diaper changing, realigning his priorities, and embracing the joys of fatherhood.

In a cultural landscape where masculinity is pluralized and increasingly unstable—whether economically, biologically, or socially—these cinematic narratives of lone fatherhood establish the family and the home as an alternative domain of worth and dominance. Michael Kimmel's work on American masculinity and the erosion of the "structural foundations of traditional manhood" points to the continuing destabilization of masculinity (216); indeed, it is conflict that, for Benjamin Brabon, characterises postfeminist masculinity, the elimination of certainty, and the recognition of multiple subjectivities (117). Out of this has grown a notable body of American cinema that establishes fatherhood as the solution to this conflict. Fatherhood, in essence, saves men from the anxieties of contemporary masculinity, what Amy Aronson and Kimmel frame as a process of the child emerging as the "savior" of

their fathers (43); fatherhood becomes the calm centre of unstable masculinity and offers a sense of purpose while reestablishing a position of power. Yet, as Hamad notes, "notwithstanding its seductive appeal as an ostensibly feminist formation of masculinity, popular cinematic fatherhood ... belies postfeminist culture's ideologically circuitous relationship to feminism" (11). What, on the surface, may appear progressive is often reconfigured as a conservative power play designed to reinstate the father while diminishing the maternal figure. This marginalization of the mother, discussed further below, is certainly a feature of the films noted above. *The Descendants* is not exempt from this move; it, too, removes the mother from the narrative, which acts as a catalyst for Matt's rediscovery of his fatherhood. The space eventually carved out to include his daughters within Matt's vision of his fatherhood does not extend to Elizabeth. Matt's fatherhood, like those fathers mentioned above, is secured through a lack of competition.

However, although *The Descendants* engages with this persistent narrative of maternal marginalization, elsewhere the film engages with that "knowingness" so central to postfeminist culture (Gill 159). The film casts a knowing look at those domesticated dads mentioned above, whose ability to cook dinner negates any need to deal with the difficulties of fatherhood. Early on, Matt makes breakfast, forgetting that Scottie does not like eggs. At the end of the film, he brings ice cream to Scottie, apparently getting the flavour right. Yet the fact that this is part of a self-reflexive, almost self-conscious final sequence, as discussed below, must be noted. *The Descendants* is not immune to the desire to create heroic onscreen fathers, and in this desire lie the familiar tropes of missing mothers and domestic success. The difference is in the way the film denies Matt an uncomplicated triumph and constructs an image of fatherhood that must recognize the place of not only himself but his daughters.

The Descendants as Postfeminist Fatherhood Narrative

As such, *The Descendants* both engages with this Hollywood narrative of postfeminist fatherhood as laid out above, and works to complicate it. Matt is an attorney who controls his family's considerable tract of land in Hawaii. His marriage is troubled, and the film implies that his inability to communicate effectively is a factor in Elizabeth's consequent affair. With Elizabeth in a coma, Matt is effectively a single parent;

Elizabeth's death at the end of the film solidifies this position. In this respect, *The Descendants* bears the cinematic legacy of Atticus Finch and those men that followed on screen. A relatively young widower, left to care for two teenage children with whom he initially struggles to connect, Matt's discovery of his paternal responsibility looks set to follow a familiar cinematic narrative pattern.

Yet *The Descendants* complicates this familiar narrative. The film is not a Hollywood production, although its profile is undoubtedly raised by Clooney's involvement. Perhaps as a result of its independent origins, the tone of *The Descendants* is both darkly comedic and sombre—a notable departure from the more straightforward comedy on display in those films discussed above, which often act as vehicles for noted comedy actors, including Jim Carrey, Robin Williams, Tim Allen and Eddie Murphy.[1] This tone is evidenced in a scene where Matt, stricken with anger over the discovery of his wife's affair, runs down the street in his slippers, a pathetic interlude to his grief. The narrative is similarly nuanced. There is, crucially, no paternal epiphany awaiting Matt at the end of the film. Although he does, gradually, begin to build a relationship with his daughters, this is neither straightforward nor fully accomplished by the film's close. There is a concerted effort to undermine any notion that Matt will magically transform into a heroic father. His character is weakened by his ineffectual attempts to connect with rebellious Alex and to control Scottie's behaviour; he cannot even hold the interest of his wife. The film is clear that it is Matt's own actions, as much as anything, that have contributed to this distance from the ideal husband and father role.

Likewise, Matt's occupation as a lawyer does not offer the sheen of authoritative, benevolent paternalism associated with Atticus Finch's lawyer-father role. Amy Lawrence suggests that in Atticus, these two roles are almost impossible to unravel: "the role of the father is everywhere inflected by Atticus' function as upholder/performer of the Law" (171). In comparison, Matt is rarely shown at work, particularly in the first half of the film. The benefits of his career are evident (the large house, the comfortable middle class lifestyle, the private schooling for Alex), yet this is divorced from any real knowledge of what he does, and, thus, his authority remains ambivalent. Nevertheless, his job ensures that he will not have to worry about the economic concerns of being a single parent.

Crucially, early in the film Matt is shown to be singularly incapable of upholding the law in his own home: he is respected as neither a husband nor a father, and his grasp on his own paternal role is weak and uncertain. However, as the film progresses, Matt's profession becomes more visible in parallel to his returning paternal authority. His legal work surrounding the proposed sale of his family's land, as well as the reminder that Matt is by far the most competent and responsible of the King cousins, suggests that he does, after all, have some claim to legal authority. It is no coincidence that as Matt (successfully) negotiates the legal ramifications of refusing the sale of the land, he is simultaneously reestablishing the paternal authority that reveals the traditional construction of American fatherhood, even as the film expands its definition of fatherhood beyond the parameters of "outmoded conceptions of masculinity" (Griswold 244).

Through a Crack in the Door: The Marginalization of the Mother

The Descendants ventures into more familiar territory in the marginal-ization of the mother, which is crucial to any consideration of appar-ently postfeminist fathering in film. In cinema, images of ostensibly feminist fathers have tended to coalesce around emotionally engaged and domestically involved men who come to understand that their fa-therhood is likely to thrive not simply from providing materially and financially for his children but from investing time, interest, and care in them. This representation owes much to the image of the new man—a cultural construction of masculinity that (much like postfem-inism) embodies a central contradiction. In this case, that contradic-tion is one of progress versus encroachment. The new man is often as-sociated with nurture and emotionality—an "ostensibly sensitive, compassionate and family-focused" individual (Brabon 120). He marks a moment (beginning in the 1970s) when straight, white, middle-class masculinity began to show visible signs of the instability discussed above. As such, the new man should be seen as much as a product of shoring up power as it is a product of genuine impetus to change.

Many of the films mentioned above, beginning with Kramer vs. Kramer, emerge at a time when masculinity was increasingly a fractured, unstable concept in American culture. The notion of a once stable

masculinity is perhaps misleading and more of a desire than a reality; to think about masculine crisis as "cyclical" (Kimmel 1) rather than a new phenomenon is more useful. Nevertheless, such a view does not negate the existence of a perceived instability in masculinity and the emergence of numerous films focusing on the redeemed (or "saved," to return to Aronson and Kimmel's argument) father is revealing of the way that fatherhood becomes configured as a way out of this instability. The appearance of the new man in the 1970s may be seen as the seed of this realization of fatherhood as the key to survival. As the new man pointed to a way in which nurturing, sensitivity, and domesticity could underpin a new masculine identity, fatherhood became a crucial facet of realizing it. The cultural backdrop of deindustrialization, women's liberation, and relative peace post-Vietnam allowed questions to be raised about the role and place of men at the same time that traditional configurations of masculinity became less certain. On screen, the valorization of the domesticated father reflects the move towards fatherhood as a more stable manifestation of masculine identity. In short, it allows men to realign their priorities around a fundamentally male role during a period when male roles were perceived to be under threat. The heroism so often embedded within American ideals of masculinity was simply reconfigured from public to private, as fatherhood offered the prospect of domestic triumph.

As a result, images of feminist fathering in American cinema are complicated by the common marginalization of the mother. Heroic, domestic fatherhood often relies on moving into a space traditionally associated with the maternal, and on screen this had led to the mother being squeezed out of the frame. Berit Åström, borrowing Gaye Tuchman's term, calls this persistent marginalization the "symbolic annihilation" of the mother and observes the trend as running through the popular culture of the last few decades (594). That equal parenting is more often reimagined as lone parenting allows for the veneration of newly discovered fatherhood at the expense of the mother. Less than perfect fathers, left to their own devices, struggle, despair, and eventually prevail through a classic narrative structure of bewilderment, coping and triumph, which Tasker characterizes as initial "domestic turmoil" that must be worked through and results in the eventual recognition of the "transformative" potential of fatherhood (181-82).[2]

Åström points to the absent (or dead) mother as a "resilient trope" (594). The link between postfeminism and maternal marginalization has been identified by numerous scholars, including Tania Modleski, who suggests that "men ultimately deal with the threat of female power by incorporating it" (7)—a state that calls for the removal of the mother from the narrative in order to fully realize this continued authority.[3] The prototype for this model is *Kramer vs. Kramer*, in which feminism and fatherhood are compatible only insofar as it is Joanna's (Meryl Streep) apparently misguided forays into a feminist quest to find herself that allows Ted to belatedly discover the joys of parenting. Likewise, in *Mrs. Doubtfire*, Daniel's solution to limited contact with his children is to inhabit the persona of a middle-aged female nanny, edging out the real mother and essentially occupying twice the space (Barnett 31-32). Repeatedly, the mother's absence "enables father and child to forge a deeper emotional attachment than they previously had, suggesting that the mother is an obstacle they need to overcome in order to bond" (Åström 594). Thus, a blueprint is provided for dealing with mothers as Hollywood grappled with feminism and fatherhood. While mothers are distracted by the apparent false promise of a world outside of the family, fathers fill the domestic void. This is not feminist fathering, then; rather, it is a fathering that reveals the limitations of the feminism embraced by these onscreen mothers, as fathers discover true fulfilment inside the white picket fence. Yet to be those engaged, hands-on fathers imagined by feminist calls for parental liberation, the mother must routinely be pushed aside. These images of progressive fatherhood, therefore, must be understood as much as a product of male anxiety as of any true engagement with feminism on the part of the male filmmakers involved. In these narratives, feminism is tamed and summarily dismissed along with the mother. The fathers left behind are not products of feminism. They take up the hands-on duties of parenting not in feminist solidarity but to save themselves and hold the family together. Feminism, in these films, is recast as a mechanism by which women are permitted to be selfish at the expense of their motherhood. In marginalizing the mother, the spectre of feminism is invalidated and the threat removed. Hollywood succeeds in handing its domestic fathers the image of feminist fathering—that is, in these cases, a man who can change a diaper, learn how to cook dinner, or teach his child to ride a bike—without politicizing it.

This portrayal highlights a crucial difference between a feminist father and an image of a feminist father. Hollywood often holds up the latter as an example of the former. Theorists and historians—including Robert Griswold, Michael Kimmel, Esther Dermott, and Nancy Dowd— have aligned feminist fatherhood with the concept of "new fatherhood." Dowd suggests that "collaborative" parenting—involving "the involved, nurturing, caregiving father"—is indicative of a "refashion[ing]" of masculinity within a feminist structure (105). Significantly, this reconstruction of fatherhood away from the more authoritative, traditional model of fatherhood involves a power shift, specifically a move "away from power *over* women," whether domestic, economic, or legal (Dowd 106). It is this power shift that makes the difference and points to the political underpinnings of actual feminist fatherhood. Thus, a feminist father is one whose fatherhood does not simply serve himself and shore up his own familial authority; this father recognizes that the common gender disparities in childcare, emotional nurture, and domestic responsibility are a political issue, and challenges rather than reinforces "traditional notions of masculinity" (Lupton and Barclay 1). Here, the Hollywood example stutters. Its own images of feminist fatherhood largely serve the men who successfully enact this vision of domestic competence and emotional engagement (rather than, for example, the children or the wider family structure). The marginalization of the mother is a symptom of this continued quest for masculine dominance.

The Descendants is not immune to this marginalization. The audience's first glimpse of Elizabeth is of her laughing, head thrown back as her speedboat moves through the ocean. The scene, however, is silent: Elizabeth's laughter is muted. The audience is seeing her in a flashback, one step removed from reality. As the film begins, it transpires that she is already in a coma as a result of the accident that resulted from this speedboat excursion. From this point on, Elizabeth will only be a figure in a hospital bed.

As a result, Elizabeth is discussed but barely seen. She is the "mute, abjected" mother that becomes a popular onscreen figure in the twenty-first century (Karlyn 13). Her husband, her father, her children, and her friends are all permitted to discuss her life, with no opportunity for correction or rebuttal. For instance, family friend Kai (Mary Birdsong) reveals to Matt that Elizabeth loved Bryan, the man with whom she was

having an affair, and was planning to divorce Matt. Elizabeth's agency is soundly removed at this point; her intentions are relayed second hand and in anger. After Kai's revelation, Matt confronts Elizabeth: "You were gonna ask me for a divorce so you could be with some fucking fuckhead Bryan Speer? Are you kidding me? Who are you? The only thing I know for sure is you're a goddamn liar. So what do you have to say for yourself?" Elizabeth, of course, cannot say anything, cannot defend herself against the charges that Matt levels at her and—whether she hears him or not—is at the mercy of Matt's barely controlled anger and frustration. At other moments, in her own hospital room, she is something of a forgotten figure. When Elizabeth's father Scott (Robert Forster) visits, the scene focuses on his anger towards Matt. Elizabeth remains on the margins, either out of focus or out of shot. Similarly, when Scott remains in the room to say goodbye to Elizabeth, the scene is shot from the perspective of Matt, Alex, and Alex's boyfriend Sid (Nick Krause), out in the corridor, watching through a crack in the door. Here, Elizabeth is symbolically closed out of the scene, her disappearance almost complete.

Elizabeth's marginalization may be the result of her failure to live up to the myth of the good mother, as identified by Kathleen Karlyn (13) and Rebecca Feasey (6). Åström similarly suggests that mothers are routinely punished "for not living up to a culturally produced ideal" (594). Such an ideal involves mothers being fully committed to their children, nonsexual, self-sacrificing, and self-effacing, and Elizabeth's performance of motherhood in The Descendants is presented as lacking. The brief glimpse of her alive shows a woman who has sought pleasure outside of her children and her husband; she pursues a sexual relationship with another man as well as the thrills of high-speed boat racing. Ultimately, Elizabeth's punishment for such transgressions is her removal from the narrative.

Matt's Performance of Fatherhood

Elizabeth's imminent death forces Matt into the role of an active father, whereas he was previously passive. In her place, he must rediscover and rebuild his fatherhood. This quest forms the heart of The Descendants, which begins with Matt, in a voiceover, suggesting that he has not lived up to his family's expectations. "I'm ready to be a real

husband and a real father," he declares. Matt cannot hope to fulfil this pledge in relation to Elizabeth. Instead, it is his struggle to be a "real father" that provides the film's underlying structure. To begin with, Matt seems clear of only one tenet of his parenthood: "I don't want my children growing up spoiled and entitled," he states. Beyond this, there is little evidence that Matt has given much thought to how to be a father.

In declaring his intention to be a "real husband" and a "real father," Matt laments his failure to emotionally connect with his family. His suggestion that there exists a model of real fatherhood is not uncommon, but it is worth interrogating here in relation to dominant ideas about American fatherhood. It becomes clear that, for Matt, a "real father" is one who possesses the traits of the nurturing, emotionally involved father—that is, what has been increasingly associated with the notion of a feminist father (Lupton and Barclay; Balbus). As discussed above, often, rather than being labelled explicitly as "feminist fathering," these traits are often aligned with the concept of "new fatherhood" (Griswold 6; Dermott 65; Lupton and Barclay 1). New fatherhood prioritizes paternal nurturance and equal parenting, responding (in part) to those feminist calls, noted earlier, for fathers to take a more active and involved parental role.

Robert Griswold's extensive work on American fatherhood is useful here. "Father" has both biological and cultural connotations, and these are by no means stable: over time, "its terms [have been] contested, its significance fragmented, its meaning unstable" (Griswold 9). He suggests that "fatherhood has lost its cultural coherence" (244) as it becomes pluralized and highlights the "transformation of male bread-winning and the rise of feminism" as two external factors that affect the cultural construction of fatherhood in the twentieth century (6). Fatherhood is structured variously around biology, economics, and the social performance of care, and the emphasis afforded these different elements has changed and expanded over time. There are multiple ways in which Matt might be a father; he must determine how these elements will come together to form an individual image of real fatherhood. Although Matt never labels his fatherhood as such, it seems that real fatherhood has some alignment with feminist (or, to use the preferred sociological term, "new") fatherhood here: as discussed below, the real elements of being Alex and Scottie's dad appear to coincide with an

emotional investment that reflects those second-wave feminist calls for a more hands-on, emotional performance of the paternal role.

Matt's anxiety owes nothing to his secure biological paternity. Rather, his declaration that he is ready to be a "real father" has its basis in cultural constructions of fatherhood. Traditionally, cultural ideas about fatherhood have coalesced around expectations of financial and material provision as well as physical protection. Matt is a financially responsible father, as evidenced by his ability to manage his money while his cousins squander their own inheritance. Therefore, it is reasonable to suggest that neither biology nor economics are at the heart of Matt's concerns that, thus far, he has not lived up to his fatherhood.

Real fatherhood in *The Descendants* goes beyond these easily measurable criteria. Early in the film, Matt gives some clues as to what he seems to believe constitutes being a "real father." Regarding Scottie, he observes the following: "The last time I took care of [her] by myself was when she was three. Now she's ten and I have no idea what to do with her." Caregiving and connection form part of Matt's understanding, which aligns with dominant notions of feminist fatherhood. He later suggests that "a family seems exactly like an archipelago, all part of the same whole, but still separate and alone." There are parallels here with the Kings' life in Hawaii. Matt lives and works in Honolulu, on Oahu; Alex, meanwhile, is away at school on Hawai'i, and the family's land is part of Kauai. Part of Matt's imagining of effective fatherhood coalesces around a desire to overcome this separateness and to bring the father and daughters back together to form a closer bond. If he is able to reconnect the archipelagos of his family, his fatherhood may be on more solid ground.

Matt's form of authentic fatherhood is predicated upon a desire to understand his daughters. There is a definite sense that Matt knows his salvation, if there is to be any, lies in the rediscovery of his fatherhood. Without it, he is lost. His reluctance to reveal to friends and family that Elizabeth is dying should be read in this context. He only begins to admit that she will not recover as he starts to figure out his relationships with his daughters. Essentially, only once he can envisage some kind of future with his daughters can he admit that Elizabeth is not coming back to them. As he and Alex team up to track down Elizabeth's lover Bryan, forming an impromptu father-daughter detective duo, Matt sees for the first time that rebuilding this bond with his daughters may be the anchor

he needs. This realization is common to many of the films mentioned above, in which fatherhood becomes the solution to masculine anxiety. Unlike many of these films, however, whether Matt can achieve this salvation is not a foregone conclusion.

Matt's declaration that he is "ready to be ... a real father" is followed by a scene in which he must attend a parent-teacher meeting to discuss Scottie's behaviour, a role that would usually fall to Elizabeth. "Role" is the key word here. There are two versions of Matt evident in these scenes. In the first, he speaks to Scottie's teachers. "Have you been engaging with Scottie and really talking about everything that's going on?" one of them asks. "Yes, absolutely," Matt replies, his demeanour sober and serious. This version of Matt is in control; he is cognizant of what good parenting looks like. Yet in a voiceover, he admits that he has "no idea" what to do with Scottie. Shortly afterwards, he must take Scottie to apologize to a classmate she has been tormenting. Matt stands awkwardly as Scottie offers a lacklustre apology. The girl's mother (Karen Kuioka Hironaga) suggests that Scottie is not remorseful at all. Matt turns to her: "You're gonna stop, right? And you're really, really sorry, right?" He holds up his hands to the mother, as if this will suffice. Here, the viewer sees a second version of Matt, much closer to the reality of his own thoughts. Like the mother, the audience is left suspecting that Scottie will not modify her actions. Able to say the right things to the teachers, Matt's authority does not extend to his younger daughter.

"There's Something Wrong with Them": The Difficulty of Raising Daughters

Matt has a particular anxiety about raising daughters, a concern that leads him to ask Sid for advice. "I'm worried about my daughters," he tells him. "I think there's something wrong with them." Laconically, Sid suggests the solution is to "exchange them for sons, I guess." Killian notes that both Alex and Scottie have male-sounding names, and suggests this may indicate an unconscious desire for sons rather than daughters (365). Although Matt considers the possibility that, with a son, he may "wind up with something like [Sid]," he appears to agree that sons, somehow, would be the easier option.

In particular, it is his daughters' behaviour, often coded as nonfeminine, and their sexuality that trouble Matt. Alex's headstrong

nature and propensity for bad language ("Fuck Mom!" she declares furiously when Matt broaches the subject) alarm her father. "What is it about the women in my life that makes them want to destroy themselves?" he wonders, as if his older daughter is doomed to be a perennial mystery. Meanwhile, as Scottie approaches adolescence, Matt struggles to deal with her developing—though largely innocent—awareness of sex and her body. When she dances mock provocatively in Alex's bra and pants, taunting her sister, Matt yells at her, his expression somewhere between bewilderment and resignation. Later, he becomes angry when Scottie creates "beach boobs" for herself by piling sand into her swimsuit. Matt's panic is exacerbated by the discovery that Scottie and her friend Raina (Celia Kenney) might have been watching porn.

Matt appears to be wary of his daughters as women and, as such, is left questioning his own competence. Contemplating Scottie, he wonders, "what kind of chance will she have with just me?" He "feels he is flailing and failing as a father to his daughters," particularly when struggling to correct Scottie's misinformed ideas about sex and sexuality (Killian 365). Likewise, he implores Alex and Sid to "stop touching" in the car, although his request has little effect. When Alex declares that Sid "might stay over," Matt does not comment. The loss of the girls' mother means that the task of deciding what is appropriate (or not) for his daughters falls to him, yet he lacks the confidence to make a decision and enforce it.

Eventually, Matt is able to articulate his paternal authority without stifling either of his daughters; he recognizes the positive qualities beneath the previously troubling behaviour. He is initially dismissive of Scottie's photography, a hobby she uses primarily to scare classmates with pictures of Elizabeth in a coma, although it becomes clear later in the film that Scottie is really using her photography as a way of processing her feelings. Belatedly, Matt begins to recognize Scottie's creativity and appreciate her inquisitive nature, telling her, "You ask good questions, Scottie. You're getting too smart for me," although this does also allow Matt to sidestep Scottie's grief in this moment, as discussed below. Equally, despite his concerns over Scottie's sexualized consideration of her own body, she does not succumb to the critical body image of Raina, who turns down Matt's offer of ice cream because it has "too many carbs." Beyond her grief, Scottie has a clear sense of her own self, and, in time, Matt comes to appreciate and nurture this. The final scene shows Matt and Scottie both eating bowls of ice cream, suggesting that

Scottie has, so far, rejected the image-conscious girlhood of her peers.

Similarly, his relationship with Alex shifts during the course of the film. Initially, when they pair up to track down Bryan, their interactions are reminiscent of allies in a bad detective drama. It is a relationship in which Matt and Alex both seem relatively comfortable, yet it ultimately cannot last if Matt's fatherhood is to develop. The turning point comes in the hospital, shortly before Elizabeth dies. Her father, Scott, accuses Matt of neglecting Elizabeth, to which Alex responds: "You know, my father has been doing a really amazing job under these circumstances." Alex's respect here is not simply for Matt but for her father. Here, it is Alex's outspokenness—formerly critiqued by Matt—that allows her to express her newfound admiration for her dad.

There is a lingering question regarding the efficacy of Matt's fatherhood in these moments. In praising Scottie's inquisitive nature, he can effectively uphold the myth that Scottie is smart enough to be able to deal with her mother's death with minimal intervention from him. Her behavioural problems, meanwhile, can be reframed not as the actions of a disturbed young girl but of a girl who simply needs mental stimulation. Likewise, in co-opting Alex as his equal, he sidesteps the immediate need to help his older daughter work through her own grief. In reorienting his own grief towards tracking down Bryan, he takes Alex on the same journey, displacing her anguish—so clearly seen in the pool scene discussed at the beginning of this chapter—into a more practical mission.

Here, the limitations of Matt's rediscovered fatherhood are thrown into relief. Just as those domesticated Hollywood fathers of the past are permitted to cook a meal without burning down the kitchen and, thus, be rehabilitated as model parents, Matt's fatherhood in these moments may be read as visible but lacking in substance. The difference is that *The Descendants* seems to be aware of this disconnect. In allowing Matt these token paternal gestures, the film does not fully legitimize them. When interacting with his daughters, Clooney performs Matt as physically uncomfortable and at a loss as to what to say, how to stand, and where to look. In taking this approach, *The Descendants* both acknowledges the cinematic history of apparently feminist fatherhood and its cynicism.

The Descendants and Self-Reflexive Knowing

In her book on postfeminism and paternity, Hamad highlights the final scene of *The Descendants*, in which Matt, Alex and Scottie sit and watch *March of the Penguins* (Luc Jacquet 2005). Within the diegesis of *The Descendants*, the film is seen rather than heard. Morgan Freeman's voiceover for *March of the Penguins* dominates the soundtrack as they sit silently, eating ice cream and sharing a blanket previously seen on Elizabeth's hospital bed. The scene lingers before fading out.

This scene follows shots of the family scattering Elizabeth's ashes from a boat while discarding their leis. An underwater shot captures the leis bobbing together in the sunlit water as three separate rings that are, nevertheless, framed together, which recalls Matt's comparison of the members of a family with an archipelago. The image of the leis in the water, like this final scene, suggests that Matt and his daughters, though still separate, have begun to move closer together.

Though brief, Hamad's discussion of the *March of the Penguins* scene points to its self-reflexivity. She notes that the thematic congruence between *March of the Penguins* and *The Descendants* suggests a knowingness in the latter, and her comparison of the two films recognizes the similarities between them based on their postfeminist father narratives. The "thematic centrality of protective and involved fatherhood" embedded with *March of the Penguins* places it within the wider trend of films that imagine "fatherhood as ideal masculinity" (2). It is an astute point regarding the film's final moments and one I wish to expand briefly here. The anthropomorphizing of the penguins constructs the male as exemplary parent, who is committed to the nurturing of his child while the female returns to the sea. That this is the film that Matt and his daughters watch is particularly significant, given that they have just bid farewell to Elizabeth on the water. It is now Matt who must take up the mantle of parenthood. There is a certain comfort to this final scene—the television, the ice cream, the blankets—yet despite its inherent optimism for the future, its self-reflexive nod to the onscreen penguins also suggests the limitations of this idealized image of fatherhood. *The Descendants*, in this moment, recognizes itself as a descendant of these previous cinematic narratives and, in doing so, reveals an awareness that Hollywood has often elevated the routine actions of fathers to heroic status in a bid to glorify the paternal role. In this context, Matt remembering his daughters' ice cream preferences becomes a step in the right

direction but not enough in itself to fully rehabilitate him.

As discussed, cinematic images of postfeminist fatherhood all too often rely on the valorization of the father at the expense of the mother. Fatherhood becomes the catch-all solution to anxious masculinity—the anchor that will stabilize male identity. Rowena Chapman's claims regarding the new man—that as a cultural figure, he claims more space while professing to make room for others—remain useful in considering the function of the postfeminist father on screen (235). Yet *The Descendants*, in ending on this scene of the family viewing *March of the Penguins*, reveals a knowingness of this persistent paternal image. "Ultimately, whether such knowingly self-reflexive treatments of cinematic postfeminist fatherhood will herald the diminishment of this discourse of masculinity is yet to be determined," according to Hamad (152), but *The Descendants* does perhaps point towards a more nuanced awareness of the postfeminist father figure of 2000s American cinema.

In its place, Matt is an imperfect father still navigating his paternal role. The final scene is quiet rather than triumphant. If there is a moment of triumph in the latter stages of the film, it comes from Matt's refusal to sell his family's land. "We've got Hawaiian blood," he says. "We're tied to this land, and our children are tied to this land." His decision places him and his daughters in a generational continuum rooted in the ground beneath their feet. Matt's epiphany is one of family and continuation, whereby his own paternal authority is acknowledged yet necessarily fleeting. He is the link between his great-great-grandmother, a Hawaiian princess, and his daughters: essentially, as a father, Matt serves as the link between one powerful woman of his past and two self-possessed women of the future. For once, this postfeminist fatherhood narrative leaves room for someone other than Matt himself—the very thing, as noted above, that Hollywood's images of feminist fatherhood so often overlook.

Once again, the narrative is reliant on the erasure of the mother; Matt's fatherhood is not so stable, it seems, as to allow space for the mother to co-parent alongside him. However, the narrative does carve out a space for both Alex and Scottie, a feminine and feminist presence within Matt's fatherhood. Unusually for these cinematic father narratives, there is an acknowledgment that the children are a crucial element of any man's paternity. The gradually shifting relationship between them does not rely on Matt's daughters changing overnight to

suit their father's vision of what a daughter should look like, sound like, or behave like. Matt's postfeminist fatherhood leaves room not only for his own development and growth but also for his two daughters, who are not subsumed into their father's paternal transformation at the expense of their own autonomy. Perhaps the greatest triumph of his fatherhood quest is the recognition of Alex and Scottie as two distinct young women, both with their own needs and strengths. In making space for his daughters, Matt finally steps beyond the neoliberal postfeminist narrative of Hollywood fatherhood that sees the focus turned inwards on the self—the self being, in these cases, the father—as he recognises the lineage of the young women behind him.

Conclusion

The Descendants both stands as a continuation of the postfeminist fathering narrative of post-1990s American cinema and edges towards a more nuanced version of feminist fatherhood that proffers a final scene of quiet acceptance and companionship rather than heroic triumph. In doing so, it acknowledges the limitations of such cinematic narratives and suggests that Matt's success as a father will come from the gradual building of bridges with his daughters—the three of them all flawed and grieving in their own ways. Pertinent here is Killian's suggestion that "people are not either/or—they are both/and, and this is clearly conveyed in Payne's films", of which *The Descendants* is a prime example (366). It would surely be tempting, given earlier scenes in the film, for Matt to be shown cooking a meal for Scottie that he knows she likes (rather than the eggs she does not) or demonstrably turning Alex away from her destructive behaviour. Instead, the audience must be content—as must Matt, Alex, and Scottie—with the subdued image of the three of them sitting silently together. Matt is both flawed and a father—a father and a man who is still learning how to be a father.

Nor does Matt's fatherhood consume his daughters. The temptation, too often, in these postfeminist fatherhood films is to press the child into the service of saving the father or into being the mirror in which his newly secured paternal masculinity will be reflected. This practice is the crux of Kimmel and Aronson's argument when they mark out the child as the cinematic saviour of men, whereby fatherhood becomes the

answer to stabilizing masculinity in a postfeminist culture (44-45). Here, however, Matt's daughters retain their selfhood throughout *The Descendants*. Matt's quest to be a "real father" is realized alongside his daughters rather than at their expense. Perhaps it is this difference, more than anything, which points to a more edifying feminist fatherhood underlying the narrative. Matt is no longer the understudy, but there remains room on the family stage for Alex and Scottie, without whom Matt's newfound fatherhood would be meaningless.

Endnotes

1. For example, *Liar Liar* (Tom Shadyac 1997), starring Jim Carrey; *Hook* (Steven Spielberg 1991), *Mrs. Doubtfire* (Chris Columbus 1993) *and Father's Day* (Ivan Reitman 1997) starring Robin Williams; *The Santa Clause* (John Pasquin 1994), *Jungle 2 Jungle* (John Pasquin 1997), and *The Shaggy Dog* (Brian Robbins 2006) starring Tim Allen; and *Daddy Day Care* (Steve Carr 2004) starring Eddie Murphy.

2. This same pattern is further noted by Tania Modleski in her discussion of *Three Men and a Baby*; Nicole Matthews in her work on gender and parenting in comedy films; and by both me and Stella Bruzzi in relation to *Mrs. Doubtfire*.

3. The marginalization or removal of the mother has been discussed elsewhere by (among others) Elizabeth Traube in her work on 1980s Hollywood, who suggests that images of domestic fatherhood have often worked to "[show] us what fun mothering can be when it's done by the right men" (145); Yvonne Tasker, who notes the "erasure" of mothers in narratives of postfeminist fatherhood (183); and Susan Jeffords, whose theory of the "big switch" considers how the shift in dominant onscreen masculinity, from physical to emotional, focuses on male transformation while largely overlooking the women in the narrative.

Works Cited

American Film Institute. "AFI's 100 Years: 100 Heroes and Villains." *American Film Institute*, 4 June 2003, www.afi.com/100years/handv. aspx. Accessed 10 February 2018.

Aronson, Amy, and Michael Kimmel. "The Saviours and the Saved: Masculine Redemption in Contemporary Films." *Masculinity: Bodies, Movies, Culture*, edited by Peter Lehman, Routledge, 2001, pp. 43-50.

Åström, Berit. "The Symbolic Annihilation of Mothers in Popular Culture: *Single Father* and the death of the mother." *Feminist Media Studies*, vol. 15, no. 4, 2015, pp. 593-607.

Barnett, Katie. "'Any Closer, and You'd be Mom': The Limits of Post-Feminist Paternity in the Films of Robin Williams." *Screening Images of American Masculinity in the Age of Postfeminism*, edited by Elizabeth Abele and John Gronbeck-Tedesco, Lexington, 2015, pp. 19-34.

Balbus, Isaac D. *Emotional Rescue: The Theory and Practice of a Feminist Father.* Routledge, 1998.

Brabon, Benjamin. "'Chuck Flick': A Genealogy of the Postfeminist Male Singleton." *Postfeminism and Contemporary Hollywood Cinema*, edited by Joel Gwynne and Nadine Muller, Palgrave Macmillan, 2013, pp. 116-30.

Bruzzi, Stella. *Bringing Up Daddy: Fatherhood and Masculinity in Post-War Hollywood.* BFI, 2005.

Chapman, Rowena. "The Great Pretender: Variations on the New Man Theme." *Male Order: Unwrapping Masculinity*, edited by Rowena Chapman and Jonathan Rutherford, Lawrence and Wishart, 1988, pp. 225-48.

Clare, Anthony. *On Men: Masculinity in Crisis.* Chatto & Windus, 2000.

Dermott, Esther. *Intimate Fatherhood.* Routledge, 2008.

Dowd, Nancy L. *The Man Question: Male Subordination and Privilege.* New York University Press, 2010.

Faludi, Susan. *Stiffed.* Chatto & Windus, 1999.

Feasey, Rebecca. *From Happy Homemaker to Desperate Housewives: Motherhood and Television.* Anthem Press, 2012.

Gill, Rosalind. "Postfeminist Media Culture: Elements of a Sensibility." *European Journal of Cultural Studies*, vol. 10, no. 2, 2007, pp. 147-66.

Griswold, Robert L. *Fatherhood in America: A History.* Basic Books, 1993.

Gwynne, Joel, and Nadine Muller. *Postfeminism and Contemporary Holly-wood Cinema*. Palgrave Macmillan, 2013.

Hamad, Hannah. *Postfeminism and Paternity in Contemporary U.S. Film*. Routledge, 2014.

Karlyn, Kathleen Rowe. *Unruly Girls, Unrepentant Mothers: Redefining Feminism on Screen*. University of Texas Press, 2011.

Jeffords, Susan. "The Big Switch: Hollywood Masculinity in the Nineties." *Film Theory Goes to the Movies*, edited by Jim Collins et al., Routledge, 1993, pp. 196-208.

Killian, Kyle. "The Descendants." *Journal of Feminist Family Therapy*, vol. 24, no. 4, 2012, pp. 363-67.

Kimmel, Michael. *Manhood in America: A Cultural History*. 4th ed., Oxford University Press, 2012.

Lawrence, Amy. *Echo and Narcissus: Women's Voices in Classical Holly-wood Cinema*. University of California Press, 1991.

Lupton, Deborah, and Lesley Barclay. *Constructing Fatherhood: Discourses and Experiences*. Sage, 1997.

Matthews, Nicole. *Comic Politics: Gender in Hollywood Comedy after the New Right*. Manchester University Press, 2001.

Modleski, Tania. *Feminism without Women: Culture and Criticism in a "Postfeminist" Age*. Routledge, 1991.

Payne, Alexander. *The Descendants*. Fox Searchlight Pictures, 2011.

Steinem, Gloria. "Women's Liberation Aims to Free Men, Too." *The Washington Post*, 7 June 1970, pp. 192-93.

Tasker, Yvonne. "Practically Perfect People: Postfeminism, Masculinity and Male Parenting in Contemporary Cinema." *A Family Affair: Cinema Calls Home*, edited by Murray Pomerance, Wallflower, 2008, pp. 175-87.

Traube, Elizabeth. *Dreaming Identities: Class, Gender, and Generation in 1980s Hollywood Movies*. Westview Press, 1992.

Tuchman, Gaye. "The Symbolic Annihilation of Women by the Mass Media." *Hearth and Home: Images of Women in the Mass Media*, edited by Gaye Tuchman, et al., Oxford University Press, 1978, pp. 3–37.

Chapter Five

"We Raise Our Children to Believe that They Can Be Anything": Analyzing the Feminist Fathering Possibilities on *Black-ish*

Nancy Bressler

Introduction

Because our social and cultural assumptions are constantly in flux, it is vital to analyze how gender, race, and socioeconomic class are portrayed in media representation. Although humour is just one possible genre for uncovering social inequality as depicted in media representation, it is one that deserves further consideration. Studying humorous media texts is essential because humour is representative of the dominant ideologies within a culture. Specifically, I analyze in this chapter the ABC show *Black-ish* to consider to what extent this family sitcom defies traditional sitcom norms by embracing feminist ideas within its media narratives.

During the 1950s, idyllic family images in the media marginalized social and cultural tensions. Sitcoms depicted happy families and no social problem that could not be solved in thirty minutes or less. Representations of cultural norms faced similar problematic portrayals during the 1980s, particularly from Cliff Huxtable and *The Cosby Show*.[1]

Instead of challenging social problems that many real life African American families faced (Jhally and Lewis 72), *The Cosby Show* emphasized conformity to 1950s middle-class lifestyles and family values. Rather than discussing broader social and cultural concerns and instilling values of defiance, the show prioritized complacency with the status quo (Staiger 152).

Domestic sitcoms began in the 1950s and 1960s as a subcategory of situation comedy. Although they still focus on a situation that needs to be resolved within each episode, domestic sitcoms also tend to highlight the members of the family as characters and focus on them instead of addressing broader social issues. The problems discussed are everyday ones and are relevant to a large number of people (Hamamoto 17);social and political taboos are rarely addressed, since the focus of the plot is typically on the family.

When *Black-ish* premiered in 2014, television critics noted the similarities and differences from *The Cosby Show* (Surette par. 2). However, Dre Johnson, the father on *Black-ish*, differs considerably from previous fatherly representations because he embodies a feminist fatherly approach to parenting. *Black-ish* highlights Dre's desire for his children to better understand their cultural norms, yet Dre also demonstrates how a father can transform his perspective, recognize the value of others' opinions, and encourage his children to work together to create their own future. Whereas *The Cosby Show* depicts social barriers and inequality as ideas of the past (Jhally and Lewis 71), *Black-ish* portrays a father who encourages his children to analyze, discuss, and critique those barriers. Analyzing fatherhood and the representation of fatherhood in media is crucial because how fathers are portrayed in the media also influences fathers in the real world. If certain behaviours and dialogues are normalized in media representations, they may serve as suggestions for real world fathering.

Using standpoint theory and the rhetorical possibilities of feminist humour, this chapter analyzes to what extent Dre embodies feminist fathering. Through the narratives of *Black-ish,* Dre is depicted as a flawed character but one who is reflexive enough to contemplate his point of view. His relationship with his wife, Rainbow, while complex at times, is one of mutual respect for each other's positions and decisions. Dre also advocates for his children to take an active role in creating their future and constructing a better society. For these reasons, Dre demonstrates

feminist fathering. Because Dre's cultural values are a main focus of the plots of the show, *Black-ish* shows that a sitcom focused on the family can also express and champion feminist perspectives about gender and race.

Standpoint Theory and Intersectionality

To address these interlocking identities surrounding gender and race, it is vital to comprehend how one's life experience factors into his or her perception. In this chapter, I use standpoint theory—a feminist method that values the lives of women and the daily struggles that they live with and fight against—to frame my findings about feminist fathering. Standpoint theorists value epistemologies that emphasize the ways in which oppressed women see the world. Thus, theorists have moved beyond considering varying individual political identities, such as gender, class, or sexuality, and more towards reflexive perspectives that emphasize collective struggles. As a result, the locations of those who are marginalized offer "superior vantage points for critically understanding power relations" (Mann 423). A standpoint is a perspective of the world that considers one's lived experience and critiques one's social location as a way of challenging the domination it faces. The goal is not focused specifically on an individual's social life but instead emphasizes the power structures that affect it. As a result, a central and vital aspect of standpoint theory is that it is not an empirical observation or a combination of any one individual's beliefs. Rather than present one individual's problems, standpoint theory addresses concerns about prevalent patterns of oppression.

Standpoint theory also addresses hierarchies of oppression, which occurs when "one form of oppression [is treated] as more fundamental and important than another" (Mann 416). Such a hierarchy of oppression questions whether one form of gender, race, class, or sexuality marginalization came before the others and acts as the model for all forms of oppression. For example, Heidi Hartmann has argued that because Marxist theorists focused on the relationship between women and the economic system—rather than women and their relationship to men—capitalist struggles were prioritized over feminist ones.

However, standpoint theory acknowledges that people who face oppression can belong to more than one social group; thus, it values the insights and the convergences that can be garnered from each group's

members. "'Uma Narayan notes that the oppressed 'have epistemic privilege when it comes to immediate knowledge of everyday under oppression', but that this epistemic advantage is neither automatic nor all encompassing" (qtd. in Jaggar 306). Nancy Hartsock has used Marx's observation that the proletariat has an epistemological benefit in comprehending bourgeois ideology to demonstrate how women also have a vantage point concerning the patriarchal ideologies facing them. She has argued that the position of the oppressed person will look rather different from the person who stands at the top of the hierarchical pyramid.

Intersectionality "conveys the sense that individual identity and our social life are both shaped by multiple, overlapping, and contradictory systems of power that operate simultaneously" (McCann and Kim 147-48). It suggests that people maintain different identities at the same time, but often those identities are also subordinated. As a result, this intersectionality began as a theoretical framework to analyze and discuss how those multiple oppressions intertwine and overlap to produce new positions of subordination. Overall, Thornton-Dill et al state that "intersectional feminist theory 'locates its analysis within systems of ideological, political, and economic power as they are shaped by historical patterns of race, class, gender, sexuality, nation, ethnicity, and age'" (qtd. in McCann and Kim 148). At its core, intersectionality focuses on how social justice can be achieved across multiple sites of oppressions.

Therefore, both standpoint theory and intersectionality will be vital to the analysis of the character of Dre Johnson on *Black-ish*. Dre is the narrator of the series, and the sitcom narratives regularly follow his perspective or standpoint. The audience views the world through Dre's point of view and his deeper understanding of the social world around him. As Dre struggles to ensure that his racial identity is maintained, he also struggles with the intersectional oppressions that his family members face. This research will further explore to what extent Dre's standpoint ultimately embodies an intersectional approach.

The Rhetorical Possibilities in Feminist Humour

Before I can analyze the feminist (fathering) possibilities within *Black-ish*, a sitcom that uses humor as a rhetorical device, a clear conceptualization of feminist humour is warranted. There is a clear distinction between women's humor and feminist humor. Women's humor embodies traditional, even hegemonic stereotypes, whereas feminist humor "empowers women to examine how we have been objectified and fetishized and to what extent we have been led to perpetuate this objectification" (Merrill 279). Women's humour has typically reflected two main approaches: men as the target of differential humour or self-deprecating humour towards the woman telling the joke. Feminist humour, in contrast, focuses on the dismantling of hierarchies of oppression.

Women's humour is more problematic because of the focus of the humour; the faults of individual people, whether male or female, are highlighted through women's humour: "As long as women's jokes focus on men, male definitions, and male behavior, women are marginalizing females, even if their jokes target males" (Bing 22). As a result, marginalizing men through humour only serves to further normalize social stereotypes. Male and female behaviours are still categorized into socially acceptable categories. Additionally, women's humour also serves to marginalize the female experience: "By targeting men, disparaging humor ignores women, and makes women, their lives, their values, and their interests invisible" (Bing 27). A female perspective and the value of those viewpoints are absent from this approach to humour.

In contrast to the individualistic nature of women's humour, feminist humour can highlight the collective oppressions that women face in society: "When women use inclusive humor, they can still target problems, but they do not necessarily have to target men" (Bing 28). Rather than focusing on an individual target, the focus is on the broader, systematic oppressions that are socially and culturally instilled in them. As I have argued elsewhere, "subversive humor would challenge the power relations and hierarchies in society as opposed to finding humor in individual sources. Humor would need to evolve from a source of individualistic differentiation to one of identification and clarification of collectivistic desires" (Bressler 55). In this chapter, using a feminist approach to humour, as described above, I examine the portrayal of the character Dre in the sitcom *Black-ish*.

Black-ish

Black-ish premiered on September 24, 2014. The show stars Anthony Anderson as Andre "Dre" Johnson and Tracee Ellis Ross as Rainbow "Bow" Johnson. Together they have five children (Zoey, Junior, Diane, Jack, and Devante). Dre's father, Pops, who lives in their guest house and Dre's mother, Ruby, both frequently appear on the show as well. *Black-ish* premiered after the hit sitcom *Modern Family* to more than 11 million viewers. Since then, the show has received many critical awards.

Black-ish airs on the ABC network, which is owned by Disney. Since Disney media texts are often considered "family-friendly," it is vital to examine what sitcoms airing on this network communicate because of the cultural influence of Disney itself. Yet as Souad Belkhyr argues, Disney products are "cultural products, [which] more than any others, reflect the cultural values of their producers and the social conditions under which they are produced" (704). Because Disney now owns major broadcasting stations, such as ABC, the cultural values depicted within the sitcoms cannot be ignored (Tanner et al. 356).

Based loosely on his real life, creator and showrunner Kenya Barris wanted to make a show that challenged preconceptions of race and class (Montgomery par. 2). Barris faced cultural barriers in his childhood, where he grew up in a poor neighbourhood in Los Angeles (NPR Fresh Air par. 1). While reflecting on the premise of the show, Barris commented, "You're taught to give your kids more, but in giving them more, what do they lose? That sort of was the conceit and premise of [*Black-ish*]" (NPR Fresh Air par. 2).

As the father figure on the show, Dre is the focus of this analysis. Dre is a successful advertising executive who lives a comfortable upper-middle-class lifestyle. However, Dre's character on the show differs significantly from previous African American fathers on sitcoms. As a father who acknowledges and advocates for social justice, Dre challenges broader social and cultural norms in ways that previous African American sitcom fathers had been unable to do. Whereas *The Cosby Show* depicts Cliff Huxtable as having achieved the American Dream (Haggins 34), Dre still strives to improve not only his own family's social position but the position of other marginalized people.

Source of the Humour

Studying humorous texts often requires analyzing who creates the joke and who is the target of it. The analysis of analyzing humour also gives insight into the perspective of the joke teller. If the joke emphasizes one's lived experience and how social structures are created and maintained, it could be viewed through standpoint theory. In contrast, if the humour has an individual target, such as another character on the show, the joke overlooks the opportunity to present feminist insights. For example, superiority theory, according to John Meyer, "allows for open displays of humor to be used as social correctives... 'disciplining by laughter' was one of the functions of the royal fool throughout the ages. Foolish antics were laughed at to show that such behaviors or beliefs were unacceptable in serious society" (314). If an individual's flaws and mistaken point of view is the source of the humour, it acts as a "social corrective" towards any cultural norm or behaviour that disagrees with the social status quo (Meyer 314).

The Cosby Show, for example, constructed humour through the use of one liners and misunderstandings (Staiger 154). Although these sitcom formats may draw laughter, they offer no critical thinking or discussion of broader viewpoints. The narrative—and therefore the jokes that are created within it—is lacking real meaning. Perhaps, the audience understands the characters better or believes they are better than the characters, since the audience knows about the misunderstanding that happened within the narrative. However, there is a formulaic plot with a conclusion that either leads to a discussion of the characters or results in a reward for the characters. Consequently, the focus of the humour is solely on the individual characters' shortcomings and is devoid of any broader social or cultural context.

In contrast, *Black-ish* challenges substantial issues, often by depicting them as lessons for the characters and, by extension, the audience. Instead of emphasizing only the domestic problems of the family, the show advocates feminist ideas. Dre is portrayed as a father who asks questions rather than thinking he has all the answers. Rather than perceiving he has all the answers, the narrative of the plots follow Dre's journey as he himself discovers how to instill the life lessons he hopes his children will learn. For instance, in season one, episode seven, titled "The Gift of Hunger," Dre worries that his children have become too spoiled because of the lifestyle that Rainbow and he provide for them.

He insists that the children get jobs to earn their own money to buy the things they want. Yet Dre ultimately stands in the way of his children succeeding at those jobs. So by the end of the episode, he says the following: "I guess this whole journey was really about character. See I was trying to give my kids the gift of hunger because hunger was the obstacle that gave me character. But my kids had a different obstacle... me. Let's face it: I'm a lot. And if they can get past me, they can get past anything." By questioning his own parenting style and engaging in self-reflection, Dre discovers that his approach may not be what is best for the family. This portrayal is contrary to previous representations of fathers who knew everything and who had to be the best the majority of the time. Dre is by no means portrayed as a foolish father in this situation; he can recognize when adjustments are needed to his parenting style.

Questioning One's Own Standpoint

Dre not only questions his parenting style on the show but also his own standpoint. Although Dre always embraces his cultural background and understands how his race situates him within society, he often needs to learn how gender and class also play a role. As a result, Dre's questioning of his standpoint can lead to feminist revelations for the character. Tina Phillips has recognized the following: "we need men willing to be humble and courageous at the same time. It also requires a consistent process of self-evaluation, self-examination, and self-reflection. It's a constant process of learning and teaching, and being adaptable and flexible to what is needed at any given moment (13). In this context, Dre demonstrates his ability to understand and appreciate where his perspective may be wrong. Rather than embracing an authoritarian perspective, Dre is open to learning about different points of view.

For example, in season four, episode twelve, titled "Bow Knows," Dre is frustrated with his co-workers who refuse to understand his cultural perspective of "the talk." Dre attempts to explain to them how African American fathers must explain to their children that there is racial bias within society. Rather than remain frustrated that his white co-workers cannot understand, Dre attempts to relate to them by understanding where they might have faced adversity in their lives. He

has a discussion with Lucy about how her version of "the talk" with her mother emphasized the gender bias that Lucy would face throughout her life. As a result of the experience, Dre concludes that "when you listen to people, they end up listening to you too." Through this shared moment, not only does Dre only convey his perspective about racial prejudice but he also learns a little more about gender bias as well.

Another example of Dre's realization of gender bias comes from season four, episode fourteen, titled "R-E-S-P-E-C-T." When Dre learns that his son, Junior, lost his virginity, he is excited and proud; however, when he learns that his daughter, Zoey, is also sexually active, Dre is traumatized by the news. While his male co-workers are sympathetic to Dre's point of view, his female co-worker, Lucy, presents an alternative position. The following scene occurs while the two co-workers are alone:

Dre: It was so much fun talking about my son having sex. It's ruined now that I know that Zoey's doing it too.

Lucy: Oh, cause seeing it through your daughter's eyes made you realize that women are people.

Dre: Exactly. It's so weird.

Lucy: What I think is weird is how men only seem to care about a woman's point of view when they suddenly remember they have a daughter.

Dre: I do care about women. All I was doing was celebrating my son.

Later in the scene, the following occurs:

Dre: You know I never realized that every girl is somebody's Zoey.

Lucy: Yeah. It's why getting through the day is so hard here. The way the men in that conference room talk about women. It's so demoralizing. It's like they're monsters.

Dre: Hey, hey wait a minute. I'm in that conference room. Am I a monster?

Lucy: You're like monster adjacent. But you don't have to be. And neither does Junior.

Dre hurries home to discuss his realization with Rainbow. He comments, "I know I'm supposed to say that I treat my son and my daughter when it comes to sex equally, but I can't." Despite Dre's irrational reaction to his daughter losing her virginity, it provides him the opportunity for self-evaluation and self-examination. Dre concludes with the following:"we may not be able to end the double-standard in the world. But we could do a little better in our house."Although this is a positive moment for Dre overall, it is still troublesome. Throughout the series, Dre attempts to change his co-workers', neighbours', and other characters' perceptions about the racial inequality existing in the world; however, his perception is more limited when it comes to gender inequality. He wants his children to behave better, which shows his concern as a parent. However, why cannot Dre also strive to emphasize how gender bias in society affects women on a broader level?

Moreover, *Black-ish* presents Dre and his path towards a deeper understanding of varying perspectives in a positive manner. Sitcoms have historically used the role of the fool as a device to denote an inferior character and to diminish his or her point of view. This use of the genre convention serves to further marginalize a character and any similar person in real life. The fool is portrayed as a substandard member of society:

Inferior statuses are represented using negative stereotypes of women, blacks and other minorities, the old and the young, and other low statuses. Already embedded in the larger culture, these stereotypes are useful for their familiarity.... The foolishness in sitcoms is almost always attached to a character's lower status, by representing well-known stereotypes of this status group. (Butsh 112)

As a result, foolish characters are often shown as a social corrective. These are the characters that audience members do not want to emulate because of their inferior social position.

Within *Black-ish,* many characters exhibit plenty of foolish behaviour and dialogue. However, Dre can hardly be considered foolish because of his questioning of his position; rather, Dre is portrayed as thoughtful and reflexive of his behavior when he recognizes that he is wrong. Through reflecting upon his viewpoint, he understands that he must adjust his way of thinking when addressing difficult situations.

A great example comes from season two, episode thirteen, titled "Keeping Up with the Johnsons." Rainbow and Dre are arguing about how much Dre spent on new sneakers that day, when Pops enters the room. The following scene occurs:

> Pops: Sounds like money trouble. And no wonder the way that you two spend. The latest jeans, mail-order high top sneaker boot tennis shoes. When I was coming up, all you needed was a pair of black leather pants and a denim vest. You didn't even need a shirt. That's why I moved to LA.

Moments later:

> Pops: You two are the ones trying to keep up with the Jones. Damn subzero fridge—how cold does stuff really need to be?
>
> Rainbow: I love my refrigerator.
>
> *Camera cuts to a tweet of Rainbow posing in front of the fridge.*
>
> Dre: Pops, we work hard for everything we have.
>
> Pops: "Yes, and you're working hard to spend it with this crazy big house with a guest house in the back. You really need to be renting that damn thing out.
>
> Dre: You live in that guest house.
>
> Pops: Just saying...it's not financially responsible.

In this example, Pops is both the voice of reason as well as a source of humour for pointing out Dre and Rainbow's financial shortcomings. Dre and Rainbow also exhibit foolish behaviors, but they also make valid, well-argued statements. At the end of the episode, Dre explains to Rainbow why he wants to buy expensive items: "Yep. And I do all that for a reason. Take these sneakers, all right... I only started buying them because I wanted the same ones my mother couldn't afford when I was a kid. And I guess that thinking spilled into the house I always wanted and the car I always wanted. But babe, the truth is the only thing that really matters is that I got the woman I always wanted." In this moment, Dre recognizes the meaning behind him wanting specific clothing so badly and discovers what is really valuable to him. Consequently, *Black-ish* rarely presents Dre as the fool character. Rather, he

is presented in similar fashion to the other family members. They all have their foolish moments when it comes to dialogue, clothing, or flashbacks to ridiculous actions they have done in their past. However, there is no consistency in using the fool trope to portray any one character as inferior. The characters contemplate how to approach problems and work together to find solutions.

In contrast to *The Cosby Show* and other sitcoms featuring fathers who knew best, Dre also discovers that his perspective may not always be right. Rather than focusing on hard work corresponding with material possessions, Dre contemplates what those expensive things mean to him. Ultimately, he decides which physical possessions are important to him and which ones are unnecessary. This is in stark contrast to *The Cosby Show* and other African American sitcoms, which emphasize the father's success is related to the more expensive material items he could afford. Instead of depicting an African American father who works hard in order to buy things and conform to middle-class standards, *Black-ish* portrays a thoughtful father who reflects upon the significance of those decisions. Consequently, not only does Dre reject the fool stereotype, but he actually demonstrates a juxtaposition to previous fathers, specifically African-American fathers, who conformed to middle-class cultural norms.

Spousal Relationship

Ann Snitow argues that a partnership among men and women is vital for feminist social struggles (84). Snitow contends that a "shared political ground" is required so that it reduces the perception of individuality among genders. Dre and Rainbow portray a committed relationship that demonstrates their own individual standpoint yet also depicts flawed points of view. Rob Palkovitz, Bahira Sherif Trask, and Kari Adamsons argue the following: "mothers and fathers experience, enact, and thus lead their children to experience parenting differently. This is largely due to cultural and societal differences in the attitudes and policies enacted toward fathers relative to mothers" (414).The authors maintain that fathers will often alter their parenting behaviours and interpretations.

Dre engages in feminist fathering through his respect and partnership with his wife, Rainbow. For example, when Rainbow decides to stay

home with the children for awhile in season four, episode thirteen, titled "Unkept Woman," Dre struggles with the idea. Yet by the end of the episode, he comes to the following realization: "I'm sorry I got all crazy. It's just that when you said you'd stay home, I didn't expect it to be like this. To tell the truth, I spent all my time imagining what you being home would be like for me and the kids and not what it would be like for you." Dre recognizes the reason behind his resentment towards her staying home with the children and finally puts her needs before his own. As a result, Dre does transform both as a parent and as a husband, which also reinforces how he enacts standpoint theory through the knowledge he obtains from the relationship with his wife. By recognizing what Rainbow needs and how he can help her, Dre demonstrates the importance of his relationship with his wife.

These examples contrast with previous representations of husbands and wives on television. Tracee Ellis-Ross, who plays Rainbow on the show, has said the following: "This is not the old-school television husband-and-wife duo where the husband is crazy and the wife is the sane voice of reason who's constantly rolling her eyes. It's more of a match for what really happens in life where two people are really well suited for each other" (qtd. in Montgomery par. 3). Because *Black-ish* portrays Dre as a partner who listens and responds to his wife, the show also depicts feminist fathering. Dre embodies feminist action by being a reflexive partner with Rainbow.

Creating a Collectivistic Future

Throughout sitcom history, most narrative plots were resolved by the end of the episode and the main characters rarely changed. This formulaic sitcom pattern rarely provides the opportunity to confront broader social and/or cultural issues. Consequently, even though a solution is shown, it only solves that narrative's problem, without challenging any broader, systemic social problems. Moreover, since the familial characters are the main part of the show, the audience is focused on their individual problems; broader social hierarchies are ignored (Mills 45). As a result, domestic sitcoms imply that one's individual problems are more critical than broader social concerns. Paul Attallah has argued that the subjects a sitcom concentrates on make the difference between it being a domestic comedy or a "socially

relevant" one (106). If the narrative addresses the family's urgent problems quickly but fails to consider the broader implications, the sitcom is seen as a domestic comedy. In contrast, a "socially relevant" sitcom may make greater statements about social or cultural concerns (Attallah 106). B. Mills argues the following: "this focus on the domestic and the individual has been one of the reasons for the criticism of sitcom's failure to comically interrogate and undermine dominant ideologies. Sitcom has been a reflection of social changes, rather than an intervention into them" (45). Therefore, this analysis will specifically consider the extent to which the domestic sitcom *Black-ish* can depict systemic social problems in which there is often not an easy solution.

The Cosby Show, for example, provided situations and character flaws within the realm of the real world (Staiger 151), yet because it rarely dealt with broader social or cultural issues, it was hardly a socially relevant sitcom. As Janet Staiger points out, "all of this was set into narratives that did not threaten the middle-class status quo while promising the possibilities of the American myth to working people" (152). Consequently, there was no discussion of any social concern that might have challenged the status quo.

Black-ish, in contrast, defies this formulaic pattern. The greatest example of this comes from season two, episode sixteen, titled "Hope." This episode directly addresses police brutality in the African American community and its increased attention by society. Dre's children, Zoey, Junior, Diane, and Jack all start to ask questions about what is happening in the world around them. Dre and Rainbow have the following conversation:

Rainbow: Dre, what are we going to tell them.

Dre: The truth.

Rainbow: They're children.

Dre: They're not just children, Bow...they're Black children. And they need to know the world that they're living in. Come on Bow—think!

Rainbow: Dre, I'm not clueless here, all right. The twins are just so little. And I'm not ready for them to think and see the world the way you do.

In the other room, the family is watching news coverage of a police officer who was involved in shooting an unarmed Black suspect. Although Bow is convinced that there is enough evidence, Pops and Dre are less sure that the police officer will be indicted. The following scene occurs:

Diane: What's an indictment?

Rainbow: Oh, okay. Well, listen. It seems as if some people that were supposed to protect us, didn't do the right thing. But it doesn't happen very often.

Dre: It happens all the time.

Rainbow: It doesn't happen very often. But this time it did and if it did, then they're going to get in trouble.

Jack: So the cops are the bad guys?

Pops and Dre: Yes.

They nod their heads.

Rainbow: No. no. Some of them are.

Junior: It's a grey area.

Mom: Charcoal grey.

Pops: Basically black.

Rainbow: The point is ...if something bad happened, then that's why we have laws and trials and we just let the justice system do its job.

The television announcer reveals that the justice department is not filing any charges.

Dre: Kids, this is your justice system doing its job.

Pops: Same old story.

Jack: I don't understand.

Diane: Yeah, how did this happen?

This scene unpacks a lot of questions within just a few minutes. The younger children, Diane and Jack, are attempting to understand the justice system in America. Rainbow tries to explain that when bad

people do bad things, they go to jail. Yet that statement is immediately contradicted, as an indictment is not issued. When Jack asks, "So the cops are the bad guys?" there is no simple answer that the family can provide. Yet perhaps the most thought-provoking question comes from Diane, when she asks, "How did this happen?" This narrative shows how *Black-ish* directly confronts current social and cultural issues within its plot. Rather than have a straightforward, one-sided approach, the show presents multiple viewpoints from various family members.

Yet Dre's perspective is made clear by his voiceover to the next scene: "Hope is what keeps us as a people and a country moving forward. And sadly, the best way to end that movement, is to take away that hope, which at its core, is all we really have to give our children. But when everything around them is doing its best to squash that belief, what do you do?" In this moment, Dre is searching for answers to his children's as well as society's prevalent questions. How can we approach these questions? Dre emphasizes in the next few scenes that by having the difficult discussions, rather than avoiding them, takes an enormous step forward.

As the news coverage continues, one of the lawyers argues that the victim was not innocent in the case. The following scene occurs:

Pops: They are talking about someone's child. That could easily be one of these children here.

Jack: That could have been one of us?

Rainbow: No.

Dre: Yes.

Rainbow: No, sweetie, because if you get stopped by the cops, you are going to do exactly what they say, ok?

Mom: She's right. Listen to me. If you have to talk to the cops, there's only seven words you need to know: "Yes sir," "no sir," and "thank you sir."

Rainbow: Exactly. You make sure that you live to fight your case in court. You hear me?

Dre: Bow! Mama! Enough! Wake up! Let's say they listen to the cops and get in the car. Look what happened to Freddie Gray.

Pops: Yeah and what if they make it all the way to the station. Remember Sandra Bland?

Dre: And let's say they do make it to trial. You see where that gets us. Don't you get it Bow? The system is rigged against us.

Rainbow: Maybe it is Dre. But I don't wanna feel like my kids are living in a world that is so flawed that they can't have any hope.

Dre: Oh, so you wanna talk about hope, Bow? Obama ran on hope. Remember when he got elected? And we felt like maybe, just maybe, we got out of that bad place and maybe to a good place—that the whole country was really ready to turn the corner. You remember that amazing feeling we had during the inauguration? I was sitting right next to you. And we were so proud. And we saw him get out of that limo and walk along side of it and wave to that crowd. Tell me you weren't terrified when you saw that. Tell me you weren't worried that someone was going to snatch that hope away from us like they always do. That is the real world, Bow. And our children need to know that that's the world that they live in.

As the children continue to have questions, Dre makes his viewpoint clear to his family. He questions how hope can exist in a world that is so deeply flawed. Although he makes declarative statements that express his point of view, Dre also questions how he can enact social change. He desires a world that is better for his children. The premise of the show focuses on Dre wanting his children to understand their culture and what it means to be Black in America today. This visualization depicts Dre's desires clearly: he wants his children to understand their culture and keep it relevant to their own lives.

The episode concludes with the following scene:

Diane: If you give up, who's going to fix it for us?

Rainbow: Okay, come here babies. Nobody is giving up, okay?

Dre: All right, look here's the deal. This is the world that we live in. A whole lot of white, a whole lot of black, but mostly grey. But as a family, we're going to figure it out together.

Pops: That's right.

Dre and Rainbow decide they will take the older children down to the protest to contribute. Even though there are safety concerns, they recognize how important it is to make their voices heard. Dre receives the final perspective in the scene with his powerful concluding statement to his family. He understands the power of his family fighting together to enact social change, rather than questioning it alone. His final voiceover solidifies that perspective: "As a parent, it's hope that we pray we can pass to our children. But sometimes, it's your children that give you hope." Moreover, the Johnson family demonstrates the power of collectivism. They join the protests in Los Angeles and join the rest of the community in fighting against the racial inequality that they have just witnessed on the news.

In the concluding moments of the episode, *Black-ish* demonstrates how a domestic sitcom can blend a focus on the family with broader social issues. The narrative of the plot has focused on how Dre and Rainbow can discuss difficult topics with their children. Yet the episode also draws on real life broader social issues: Junior is reading a book by Ta-Nehisi Coates and directly quotes him within the arguments he makes to his family. Dre recalls when he first read Malcolm X and heard about different kinds of resistances. Pops remembers when he joined the Bobcats (a group similar to the Black Panthers") resistance group and uses Freddie Gray and Sandra Bland as examples for his viewpoint. In these moments, *Black-ish* surpasses the sitcom limitations of the genre that suggest that the fictional family cannot effectively discuss real world, broader cultural issues. The family demonstrates that it is possible to have the difficult discussions and then chooses to join their neighbours in social resistance. The narrative connects the personal of the family's viewpoints and concerns, with the broader social discussions that exist in America. The final scenes of the episode are snapshots of Obama taking the oath of president and real people protesting and fighting for change within their own culture. Dre's perspective, dialogue, and actions are nuanced, as he leads his family through questions and answers to arrive at their own decisions. In these moments, Dre embraces social activism through his defiance of the status quo while also guiding his family toward their own individual realizations.

Throughout these examples, *Black-ish* demonstrates standpoint theory through its reflexive perspectives that emphasize collective struggles. The narrative of the episode and the characters openly critique

systems of oppression that the characters face. They ground this critique through their own lived experiences, both through personal events that served to oppress them as well as through their thoughts and interpretations about those events. The characters are not focused on their individual needs but on the power of collectivistic social action; this is evident by the end of the episode in which Dre and Rainbow agree to join their children in the protest. In that moment, the safety and security of the home setting is eliminated in favour of making a difference in the real world. As Nancy Hartsock has argued, "the vision available to the oppressed group must be struggled for and represents an achievement that requires both science to see beneath the surface of the social relations in which all are forced to participate and the education that can only grow from struggle to change those relations" (316-17). *Black-ish* embodies this sentiment throughout the episode. Moreover, through the narration of the episode, it is Dre's perspective that is foregrounded. It is his desire for social hierarchies to be fundamentally changed for the sake of his children that conveys his feminist fathering approach.

Hierarchicalizing Oppressions

Although the examples presented here depict Dre as embodying feminist fathering in many ways, I am also concerned with Dre's compliance with hierarchicalizing oppression, which questions whether one form of gender, race, class, or sexuality marginalization came before the others and acts as the model for all forms of oppression. Through these examples, Dre's interpretations on racial identity and his knowledge of feminist ideas expand. Yet his class consciousness does not seem affected by the narrative of the episodes. Even though he acknowledges the struggles related to race and gender, he seems less concerned with oppressive class structures and openly endorses capitalist ideas.

In this way, Dre demonstrates the matrix of domination. Patricia Hill Collins "describes how, within this matrix, people have a social location and an identity in terms of such important structural forms of oppression as race, ethnicity, social class, gender, and/or sexual orientation. She also describes how people can simultaneously be both oppressed and oppressors because they could occupy social locations of both penalty

and privilege" (Mann 179). Dre embodies this idea in his passionate desire to challenge oppressive ideas related to race and gender while consenting to issues related to economic class. He is concerned that his children may act spoiled, but he does not address how his own capitalistic needs contribute to class oppression. He may momentarily note them in the conversation, but they are never the central focus of the narrative of the episode. Dre embodies the capitalist need for an "earn and spend" mentality yet fails to recognize how these ideas further marginalize other people. Dre clearly emphasizes racial and gender cultural norms, yet cultural norms related to class are never his primary focal point.

Moreover, Dre fails to recognize how race and class or gender and class are intertwined. For example, how might his wife and daughters face adversity because of both their race and gender? Dre does not even consider that these two identities may be intertwined with one another. He prioritizes racial marginalization rather than contemplating how race, gender, and class work together. Therefore, I question to what extent Dre can truly embody feminist fathering when he is oblivious to the hierarchical oppression associated with class and consumerism. His lack of recognition of intersectional concerns reduces the impact that the portrayal of this character has on feminist research.

Conclusion

In this chapter, I have examined to what extent Dre, the father figure on *Black-ish*, demonstrates feminist fathering. Through these examples and plot narratives, Dre mainly embodies feminist fathering through his denial of the status quo. Tina Phillips argued that men should engage in feminism and aid in the fight for a non-hierarchical society (12). Dre's social consciousness exhibits the mutual benefit that men and women who fight for socialist feminism can achieve (Phillips 12). About men and feminism, Phillips has argued the following: "If men are to be allies acting in solidarity with others, they are going to encounter being told they are wrong a lot. This is the reality of being a feminist man" (13). Consequently, the show depicts Dre as an equal member of the family, both as a voice of reason, as well as a character who presents a foolish perspective but learns to alter that point of view. Dre is certainly a flawed character, but he is also one who engages in self-evaluation and self-reflection; because *Black-ish* also demonstrates

Dre striving for self-improvement, it expresses a feminist fathering approach. By aspiring to demolish patriarchal structures, stereotypes, and cultural norms that reinforce existing power structures surrounding race and gender, Dre demonstrates that social commentary can be discussed within the family and on a Disney-owned sitcom. However, the casual—if not outright denial of how economic class issues affect this family and families across America—leads to a capitalist escapism for the audience. Although cultural issues related to gender and race are readily discussed, it is the lack of discourse about how class anxiety resonates with these issues that prevents *Black-ish* from truly being a feminist platform.

Not only does Dre embody feminist fathering but the entire show of *Black-ish* takes a step forward in challenging the premise of domestic sitcoms. Although domestic sitcoms traditionally focus only on the family, *Black-ish* situates its family problems and concerns within broader cultural and social issues. Specifically with the episode "Hope," *Black-ish* demonstrates not only various viewpoints within the family but how those viewpoints can still join together to emphasize collectivistic social action. Even though he is scared for his family's safety, Dre encourages the family to join the protests in their city to fight for social justice. This movement from a fictional narrative to real world implications is a sharp departure from most sitcoms, particularly *The Cosby Show*.

Although there are many positive aspects to Dre's feminist fathering, there is a glaring flaw in Dre's perceived endorsement of capitalism and ignorance of class oppression. Dre openly engages in "competitive consumption," which is the idea that "individuals try to keep up with the norms of the social group with which they identify—a reference group" (Schor 207). The need for consumption and a foremost goal of achieving material possessions demonstrates a capitalistic view: the more goods that society purchases, the more beneficial it will be for the capitalist's economy. Class consciousness is something that television as a whole does not really acknowledge; instead, class is regularly disregarded in favor of an emphasis on consumerism. Therefore, even though it is not unusual for a major broadcast sitcom to engage in consumerism at the expense of class consciousness, it does undermine the conclusion that Dre is a feminist father because he openly engages in hierarchical oppressions. He discusses and emphasizes racial and gender inequality and biases but readily ignores class concerns. While

Dre appears financially stable, his parents have had to work their whole lives to support their family. Dre enacts the myth of the American Dream; because his parents worked hard and gave him more and because Dre now works hard to give his family more, class struggle is not a primary concern for him. Yet Dre does not recognize how race and class could be multiple sites of oppression for his family and others; his emphasis remains solely on the racial struggles that he faces and his drive to better understand gender oppressions. Because Dre is the narrator of the show and the audience views the world primarily through his perspective, this lack of class consciousness undermines the show's feminist fathering conclusions. The message is clear: social commentary can be discussed in this medium, but only if it supports capitalism.

Ultimately, *Black-ish* does embody a lot of positive feminist ideas throughout its narratives and its primary character, Dre Johnson. The narratives provide social commentary and Dre's perspective is evident through his behavior, dialogue, and voiceovers to the audience. Even though the family sitcom airs on a major broadcast network and conforms to some sitcom genre conventions, it still shows that feminist fathering is possible when engaging in deeper dialogue about feminist thought. Through the humour, his questioning of his perspective, his relationship with his wife, and his desire for collectivistic social action, Dre embodies feminist fathering. Whereas the father on *The Cosby Show* emphasized complacency with the status quo, *Black-ish* reveals that by recognizing one's standpoint and challenging systematic oppression, Dre often demonstrates what it means to be a feminist father.

Endnote

1. Although this research does reference *The Cosby Show* and cites analysis of the television show, it includes material that was written prior to the revelations of Bill Cosby's sexual misconduct. The discussion that follows focuses on the sitcom genre and how this particular television show, which had many cast and crew members contributing to it, maintained or challenged social narrative with its plot and character development. Even though Bill Cosby's actions were disgraceful, he was only one voice and contributor to the show. The cultural norms and values that stem from the show and how they relate to this feminist analysis make the discussion of the television show an important inclusion in this analysis.

Works Cited

Attallah, Paul. "The Unworthy Discourse: Situation Comedy in Television." *Critiquing the Sitcom*, edited by Joanne Morreale, Syracuse University Press, 2003, pp. 91-115.

Belkhyr, Souad. "Disney Animation: Global Diffusion and Local Appropriation of Culture." *International Journal of Human Sciences*, vol. 9, no. 2, 2012, pp. 704-14.

Berger, Arthur A. "What's So Funny about That?" *Society*, vol. 47, no. 1, 2010, pp. 6-10.

Bing, Janet. "Is Feminist Humor an Oxymoron?" *Women & Language*, vol. 27, no. 1, 2004, pp. 22-33.

"Bow Knows." *Black-ish*, written by Laura Gutin, directed by Rob Sweeney, ABC, 2018.

Bressler, Nancy. "'It's So Wrong, It's Right!': Analyzing Feminist Humor in Sitcoms." *Ohio Communication Journal*, vol. 56, 2018, pp. 47-58.

Butsch, Richard. "Five Decades and Three Hundred Sitcoms About Class and Gender." *Thinking Outside the Box: A Contemporary Television Genre Reader*, edited by Gary R. Edgerton, the University Press of Kentucky, 2005, pp. 111-35.

Butsch, Richard. "Five Decades and Three Hundred Sitcoms About Class and Gender." *The Social Construction of Difference and Inequality*, edited by Tracy Ore. 4th ed., McGraw-Hill Higher Education, 2009, pp. 444-62.

Campbell, Richard, et al. *Media Essentials: A Brief Introduction*. Bedford/St. Martin's, 2010.

DiCioccio, Rachel L. *Humor Communication: Theory, Impact, and Outcomes.* Kendall Hart Publishing, 2012.

Fiske, John. "British Cultural Studies and Television." *What is Cultural Studies? A Reader*, edited by John Storey, Arnold, 1996, pp. 115-47.

"The Gift of Hunger." *Black-ish*, written by Peter Saji, Njeri Brown, and Devanshi Patel, directed by Victor Nelli Jr., ABC, 2014.

Hamamoto, Darrell Y. *Nervous Laughter: Television Situation Comedy and Liberal Democratic Ideology.* Praeger, 1989.

Hartmann, Heidi. "The Unhappy Marriage of Marxism and Feminism: Towards a More Progressive Union." *Feminist Theory Reader*, edited

by Carole R. McCann and Seung-Kyung Kim, Routledge, 2010, pp. 169-84.

Hartsock, Nancy C.M. "The Feminist Standpoint: Toward a Specifically Feminist Historical Materialism." *Feminist Theory Reader*, edited by Carole R. McCann and Seung-Kyung Kim, Routledge, 2010, pp. 316-332.

"Hope." *Black-ish,* written by Kenya Barris, directed by Beth McCarthy-Miller, ABC, 2016.

Jaggar, Alison M. *Just Methods: An Interdisciplinary Reader,* edited by Alison M. Jaggar, Paradigm Publishers. 2008.

Jhally, Sut, and John Lewis."Class and the Myth of the American Dream."*Enlightened Racism: The Cosby Show, Audiences, and the Myth of the American Dream*, edited by Sut Jhally and John Lewis, Westview, 1992, pp. 71-92.

"Keeping Up with the Johnsons."*Black-ish,* written by Courtney Lilly, directed by Millicent Shelton, ABC, 2016.

Kutulas, Judy. "Who Rules the Roost?: Sitcom Family Dynamics From the Cleavers to the Osbournes." *The Sitcom Reader,* edited by Mary M. Dalton and Laura R. Linder, State University of New York Press, 2005, pp. 49-60.

Mann, Susan A. *Doing Feminist Theory: From Modernity to Postmodernity.* Oxford University Press, 2012.

McQueen, David. *Television: A Media Student's Guide.* Arnold Publishers, 2009.

Merrill, Lisa. "Feminist Humor: Rebellious and Self-Affirming." *Women's Studies,* vol. 15, 1988, pp. 271-80.

Meyer, John C. "Humor as a Double-Edged Sword: Four Functions of Humor in Communication." *Communication Theory,* vol. 10, no. 3, 2000, pp. 310-31.

Mills, B. *Television Sitcom.* British Film Institute, 2008.

Montgomery, Daniel. "Producers Kenya Barris, Jonathan Groff on 'Black-ish' 'Renaissance'."*Gold Derby.* 2015, www.goldderby.com/article/2015/kenya-barris-jonathan-groff-interview-black-ish-abc-emmys-entertainment-13579086-story/. Accessed Feb. 28, 2016.

Morreall, John. *Comic Relief: A Comprehensive Philosophy of Humor.* Blackwell Publishing, 2009.

Narayan, Uma. "Dislocating Cultures: Identities, Traditions, and Third World Feminism." *Just Methods: An Interdisciplinary Reader,* edited by Alison M. Jaggar, Paradigm Publishers. 2008, pp. 213-25.

NPR Fresh Air. "Kenya Barris on 'Black-ish' and What Kids Lose When They Grow Up with More." *NPR.org,* May 2016, www.npr.org/2016/05/18/478414550/kenya-barris-on-black-ish-and-what-kids-lose-when-they-grow-up-with-more.Accessed June 14, 2018.

Palkovitz, Rob, Trask, et al. "Essential Differences in the Meaning and Processes of Mothering and Fathering: Family Systems, Feminist and Qualitative Perspectives." *Journal of Family Theory & Review,* vol. 6, 2014, pp. 406-20.

Phillips, Tina. "The Role of Men in the Feminist Movement."*Judgment & Decision Making,* vol. 10, no. 2, 2015, pp. 11-14.

"R-E-S-P-E-C-T."*Black-ish,* written by Steven White, directed by Gail Lerner, ABC, 2018.

Schor, Juliet. "The New Politics of Consumption: Why Americans Want So Much More Than They Need." *Gender, Race, and Class in Media: A Critical Reader,* edited by Gail Dines and Jean M. Humez, Sage Publications, 2011, pp. 205-212.

Senzani, Alessandra. "Class and Gender as a Laughing Matter?: The Case of Roseanne." *Humor,* vol. 23, no. 2, 2010, pp. 229-253.

Snitow, Ann. "Gender Includes Men: An Exploration of Feminist Thought on Masculinity." *Gender, Equal Opportunities, Research/ Gender,* vol. 16, no. 1, 2015, pp. 84-88. DOI: http://dx.doi.Org/10.13060/12130 028.2015.16.1.172

Staiger, Janet. *Blockbuster TV: Must-See Sitcoms in the Network Era.* New York University Press, 2005.

Surette, Tim. "Black-ish Series Premiere Review: Not the New Cosby Show – And That's More than Okayish." *Tv.com,* 2014, www.tv.com/shows/blackish/community/post/blackish-season-1-episode-1-pilot-review-141159116644/. Feb.28, 2016.

Tanner, Litsa R., Haddock, Shelley A., Zimmerman, Toni S., and Lori K. Lund. "Images of Couples and Families in Disney Feature-Length Animated Films." *The American Journal of Family Therapy,* vol. 31, 2003, pp. 355-73.

Taylor, Ella. *Prime-Time Families.* University of California Press, 1989.

"Unkept Woman."*Black-ish,* written by Christian Lander, directed by Pete Chatmon, ABC, 2018.

Chapter Six

Choose Your Own Fathering Style: Neil Patrick Harris and Feminist Fathering

Nicole L. Willey

Neil Patrick Harris: *Choose Your Own Autobiography* is a truly unusual memoir in both form and content. A fun read, especially for fans, readers find themselves learning about Harris's path to fatherhood, along with the choices he and his partner, David Burtka, have made about raising their children. For Harris and Burtka, co-parenting Gideon and Harper is clearly a joy and struggle, as parenting is for most parents, but in this case, no decision comes easily because each biological or stereotypical parenting gender role must be constructed and planned for this loving family. Although studies show that gay men's desire to have children does not vary greatly from heterosexual men's feelings on the issue, "nonetheless, gay fathers think more about the motives and meaning of their desire to become parents" (Kleinert et. al 175). For Burtka and Harris, and any gay couple who explores having children, every step—starting with the desire to parent, to choosing how to become parents, to determining how to parent—requires thought, planning, and commitment that goes beyond what most straight couples have to face. Since little research exists on feminist fathering, and even less on queer feminist fathering, this chapter is my attempt to theorize the possibilities for queer fathering as transgressive and antipatriarchal—in other words, potentially and often feminist—using Harris's memoir as a case study. Feminist and queer theory can have disparate goals, but in this queer family, the lack

of a mother opens up a space for feminist fathering that any family, queer or traditional, could emulate.

Feminism and Fathering: Theoretical Underpinnings

To begin to make a claim for feminist fathering, each word must be unpacked. As those of us who study fathering know, this is a burgeoning field, but one that has yet to fully arrive at the level of mothering studies, which has observed, defined, critiqued, explored, and even transformed actual mothering practice. Authors like Andrea Doucet and Nancy Dowd are observing, defining, and exploring fathering practice, which is what we need to do before we can transform it. Of course, individual families have been working on transforming fathering practice ever since the initial definition proved shallow and full of shortcomings to all kinds of parents. Scott Coltrane notes that whereas a common definition of mothering "implies ongoing care and nurturing of children," fathering "has typically implied an initial sex act and the financial obligation to pay" (4). Like Coltrane, I hope work on fathering, and specifically the work of finding feminist fathering, can enable us to change family structures that "carry the potential of richer lives for men, more choices for women, and more gender equality in future generations" (Coltrane 4). Patriarchy is alive and well in many corners of the U.S., as has been even more painfully clear than usual under the current U.S. administration. Adrienne Rich defines it this way: "Patriarchy is the power of the fathers: a familial-social, ideological, political system in which men—by force, direct pressure, or through ritual, tradition, law, and language, customs, etiquette, education, and the division of labor, determine what part women shall or shall not play, and in which the female is everywhere subsumed under the male" (57). To dismantle patriarchy, then, we must also dismantle regressive fatherhood practices, and as she rightly demonstrates, these attitudes and ideals begin for many in the home.

Feminists use the tools of feminism to break down these harmful patriarchal structures. Of course, feminism itself is a contested term, and who fits under the umbrella of feminism and who wants to is a moving target. Katha Pollitt covers this debate in "Too-Big-Tent-Feminism" in a recent issue of *The Nation*, in which she summarizes the debate that exploded when New Wave Feminists (an antichoice group)

were briefly listed as a sponsor of the Women's March on Washington in 2017 (6). I agree with Pollitt: the primacy of women's choice and control over their bodies is non-negotiable to feminism (although certainly women can be antiabortion for themselves as individuals). So, how do we define feminism in this intersectional, third-wave, post-feminist, Trump-presidency moment? I find Andrea O'Reilly's "open-ended" definition of feminism useful:

> [It is] the recognition that most if not all cultures are patriarchal and that they give prominence, power, and privilege to men and the masculine; they depend on the oppression, if not disparagement, of women and the feminine. Feminists are committed to challenging and transforming this gender inequity in all of its manifestations: cultural, economic, political, philosophical, social, ideological, sexual, and so forth. As well, most feminisms (including my own) seek to dismantle other hierarchical binary systems, such as race, (racism), sexuality (heterosexism), economics (classism), and ability (ableism). (48-49)

Broadly, then, feminists are concerned with dismantling oppressive hierarchies and binaries to transform and empower the very people who are oppressed under patriarchy. Feminist parenting, then, must be concerned with "consciously parent[ing] from a feminist perspective, by which respecting individual rights and opposing acts of domination and oppression is fundamental" (Comerford et al. 2). Almost by definition, then, feminist parents are going to be deemed unfit by those who wish to maintain the status quo. Borrowing from Njoki Wane, who suggests that entire categories of women who are considered "other" are labelled unfit mothers, and Alice Walker, who reminds us that being outside of the mainstream can be powerful,[1] I would suggest that being on the outside of heterosexist and patriarchal fathering is subversive by definition, with the possibility for positive transgression and transformation almost a given. In the U.S., with national rights for the freedom of queer couples to marry, new rights have still "not eliminated the legal and social disparities that continue to impact the LGBTQ community more broadly; some areas of the country continue to introduce and defend antigay legislation" (Ollen and Goldberg 369). The fact that gay parents are still victims of (wrongful) claims of being more likely to abuse their children, failing to provide appropriate role models,

and encouraging "inappropriate gender and sexual identities" (Ollen and Goldberg 365) shows the threat that gay couples make to the status quo just by existing. Yet transgressing the status quo is the way forward. Myriam Miedzian points out the following:

> Psychological studies of families in which child-rearing is shared by the parents or in which the father is the primary caretaker reveal that the sons in these families are more empathic than boys raised in the traditional way. In a twenty-six-year long-itudinal study of empathy, researchers found that the single factor most highly linked to empathic concern was the level of paternal involvement in child care. (82)

If paternal care is linked to empathy in sons, and if in the Burtka-Harris household there are two involved fathers—fathers who are bucking mainstream definitions of family (albeit from the comfort of wealth and celebrity)—then we can look to their family for potential transgressions and transformations that could serve as a model for making fathering more feminist in anyone's individual practice. Indeed, there "is *no evidence* that gay parents are less good at parenting than heterosexual parents, despite the challenges of community and societal bias against them" (Palfrey 900). My claim is that, perhaps, gay couples like this one are a good place to look for families who are searching for feminist-fathering models.

Although the goal of this entire collection is to theorize and define feminist fathering, which has been done in divergent ways in the other chapters, I will use the following markers as central to the definition I am developing. A feminist father is aware of patriarchal discrimination and works to break down those harmful hierarchies in the home and the world, particularly in the realms of gender and sexuality. Gender stereotypes and binaries should be fought against by a feminist father; likewise, he should not enforce his way of being on his children and should give them room to be who they are and help them discover their own truths. A feminist father should love and care for his children, and should extend his feminist (antipatriarchal) advocacy into the world; he should find ways to help others break down the same stereotypes, binaries, and obstacles he is trying to help his children overcome. This is a tall order for any feminist parent, although Harris's own identity positions may help him grow toward this definition.

Queer Theory, Intersections, and Fathering

Of course, it is no secret that feminism and queer theory are often at odds. For instance, some feminist theorists rely upon gender and sex definitions that reinforce binaries that queer theorists strive to break down, whereas, queer theorists sometimes prize private queer choices over the lived lives of women, even in some cases uncritically embracing sex positivity without accounting for real harm done to women through sexual violence (Craig 210, 214). Despite these differences, Elaine Craig sees potential for feminism and queer theory to be mutually beneficial in the current context of family law. She references a three-parent custody battle, C. (M.A.) v. K. (M.), in Ontario courts in 2009, in which the parties were lesbian and gay, biological and nonbiological parents (211-12). Craig notes that feminism and queer theory "converge on legal projects aimed at advancing the complex justice interests of women and sexual minorities" (211). In this contested space of nonheterosexist parenting, if we employ intersectionality, Craig argues, we can find productive ways toward justice: "The benefits of intersectional approaches to issues of sexism, heterosexism, (and racism and classism) derive from the deployment of mutually reinforcing theoretical approaches in those instances where justice interests converge" (212-13). So the breaking down of gender binaries (queer theory) coupled with a commitment to overcoming inequities based on those hierarchical binaries (feminism) can lead us to feminist fathering practice.

A queer father is by definition going to be outside of the mainstream and is suspicious of patriarchal notions of privilege and "right-ness." Queer theory is largely concerned with challenging "hegemonic sex and gender norms" (Craig 214). For the purposes of this chapter, I see Harris's memoir as a queer project—one that uses postmodern techniques (a nonlinear narrative, disruptions of truth telling, and a second-person voice) to tell the queer story of his fathering two children as a gay man with his partner, another gay man. I do not argue that Harris sets out to reframe what fathering, queer fathering, or feminist fathering is; rather, I argue that his project interrogates normative notions of who can be a father and through his transformation of patriarchal notions of fathering, his memoir provides a better than typical model of feminist fathering.

Choose Your Own Fathering Style: Lessons from the Memoir

Choose Your Own Autobiography is atypical as a memoir in several ways. It is written in the style and shape (roughly) of a choose your own adventure book, so it is written in second person (as though "YOU," the reader, are Neil Patrick Harris, which is amusing and not as off putting as it sounds because most of the writing is surprisingly elegant), and the reader can choose pages based on their choices at the bottom of sections. Additionally, the book can be read largely chronologically simply by reading from front to back; amusing (and fictional) side trips (where YOU, the reader as Neil Patrick Harris, work at Schlotzky's Deli, are in a police chase, or are about to be murdered) are short, fanciful detours that can be read or ignored. The meat of the book moves from, literally, Harris's birth to his life at publication. It is at once a seeming celebrity tell all, complete with adventures on the sets of *Doogie Howser, Rent, Cabaret, How I Met Your Mother,* and *Hedwig,* along with details about celebrity hangouts and some (noncelebrity) hookups. It is also about Harris's tale of coming out to his family, friends, and the public. Like other skillful memoirists, he shapes his story in a way that feels honest and real, as though he has not manipulated the story. In recounting his development and awareness of self and sexuality, he shares his coming out in a way that both explains what happened (being outed by Perez Hilton and ultimately needing to speak for himself) and what the private facts of his life are that enabled, finally, his ability to control his own narrative. As a celebrity, Harris lives up to fans' expectations of being able to hear the stories behind the stories they already know; he also makes this memoir his own by telling the chunks he chooses of his private life, stories that were likely largely unknown to his fans. After all, many of his fans know him primarily as Barney Stinson, from *How I Met Your Mother,* which leads him to write: "I was an out, gay, monogamous family man who, in the eyes of millions of people, represented an archetype of raging hetero boorishness" (138). Whether fans had followed his theatre, small screen, or movie career, chances are they were able to learn more about his acting roles (his public life) as well as his private life.

This is not a fathering memoir; however, fathering, co-parenting with Burtka, and their children themselves are the focus throughout

much of the book. For instance, to showcase the primacy his fathering role has in his life, very early in the book, one of his "choose your own adventure" directions reads: *"If you are eager to meet your own children, skip ahead 30 years and turn to page 276"* (7). Readers will learn that this focus on his family runs throughout the book, even though he had only been a father for three and a half years before publication. The memoir is not a warts-and-all look at the realities and challenges of parenting, although he touches on some of the difficulties. Instead, this book reads as more of a celebration of his great good luck in finding the right partner and living in a time when having children and a family is something he can realize as a gay man. He writes the following: "You know that not everyone had a childhood as happy as yours, or parents as loving. You were fortunate, and always in the back of your mind you had the hope and ambition that someday your own children would reflect on how fortunate they were too. But for a long time it was hard to imagine the circumstances by which such a family could be created" (191). His book is largely a celebration of achieving his family.

To get his family, he first had to find the right partner. Here, he describes meeting Burtka:

> And then you meet David. Not only does he come from a close-knit family that, like you, he longs to replicate, but—and how's this for a good sign—*he's already helped raise kids ...* you are enamored by the fact that this guy you're falling for has already had a chapter like this in his life, and therefore is not unfamiliar with the day-to-day details of knowing what diapers to buy and how long to refrigerate the formula and what a baby's forehead should feel like. And all this makes you fall quicker and deeper in love with him, because you don't often meet a man this handsome who's also had this kind of experience. (191-92)

Their love story is a considerable portion of the book, and it is capped off with a cross-country birthday party that Burtka plans for Harris, in which he visits the significant places and people of Harris' life:

> And by your side, as he has been the whole time, is David Michael Burtka. The man who planned, produced, and organized the whole thing with the insight of someone who genuinely knows you better than you know yourself, and the wholehearted commitment of someone who quite possibly loves you better

than you love yourself. But also quite possibly, not as much as you love him. (283-84)

This memoir is a shaped but open book, one in which Harris constructs a persona who is searching, joyful, and loving. One gets the impression that the book would not or could not have been written prior to meeting Burtka, and quite possibly, without the arrival of their twins. In reading Harris's own coming-of-age, coming-out, and fathering story, I am reminded of Audre Lorde's recommendation for raising whole children: "The strongest lesson I can teach my son is the same lesson I teach my daughter: How to be who he wishes to be. The best way I can do this is to be who I am and to hope that he will learn from this not how to become me, which is not possible, but how to become his own person" (qtd. in Bartlett 35). Through learning about who he is as a person, Harris was able to form a family and help his children become who they are. His memoir shows a model for fathering that can be considered feminist in multiple ways, even as some blind spots are revealed.

The most obvious task for a feminist father is to break down gender stereotypes. And although Harris seems committed to breaking down these stereotypes, at times he still affirms them in his descriptions of his children. After heartbreak and obstacles in attaining pregnancy through a surrogate, he and David get the news that one of each of their specimens has become viable. Later, he finds out more: "And the sexes are... one of each! Again, you completely luck out. You couldn't ask for a better situation: had it been two boys you might have wanted to do it all over again so you could experience having a girl, and vice versa" (201-2). He is excited to experience parenting a boy and a girl, and he hopes that the names they have chosen, Gideon Scott Burtka-Harris and Harper Grace Burtka-Harris, "won't automatically leave other people with an impression of who they are or what they are like. You feel like 'Gideon' could be a scientist or an investment banker or a bassist, and that 'Harper' could be a girly-girl cheerleader or a tomboy pro-volleyball player. They're both names that, at least to your ears, don't come with any kind of stereotype" (204). Here, unfortunately, he chooses career fields statistically greater for men for his son, where he does not discuss a (realistic) career for his daughter at all.

Later, in describing his children's personalities, he actually calls Gideon a "boy boy" and Harper a "girl girl" (276-77). He describes their

interests and shows concern both at Gideon's interest in guns and Harper's flirtatious nature. He is mystified by the fact that he is raising these children who live out these gendered stereotypes, but the reader also sees a father who shows more concern over his daughter's gendered behaviours than his son's: "Sometimes you and David worry that you're raising a stripper because she has such an affinity for taking her clothes off" (277). This description is shared for a clear comedic effect, yet Harris does not share any concerns for Gideon's interest in guns. Despite his seeming concern for their gendered behaviors, he does not seem to want them to be anything other than they are; he is not trying to enforce his normative or non-normative gender views on his children. Instead, he celebrates who they are: "They are your children, Gideon and Harper, the ones you worked so hard to get, the ones you waited for so long, and you love them madly, crazily, bottomlessly" (278-79). Part of feminist fathering, I would argue, is clearly seeing your children and loving them just as they are. He does this well.

As is completely appropriate for children who are three and a half years old, he makes no mention of their sexuality; one can surmise, though, that as a gay man who had a decades-long struggle with his own sexual orientation and status regarding it, he will be fully accepting of however his children will present. Certainly, in the family structure itself, stereotypical roles must be renamed and renegotiated. Here, Harris discusses what their children call him and his partner: "To the kids, David is 'Daddy' and you're 'Papa.' You find it a more convenient system of nomenclature than "Daddy 1" and "Daddy 2," or "Sinners A and B" (278). As is probably becoming clear, humour is used to lighten many moments in the book, although his love for his family and the care with which he and his partner are raising them is never a laughing matter. He also considers what part he should play as a public role model:

> You know there may be some people who look to you and your family as a source for pride, a reason to stand tall. And you're glad for that, because standing tall is what is most important. Yes, overt advocacy is vitally necessary in a bigoted world, and you do not shy away from it when appropriate.... But you have seen instances when the hard-core vehemence of some gay-rights activists creates a backlash, making homophobes even more homophobic. For you it all goes back to the fundamental rule of creative endeavor, and life is if nothing else a creative

endeavor: "Show, don't tell." Personal confidence, ease, conducting yourself publicly with grace and humility—these are the qualities you consider most effective. Directly *showing* family and neighbors and co-workers that you're proud of the way you live accomplishes something on a core level that intense advocacy sometimes can't. (178)

In this statement he shows his willingness to "stand tall" for himself and his family, when appropriate. But he also demonstrates that being a role model is more important to him than being an activist. Additionally, Harris is committed to intense privacy for his children. This is a shaped memoir in which we get glimpses of the details he chooses to share of his life and his family. He also describes in detail the great pains he took to keep his children's surrogacy process and birth out of the public eye. Taken together, these impulses show us a father who is proud to be a gay man, father, and family man, and one who will both stand up for others (as he deems necessary) and protect his children.

In terms of other oppressions that feminist fathering could actively work to overcome (e.g., classism, racism, or ableism), the book is largely silent. It is clear in his narrative that he loves to be part of the theatre, a world that is more diverse than filmmaking. He speaks generally about a social and dating life that includes a wide variety of people of diverse backgrounds. However, as an actor who has made it, he does not seem to cross paths with many who are poor or working class. However, he does seem to situate himself as someone who is in awe of Elton John's wealth and appreciative of it, perhaps speaking to his middle-class roots. I cannot recall any mentions of people who are differently abled. In general, his persona is welcoming and open, but I cannot speak to those greater levels of resistance, and to be fair, I am asking questions of the book that he likely never meant to answer. Still, if he were an activist in other areas, it would probably shine through in his book more clearly.

His book narrates the exhaustion of parenting, showing details about the food served, the screen rules, the bedtimes, and the pain of being away from his family. He shares some of the reality of fathering along with some of his philosophies of fathering. In the end, I am not sure that I would call Harris a feminist father, and I certainly do not know if that is a term he would claim. A feminist father should be aware of patriarchal discrimination and work to break down harmful hierarchies, particularly in the realm of gender and sexuality, in his home and in the world.

Although gender stereotypes and binaries should be fought against by the feminist father, he should not enforce his way of being on his children, giving them room to be who they are, even helping them discover their own truths. Finally, a feminist father should love and care for his children; he should nurture them as well as provide for them. As a gay man, Neil Patrick Harris has quite literally queered the nuclear family; he displays a loving commitment to his partner and his children, one in which he necessarily pushes back against heterosexist norms, privately and publicly. Throughout his book, he is an example of a father who models perseverance, openness, and unconditional love for his children, with no desire to change them. He ends his book with a description of him and his family going to Disney World for his annual job of narrating the Christmas Story. Here is his description of riding his favourite ride:

> But some of the wonder, you admit to yourself, is gone. Until you gaze at your two-year-old son sitting on your lap, and his twin sister, sitting on the lap of the man you love so much, and this five-minute climate-controlled adventure that you've grown a little jaded about is once more a spellbinding enchantment, because you're seeing anew through their eyes.... You experience *them* experiencing pure magic, unadulterated by cynicism or irony or self-consciousness. And as the ride makes its full circle, so do you, until Peter Pan has done it again, and you are once more a child, taking it all in, amazed, overwhelmed, and enchanted. Then it's over, and Gideon and Harper, these two little organic walking talking miracles that are somehow yours, are cheering at the end for the ride they called "Boat." "More, more!" they shout. And so you cry your eyes out. And you ride it again. (287)

Through transgressing what a traditional father and family look and act like, he shows us a model of fathering that gets us at least part way to a liberatory feminist practice of parenting, which allows for a capacious definition of fatherhood marked by caring, nurturing, and love.

Endnotes

1. Similar to African American mothering, queer fathering is, then, almost by definition subversive. As Njoki Wane argues, "mother-

hood has been ideologically constructed as compulsory only for those women considered 'fit,' and not for women who have been judged 'unfit' on the bases of their social location" (235). She goes on to discuss that "unfit" mothers include "disabled women, Black women, First Nations women, immigrant women, Jewish women, lesbian women, women who are the sole-support of parents, poor women, unmarried women, young women, and others" 235). Since "mothering remains a site of struggle"—indicating who in our society is able to live up to its demands and be considered worthy— African American women are once again placed outside of the institution of motherhood (Wane 235). And, as Alice Walker notes, being placed outside of the mainstream is not always a bad thing and can lead to greater strength. Walker opens her book *In Search of Our Mothers' Gardens: Womanist Prose* with a definition of womanism that highlights the word's relationship to feminists of colour, strong women, willful behaviour, and the like. She ends with the analogy: "Womanist is to feminist as purple is to lavender" (xii). There is strength in being on the outside, which Walker points out here.

Works Cited

Bartlett, Elizabeth Ann. "Feminist Parenting as the Practice of Non-domination: Lessons from Adrienne Rich, Audre Lorde, Sara Ruddick, and Iris Marion Young." *Feminist Parenting*, edited by Lynn Comerford et al., Demeter Press, 2016. pp. 23-37.

Coltrane, Scott, *Family Man: Fatherhood, Housework, and Gender Equity.* Oxford University Press, 1996.

Comerford, Lynn, et al. "Introduction." *Feminist Parenting*, edited by Lynn Comerford et al. Demeter Press, 2016. pp. 1-20.

Craig, Elaine. "Converging Feminist and Queer Legal Theories: Family Feuds and Family Ties." *Windsor Yearbook of Access to Justice*, vol. 28, no. 1, 2010, pp. 209-30.

Doucet, Andrea, *Do Men Mother? Fathering, Care and Domestic Responsibility.* University of Toronto Press, 2006.

Dowd, Nancy, *Redefining Fatherhood*. New York University Press, 2000.

Harris, Neil Patrick. *Choose Your Own Autobiography.* Crown, 2014.

Kleinert, Evelyn et al. "Motives and Decisions for and against Having Children Among Nonheterosexuals and the Impact of Experiences of Discrimination, Internalized Stigma, and Social Acceptance." *Journal of Sex Research*, vol. 52, no. 2, 2015, pp. 174-85.

Miedzian, Myriam. *Boys Will Be Boys: Breaking the Link between Masculinity and Violence*. Doubleday, 1988.

Ollen, Elizabeth Weber and Abbie E. Goldberg. "Parent-Child Conversations about Legal Inequalities in Gay- and Lesbian-Parent Families in Florida." *Journal of GLBT Family Studies*, vol. 12, no. 4, 2016, pp. 365-85.

O'Reilly, Andrea. "Feminist Mothering." *Feminist Parenting*. Edited by Lynn Comferford et al., Demeter Press, 2016. pp. 38-62.

Palfrey, Judith. "Conscientious Refusal or Discrimination against Gay Parents?" *American Medical Association Journal of Ethics,* vol. 17, no. 10, 2015, pp. 897-903.

Politt, Katha. "Too-Big-Tent-Feminism." *The Nation,* 27 Mar. 2017, 6+.

Rich, Adrienne. *Of Woman Born: Motherhood as Experience and Institution*. Norton, 1976.

Walker, Alice. Epigraph. *In Search of Our Mothers' Gardens: Womanist Prose*. Harcourt Brace, 1983. pp. xi-xii.

Wane, Njoki Nathani. "Reflections on the Mutuality of Mothering: Women, Children, and Othermothering." *Mother Outlaws: Theories and Practices of Empowered Mothering*, edited by Andrea O'Reilly, Women's Press, 2004. pp. 229-39.

Chapter Seven

Caring Masculinities and Feminist Fathering in Contemporary Spain[1]

Marina Bettaglio

In Spain, the increased visibility of fatherhood in the media points to the emergence of new configurations of masculine identities. Examining the profound changes in the social construction of fatherhood—changes that reflect the peculiarities of the Iberian situation and the global transformation of parental practices—this chapter explores the articulations of caring masculinities and feminist fathering through the lens of popular culture. Studying this phenomenon against the background of neoliberal labour market reforms highlights the complexities and challenges of contemporary fathering in a period of transition—from the distant breadwinning paradigm to a kind of feminist fathering that goes beyond the mere playful involvement made popular by advertisements and television. To this end, this chapter analyzes emerging forms of involved fathering—a socially approved mode of parenting predicated on caring masculinity. Although it has become commonplace to talk about new masculinities and involved fathering as innovative gender paradigms that have the potential to dismantle patriarchy, this chapter questions whether this switch in the construction and representation of fathering really has the capacity to disrupt normative gender roles or is simply a reaction to prevailing neoliberal market practices that in the absence of state-funded programs such as daycare centres seek men's willing collaboration in carework.[2]

The traditional Spanish family structure has undergone significant

changes in the last two decades, with an increase in cohabiting families, blended and reconfigured families, same-gender families, and lone parent families (Avilés-Hernández and Pérez-Pérez 80). Indeed, as Patricia Merino indicates, *"la paternidad es hoy una institución en plena reconversión"* ("nowadays, fatherhood is an institution in a state of total redevelopment"); it has transitioned from the outdated model of authoritarian and aloof breadwinner to a more involved and participatory role (79).[3] The transformation of family structures, parental roles, and household dynamics has been particularly striking in Spain, where gender roles and fertility rates have undergone a drastic reconfiguration over the last fifty years.[4]

Emerging from almost four decades of dictatorship, since the death of Francisco Franco in 1975, Spain has witnessed important legislative changes: the legalization of contraception (1978), divorce (1981), abortion (1985), and same-sex marriages (2005). The country has experienced a democratization of parental roles along with a resignification of reproduction itself, thanks to the aforementioned breakthroughs as well as women's increased participation in the labour market. As a result, the role and meaning of parenthood has changed in Spain over the last few decades.

As the sociologist Inés Alberdi points out in her study of new family configurations, when reproduction becomes a choice, the value assigned to children increases as well as parental dedication. This change of attitude towards procreation can be summed up as follows: *"Los hijos ya no son un destino sino una elección y esto los hace más valiosos a los ojos de sus padres"* ("Children are no longer a destiny but a choice, and this makes them even more valuable in their parents' view") (Alberdi 18). At a time in which having children has become an increasingly female decision— often carried out outside of traditional family structures—both motherhood and fatherhood as institutions, and mothering and fathering as practices, have undergone a process of redefinition and recon-ceptualization.[5] Despite the patriarchal legacy that assigned the role of main financial provider to men, fathers have become more involved in family activities since the late nineties. The severe, authoritarian, and repressive father as an incarnation of the law is but a distant memory; as Spanish psychoanalyst Victoria Sau points out, a great change has taken place in his symbolic conceptualization: he has been replaced with a benign, nurturing, and understanding figure. Portrayed in popular

culture, advertisements, newspapers, and television, these new paternal images reveal a more involved parental figure, intent on playing with his children, collaborating on household activities, and sharing his passion for soccer and video games. This "revolution within family life" (Alberdi and Escario 166), though incomplete, has opened the way to new paternal roles. In response to feminist activism and to government campaigns for gender equality, Spanish men have acquired a more active role in their children's upbringing.[6] Many of them display traits of a caring masculinity—that is, "masculine identities that reject domination and its associated traits and embrace values of care such as positive emotion, interdependence, and relationality" (Elliott 240).

Nonetheless, as numerous mother bloggers are keen to underline (Bettaglio, "Luces y sombras"), women still feel mainly responsible for parenting duties. Despite the speed with which Spanish society has evolved over the course of the last fifty years, a significant backlash has taken place since the nineties (Cruz and Zecchi 8). This regressive trend has worsened as a result of the 2008 economic crisis, which led to an increase in casual work that has further penalized women. In the wake of deeply antimaternal conditions, a paradoxical situation has emerged. The praise and glamourization of motherhood (Bettaglio, "Maternal Chronicles" 230) goes hand in hand with the commercially supported image of the involved father, who appears in print and online media, on television, in advertising campaigns, in parenting magazines, and even in comics as playful companions for his children. Often klutzy and endearing, these newly minted paternal figures participate in insidious neoliberal strategies aiming to change the appearance but not the substance of the existing gendered division of labour. Moreover, presenting an attractive view of paternal involvement can be read as a shrewd way to get men to pitch in and, thus, place the burden of childrearing duties back onto the family unit. Such a move would, thus, absolve the state of any blame for the dismantling of the welfare system—a system whose existence is necessary for the achievement of effective work-life balance and gender equality for women as well as men.

The transformation of the labour market from a Fordist to a post-Fordist scenario has brought about a drastic increase in precarity, which has affected not only women, who are on the receiving end of contrasting imperatives and subject to impossible standards of perfection, but also

men. No longer cast in the role of the sole breadwinner and provider, "The new ideal of caring and present father" (Johansson and Klinth 42) in Spain is articulated through the figure of the cool daddy, the so-called *padrazo* (i.i. a cool daddy), who practices the three pillars of involved fathering: participation, accessibility, and responsibility (Martín García par. 6). This kind of *"paternidad positiva"* ("positive fathering") requires greater immersion in all aspects of childrearing, including family organization and domestic chores, from changing diapers to taking children to the paediatrician (Martín García par. 5). As men transition to fathering later in life, they tend to aspire to have a more egalitarian role within their family unit.

At a time of increasingly precarious working conditions, high unemployment rates, and falling birth rates (INE 2020), the crisis of care that accompanies the dismantling of the welfare system bears heavily on families and on parenting. As demographers and sociologists highlight, Spain has been "short on children and short on family policies" for a long time (Delgado et al. 1059). As the state withdraws funds and privatizes health and education services, Spain has witnessed a "popular revival of domesticity" (Stephens xiii) and a rhetoric of retreatism as well as a new kind of maternalism that "reinforces tra-ditional gender roles and undermines both the legal equality of women and the domestic equality of men" (Stephens xiii). As a result, profound socioeconomic and demographic changes have affected family structures and normative gender roles while at the same time glamourizing intensive mothering and supporting greater paternal activity. According to Avilés-Hernández and Pérez-Pérez, "in response to women's emergence in the public sphere, men are turning inwards towards the home, not only helping with certain domestic tasks but also taking on household responsibilities historically attributed to women" (84). Whether this paternal model can be considered a step in the direction of feminist fathering or whether it represents a postfeminist resign-ification that eventually normalizes and reinstates gendered divisions of labour is something that this chapter will address.

At a time characterized to a certain degree by a "regendering of care" (Boyer et al. 57), the path towards feminist fathering is still an arduous one, fraught with legal and practical difficulties. The gendered division of labour and the father's involvement in carework continue to be crucial sites of feminist activism as antidotes to the unequal burden placed on women in childrearing. As feminist theorist Sara Ruddick points out,

"the most revolutionary change we can make in the institution of mothering is to include men in every aspect of childcare" (89). Indeed, as Ruddick explains, "radically recasting the power-gender roles in these dramas might just revolutionize social conscience" (89). Although men's active involvement in various forms of domestic labour and carework need not result in feminist fathering, it can represent a step in the direction of a more equitable division of labour. Regarding the North American context, Louise Silverstein has theorized the following: "Redefining fathering to emphasize nurturing, as well as providing will place men in equivalent dual roles. Men may then become motivated to revise government and workplace policies to support working parents" (5). In recent years, grassroot profeminist organizations—such as *Red de Hombres por la Igualdad* (Men's Network for Gender Equality); AHIGE (*Asociación de Hombres for la Igualdad de Género*) (Men's Association for Gender Equality); *Hombres Igualitarios de Catalunya* (Catalonia's Egalitarian Men); and more strongly PPiiNA (*Plataforma por Permisos Iguales e Instransferibles de Nacimiento y Adopción*) (Platform for Equal and Non-transferable Parental and Adoption Leave)—have been catalysts for social action in support of greater gender equality in parenthood and in society.

In this social landscape, the March 8, 2018 and 2019 feminist strikes that filled the streets and squares of all major Spanish cities demonstrated widespread dissatisfaction with the existing gender imbalance—especially regarding gender-based violence, workplace discrimination, the problem of the glass ceiling and the sticky floor, the persistent pay gap, and widespread patriarchal attitudes. Requesting equality not only in the public sector but also, and especially, within the domestic sphere, women of all ages, social classes, and political affiliations joined to strike against structural inequalities and to demand major changes. Hanging up their aprons in their balconies in solidarity with women marching in the streets, a large segment of society—including gay and heterosexual men, retirees, and housewives—have increasingly aligned themselves with a social movement that brings to light the political dimension of carework. As Spanish women still shoulder a disproportionate share of domestic work, their insistence on concrete gender equality foregrounds the dissatisfaction and empowerment of those who are no longer comfortable with oppression rooted in the allegiance to patriarchy and neoliberal structures.[7]

Indeed, the theme of men's equal involvement in parenting and in carework is a pressing issue in contemporary Spain, where the ruling Socialist Party has approved a gradual increase in paternity leave in March, 2019, which will result in equal parental leaves in 2021. This important legislative change reflects a European trend, in which "policy makers ... are developing and implementing new models of parenthood, trying to increase men's involvement as fathers and at the same time to promote women's empowerment on the labour market" (Johansson and Andersson 1-2). Created in order to foster equality in the workplace, this measure marks a radical departure from the structural reforms carried out by the right-wing *Partido Popular* after 2008, which resulted in substantial cuts to the welfare system. In the name of austerity, the "dismantling of employment protection legislation" (Picot and Tassinari 462) was accompanied by a reduction in social services in the field of healthcare, education, and dependent care that has further penalized women. In response to growing social inequality, Spain has experienced an increase in feminist activism and critiques of capitalist androcentrism in recent years, leading to the victory of the Socialist party in the April 2019 elections.

The feminist struggle to depatriarchalize Spanish society is supported by an influential group of intellectuals. At the forefront of the critique of male domination and hegemonic masculinity are a growing number of feminist men, such as law professor Octavio Salazar and stay-at-home dad and anthropologist Ritxar Bacete. Their recent books—Bacete's *Nuevos hombres buenos. La masculinidad en la era del feminismo* (*New Good Men. Masculinity in the Age of Feminism*) (2017) and Salazar's *El hombre que no deberíamos ser. La revolución masculina que tantas mujeres llevan siglos esperando* (*The Man We Should Not Be. The Masculine Revolution that for Centuries Many Women Have Been Waiting for*) (2017)—consider fathering as a crucial relational role for the resignification of masculinity. Therefore, they advocate for a redefinition of masculinity that involves a paradigm shift, centring on carework and thus on fathering. The new man, as theorized by Bacete, is characterized by "*la ternura, ayudar, compartir, comprender, dudar, rectificar, sonreír, reconocer, escuchar, conectar, acompañar, arropar, cooperar, pedir perdón, confiar o poner límites*" ("tenderness, helping, sharing, understanding, doubting, rectifying, smiling, recognizing, listening, connecting, providing companionship, sheltering, cooperating, asking for forgiveness, trusting, setting limits") (40).

Likewise, Salazar underlines the importance of fathering as a means for rethinking and rearticulating masculinity in opposition to the prevailing model based on assertiveness, power, strength, and domination—all qualities summed up by the socially acclaimed figure of the football player. Salazar urges us to "*dar valor social y económico, y hasta emocional, a los trabajos de cuidado*" ("give social and economic value to carework"), which can lead to being "*más empáticos, más conciliadores, menos violentos*" ("more empathic, more conciliatory, and less violent") (86). This change in attitude towards self and others translates into an invitation to "*ser cuidadores y asumir la necesidad de los otros y las otras para sobrevivir*" ("being caretakers and attending to the vital needs of others") (86).

For activist fathers such as Salazar and Bacete, feminist fathering can be defined via their theorization of feminist masculinities as a set of parenting practices that actively engage in dismantling patriarchal social structures in the public and in the private arena. Interrogating feminist fathering thus involves an analysis of the links between patriarchy and paternal authority, two etymologically related terms. Patriarchy, in fact, as the Oxford English Dictionary defines it, refers to "a form of social organization in which the father or oldest male is the head of the family, and descent and relationship are reckoned through the male line" (OED). Although this is not the only definition of the term, which also means "government or rule by a man or men" (OED), the link to paternal authority is a foundational element of the word. For this reason, an analysis of the struggle for the emergence of multiple forms of more equitable and even feminist fathering involves a questioning of links between patriarchy and normative masculinity.

Practicing feminist caring masculinity thus implies undoing the social conditioning that structures a kind of toxic masculinity predicated on the suppression of empathy and care. It involves a change in attitude towards dependency and a call to action to transform current power structures and the organization of paid labour. In line with research in the field of critical studies of men and masculinity, Bacete and Salazar unveil the cultural practices at work in shaping what both term, after Raewyn Connell, "hegemonic masculinity," which in the Spanish context continues to be based upon emotional detachment, combativeness, and competitiveness. In opposition to that toxic notion of proper male conduct, they propose a more cooperative and supportive kind of masculinity: "*Lo realmente fundamental, universal, lo que nos hace humanos*

y posibilita la vida, son los cuidados, por lo que estos deberían pasar a formar parte de la centralidad política y ética en la estructuración de nuestras sociedades" ("What is really fundamental and universal, what makes us human and makes life possible, is caregiving; therefore, it should be at the political and ethical core of the structure of our societies") (Bacete 27). Fathering for Bacete, Salazar, and a number of profeminist activists implies leaving behind the cultural imperatives to be "*aguerridos, combativos*" ("belligerent, combative") (Salazar 42) in order to embrace one's own fragility and that of those who are in a dependent position. Fathers can, therefore, learn to be "*cuidador, empático, expresivo o, lo que es lo mismo, más libre*" (*caring, emphatic, expressive, i.e. more free*) (Bacete 218-219). All of these these qualities are displayed especially when fathering.

Fathering for these feminist men is, then, a deeply transformative experience, a fundamental practice that calls into question their sense of self. It demands a reconfiguration of their own identity, since it interrogates their sense of self and their assumptions about masculinity. Embracing a new kind of fathering thus leads to a critical stance towards the traditional distant and unengaged breadwinning role, and a questioning of the implicit assumptions regarding male privileges. Yet this profound transformation, Bacete warns, is not without side effects. Becoming aware of gender privileges and dismantling them in an effort to acquire a new identity as a feminist father can be rather unsettling. Whereas Connell describes "the sense of vertigo experienced as a result of undoing masculinity" (37), Bacete points to the emotional turmoil and sense of loss of agency that can be experienced, since "*la paternidad consciente nos hace enfrentarnos a un mundo emocional intenso para el que a veces nos faltan códigos, referencias y herramientas*" ("mindful fathering forces us to face an intense emotional world for which we sometimes lack the necessary codes, references, and tools") (142). As a result, men often feel unprepared to face the challenges of confronting their emotions and of losing control over their own lives. Since, unlike women, men are not socialized to give up their own birth rights to independence and self-sufficiency, caring for a newborn could be a rather destabilizing experience—one that would involve stepping outside the privileged position of the universal subject, unhindered by the needs and demands of others. It would imply becoming aware of one's own fragility and future needs for care; it would necessitate his ethical acknowledgement

of the alterity of a child who requires his complete attention and energy in order to survive. Coming to terms with the limits of one's individuality can be particularly destabilizing: "*Probablemente por primera vez en nuestra existencia, vivimos en primera persona cómo los cuidados nos desempoderan, nos roban el tiempo, el protagonismo y la posibilidad de seguir siendo libres y omnipotentes en el trabajo, el partido, la asociación o el sindicato*" (Probably for the first time in our lives, we experience firsthand the disempowering effects of carework, the way it strips us of our time, our agency and the possibility of continuing to be free and in control in the workplace, in a political party, in an association or in a trade union) (Bacete 142). Nonetheless, confronting our own limits, Bacete concludes, can also be liberating and empowering, as it is the incentive to strive to bring about significant changes to the structures of society and shape human existence according to principles of equality and mutual support.

Both Salazar's and Bacete's stances on the need to put carework at the centre of public policy reflect the position of a growing segment of the population preoccupied with the persistence of discriminatory practices that limit men's possibility to engage in carework. Their defense of caring masculinities reflects the ideas on gender equality put forth by the European Union, whose recent policy on this matter stresses "the role of men and fathers in the reconciliation of work and private life" (Scambor et al. 554). For these feminist men, carework should not be confined to fathering or to a benevolent form of paternalistic involvement in housework, but should extend to include elder, family, and self-care.

Like Salazar and Bacete, a new generation of egalitarian fathers—using blogs, especially *Padre en estéreo. Aventuras y desventuras de otro padre friki suelto* (*Dad in Stereo. Adventures and Misadventures of another Freaky Father on the Loose*), and the platforms *Blogdad* and *Papasblogueros*—actively encourage and support critical reflection on contemporary fathering roles. Participating in "*una comunidad abierta, dinámica y adaptable de hombres que están deseando escuchar vuestras voces sobre un nuevo tipo de masculinidad*" ("an open, dynamic, and adaptable community of men who wish to listen to your voices about a new kind of masculinity") ("*Comunidad de Padres*" in *BlogDads*), these millennial fathers model a new kind of emotionally engaged parental involvement and reveal persistent societal obstacles. In doing so, they point to the need for a series of labour reforms leading to greater gender equality. For example, the issue of parental leave is a battle that feminist fathers have fought

alongside feminist organizations rallying around the aforementioned platform PPiiNA. Like feminist mothers, these feminist fathers consider access to equal parental leave a necessary step towards gender equality. In order to break down the institutional barriers that make it impossible for men to fully participate in their children's upbringing, they advocate for legislative changes.

Salazar, one of the most prominent supporters of this platform, is very explicit on this matter, underlining the need to undo the patriarchal structures that hinder effective gender equality, especially regarding carework. In his essay "*Masculinidades y ciudadanía*" ("Masculinities and Citizenship"), he analyzes the legislative framework to show the actual barrier to gender equality in a country structured on a male model of citizenship. Examining Spanish legislation, he advocates at least four weeks of paternity leave on top of the sixteen weeks normally granted for maternity leave (302). Along with a revision of the laws regulating parental leaves, he argues for a change in mentality so that men are not forced to choose between feminist fathering and paid work. Another crucial reform that those rallying around PPiiNA call for has to do with the work schedule that in Spain, which unlike that of other societies, keeps workers at their desks until well into the evening, thus making work-life balance even more arduous.[8] In this sense, both feminist mothers and fathers share similar goals in their aim to dismantle patriarchal structures. Having time to perform parental duties and live fatherhood in a more committed way represents a stark contrast with the traditional notion of the breadwinner, whose only responsibility extended to the financial and disciplinary aspect of parenting.

As a recent article in the popular Spanish newspaper *El País* announces, contemporary fathers are struggling to implement a new kind of parenting predicated on feminist principles, equal involvement, and the display of more sensitive and nurturing features—traits that are not normally associated with mainstream masculinity. As the title, "*Feministas, corresponsables y sensibles: la paternidad reivindica nuevas formas de ser*," indicates, the new faces of contemporary fathering are portrayed as "feminist, co-parenting, and sensitive" (Ávila). Although the initial part of the title foregrounds the fathers' request to be equally involved in parental duties, the claim that "Fatherhood Reclaims a New Way of Being"—with its allusion to Mary Shelley's *Vindication of the Rights of Women*—points to the difficulties that men encounter in their pursuit

of gender equality in childrearing. Just as feminists fought to win certain rights for themselves, fathers are now speaking out in favour of their new vocations in an effort to reinvent fathering.

Foregrounding the feminist aspect of this new form of parenting, the *El País* article, published on July 2, 2017, introduces the work of several well-known bloggers who share "*una impliación más activa en la crianza, más comprometida e igualitaria*" ("a more active and egalitarian engagement in child rearing") and frame societal change in language that alludes to the emancipatory struggles in which women were engaged in previous decades (Ávila). Supporting gender egalitarianism, these millennial fathers rebel against a patriarchal tradition that excludes them from a more involved paternal role, suppresses their sensitivity, and negates their right to be emotionally and physically involved in their children's upbringing. Even though their predecessors' role as breadwinners was only to provide financially for the wellbeing of their family and offspring, the new generation of fathers is not afraid to display emotional involvement at all stages of the child's life, from delivery onwards. Champions of co-responsibility in parenting, the authors of well-known blogs hosted in the platform *Blogdad* and *Papablogueros* have participated in the social movement #*Papiconcilia*, which like the work carried out by PPiiNA, urges the creation of new labour laws that foster gender equality among parents.

In their activism, these fathers reveal a deep awareness of the generational changes that set them apart from their own progenitors, who reproduced a rigid patriarchal division of gender roles within the traditional heterosexual family structure. Moreover, their insistence on the importance of paternal involvement reflects research carried out in the field of fathering studies that shows that "men have been busy documenting the personal and relational losses that they incur from not being fully involved in caring for children" (Doucet, *Do Men Mother?* 8). The emotional gains of children who receive both maternal and paternal care are also remarked on in their blogs; this consideration, likewise, appears prominently and with increasing frequency in parenting magazines.[9]

The titles of paternal blogs—such as *Un papá en práctica* (*An Apprentice Daddy*) and *Ya no soy un padre novato o sí* (*I Am No Longer a New Father, Am I?*)—show that most of them centre on the vicissitudes of first-time dads who, very much like their female counterparts, chronicle their adventures

in parenting. Caught between often antithetical views of proper parental behaviour, many of the above-mentioned authors opt to share their own experiences rather than relying on the authority of the experts in addressing the doubts and misgivings common to first-time fathers. As men acquire greater prominence in the domestic sphere and demonstrate greater participation in children's upbringing, new fathers express their sense of bewilderment, if not discomfort, in their narratives. Breaking new ground in the conceptualization and representation of fatherhood, contemporary fathers who chronicle their parental activities struggle with the notion that—as Andrea Doucet points out regarding the North American context—"Men ask their wives, sisters, and mothers for advice, but they rarely turn to other dads" ("Foreword" x).

Whereas self-proclaimed feminist fathers acquire increased visibility in Spanish media, male reluctance to give up their carefree lifestyle—a hallmark of their patriarchal privilege—finds expression in popular culture. Romantic comedies, such as the 2016 movie *Embarazados* (*Pregnant*), show the fear men have of women over thirty, who consider them only for their reproductive potential. Popular culture offers numerous examples of men fleeing commitments and responsibilities regarding their affective life in general and reproductive choices in particular. The trope of the man evading engagement, responsibility, and reproduction is present, even in the confessions of involved fathers in what can be termed "paternal chronicles"—a heterogeneous body of autobiographical texts that mix anecdotes with advice centring on the experiences of first-time fathers.

The complexities of contemporary fathering—caught between a desire to embrace change and the resurgence of deeply rooted notions of male incompetence—appear in such books as Carles Capdevila's *Parir con humor* (*Giving Birth with Humour*), Javier Serrano's *Papá, el niño también es tuyo* (*Daddy, the Child Is Yours As Well*), Fran Blanco's *Cómo ser padre primerizo y no morir en el intento* (*How To Be a First-time Father and Not Die in the Attempt*), and Berto Romero's co-edited volume *Padre, el ultimo mono* (*Father, Mr. Nobody*). These books all foreground men's resistance to embrace fatherhood and their humorous strategies to avoid their partners' attempts to convince them to have children. These books were published from 2000 onwards and were written by fathers involved in journalism, media, and computer science. The journalist Carles Capdevila, the television presenter Frank Blanco, the comedian Berto

Romero, and involved fathers, such as Rafa Esteve and Javier Serrano, reveal the high level of anxiety with which they approach their new social status while offering a reassuring message to their readers. Each with its own peculiarities, these works frame the transformations and contradictions of contemporary fathering. Armed with a sense of humour as well as an ironic and often sarcastic tone, these young, heterosexual, middle-class, educated men confront the hurdles of their parental role and offer advice to prospective and first-time dads. Enmeshed in the contradictions of postfeminism, neoliberalism, and postmodernism, their writings implicitly respond to the resignification of motherhood from the time when it constituted women's exclusive option in life to the current historical moment, showing the mental obstacles to feminist fathering. In dialogue with a series of laudatory discourses that foreground maternal enjoyment, these paternal narratives reflect the tensions that accompany parenting today (see Bettaglio, "Luces," "(Post)Feminist"). Indeed, although their incursions into the jungle of first-time parenting differ from the forays into fatherhood made by earlier generations, their stories often reinforce deeply rooted notions regarding the primacy of the mother in parenting.

Each in his own way, they reveal their doubts and resistance towards fathering and share their immaturity and cluelessness with fellow readers. Much like the fictional character Mauricio, protagonist of the highly entertaining comic strip *La parejita* (*The Little Couple*), these men confess their hesitation to step into parenthood. Mauricio—whose weekly short stories were collected in the bestselling graphic novel *Guía para padres desesperadamente inexpertos* (*Guidebook for Desperately Inexperienced Parents*)—is unabashed in confessing that he is emotionally unready to transition into fatherhood. He complains bitterly to his best friend about his girlfriend Emilia's sudden desire to have children and bemoans her surge in libido and displays of affection. Stressing the role of homosociality as a policing force of masculinity, Mauricio is afraid to be expelled from the community of his fellow male friends if he were to have children. Seemingly clueless about his partner's maternal desire, this perpetual Peter Pan continues to find excuses to postpone childbearing in an attempt to hold on to his freedom, even as she plots to convince him. While she mobilizes all her seductive strategies to lure him to help her conceive a child, he complains about being used as a sexual object. In a significant change of roles, he is shown hiding behind

the bed, claiming to suffer from the proverbial headache in order to avoid having to perform his marital duty.

A similar reaction to the feeling of being reduced to a sexual object is displayed in humorous tones by Esteve, who in his "guidebook," recounts his wife's insistence on selecting fertile days and times, a routine which turns a pleasurable activity into something almost dreaded. The narrating voice thus expresses his frustration: "*Empecé a sentirme utilizado, imaginé que mi pareja solo me veía como un pene y unos testículos con patas! Yo para ella no era más que una mera herramienta reproductiva!*" ("I began to feel used. I imagined that my partner considered me only as a penis and testicles with legs. For her, I was nothing more than a reproductive tool!") (14). Similar language is used regarding the frequency and planning of theoretically amorous encounters that men consider profoundly antiromantic. Like the cartoon character Mauricio, the nameless autobiographical selves of these paternal memoirs distinguish between recreational and procreative sex, showing discontent with the latter. Comic and ironic expressions are employed to describe the male sense of being objectified and sexually exploited for reproductive purposes by female partners, who prepare elaborate charts, consult apps, and sign up to special websites in order to achieve their goal of conception. As a result, the men tend to long for the time when they were the ones who seduced their partners, took the initiative, and enjoyed intimacy.

Mammasutra, a maternal graphic novel, shows a group of male friends at a bar with the prospective father complaining about his significant other's excessive interest in him. The authors of the paternal memoirs discussed here are not timid about recounting the negotiations they underwent on their way to parenthood. Their narrations reveal a stark contrast between women's and men's attitudes towards reproduction. Undoubtedly, "fatherhood and motherhood are intimately tied to societal concepts of masculinity and femininity (what it means to be a man and woman) which in turn are products of people's collective imagination" (La Rossa 15). The changing scripts of masculinity and femininity are thus reflected not only in parenting styles but also in negotiations leading up to conception. In these books, despite the initial reluctance, the men eventually embraced fathering and, having converted to parenthood, can now assuage the fears of their commitment-phobic readers.

Capdevila is adamant about the clash in aspirations and expectations between the man and the woman. Whereas she presents compelling evidence in favour of having children, he resorts to a series of increasingly less convincing counterarguments, starting with practical considerations: their precarious job situation; the smallness of their apartment and car, which are not suitable for children; and his personality, which is not reliable enough to shoulder such a responsibility. Then he ventures to ask whether she is sure she is willing to give up her current lifestyle, her career, and her waistline, and in doing so, he reveals how much more taxing it is for an independent and a professional woman to embrace such a demanding and absorbing role. Nonetheless, he is the one who is truly scared and incompletely convinced. Although she offers sensible reasons for leaving behind their carefree existence in order to have children, he resorts to increasingly absurd excuses to justify his fear of commitment.[10]

These reactions foreground very different expectations of parenthood: whereas men hold on to their socially validated immaturity and irresponsibility, their female counterparts display an enthusiasm for children that the fathers do not share. This differential attitude can be ascribed to the laudatory discourses that abound in Spanish society regarding motherhood (Molina Petit 150; Gimeno). For Esteve, Capdevila, Serrano, and Blanco, acquiring and performing a paternal role involves a complex renegotiation of their identity and the search for a new form of masculinity that can accommodate more nurturing aspects along with the demands of normative gender roles. In doing so, they reveal that moving away from more traditional notions of parenting includes embracing more egalitarian forms of parenting. Esteve is clear in explaining the following: "*Ya ha pasado de moda eso de jactarse ante los amigotes de que 'yo nunca le cambio el pañal. Eso es cosa de mujeres'. Ahora él que habla así es un cretino. Si lo que quieres es impresionar, presume de ser un mago de los Dototis*" (It is out of fashion to brag to your friends that 'I have never changed a diaper. That's a woman's job.' Nowadays the person who talks that way is stupid. If you want to impress people, boast about being a wizard at Dodotis [a well-known brand of diapers]) (72). This imaginary exchange taking place among a group of male friends demonstrates the changes that have taken place in the construction of masculinity, and foregrounds the need to point out that shirking one's parental duties is no longer acceptable.

In this time of reconfiguring parental roles, the publication and, in the case of Parir con humor, reprinting of these books point to a crisis of fatherhood that interrogates the social identity and role of the paternal figure. Although at the legislative level the path towards equality in the family has been steady since the mid-seventies in Spain, the social construction of fatherhood has been a much slower and more complicated process. Proclaiming equality within the family and democratizing the family structure have opened the way to social progress, but real equality in terms of co-responsibility and equal commitment to domestic and care labour requires more than legislative innovation.

Research demonstrates a gap between aspirations and reality regarding gender equality in parenting. In a study involving sixty-eight couples, researchers observed that although "most couples aim to maintain a dual earner model after the transition to parenthood," the reality is quite different. In fact, "when difficulties balancing work and family are anticipated, women continue to reveal a greater predisposition to develop 'adaptive preferences' to meet childcare needs" (Abril et al. 3). Even when both parents plan to share parental duties in an egalitarian fashion, women continue to be the ones who end up sacrificing their professional expectations and shouldering the lion's share of care duties due to a series of structural problems that still favour men in the workplace.

The increased visibility of fathers in popular culture is not unproblematic, since in order to be considered a *padrazo*, men have to do little more than play with their children and be affectionate, as the promotional campaign for a famous brand of diapers reveals. This commercially sanctioned kind of active fathering is based on personal enjoyment and on companionship with the children, not on responsibility. In this scenario, while men regress to an infantile stage, women take on the heavy burden of carework and mother the rest of the family. In this sense, Spain is not unlike other Western countries in which sociologists have discovered a persistent gender imbalance.[11] As Ana de Miguel explains in her ground-breaking book *Neoliberalismo sexual* (*Sexual Neoliberalism*), "*Vivimos en sociedades formalmente igualitarias y en que la mayor parte de las personas declara apoyar el valor de la igualdad*" ("We live in societies that are formally egalitarian, in which most people claim to support gender equality") (9). Fathering with its link to notions of hegemonic masculinity displays the difficulties of altering deep-seated notions regarding gender roles.

Feminist fathering—understood as a new sensibility that favours the construction of a more socially egalitarian society—is gaining greater visibility and social acceptance especially among left-wing intellectuals. A growing number of men now desire to father differently from their progenitors, whose involvement in their children's upbringing was marginal. That change, nonetheless, does not necessarily constitute a step in the direction of real gender equality, as it may be a way of reinstating the primacy of the mother in carework or of reinstating a more glamorous form of patriarchal control on the family unit. The changes in the construction of fatherhood may be more cosmetic than substantial, as the commercial commodification of the image of involved fathering demonstrates. For feminist fathering to become a widespread reality, deep structural changes should be implemented. Although the newly constituted Spanish government with a female majority seems to favour the request for greater paternal leaves, many structural obstacles to gender equality remain.

Endnotes

1. This research was made possible thanks to the generosity of several communities of scholars and institutions both in Spain and in Canada. The *Escritoras y Escrituras* research group at the *Universidad de Sevilla* (Spain) sponsored my initial research trip. The author would like to thank Dr. Mercedes Arriaga Flórez and Dr. Daniele Cerrato for their prolonged support. Special thanks go to the feminist group *Más Mujeres* and to Lola López Mondéjar, and to Maye Bobadilla. Gabriel Navarro and Raquel Gallego also deserve my gratitude for their generous assistance at various stages of this research. A fellowship at the Centre for Studies in Religion and Society at the University of Victoria as well as the intellectual camaraderie of its active community of scholars has provided a congenial working environment, where this article could be completed. The unwavering love and support of Joseph Grossi, his feminist fathering, and caring masculinity are the inspiration for this research.

2. For a study of the representations of "the seismic sociocultural transmutations of twentieth and twenty-first-century Spain [that] reconfigured masculinity," see Ryan and Corbalán (1).

3. All translations are mine.

4. According to the Spanish National Institute of Statistics (INE), the descending trend in birthrates continued with a further reduction of 4.5 per cent in 2017 and of 6.2 in the first semester of 2019. In 1976 women had an average of 2.77 children, whereas in 1996, the average was 1.16. Since then, a small increase in the birthrate has been noticed, resulting in an average of 1.44 in 2008. In the last decade, the effects of the profound economic crisis and of a series of variables have resulted in a steady decline in birthrates, while women's age at first birth has undergone a steady increase—from 28.5 in 1976 to 32.2 in the first semester of 2019. Demographers have struggled to understand the complex factors causing these dramatic trends while government policies have been particularly scarce and ineffective. Studying reproductive decisions among stable heterosexual couples in Catalonia, Bruna Álvarez notes the influence of neoliberal ideology in the way in which actual parents underscore the importance of choosing the right moment for having children (Álvarez 3501-2).

5. I am applying Adrienne Rich's distinction between motherhood as an institution and mothering as a personal practice to fatherhood and fathering.

6. Over the last two decades the *Instituto de la Mujer* (Women's Institute for Gender Equality)—currently managed by the Ministry of Health, Social Services, and the short-lived *Ministerio de Igualdad* (Ministry for Gender Equality) (2008-2010) and created by the Socialist Party—has promoted several campaigns to spur men's involvement in domestic work and has sponsored numerous campaigns to support gender equality and equal responsibility regarding domestic chores with the aim to foster better work-life balance.

7. On this topic, see my forthcoming article "Los cuidados en la economía neoliberal: reivindicaciones feministas en la España actual."

8. With a two-hour lunch break between 2:00 and 4:00 p.m., the typical workday does not end before 8:00 p.m., which makes work-life balance especially challenging for working parents. The need to address this problem has received considerable media coverage (Crehuet).

9. One of the most famous Spanish parenting magazines, *Crecer Feliz*, has recently featured a series of articles that emphasize the cognitive gains of paternal involvement while underlining the societal changes that have taken place regarding the paternal role.

10. Likewise, Serrano in *El niño también es tuyo* displays a certain degree of reluctance to bid farewell to his childfree lifestyle, his social life, and his hobbies. Esteve is forthright in admitting that he was not willing to give up sports and outings with his friends.

11. In Germany, studies indicate that traditional forms of gendered division of labour tend to persist even when both parents support the notion of involved fathering. In those cases, fathers play a secondary role (Ruby and Scholz 78). Even in Sweden, despite their progressive stance on gender equality, "women still have primary responsibility for the children and the home" (Johansson and Klinth 58). Research from Australia shows similar results: "Secondary involvement remains the norm, and generation X men only take responsibility during designated small blocks of time" (Singleton and Maher 237).

Works Cited

Abril, Paco, et al. "Ideales igualitarios y planes tradiconales: análisis de parejas primerizas en España." *REIS Revista Española de Investigaciones Sociológicas*, vol. 150, 2015, pp. 3-22, www.reis.cis.es/REIS/PDF/REIS_150_011428567 877977.pdf. Accessed 10 Jan. 2020.

Alberdi, Inés. *La nueva familia española*. Taurus, 1999.

Alberdi, Inés, and Pilar Escario. *Los hombres jóvenes y la paternidad*. Fundación BBVA, 2007, www.fbbva.es/wp-content/uploads/2017/05/dat/DE_2007_hombres_jovenes.pdf. Accessed 10 Jan. 2020.

Álvarez, Bruna. "Reproductive Decision Making in Spain: Heterosexual Couples' Narratives About How they Chose to Have Children." *Journal of Family Issues*, vol. 39, no. 13, 2018, pp. 3487-507.

Ávila, Maika. "Feministas, corresponsables y sensibles: la paternidad reivindica nuevas formas de ser." *El País*, 2 July 2017, cadenaser.com/ser/2017/06/26/sociedad/1498462762_371179.html. Accessed 10 Jan. 2020.

Avilés-Hernández, Manuela, and Carmina Pérez-Pérez. "Lone Father-hood in Spain: An Increasing Familiar Reality." *Fathering: A Journal of Theory, Research, and Practice about Men as Fathers*, vol. 31, no. 1, 2015, pp. 80-93, www.mensstudies.info/OJS/index.php/FATHER-ING/article/view/712. Accessed 10 Jan. 2020.

Bacete, Ritxar. *Nuevos hombres buenos. La masculinidad en la era del feminismo.* Península, 2017.

Bettaglio, Marina. "Los cuidados en la economía neoliberal: reivind-icaciones feministas en la España actual." *Todos a movilizarse: Protesta y activismo social en la España del siglo XXI*, edited by María José Hellín and Ana Corbalán, Anthropos, 2019.

Bettaglio, Marina. "Luces y sombras de la maternidad 2.0: Entrevista a Isabel García Zarza." *Ambitos Feministas*, vol. 3, October 2013, pp. 207-11.

Bettaglio, Marina. "(Post)Feminist Maternal Memoirs and their Dis-contents" *Letras Femeninas*, vol. 41, no.1, 2015, pp. 228-45.

Blanco, Fran. *Cómo ser padre primerizo y no morir en el intento. Blogdads*, 2012, blogdads.es/. Accessed 10 Jan. 2020.

Boyer, Kate, et al. "Regendering of Care in the Aftermath of Recess-ion?" *Dialogues in Human Geography*, vol. 7, no. 1, 2017, pp. 56-73.

Capdevila, Carles. *Parir con humor.* La Campana, 2016.

Carbajosa, Ana. "Ellos también crían." *El Pais.* 9 Dec. 2014, politica.elpais.com/politica/2014/12/04/actualidad/1417690549_128325.html. Accessed 10 Jan. 2020.

Castro García, Carmen. *Políticas para la igualdad. Permisos por nacimiento y transformación de los roles de género.* Catarata, 2017.

Connell, Raewyn. *Masculinities.* University of California Press, 1995.

Crehuet, María Fernández. *La conciliación de la vida profesional, familiar y personal. España en el contexto europeo.* Ediciones Pirámide, 2016.

Cruz, Jacqueline, and Zecchi Barbara. *La mujer en la España actual. ¿Evolución o involución?* Icaria, 2004.

Delgado, Margarita, et al. "Spain: Short on Children, and Short on Family Policies." *Demographic Research*, vol.19, July 2008, www.demographic-research.org/volumes/vol19/27/19-27.pdf. Accessed 10 Jan. 2020.

Doucet, Andrea. *Do Men Mother? Fathering, Care, and Domestic Responsibility.* University of Toronto Press, 2006.

Elliott, Karla. "Caring Masculinities: Theorizing an Emerging Concept." *Men and Masculinities*, vol. 19, 2016, pp. 240-59.

Esteve, Rafa. *Guía urgente del padre primerizo.* Larousse, 2015.

Gimeno, Beatriz. "Construyendo un discurso antimaternal." *Píkara Online Magazine*, 13 Feb. 2014, www.pikaramagazine.com/2014/02/construyendo-un-discurso-antimaternal/. Accessed 20 Jan. 2020.

INE. *Notas de prensa. January 9, 2020, ine.es/en/daco/daco42/daco4210/ tvl119_en.pdf.* Accessed 10 Jan. 2020.

Johansson, Thomas, and Jesper Andersson. *Fatherhood in Transition: Masculinity, Identity, and Everyday Life.* Palgrave Macmillan, 2017.

Johansson, Thomas, and Roger Klinth. "Caring Fathers. The Ideology of Gender Equality and Masculine Positions." *Men and Masculinities*, 11.1, 2008, pp. 42-62.

La Rossa, Ralph. *The Modernization of Fatherhood: A Social and Political History.* University of Chicago Press, 1997.

Martín García, Teresa. "Transición a la paternidad y nuevas paternidades entre los jóvenes adultos en España." *Politikon*, 19 Oct. 2016, politikon .es/2016/10/19/transicion-a-la-paternidad-y-nuevas-paternidades-entre-los-jovenes-adultos-en-espana/. Accessed 10 Jan. 2020.

Merino, Patricia. *Maternidad, Igualdad y Fraternidad. Las madres como sujeto político en las sociedades poslaborales.* Clave Intelectual, 2017.

Miguel, Ana, de. *Neoliberalismo sexual. El mito de la libre elección.* Cátedra, 2015.

Molina Petit, Cristina. "Género y poder desde sus metáforas. Apuntes para una topografía del patriarcado." *Del sexo al género*, edited by Silvia Tubert, Cátedra, 2003, pp. 123-60.

Picot, Georg, and Arianna Tassinari. "All of One Kind? Labour Market Reforms Under Austerity in Italy and Spain." *Socio-Economic Review*, 15-2, 2017, pp. 461-482.

Rich, Adrienne. *Of Woman Born: Motherhood as Experience and Institution.* Norton, 1976.

Ryan, Lorraine, and Ana Corbalán. "Introduction: The Reconfiguration of Masculinity in Spain." *The Dynamics of Masculinity in Contemporary Spanish Culture*, edited by Lorraine Ryan and Ana Corbalán, Routledge, 2017, pp. 1-15.

Ruby, Sophie, and Scholz Sylka. "Care, Care Work and the Struggle for a Careful World from the Perspective of the Sociology of Masculinities." *Österreichische Zeitschrift für Soziologie*, vol. 43, no. 1, 2018, pp. 73-83.

Ruddick, Sara. *Maternal Thinking: Towards a Politics of Peace*. Beacon Press, 1995.

Salazar, Octavio. *El hombre que no deberíamos ser. La revolución masculina que tantas mujeres llevan siglos esperando*. Planeta, 2018.

Salazar, Octavio. *Masculinidades y ciudadanía. Los hombres también tenemos género*. Dychinson, 2013.

Sau, Victoria. *Paternidades*. Icaria, 2010.

Scambor, Elli, et al. "Men and Gender Equality: European Insights." *Men and Masculinities*, vol. 17, no. 5, 2014, pp. 552-577.

Serrano, Javier. *Papá, el niño también es tuyo*. Ambar, 2008.

Silverstein, Louise. "Fathering Is a Feminist Issue." *Psychology of Women Quarterly*, vol. 20, 1996, pp. 3-37.

Singleton, Andrew, and Jane Maher. "The 'New Man' Is in The House: Young Men, Social Change, and Housework." *The Journal of Men's Studies*, vol. 12, no. 3, 2004, pp. 227-40.

Stephens, Julie. *Confronting Postmaternal Thinking: Feminism, Memory, and Care*. Columbia University Press, 2011.

Torrón Villalta, Cristina. *Mammasutra. 1001 posturas para madres en apuros*. Lumen, 2016.

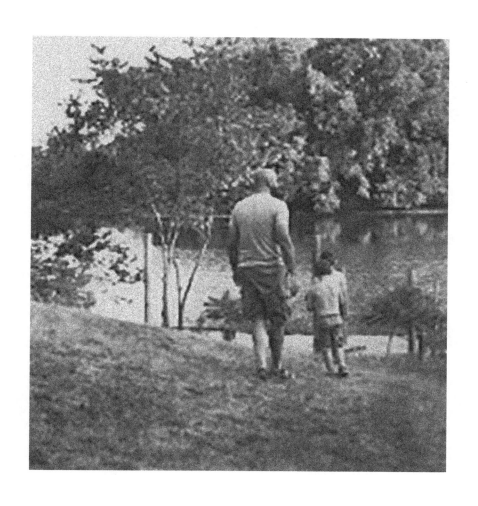

Section II

Fathering in Personal Contexts

Chapter Eight

Co-Parents Who Share Family Work: Feminism, Co-responsibility, and "Mother Knows Best" in Spanish Heterosexual Couples

Bruna Alvarez

Parenting culture in Spain is changing according to new global models of masculinity (Barbeta-Viñas and Cano 23). Today's Spanish fathers generally grew up with fathers who were authoritative, absent breadwinners. This model of fathering was linked to the traditional gendered division of labour and reinforced by forty years of fascist dictatorship. New models favour egalitarianism, and studies show that fathers' and mothers' behaviour is moving towards greater gender equality in Spain, although qualitative studies show a contradiction between an increase of equality gender ideology and the continuation of traditional practices (Abril et al. 4; Barbeta-Viñas and Cano14; González and Jurado11). Today, more and more Spanish heterosexual couples perceive themselves as egalitarian, and some of them define themselves as feminist, too. However, statistics still show that women spend two hours more than men every day doing housework and childcare (Encuesta del Empleo del Tiempo). I call this work "family work" to reinforce the idea that housework is also a way of

caring for a family and that—together with childcare—it is a facet of parenting. This chapter examines contradictions between ideology and behaviour among couples who say they share family work equally; it pays particular attention to differences between couples who describe themselves as feminists and couples who do not.

This study examines ideology and perceptions in a sample of eight couples who reported sharing family work equitably, though not necessarily equally; in two cases, the woman had reduced her paid working hours and worked correspondingly more hours at home. Four of these couples labelled themselves as feminists, three did not, and in one couple, the woman described herself as feminist, whereas the man did not. Curiously, couples without an expressly feminist outlook tended to report a satisfactory distribution of family work, whereas declared feminist couples often disagreed. Mothers complained of being household managers despite significant contributions of their male partners, whereas fathers complained that if they failed to manage family work in exactly the way their female partners wanted, they were accused of not doing their fair share. In short, feminist mothers expected their male partners to be co-responsible and complained when they were not, whereas nonfeminist mothers did not expect co-responsibility and were happy sharing family work but not household management. In this study, we, the research team and I, used participants' own self-identification to classify participants as feminists or nonfeminists. Co-responsibility refers to whether couples take an equal share not only in performing family work but also in managing it and making decisions about it.

According to Lynn Comerford and her colleagues, "to be a feminist parent is to confront and correct systemic gender inequalities and injustices associated with parenting children" (1). Feminist parents bring up their children under antisexist ideology; they believe that parenting can help eradicate gender inequalities. Inspired by these authors, I suggest that fathers who define themselves as feminists have a political awareness of gender inequality and an egalitarian attitude towards family work (housework and childcare). Feminist parents have an attitude towards everyday family life that contests traditional gender roles and the social construction of men as noncarers. Feminist fathers take into account their role as their children's main model of masculinity, and they believe that if they participate equally in family and caring

work, their sons and daughters will assimilate this model. However, feminist attitudes towards fathering are also found in fathers who do not describe themselves as feminists but who have an egalitarian behaviour with their female partners.

According to the results of this research, feminist fathering in Spain is starting to demonstrate more gender equality fathering behaviour, which includes a more equitable sharing of domestic and childcare tasks as a way of educating children in non-normative gender behaviour. This way of parenting is being spread into new models of masculinity and fatherhood, although it is not always labelled feminist.

Methodology

The sample of eight couples who share family work equitably emerges from qualitative research conducted by the author of this chapter and two research assistants with twenty-one heterosexual couples in Catalonia (Northeastern Spain),[1] as part of the author's dissertation research on the influence in gender roles in reproductive decisions in Spain.[2] The data were collected in Catalan and Spanish and translated into English. Individual interviews lasting one and a half to two hours were conducted with eighteen couples (thirty-six participants). Participants were asked how they defined fathering and mothering, how they decided to become parents, how they organized everyday family work, how they negotiated gender (in)equalities at home, and how they perceived their own and their partners' contribution to family work.

After these thirty-six individual interviews, we conducted two same-sex focus groups with three new couples (one group of three men and one group of three women). In the focus groups, participants were asked about gender relations at home with their partners, how they had learned to carry out family work, how they negotiated the tasks that each party would perform, and who had ultimate responsibility for the household. We thought that same-sex groups would complement the individual interviews by providing additional information about gender expectations, ideology, and behaviour. The focus groups lasted approximately two-and-a-half hours each. In these focus groups, feminism emerged as an important aspect for some participants, and we noticed dissatisfaction among feminist mothers with the participation of their

feminist male partners, even when they reported that work was shared equitably. This early finding raised the question of whether a feminist outlook was affecting couples' behaviour and/or their perceptions. On that point, we returned to the total sample (N= forty-two) and selected the couples that reported sharing family work equitably (eight couples, five who had been interviewed, and three who participated in the focus groups). We recontacted the interviewees to ask if they considered themselves to be feminists, information that we had not initially collected when conducting the interviews. This procedure allowed us to compare ideology and perceptions among feminists and nonfeminists in the subsample of couples who shared family work equitably.

As shown in Table 1, most participants who shared work equitably had university degrees; they worked in a range of fields across the public and private sectors. All of them had children between one and twelve years old. One of the couples was a blended family.

	NAME	AGE	CHILDREN	STUDIES	JOB		SEFL-DECLARED FEMNIST
Couple 1	Maria	35	2 (4 and 7)	University	Accountant - private - fulltime		Yes
interviewed	Joan	37	2 (4 and 7)	Secondary	Factory - private -fulltime		Yes
Couple 2	Claudia	41	3 (12, 10, 1)	University	Administrative - private -fulltime	blended family	No
interviewed	Pau	47	1 (1)	University	Teacher - public - fulltime		No
Couple 3	Abril	52	1 (10)	University	Psychologist - private - fulltime		No
interviewed	Pere	49	1 (10)	University	Public technician - fulltime		No
Couple 4	Olga	43	2 (9 and 6)	University	Business owner - fulltime		No
interviewed	Miquel	43	2 (9 and 6)	University	Insurance director - fulltime		No
Couple 5	Irene	42	2 (11 and 7)	University	Teacher - public - part time		Yes
focus group	Gonzalo	47	2 (11 and 7)	University	Psychologist - private -fulltime		Yes
Couple 6	Sandra	40	2 (7 and 2)	University	Teacher public -part time		Yes
focus group	Marc	41	2 (7 and 2)	University	Computer Science - private - fulltime		Yes
Couple 7	Paqui	35	2 (7 and 3)	Secondary	Teacher assistant - private		Yes
focus group	Adrian	40	2 (7 and 3)	Secondary	Parking reinforcement officer - private		Yes
Couple 8	Daniela	46	1 (10)	University	Anthropologist - freelance		Yes
interviewed	Eric	46	1 (10)	University	Photographer - freelance		No

Table 1: Participant's sociodemographic information (All names are pseudonyms)

We used narrative thematic analysis (Riessman 53) to interpret what the participants told us in interviews and focus groups. We coded interviews with the aim of detecting narrative patterns across the transcripts. In particular, we looked for intersections between ideology (feminist or not), behaviour (reported contribution to family work), and perceptions (women's perceptions of men's contribution to family work).

Reproductive Context in Spain

Spain suffers from strong fertility decline caused by difficulties in work-life balance, gender inequality in heterosexual couples, and the lack of public policies surrounding childbearing and childrearing, defined by Diana Marre as "structural infertility" (Marre 114). Women in Spain delay motherhood due to gender inequalities in the labour market and often suffer age-related fertility problems, which are addressed through international adoptions and assisted reproduction. Spain was classified as having a "lowest-low" fertility rate—that is, a total Fertility Rate at or below 1.3 (Kohler et al. 641). In 2015, Spain's TFR was 1.32 children per woman (Indicador Coyuntural) and the average maternal age at first birth was 30.67 (IPFE). Furthermore, recent demographic studies foresee that between 25 per cent and 30 per cent of women born in the second half of the 1970s will not have children (Esteve et al. 1). The lowest-low fertility levels have been explained as an increase in one-child families rather than the increase in childlessness (Harknett et al. 2).

Gender Roles in Heterosexual Families in Spain

Gender roles in Spain have drastically changed since the end of the Franco dictatorship in 1975. Since then, the proportion of women in the labour market has doubled (Tobío 400). However, there are still stark inequalities between the labour conditions that men and women face. In 2013, 66.1 per cent of adult males were employed in contrast to 53.3 per cent of adult females (López and Gómez de la Torre 11). In 2015, the gender salary gap was as high as 20 per cent (Bolaños). Furthermore, obtaining a job is more difficult for women who have children (Moreno 485)—there is high opportunity cost for motherhood in the Spanish labour market (Bote and Cabezas 208). Common wisdom in Spain holds that mothers are bad workers because they supposedly prioritize their children over their jobs (Alvarez 113). The belief that women have more responsibility for childcare than men is reflected in Spain's maternity and paternity leave policy. Mothers in Spain receive sixteen weeks of paid maternity leave. In January 2017, the Spanish Parliament extended paid paternity leave from thirteen to thirty days and in July 2018 to five weeks (Spain 2018). The last modification was in April 2019; it was extended to eight weeks ("Real Decretoley 6/2019").

Spanish women's entry into the labour market in the last forty years has not been matched by men's entry into family work. A survey conducted by the Spanish National Statistics Institute in 2009 and 2010 showed that 91.9 per cent of women assume household and care responsibilities, in contrast to 74.7 per cent of men. Furthermore, women spend 4.29 hours per day on family work, whereas men only spend 2.32 hours per day. In other words, Spanish women perform a second shift (Hochschild and Machung 1) that is nearly twice as long as men's. In fact, a comparison of Spain with twenty-two United Nations countries[3] in 2001 showed that women were responsible for household and carework in all of them, and in Spain, Korea, and Japan, men performed the least amount of family work (Royo 39). According to Eurostat, Spain was in the top five European countries for gender inequality in family work in 2006, and remained so nine years later, in 2015 (Gracia and Garcia).

Some international studies reveal that when a couple's first baby is born, the mother decreases her paid working hours in order to increase her hours of family work, whereas men increase paid working hours to compensate for her lost income (Geist and Cohen 833). Women in Spain tend to follow this pattern: they reduce the time dedicated to paid labour, spend the same amount of time on household tasks, and increase time devoted to childcare, which result in a net increase of total work. Men do not increase their time dedicated to paid labour, and they reduce their time dedicated to household tasks in order to spend that time on childcare. In this sense, men experience no net difference in total work after the birth of their first child (Domínguez-Folgueras 46).

This (im)balance between work inside and outside the home comes at a time when Spain is undergoing a shift towards "intensive parenting." Under this model, parenting is no longer simply a relationship between parents and children; rather, it is an adult work identity, and parents are increasingly viewed as childrearing professionals. The pressures of intensive parenting apply not only to mothers but also to fathers, who are increasingly expected to raise their children actively rather than merely serve as breadwinners (Faircloth). But the role of family manager still seems to belong to Spanish women, and traditional gender roles make it difficult to perceive men as household managers. Qualitative research in Spain suggests a link between new models of fathering and increasing male participation in family work, such as cooking, shopping, cleaning, washing dishes, and caring for children (Meil 13). However,

women are still the ones mainly responsible for family management and household decision making (Abril et al. 15; González and Jurado 12)—a result also found in a comparative study of thirteen countries[4] (Geist and Cohen 835). Constanza Tobío has shown that fathers' co-responsibility for family work is linked to both their ability and their willingness to seek reduced hours. In theory, the labour market allows men and women to have the same time for household work and childcare. However, according to the Spanish Women's Institute, 98 per cent of part-time contracts in Spain are held by women with caring responsibilities, which reflects the fact that it is still women who are mainly responsible for taking care of the children, whereas men are still more likely to be the main breadwinners for their family (Spanish Women's Institute). Among our twenty-one male participants, only two had reduced hours at work. Both of them were public workers and had permanent contracts, which is a different situation than that of fathers who worked in the private sector. These fathers had not asked to reduce their hours to perform childcare, fearing dismissal. (It remains to be seen if the new paternity leave law will improve this situation for the next generation of fathers.)

Findings: Who Has Responsibility for Family Work?

Eight of the twenty-one interviewed couples considered themselves to share family work equitably. We classified them according to the gender ideology they expressed (feminist or not) and to the women's satisfaction with their male partners' degree of responsibility for family management. The results are summarized in Table 2 (next page).

	Mother's satisfaction with father's degree of responsibility for family management	
	Dissatisfied	Satisfied
Feminist		
Ideology (self-declared)	Irene and Gonzalo (couple five) Marc and Sara (couple six) Paqui and Adrian (couple seven) Daniela and Eric (couple eight)	Joan and Maria (couple one)
Nonfeminist		
		Claudia and Pau (couple two) Abril and Pere (couple three) Olga and Miquel (couple four)

Table 2: Gender ideology and mother's satisfaction with father's degree of responsibility for family management

As Table 2 shows, all of the feminist women except for Maria were dissatisfied with their male partner's degree of responsibility for family management. In contrast, all of the nonfeminist women were satisfied with their male partner's degree of responsibility. We first analyze the reports of non-feminist couples and then analyze those of feminist couples.

Nonfeminist Couples

All three nonfeminist couples (two, three, and four) reported that the woman was the family manager. Claudia and Pau (couple two) had a ten-month-old baby, and Claudia had two older children from a previous relationship. They did not consider themselves to be feminists, but they agreed that they shared the tasks of family work equally; in fact, each thought that the other did slightly more. Claudia explained, "Both of us do everything, but my partner has more time, so he does a little bit more." In contrast, Pau reported, "Both of us do the household tasks and child-rearing, but Claudia does more than me." Pau spent his extra time taking care of the baby, and when Claudia arrived home from work, she cared for the baby while Pau mended clothes or handled other household tasks. However, Claudia reported that she was ultimately responsible for family management: "The household is my

responsibility and so is organizing all the household and caring tasks." Claudia did not expect Pau to share this responsibility, and she was satisfied with his level of involvement at home.

Abril and Pere (couple three) also shared family work according to work schedules. This couple divided tasks into "his" and "hers" (Hochschild and Machung 143), according to the strengths of each person, which coincided with the traditional sexual division of family work. Abril was responsible for food and clothes, whereas Pere was responsible for the garden, technology, and home improvement. Both handled some tasks, such as cooking. However, Abril described being responsible for family management: "I think I know more than him how to do things. It's not that I know more, it's that I'm able to see the needs. I know it's wrong, because my husband knows how to manage the house, but I like it. I feel better if I can organize everything, especially when our child was a baby" (Abril). In contrast, Pere explained that he could replace Abril in most of her tasks, but that Abril could not replace him in tasks related to home improvement:

> We divide work 50 per cent. I prepare dinner, and she prepares lunch. We divide work according to what we do better. She irons and washes the clothes, both of us cook, and we have external help for cleaning. Home improvement is mine and so is technology.... We're complementary. If she can't do something, I can do it, but if she has to turn on the sprinkler system, ok no, it's my job. These technological and electrical things are my job; she concentrates more on our child's homework. (Pere).

This couple shared tasks along a sexual division of labour. However, Abril felt that she had final responsibility for family management.

Olga and Miquel (couple four) are another nonfeminist couple, who reported sharing work equitably. When their children were born, Olga stopped working for a year for each child, and then she reduced her working hours until the youngest was seven years old in order to have more time for family work. However, Miquel handled many household tasks, which he described as follows:

> I'm doing around 80 per cent [of the household tasks], although she denies it. I vacuum the house every weekend; I clean the toilets, the kitchen, mend, and iron the clothes.... She told me that she was in charge of deep cleaning the kitchen, and she does

it every six months. She's lying on the sofa while I'm doing all this stuff. We had a woman who helped with cleaning, but that cost 50€ per week, 200€ per month. I'm quite well paid, but before the crisis,[5] my salary was higher, so my working conditions changed, and we decided to clean the house ourselves to save some money. Olga didn't want to, so she told me that she wasn't going to clean anything, that if I wanted to cancel the help, I should take on everything myself. So that's what happened. (Miquel).

According to him, he did almost all housework. However, Olga offered another perspective. She took the children to school every day, collected them, spent the afternoons with them, and prepared dinner. Miquel put the children to sleep. When asked about family work, Olga said the following:

The kitchen and the food are my responsibility, but he helps clean the kitchen and load the dishwasher. He cleans the toilets. Both of us vacuum. However, general management is in my head.... There are lots of women who because they have the management in their heads, end up doing everything. I don't want to, so I spend all day giving orders, and then he does what I ask him to do. He doesn't know what we're going to eat for dinner or the last time we cleaned the dining room. I tell him to do it, and he does it. Performing tasks is quite gender fair, but I'm the one who thinks and gives orders. This is my responsibility. (Olga).

According to Olga, Miquel performed an equal share of tasks, but he did not take responsibility for household management. Instead, he simply obeyed Olga's orders.

These nonfeminist couples reported sharing family work equitably, although the mothers were family managers and had ultimate responsibility for the household. However, because they did not expect their male partners to share this responsibility, they seemed satisfied with their level of involvement.

Feminist Couples

In four couples, both members self-defined as feminists, whereas in couple eight, the woman was a self-declared feminist and the man was not. Of these couples, only one reported that the mother and father shared the role of family manager. Josep and Maria (couple one) considered co-responsibility for family management to be part of their relationship. She was in charge of the children during the morning—giving them breakfast, dressing them, and taking them to school. He finished work at 2:00 p.m., so he cared for them during the afternoon; he collected them from school and helped them with homework, sometimes with the help of his mother-in-law. When Maria arrived home, they shared the tasks of preparing dinner and putting the children to bed. For this couple, taking care of the children was a pleasure rather than a burden. Maria explained that when she was breastfeeding their daughter, Josep gave the baby her bath because "I spent many hours with our daughter, and he could enjoy bathing her" (Maria). They reported that they distributed family work and management equally, with no conflict; as Maria explained, "We've divided everything, since we went to live together. It wasn't a negotiation; it was just what happened day after day." Similarly, Josep noted, "We have the same involvement. We are the same figure for our children. They do not have a mother figure and a father figure; both of us are the same." They described their relationship with absolute respect for and recognition of the other's involvement, indicating that they considered themselves totally co-responsible.

Couples five and six were self-declared feminists, who shared work equitably but not equally. The women had reduced their working hours because of their poor working conditions. When the first child of Irene and Gonzalo (couple five) was born, Irene reduced her working hours to take care of him. They made this decision based on the fact that Irene was a civil servant, and, therefore, she could ask to reduce her hours without risking her job security. Gonzalo, in contrast, worked for a private company, where it was riskier to ask for a reduction. Gonzalo used Irene's reduction to complain about his participation in family work: "I use the argument that she has reduced hours, so she has nothing else to do [other than family work]. The person who handles the family schedule is her. But I wouldn't acknowledge this in front of her." Gonzalo's hesitation to admit his partner's management role may suggest

that this subject was a source of conflict for them.

Sara and Marc (couple six) were in a similar situation. Sara had reduced her working hours to handle family work, spending much more time on these tasks than her partner. When Marc was asked about the distribution of household duties, he answered as follows: "It's a question of time. I told Sara that she worked less time. I think that we have to distribute household work according to the time you have to do it." (Marc).

Marc's gender socialization meant that when he entered the relationship with Sara, he had little experience or knowledge of household tasks: "My father was only with us on the weekends; maybe he collected us from school, but nothing else. When we were young we started washing dishes, and when I went to live with my partner, she show[ed] me how to do the other tasks" (Marc). Marc's partner, Sara, explained that she had a high expectation of co-responsibility and complained about Marc's behaviour in the household:

Marc told me that I don't let him do some tasks and that he needs to be told what to do, but I don't want to. I shouldn't have to say anything to him. He's the father! He asks me, "What to buy?" Look in the fridge and decide what to make… He tells me, "Wake me up at night when the baby cries." Why it is assumed that I can hear the baby crying first? He could also wake up by himself! We're both responsible, but we don't do the same tasks. (Sara).

Sara thought she spent more time with the children and doing housework than Marc. And it bothered Sara that Marc always asked her what to do before performing tasks. His questions implied to her that he was not able to perform these tasks alone and that she was considered the only one who knew how to do them properly.

Adrian (couple seven) also explained that his gender socialization left him ill prepared to perform family work:

At home the people who did beds and washed dishes were my two sisters and my mother. And you couldn't dare to try to help. You were expelled. My sisters worked a lot, a lot! But when I tried to do something, my parents didn't let me help my sisters. When my older brothers got married, and I had my own room, I cleaned it by myself, and I didn't let anybody in. (Adrian)

The way current fathers and mothers were educated in the past can help us to understand why women are considered to know best. Most of them had to teach to their male partners how to manage the house and do caring tasks because men were expelled from these tasks.

Like Sara, Adrian's wife, Paqui (couple seven), also chafed at the idea that she should automatically know more about how to perform family work than her partner Adrian:

> We tried to do fifty-fifty, but although we don't want this, I'm responsible for more things because Adrian did nothing about them. Buy clothes for the kids? Never. He does not know the clothes they have or their shoe size. He's a father just like I'm a mother, and we became mother and father at the same time. And I was not a mother before, either. I remember about baby food. He asked me how to prepare it. Fuck you! We were together when the doctor explained it to us. How can it be possible that I know how to prepare the baby food, and you don't? And I believe that Adrian is a good father, and he spends time with his children, but there are certain things that if I don't tell him, he doesn't see them. And I lose my temper. (Paqui).

This quote reveals Paqui's resentment at being considered an automatic expert in childrearing. However, it also seems to suggest her conviction that she is the one with the appropriate standards; Adrian should do things according to her expectations and on her timeline. In this sense, when some women complained about their sole responsibility as family managers, they also expressed a conviction that they really do know best about how to run a home. In this framing, a male partner's different priorities or perceptions about family work are easily dismissed and can become evidence that he's not doing his share. In this sense, the feminist mothers evaluated men's participation according to their own standards, without acknowledging that there is no objective or universal way of performing family work.

For example, Daniela (couple eight) explained that she taught her partner Eric to be co-responsible because for her, it was an important aspect of their relationship. After a major crisis—of which Eric's lacklustre participation at home was a major component—Eric started taking more responsibility at home. Daniela explained that the situation eventually improved, but that there were still many tasks to which Eric was blind:

When I complained, he understood, and he changed. I think that he's been trained over the last three years, when we had a terrible crisis. I think that things are better now. But when I tried to get him to deep clean the toilet or change our closets from summer to winter clothes, he doesn't feel it's necessary. What about organizing clothes? Deep cleaning? "What for?" Cleaning the windows? There are lots of invisible tasks that he doesn't care about. (Daniela).

Daniela felt responsible for teaching Eric that it was important for him to participate in family work as part of their relationship. However, she begrudgingly accepted responsibility over the tasks that he ignored.

There is the possibility that some of the women's insistence that they knew best, in fact, discouraged their male partners from becoming fully responsible, which was the case for Gonzalo (couple five), who gave the example of hanging the laundry: "I have to do it exactly as she wants. In the end, Irene has to do it because she doesn't let me hang the laundry. I do it my own way, and she tells me that I hang laundry the way my mother did, and that's not the way to do it. She ends up hanging the laundry herself" (Gonzalo). Irene's own insistence that she has better knowledge of household work relegates her partner to a lesser role. But who is to say that there is only one proper way to hang laundry or that Irene knows what it is? In this sense, Irene's feminist conviction that men and women should share equal responsibility for family work contrasts with her insistence that she knows best. In 1989, Hochschild and Machung uncovered contradictions in what people "believed about their marital roles and how they seemed to 'feel' about those roles" (16). Similarly, although as a feminist Irene believes that she and Gonzalo should have the same responsibility for household management, she feels that she knows better how to manage the household.

Even though these initial findings are intriguing, our sample is admittedly small; future research should examine a larger sample and should include a phase of participant observation to collect data on how family work is actually distributed at home.

Conclusions: Contradictions between Ideology and Behaviour

In this chapter, I have analyzed how feminist and nonfeminist couples that say they share family work equitably describe their contributions and those of their partners. I consider family work (housework and childcare) to be part of fathering in the sense that fathers' and mothers' attitudes towards and contribution to it act as models of masculinity and femininity for their children. The fathers' participation in and responsibility for family work provides an opportunity to contest traditional gender roles in which men are not allowed to provide care. I found that seven out of the eight couples reported that the mother was the family manager, even though the family work tasks were shared equitably. Nonfeminist mothers were satisfied with this level of involvement, whereas feminist mothers were not: feminist mothers expected their feminist male partners and fathers of their children to be fully co-responsible. In this sense, the difference between the nonfeminists and the feminists (with one exception) was not that feminist men took more responsibility but rather that feminist women expected them to.

In the nonfeminist couples (two, three, and four), the mothers used different narratives to describe what they saw as an equitable distribution of family work. In couples two and three, an equitable distribution occurred because of professional schedules. Couple three additionally used a gendered division of expertise and tasks. In couple four, the mother gave orders, and the father obeyed. All of these couples took for granted that women know best, and they organized family work according to this principle. In these couples, the father met his partner's expectations because the woman did not expect him to share in family management, which was her job (Hochschild and Machung 153). It could be said that household management is a task associated with motherhood, but it is not a fatherhood assignment.

Feminist couples had to perform a more complex balancing act, and the women of these couples were less satisfied with their male partners' contribution to family work. Only one feminist mother (couple one) was satisfied with her partner's level of responsibility, whereas the other four feminist mothers were not (couples five, six, seven, and eight). These couples faced a conflict between their own feminist ideology and the fact that women in Spain continue to be regarded as experts in housework and childrearing. Although the women chafed against this expectation,

they also ultimately claimed that they knew best, especially given the fact that they often had to train their partners in family work, since the men had been excluded from it as children. Unfortunately, the "mother knows best" stance appears incompatible with encouraging co-responsibility in their male partners and promoting their full involvement in household management and care responsibilities. The feminist fathers felt satisfied with the significant changes they had made with respect to their own fathers' behaviour. However, they reported feeling frustrated because their female partners were never satisfied.

My point is not to suggest that feminism is the problem or that lower expectations among the nonfeminist women are the answer. Rather, I suggest that a feminist parenting partnership needs to go a step further to question the very notion that the mother knows best and to allow a space for negotiation within couples. One issue for negotiation may include the extent of sharing and co-responsibility. For example, the couples mention sharing women's traditional tasks but not men's—a point that Pere makes explicitly in describing the distribution of work in his home. Failing to bring such tasks as gardening, car repair, and home improvement into the discussion both reinscribes the sexual division of labour and fails to give men full credit for the family work that they perform.

It seems that fathers are changing their behaviours and striving to become more gender equitable, regardless of whether they consider themselves feminist fathers or not. Men are emotionally empowered through a more gender equitable fatherhood, which means that their children will grow up with more equal examples than their parents had. To go a step further, perhaps feminist women should recognize this model of masculinity and fatherhood where feminist behaviour is practiced, regardless of whether the men consider themselves feminists or not.

Acknowledgments and Funding

This chapter is part of a research project titled *Male Carers: Challenges and Opportunities to Reduce Gender Inequalitites and Face New Care Needs* (2015-2017), directed by Prof. Dolors Comas d'Argemir (URV) and Dr. Diana Marre (UAB) and funded by Recercaixa 2014ACUP00045.

I would like to thank Diana Marre, my PhD supervisor, and Dolors Comas d'Argemir, for all of their suggestions that helped me to think

about men's involvement in housework; Susan Frekko, for her comm-itment in editing this text; and the editors of this book, Nicole Willey and Dan Friedman, for their comments and their support.

Endnotes

1. Interviews were done in the Catalonia region. For more information about qualitative studies about co-responsibility in Spain, please see Paco Abril et al. (2015) and González and Teresa Jurado (2016)—two qualitative studies that analyze the contradictions between equal ideology and unequal practices within heterosexual couples all over Spain. Moreover, María del Carmen Rodríguez et al. (2010) have done a qualitative study in Asturias in the north of Spain about how heterosexual couples negotiate family roles, and Raquel Royo (2011) analyzes the co-responsibility situation in Euskadi in the north of Spain. For more information about co-responsibility in Europe, please see Livia Oláh (2015), a comparative study about family formation and household structures. For context in the U.S., please see Arlie Hochschild and Anne Machung (1989), and in Canada, please see Andrea Doucet (2015).

2. This work is part of the research project called "Male Carers: Chall-enges and Opportunities to Reduce Gender Inequalities and Face New Care Needs." 2015-2017. Recercaixa Research Project. Uni-versitites: URiV-UAB. Co-PIs: D. Comas D'Argemir—D. Marre. Relevant information can be found in Chapter 5, "Irrationalities of coresponsablity" (Alvarez 117-43).

3. Australia, Austria, Bulgaria, Canada, Finland, Germany, Holland, Hungary, Italy, Israel, Japan, Korea, Leponia, Lithuania, Norway, Poland, Russia, Spain, Sweden, the U.K., and the U.S. (Royo).

4. Australia, Austria, Bulgaria, Check Republic, Germany, Hungry, New Zealand, North Ireland, Norway, Poland, Slovenia, the U.K., and the U.S. (Geist and Cohen).

5. The economic crisis started in Spain in 2008, increasing unem-ployment and decreasing salaries.

Works Cited

Abril, Paco, et al. "Ideales igualitarios y planes tradicionales: análisis de parejas primerizas en España." *Revista Española de Investigaciones Sociológicas*, vol. 150, 2015, pp. 3-22.

Alvarez, Bruna. *Las (ir)racionalidades de la Maternidad en España: Influencias del Mercado Laboral y las Relaciones de Género en las Decisiones Reproductivas.* Universitat Autònoma de Barcelona. PhD Dissertation, 2017.

Barbeta-Viñas, Marc and Tomás Cano. "¿Hacia un nuevo modelo de paternidad? Discursos sobre el proceso de implicación paterna en la España urbana." *Reis. Revista Española de Investigaciones Sociológicas*, vol. 159, 2017, pp. 13–30.

Bolaños, Alejandro. "La Brecha Salarial de Género en España, La Sexta Más Alta de la Unión Europea." *El País*, 8 Mar. 2016 economia. elpais.com/economia/2016/03/07/actualidad/1457378340 _855685 .html. Accessed 10 Apr. 2017.

Bote, Valentín, and Alfredo Cabezas. "Conciliación y Contrato a Tiempo Parcial en España." *Pecvnia*, vol. 14, 2012, pp. 207-18.

Comerford, Lynn, et al. "Introduction." *Feminist Parenting*, edited by Lynn Comerford et al., Demeter Press, 2016, pp. 1-17.

Domínguez-Folgueras, Marta. "Parentalidad y División del Trabajo Doméstico en España, 2002-2010." *Revista Española de Investigaciones Sociológicas*, vol. 149, 2015, pp. 45-64.

Doucet, Andrea. "Parental Responsibilities: Dilemmas of Measurement and Gender Equality." *Journal of Marriage and Family*, vol. 77, no. 2, 2015, pp. 224-42.

Encuesta del Empleo del Tiempo 2009-2010. National Statistics Institute. www.ine.es/dyngs/INEbase/es/operacion.htm?c=Estadistica_C& cid=1254736176815 &menu=resultados&idp=1254735976608. Accessed 16 August 2016.

Esteve, Albert, et al. "La infecunditat a Espanya: tic tac, tic tac, tic tac!!!." *Perspectives Demogràfiques*, vol. 1, 2016, pp. 1–4.

Faircloth, Charlotte. "Negotiating Intimacy, Equality and Sexuality in the Transition to Parenthood." *Sociological Research Online*, vol. 20, no. 4 2016, www.socresonline.org.uk/20/4/3.html. Accessed 13 Jan. 2018.

Gracia, P., and Joan García. "Género y trabajo doméstico: ¿Tiende España a la igualdad?" *Eldiario.es.*, 2015, www.eldiario.es/piedras depapel/Genero-domestico-Tiende-Espana-igualdad_6_34512 5504.html. Accessed 13 Jan. 2018.

Geist, Claudia, and Philip Cohen. "Headed Toward Equality? Housework Change in Comparative Perspective." *Journal of Marriage and Family*, vol. 73, no. 4, 2011, pp. 832–44.

González, María José, and Teresa Jurado. "Introducción." *Padres y Madres Corresponsables: Una utopía real,* edited by María José González and Teresa Jurado, La Catarata, 2016, pp. 11-29.

Harknett, Kristen, et al. "Do Family Support Environments Influence Fertility? Evidence from 20 European Countries." *European Journal of Population*, vol. 30, no. 1, 2014, pp. 1-33.

Hochschild, Arlie, and Anne Machung. *The Second Shift.* Viking Penguin, 1989.

Indicador Coyuntural de Fecundidad por Provincia, según orden de nacimiento. National Statistics Institute, www.ine.es/jaxiT3/Datos.htm?t=1478. Accessed 10 June 2017.

IPFE. *Informe de la Evolución de la Familia en España.* Instituto de Política Familiar, 2016.

Kohler, Hans Peter, et al. « The Emergence of Lowest-Low Fertility in Europe During the 1990s." *Population and Development Review*, vol. 28, no. 4, 2002, pp. 641-80.

López, María Teresa, and Mónica Gómez de la Torre. *Análisis del Mercado de Trabajo Desde una Perspectiva de Mujer y Familia: un Ejemplo de Solidaridad Intergeneracional.* Fundación General Universidad Complutense de Madrid, 2014.

Marre, Diana. "Los silencios de la adopción en España." *Revista de Antropología Social*, vol. 19, 2009, pp. 97-26.

Meil, Gerardo. *El Reparto de Responsabilidades Domésticas en la Comunidad de Madrid.* Dirección General de Familia, Consejería de Familia y Asuntos Sociales de la Comunidad de Madrid, 2005.

Moreno, Almudena. "Familia, Empleo Femenino y Reproducción en España: Incidencia de los Factores Estructurales." *Papers. Revista de Sociologia*, vol. 97, no. 2, 2012, pp. 461-95.

Oláh, Livia "Changing Families in the European Union: Trends and Policy Implications." *Families and Societies. Working Paper Series*, vol. 44, 2015.

"Real Decreto-ley 6/2019, de 1 de marzo, de medidas urgentes para garantía de la igualdad de trato y de oportunidades entre mujeres y hombres en el empleo y la ocupación." www.boe.es/eli/es/rdl/2019/03/01/6. Accessed 5 May 2019.

Riessman, Catherine Kolher. *Narratives Methods for Human Sciences.* Sage Publication, 2008.

Rodríguez, María del Carmen et al. "Corresponsabilidad familiar: negociación e intercambio en la división del trabajo doméstico." *Papers*, vol. 95 no. 1, 2017, 95-17.

Royo, Raquel. *Maternidad, Paternidad y Conciliación en la CAE: ¿Es el Trabajo Familiar un Trabajo de Mujeres?* Universidad de Deusto, 2011.

Spain. Ministerio de Trabajo y Asuntos Sociales. "Estatuto de los Trabajadores Art. 48." Modificación 2017, www.boe.es/boe/dias/2015/10/24/pdfs/BOE-A-2015-11430.pdf. Accessed 5 May 2019.

Spain. Ministerio de Trabajo y Asuntos Sociales. "Estatuto de los Trabajadores Art. 48." Modificación 2018, www.boe.es/boe/dias/2015/10/24/pdfs/BOE-A-2015-11430.pdf. Accessed 5 May 2019.

Spanish Women's Institute. Statistics. Time Use, www.inmujer.gob.es/MujerCifras/Conciliacion/UsosdelTiempo.htm. Accessed 30 Apr. 2019.

Tobío, Constanza. "Cuidado e Identidad de Género: De las Madres que Trabajan a los Hombres que Cuidan." *Revista Internacional de Sociología*, vol. 70, no. 2, pp. 399-22.

Chapter Nine

From Air Base to Home Base

Ginger Bihn-Coss

My husband and I are opposites in many ways. When I met him, others described him as relaxed, nice, and happy-go-lucky. I, on the other hand, was and am highly strung, motivated, and a perfectionist. We have different political views, different diets, and different styles. When we met, he felt satisfied in his career (working for the Air National Guard on F16 fighter planes), whereas I struggled with meaning and purpose in a chosen vocation. Yet there were overlaps in our lives: we grew up (never meeting one another) less than ten miles apart, an eighth grade friend of mine was his college roommate, and he went to homecoming with a friend of mine. We like to say that we complement one another and were meant to be, but that simplifies the picture. Yet if there was one thing that we agreed on when we got married it was that family is important. We teased one another about who would stay home with the kids someday while halfheartedly knowing that neither of us would probably ever leave our careers.

Fast forward more than ten years and both of us, surprisingly, have stayed at home with our children. I stayed home for one year, following the birth of our second son (after my contract with a university had finished). My husband, in contrast, has stayed at home with our children for the past four years (we now have two sons and a daughter). Being a stay-at-home mother or a stay-at-home father (SAHF) (some researchers also refer to this as a stay-at-home dad or SAHD) was not something that either of us had planned or expected. Further, staying at home and caring for our children was not a role that we contemplated as having political consequences or being part of a feminist agenda. It was not one

239

in which we pondered how we could "empower ourselves to do more than unthinkingly reproduce the cultural patterns we have inherited" (Wood 12). In fact, I am not sure either of us initially thought about how to be a feminist parent or even if this was important to us.

I was probably more prepared and ready to stay at home (after the birth of our first son, I struggled with going back to work fulltime), yet the notion of not leaving the house each day to go to work and earn money scared me. I immediately purchased homeschooling curriculums, joined local mother groups (such as MOPS or Mothers of Preschoolers), and began about ten new projects around the house. Eventually, I began to enjoy my new role. When I learned that I would be going back to work, I was sad.

My husband's entrance into his position as a stay-at-home father was not as anticipated. After acquiring a serious autoimmune disease, the military deemed that he could no longer go overseas (if his disease flares, he needs chemotherapy), so he was released for medical reasons. After twenty-plus years in the military, he retired and started to wonder what his life, at forty years old, would be and mean. We jointly decided that I would go back to work, and he (instead of trying to find another job and also find childcare for our younger children) would stay with our children at home.

As I returned to the classroom and my research—focusing on issues related to gender, culture, and communication—my husband took our children to school and classes at our local YMCA. While I renewed my sense of activism, feminism, and empowerment, my husband befriended other stay-at-home mothers in the area. In the evening, I would hear how he conversed with mothers about homeschooling possibilities, local events and resources, and even breastfeeding (we still laugh about that one). When my eldest son started attending school more regularly, my husband and some of the other mothers planned play dates and weekend events. It took me a awhile to meet the parents and children I had heard so much about. I met many of our neighbours months after my husband had befriended them and rarely got to see or interact with school or YMCA teachers (the children were in classes during the day while I worked). Many days, I came home only in time to give the children a bath and/or snuggle with them as they dozed off to sleep. I recall attending a Halloween parade one evening when a very friendly mother asked, "I don't mean to invade your privacy or anything, but are you and

your husband separated?" Thus, not only did I feel that I was that missing out but so did other parents and teachers. I felt like the absent mother.

My husband, in contrast, missed conversing with adults. As much as he loved watching the children grow and develop, sometimes he yearned for conversations that didn't include the potty, ice in a sippy cup, or convincing three children to get out of the door and in their seatbelts in under thirty minutes. He also saw all of my work for students, classes, and committees and realized I had a much different type of busy schedule than he had at home. Coming from a masculinized workplace where the mission was clearly repeated again and again, he was less certain of his place, his future, and his duty. At times, he wondered about his purpose.

Although my husband and I knew that this arrangement was what we needed to do, we both struggled at times. In other words, our defined, stereotypical gender roles (e.g., involved mommy and breadwinner daddy) were shuffled, and, therefore, I experienced what some call the stereotypical "absent father syndrome,"[1] whereas he experienced the often-called "mother's worth syndrome."[2] The roles might have been reversed, but the feelings were the same. Or were they?

In this chapter, I begin with a discussion of my husband's transition to a SAHF and my transition to the primary breadwinner. I share some of the benefits and challenges of these roles as well as some of the research about them. I then explore the concept of feminism, particularly as I teach about feminism in the classroom and explore it in my own research. Finally, I reflect back on the role of stay-at-home fathers, particularly my own husband, as a potential feminist. I argue that although my husband's role as a SAHF defies traditional masculine roles, he is not a feminist per se.

Throughout this chapter, I rely on my own reflections as well as my husband's input. This chapter, then, is, in part, autoethnographic, as I reveal "multiple layers of consciousness, connecting the personal to the cultural" (Ellis and Bochner 739). In this way, I aim to utilize my story of being married to a SAHF to "contribute to, extend, and/or critique existing research and theoretical conversations" (Adams et al. 37). Because this story is also about my husband, I also interviewed him, using semi-structured interviewing techniques. Although I have my own, subjective perspective concerning his fathering, it was important to get his perspective about how he sees his role as a father and how he defines feminism. After writing the first version of this chapter, I asked

my husband to read my work and comment on my representations of him. Although some interpretivists argue that member checking is somewhat unnecessary, as the reality and words we say are constantly being recreated, I felt it was ethically important to assure I was representing my husband in a way he deemed credible.[3]

A key concept to this chapter is the notion of "doing gender." Benjamin West and Cheryl Zimmerman explain the term as such: "If we do gender appropriately [meaning we fit social norms], we simultaneously sustain, reproduce, and render legitimate the institutional arrangements that are based on sex category" (146). Gender in this case refers to doing masculine or feminine performances, behaviours, and/ or communication practices. Gendering is often explained as two opposing binaries: masculinity and femininity. Michael Kimmel explains that "historically and developmentally, masculinity has been defined as the flight from women, the repudiation of femininity" ("Masculinity" 273). A focus on doing gender stresses that "gender is created continually in ubiquitous ongoing social interactions" (Deutsch 122). In the case of breadwinner mothers and stay-at-home fathers, as displayed in this chapter, it may be even more important to also look at "undoing gender" or "social interactions that reduce gender difference" (Deutsch 122). In other words, how does a SAHF (and a woman as primary breadwinner) undo gender stereotypes? Moreover, does undoing such roles make SAHFs feminists?

Stay-At-Home Fathers

In terms of ungendering, one could first ask, "how did this state (where men are expected to work and where women are expected to care for children) come to be?" In other words, how did we even get so gendered? In the book *The Daddy Shift,* Jeremy Smith recognizes that although it seems "different" to have stay-at-home fathers, this concept really only emerged in recent generations: "The term *stay-at-home dad* would have made scant sense to a colonial father—or, for that matter, to a Native American: before the Industrial Revolution, the vast majority of fathers and mothers were always stay-at-home" (5). In other words, according to Smith, all fathers stayed at home for a long time in U.S. history. Michael Lamb, in "The History of Research on Father Involvement" outlines dominant themes of fathering in American

history and argues that in Puritan times fathers were seen as "the moral teacher or guide"; around industrialization, their role changed to "the breadwinner" (27). Robert Griswold, however, argues that it was actually before the Industrial Revolution when men's productive role at home declined (11-12). Either way, once men's role was identified with breadwinning, masculinity, too, was tied to the breadwinning role. Caryn Medved in "The New Female" clarifies that "in the U.S., being a good provider for men became a taken-for-granted aspect of hegemonic masculinity" (237). Thus, although the image of the father as the breadwinner seems ingrained into U.S. masculine expectations, it was really only in the past century that this expectation surfaced.

Men's desire and expectation to be the breadwinner, and only the breadwinner, was short lived. As more women entered the workforce (hence, shared in the breadwinning role), more men wanted to be better fathers. There seemed to be a reimagining of what fathers could or should be. Michael Lamb says that around the mid-1970s, "for the first time, many writers and commentators emphasized that fathers could and should be nurturant parents who were actively involved in the day-to-day care of their children" (27). Jeremy Smith describes the "daddy shift" as a move from fathers as merely breadwinners to fathers as having "capacities for both breadwinning and caregiving" (xii). He recognizes that by 1988, only 29 per cent of children in America lived in a two-parent home where a mother stayed at home (Smith 20). In other words, by 1988, most children did not grow up in a household where the mother stayed at home and did not work. Moreover, "since 1965 the number of hours that men spend on child care has tripled" (Smith x). Arthur Brittan argues that this swift change has led to a sort of crisis for many men: "Men are now 'into' fatherhood. They look after their children, they sometimes change nappies and, in some cases, they stay at home and play the role of houseperson. The speed of these changes, it is sometimes suggested, has led to a crisis in masculinity" (53). This so-called crisis[4] is perhaps heightened in my husband's case, where his choice to stay at home was determined for him.

SAHFs could be an extreme example of men's capacity for caregiving. The number of SAHFs in America has increased since the 1980s; however, the exact number is not clear. Currently, there is no unified way to define a SAHF. For example, the United States Census Bureau says a father qualifies if he is a married father with children, unemployed

(for, at a minimum, a year), and not looking for work. Of course, this omits single fathers, fathers who are a caregiver and work part time, fathers who work from the home, and fathers who "are unemployed job seekers, are underemployed and discouraged workers, and fathers who are students" (Doucet, "Stay at Home" 6). In addition, Andrea Doucet argues that "these government statistics are hetero-normative and nuclear family centric in that they exclude lesbian, gay, bisexual, transgender and queer (LGBTQ) families as well as men who are single, divorced, or living in a cohabitating union" ("Stay at Home" 6). The Pew Research Center's definition is less dependent on marital status, but it also eliminates fathers who work (even part time). In all, the numbers of SAHF in the United States ranges anywhere from to 211,000 fathers (U.S Census) to two million (Pew Research).

According to the research, one reason fathers decide to stay at home is due to a lack of employment (Kramer and Kramer 1324; Rochlen et al 281-82). Noelle Chesley found "that job conditions—particularly husbands' job conditions—play [a role] in the couples' decisions to have fathers stay at home and care for children" (650). However, Aaron Rochlen and others also cite pragmatism and strong parenting values as other reasons fathers stay at home (281). Catherine Richards Solomon explained that "For the men I spoke with, decisions to become stay at home fathers seemed to be planful ones and driven by a mixture of factors" (57); she adds that "the vast majority of participants talked about staying at home as a 'choice' they made" (58). In sum, unemployment and/or disability (an inability to return to work) may be some reasons men become SAHF.

Although lack of fulltime employment was one reason my husband decided to stay home, it certainly was not the defining reason; his medical-related retirement was a precipitating event but not the entire rationale. In fact, after retiring from the military, my husband took a few temporary positions until I found a fulltime position at a university. In addition, he currently works between five and twenty hours a week. In our situation, both the cost and quality of childcare were large factors as to why he stayed at home. On a more personal level, I also feared that if my husband was the primary breadwinner, his health could be a risk factor to his career and, therefore, our family's economic stability. I wondered if he were to have a flare, would I be able to quickly find a fulltime job to support our family. Our situation was never about my

husband's inability to find work. In fact, he was recently offered a fulltime position. However, like many families recognize, we found that paying for childcare would greatly lessen (if not eliminate) the financial benefits. Moreover, we wanted a parent to stay at home, especially when we had younger children (children not yet in grade school). That said, like many fathers who stay at home, my husband works part time and also takes classes at a university in order to complete his undergraduate degree. In other words, his position as a SAHF is seen as temporary. Andrea Doucet explains, SAHFs tend to "maintain some formal or informal, firm or loose connection to the labor market" ("Stay at Home" 8). Similarly, my husband, too, likes to keep working, in some capacity, even though his main role is to care for our children.

There are benefits in having a SAHF: "involved fathers' have been found to have better psychological health and to have more psychologically healthy offspring than less involved fathers" (Good and Sherrod 208). Involved fathers tend to be more self-confident, more open to displaying affection, more involved in the community and have higher marital quality (Allen and Daly 11-13). My husband has discussed some of these benefits. For example, since becoming a SAHF, he has not had a major flare with his autoimmune disease (prior to becoming a SAHF, he had multiple flares in just a few years). He also recognizes that the kids keep him active and "on his feet," which is beneficial for his physical health. Finally, he has made a lot of connections in the community, as he meets parents, teachers, and staff at our children's activities and schools.

These benefits are not only for the father; research also supports that having a SAHF can benefit the children and marriage. Sarah Allen and Kerry Daly reported that involved fathers have children with higher academic results and greater enjoyment of school, increased life satisfaction, lower depression rates, and fewer health problems (1-8). My husband talked about why having a parent at home is beneficial: "The children get firsthand knowledge of how much their parents care for them and are willing to do things for them. No person can replace the love of having a parent staying at home. The welfare of the children should be the top priority." He added: "Which parent stays at home is not as important as having both parents being active in the raising of the children." I agree that my children benefit from my husband's active parenting. Whereas I am more organized and a perfectionist, my husband is very laid back and patient; he enjoys playing games with the

children (my middle child will play board games all day if he could), building with them (my oldest son just got into Legos), and reading to them. It is common for me to come home and find my husband holding our daughter on the chair reading a book, sitting with my oldest son and working with him on his homework, or seeing him play a board game with my second son. My children benefit from having a father who gives them undivided attention, plays with them, and shows them love, care, and intimacy.

Moreover, I benefit from being able to work long hours without worrying that my children are without a parent. For example, when both my husband and I worked, I felt a tremendous pressure to not leave my children at daycare very long. At times, my reluctance to leave the children at daycare was stressful on our marriage. I felt that I had to do it all (drop off the children, work, pick them up, etc.), which caused some resentment. Now, although I still miss my children and wish I spent more time with them, it is a huge relief for me to know that their father is with them. When I work ten hour days, I do not stress about whether the children are cared for and safe. Additionally, now that my husband is with the children more often, we participate more equally in decisions that relate to the children. For example, when my husband worked and we had choices to make, my husband would often say, "You know best … I'll let you decide." Now, my husband wants to have input in decisions regarding schooling, extracurricular activities, etc. His increased invest-ment in the children has made our relationship stronger. My best friend is also my co-parent.

Although there are many benefits for stay-at-home fathers, it is definitely far from easy. On a day-to-day basis, my husband is extremely busy with our three children (ages two, four, and six). In the morning, he is "daddy taxi." He takes our oldest to school while I wake up our middle child. He comes back home, picks up the youngest two children, and takes the middle child to preschool. Before picking up the middle child (three hours later), he typically takes our youngest to classes at the YMCA, story time at the library, and/or to a store. At noon, he returns to pick up the middle child and then makes and feeds the youngest two children lunch. Two hours later, everyone is back in the car to get the oldest from school. As one can imagine, my youngest screams and hollers every time she is strapped into her car seat in "dad's taxi." In addition to running his taxi service, my husband cooks the children's dinner,

does the dishes, and tries to get other chores done around the house. Recently, he told me how he tried to pull out our stove and clean behind it. The job took three hours: the children would bicker, one of them would need something, and/or a child would try to help him. A task that normally would take forty minutes took almost five times as long. When I asked my husband if this is what he imagined staying at home would be like he admitted that "it is a lot, lot harder." There are days where he says that "it would be easier to go back to work."

Breadwinning Mother

As much as men are adjusting to the changing times of deindustrialization and more women working, women, too, are adjusting. The Women's Bureau at the United States Department of Labor estimates that 70 per cent of women with children under eighteen years old work outside the home. Yet at the same time, some argue that Arnie Russell Hochschild and Anne Machung's notion of the "second shift" has not shifted much (Bianchi et al. 206-11). Many women who work outside the home still feel incredible burdens in terms of housework and childrearing. Despite men's "shift," "the average mother is doing *five times* as much child care as the average father" (Smith xi). When it comes to mothers as the breadwinners (working outside the home) and SAHFs, Noelle Chesley and Sarah Flood found that "Work hours constrained breadwinner mothers' housework time on days they worked in all types of housework, but on days they did not work, they looked similar to at-home mothers" (424). In other words, on their days off, breadwinner mothers work at home as much as stay-at home mothers. Moreover, mothers who work (and have a husband who stays at home) increase their labour with "intensity ... [in] the areas of children's physical care and other tasks" (Chesley and Flood 530). Finally, some households with breadwinning mothers and SAHFs still follow the pattern of women doing more routine tasks (laundry, sweeping, shopping, etc.) and men doing less routine work (taking out the trash, mowing the lawn, etc.). This research resonated a lot with some of my experiences. Although my husband now does some grocery shopping, I still shop for all of our children's clothing and other needs (school supplies, etc.). Moreover, I do most of the laundry in our house (my husband only washes his own clothes) and on the weekends, I

often feel I am making up for a week's worth of work.

Rebecca Meisenbach reviewed some positive aspects of breadwinning women (such as ambition, control and independence) and negative aspects (including pressure and worry as well as guilt and resentment) (14). I particularly seem to struggle with some of the more negative side-effects, such as pressure and worry as well as guilt and resentment. I feel a lot of pressure to succeed in my career so our family has a source of income. Moreover, there are times that the burdens of laundry, breastfeeding, helping my children go to bed (they all want to "lie with mommy" at night), sweeping, remembering (appointments, birthdays, family obligations, who needs haircuts, etc.), and shopping feel burdensome. On my days off, I'd love to play with the children, read to them, and spend quality time—but I often feel the pressure to get everything done that I can't do on work days. (I typically work nine to twelve hours, five or six days a week). My children have even asked me "mommy, why are you always cleaning?" In addition, my husband is reluctant to do some chores. Although he said in an interview, "I have changed my own expectations. I am now responsible for the house work. It is now my job to make sure kids are fed, groceries are stocked, house is clean," I still find myself doing a lot of the shopping and cleaning. My husband has even expressed some of the excuses articulated in Beth Latshaw's study, for instance, citing a lack of skill(s) or different perceptions of cleanliness as to why he does not complete certain chores. For example, he said "[you are a] laundry Nazi so I am banned from doing laundry." In reality, he won't fold clothes immediately from the dryer or hang up some clothing articles—therefore he lets me do it all. Moreover, sometimes, when I am trying to get ready for work, the children will scream that they need me to change their diaper and/or help them put on their shoes. When I try to argue that I need to get ready for work, he will respond "they just want you." After listening to the children scream, and scream even louder when my husband tries to help ("Go away, daddy! Go away!" they yell), I give in. As a result, I am sometimes very rushed. As much as my husband and I complement one another and support one another, there are days I often feel worn out and overwhelmed.

Thus, despite the independence and ability to move forward in their careers, many breadwinning mothers, at the same time, feel guilt and pressure. Noelle Chesley describes breadwinning mothers' guilt in the

following way: "It may be more difficult for women to take on at-home father family arrangements, or persist in them, as long as women's status as 'good mothers' conveys greater personal and social benefit than their breadwinning status" ("Stay-At-Home" 654). Much like breadwinning fathers had a shift when they realized they were missing out, I, too, see the children growing at accelerated speeds (intellectually, physically, socially, and emotionally) and feel as if I am missing a lot. I do not always live up to my own expectations of being a good mother, especially in terms of the time I spend with my children. As Chesley explains, "historical patterns are entrenched in cultural values and standards that link breadwinning with masculinity and fathering" and "caring with femininity and mothering" ("What Does It Mean" 2600). In some ways, I wonder, in the case of SAHF, did we just replace the absent-working-father with an absent-working-mother? Furthermore, because many studies show that breadwinning fathers do not experience as many stresses and expectations related to chores and childcare as breadwinning mothers, do breadwinning mothers fare worse? For example, would my children demand (if my husband were working) that he dress them? Would he feel guilty (if he worked fulltime) for not spending as much time with them? Thus, in our situation, I feel that gendered work expectations were reversed, whereas the expectations for caregiving were not. I fully admit, however, that my expectations of myself are probably the highest. Being the perfectionist I am, I want to excel in all areas and oftentimes feel I fall short, especially when it comes to how much I can do with my children. However, I can't help but wonder if the roles were reversed, if I were staying at home and my husband were working, would the children demand of him what they do of me? His guilt may feel much different, as society and the children would not expect him to provide as much care and time.

Feminism

So are stay-at-home fathers feminists? I first want to address the notion that the term "feminism" is not always viewed as a beneficial quality by men or women (Anderson 206). Students in my classes, as well as some colleagues at the university, often roll their eyes when I talk about feminists, equating them with male bashers. I recall a discussion in one of my introductory communication classes about the Women's March

in which a male student commented: "I don't understand. What are they even marching for? Women have equal rights and they seem so angry about nothing." Moreover, men who label themselves as a feminist may not have much to gain socially. Diane Ehrensaft says that even men who want to be involved in parenting and have equal decision making reject the label of feminist. She explains that "for men to admit to a social purpose underlying their parenting style would be to make a commitment to feminism, to a social movement whose leaders and constituency are women, many of whom, in fact, have complaints about male behavior" (Ehrensaft 21). James Poling and others argue that "Men are not naturally pro-feminist; we enjoy our power and privileges; we have to be converted to a new way of thinking" (107). Linn Egeberg Holmgren and Jeff Hearn add the following:

> It is necessary to note that much of what men do is *not* seen as 'about gender,' related to gender equality or about making gender relations and gender divisions more or less equal or unequal—in fact it is not seen as a *political* activity at all. Much of men's practices in public and in private, are commonly not seen as gendered. They are often done, perceived and felt as (if they were) "normal." (404)

Veanne Anderson further argued that feminist men are often stereotyped to be homosexual (men, in particular, believe this stereotype), which increases men's reluctance to label themselves a feminist (212).

Resistance to feminism may be a problem of labelling—that is, the label is more problematic than the concept it represents. In the gender and communication class I teach, I use Julia Wood's definition of feminism to be "an active commitment to equality and respect for all forms of life" (4). Students openly embrace this definition, as it allows for the investigation of different forms of oppression and why there is inequality. In the class, students work on projects to raise their understanding and active commitment to address inequality. For some students, this definition explains why the Women's Marches (2016-2018) supported other causes as well as typically labelled women's issues. Michael Kimmel argues that "Feminism provides both women and men with an extraordinary powerful analytic prism through which to understand their lives, and a political and moral imperative to transform the unequal conditions of those relationships" ("Who's Afraid?" 60-61).

The infamous feminist chant of "the personal is political" is, therefore, evident in such definitions. As Patrick Hopkins explains, "A feminist intervention ... is an attempt to change culture, to change gender ideology, in a way that women are no longer oppressed" (51). In other words, feminism involves critical views and strategies. A challenge I find with such a broad definition of feminism, however, is that gender issues can be ignored and students can focus on any inequality.

My husband, like many, reflects an aversion to the label feminist. When I asked what a feminist was, he responded that it is a person who will "argue and/or fight for equal rights of women." However, when I asked if he was a feminist he replied, "I am a humanist and believe that all mankind have inalienable rights." He later added, "I am not big on labels ... everyone in the U.S. has, legally, equal rights. Discrimination does exist not just in the U.S. but throughout the whole world." In other words, my husband rejected labelling himself a feminist and argued that "everyone in the U.S. has equal rights," which suggests that in his mind, everyone, including women and minorities, all have equal rights, even as he later acknowledged there is discrimination in the U.S. Moreover, he chose to call himself a "humanist"; and, in doing so, focuses on the rights of mankind and downplays injustices towards women.

Even though my husband was resistant to feminist label, there is a growing amount of research that suggests SAHFs, by reversing gendered roles, are feminist. Michael Smith argues that "The stay-at-home dad is important because he sweeps aside myths and stereotypes about what men can and can't do for their families, tears down the walls that divide men from their children, and fulfills the promise of feminism, which has always been as much about transforming gender roles as fighting inequality" (xiv). In this way, SAHFs reverse traditional masculine roles and, in that way, are transformative feminists. Andrea Doucet, in part, argues that SAHF households "provide important lessons on shifting gender relations and the possibilities and difficulties of achieving gender equality in paid and unpaid work" ("Stay at Home" 6). She also stresses that they point "to the radical potential for gendered shifts in caregiving responsibilities, as men's time at home can engender significant personal, political and ideological shifts in gendered caregiving and breadwinning" ("Stay at Home" 11). In this way, both Doucet and Smith contend that having a father at home is in itself an act of feminism because it is an act of undoing gender. When I asked my husband what a feminist father

looks like, he agreed with the previous quotations: "I guess a feminist father would act like a strong, loving, caring person." Such a description, he added, would not be too inaccurate for himself. In this way, by being that loving and caring parent, he could slowly undo gendered norms. In making a new normal, this act could be seen as resisting the status quo and as a feminist act.

In going against stereotypical gender roles, Francine Deutsch argues that SAHFs may help "identify the conditions under which those actions change normative conceptions of gender, and how these new conceptions can take advantage of or even drive institutional change" (120). I pause here, as I do not believe that any act or condition that goes against stereo-typical gender roles is necessarily an act of feminism. I also disagree that undoing gender itself can lead to institutional change. For example, if caregiving is a feminist act, both male and female nurses, stay-at-home fathers and mothers, as well as women and men who care for aging parents would all be feminists just for the very act of caregiving they provide. Homosexuals, transgender people, and others who defy norms related to sexuality would also be considered feminist. By this definition, any woman who works and any man who cooks would be a feminist.

Similarly, I agree with Caryn Medved (who cites Hochschild's work), who says that "men and women performing sex-atypical work does not guarantee social change" ("Constructing" 141). According to this def-inition, a SAHF is not a feminist just because he is s a caregiver. Linn Egeberg Holmgren and Jeff Hearn reviewed three categories of men's relationship with feminism, explaining: some are "traditional" and hostile towards feminism; some favor it "in principle" but are passive about it; or some are supportive of gender equality and actually active about it (405). Medved argues that feminism falls under the third category: "feminism ... is a politics," in which the goal is "positive action for social change" ("Constructing" 153). Thus, according to this definition, feminism involves political acts. My husband, from this perspective, would be in category one or two—not category three.

Andrea Doucet gets at the heart of this argument:

As more and more feminist and family researchers look to SAHDs as offering evidence of moves towards gender equality and gendered social change ... [I] plea for a conceptual pause and caution. If feminist family scholars continue to accept and apply in their research projects a concept of the SAHD premised on a

division between men who choose to care and men who choose to work, then this raises questions about how this position aligns with or contradicts longstanding feminist contributions about the inseparability between work and care, the structuring of women's (and men's) work-care choices, and feminist strategies aimed at finding public and collective, rather than private and individualized, solutions for family caregiving needs. ("Stay at Home" 12)

This quote really captures the problem with assuming just because a person is a caregiver, he or she is a feminist. Smith hints at this same idea:

Many are religious and conservative in their personal incli-
nations, if not necessarily politics; even among the mothers, few
self-consciously described themselves as feminist and several
couples even rejected the label outright. There might have been a
time when becoming a "Mr. Mom" required some high degree
of ideological commitment, but research shows that this is no
longer the case. (167-68)

In other words, Smith also makes the point that staying at home to do carework is in itself not necessarily a political act. In fact, previously, caregiving was associated with oppression and a lack of choice or freedom. Mothers often felt they were forced to stay at home. Therefore, returning to the definition of feminism originally used in this chapter, if feminism requires "an active commitment to equality and respect for all forms of life" (Wood 4), caregiving, though a wonderful and generous act, it is not (necessarily) advocating for equal rights. However, a father who cares for his children and challenges his daughter's expectations that she should always care for others (especially before herself) or a mother who cares for her children while challenging her son's expectations that all women want to be sexually touched is committed to respecting all forms of life. In this way, I argue, these parents (whether they stay at home or work) are engaging in feminist acts. Therefore, fathers, too, can be feminists. According to Wood's definition of feminism, men can advocate, educate, and fight for the equality of all people.

As a feminist, I see it as my responsibility to speak up for and with those who have less of a voice. If there is a bullying issue in our schools, for example, I see it as my responsibility to work toward antibullying

programs, to push for repercussions for bullying, and to participate in activities that support antibullying. I do not wait for others to fix a problem or, as my husband often says, hope it will just go away. Instead, I aim to work with others and try different solutions. Even though I am comfortable working towards equality in politics, the universities in which I am involved, and the schools that my children attend through speaking up if need be, my husband is less vocal. We often joke that if there is something going on that is unjust—whether it be in our family, community, or workplace—I am one to speak up. My husband, however, explained his reluctance in the following way: "I'm not into protesting. I don't think it can help much because all it does is get the other side more entrenched, which results in both sides just shutting (or shouting) down all communications. Nothing gets accomplished except a self-fulfilling feeling that one just made a big difference." Not every feminist is outspoken (like myself), likes to protest, or appreciates political acts, but Wood argues that a feminist recognizes one's responsibility: "You can't avoid having influence. Instead, your only options are to decide what influence you will exert and where and when you will do it.... We are all responsible" (280-81).

Is my husband a feminist? Does he want equality? Will he stand up to inequality? I do not believe I have the power to classify who is and who is not a feminist, but in my personal opinion, my husband is still working on these issues. In some ways, I believe he still struggles to see his own power and entitlement as a white, heterosexual man (Kimmel, "Who's Afraid?" 62-67). I would argue that he is blind to his own privilege. In other ways, though, I do not believe my husband is fixated with gender roles, per se. For example, he didn't protest or raise objections when our son took a ballet class, when both boys wanted their toes polished, or when our daughter played in the mud.

To add to this discussion, my husband knows that I have volunteered with several sexual assault organizations. When I asked him "How would you react if your daughter was impacted by the "one in five"[5] statistic.... if she went to college and was raped?" he responded with the following:

I don't get the stat? If it was one in a million I would be furious and it would take a lot for me not to hunt down the person that did it ... My first priority would be of my daughter and her wellbeing, mentally and physically. Try to instill in her that she

didn't do anything wrong and that she has a very loving family that will always support her and care for her any way that we can.

[He then challenged the statistic I cited.]

This can be a problem from a PR standpoint. If you are putting out false numbers from a somewhat weak study that causes you to look untrustworthy and that can actually hurt the real issue that any rape is horrendous, no matter if is prevalent or rare.... Another concern is what was considered rape. Again if I remember correctly, one of the questions asked if they ever had an unwanted/forced kiss, and that was considered rape. Again, this would hurt the cause because it marginalizes the victims that have had really been raped.... If that stat is true, why would anyone just drop their daughter off at a rape institution? I wouldn't allow her to go. With technology, she could just stay at home and take online courses and/or attend a small college that doesn't have any on-campus living.

In my opinion, my husband's response uses several conflict management strategies, including challenging my knowledge (asking about the statistic I cited, which is cited in several places, including a text I teach from), questioning the definition of the word "rape" (discounting that someone who was forcibly kissed was not violated), and resorting to avoidance as a solution ("she could just stay at home"). In other words, instead of challenging why this happens, my husband—a father of two sons and a daughter—does not focus on ensuring such violence stops and that the perpetrators are criminalized. Although there is not one, unanimous feminist response as to how to change sexual assault in our society, a response that acknowledges injustice (rape is horrible for anyone) and taking action to improve it (teaching my children to respect others and their boundaries or advocating for different policies to deal with such statistics) seems imperative. David Kahane argues that being a feminist man requires "both a sensitivity to the small and large harms one inflicts as a bearer of this gender, and a commitment to transforming this state of affairs in oneself and the world" (229). In this way, if my husband were to respond from a feminist position, he would work to change cultural norms so that men and boys

(including his own sons) do not expect women to have sex with them; he would work to alter societal norms so that rape is not joked about or dismissed and he would work to see that the victim is not blamed. Conversely, he would not expect his daughter to have to avoid opportunities in order to stay safe.

I imagine one way that my husband may embrace feminism is through "the personal is political" perspective. I can guess that when an issue of injustice affects my husband or his family (whom he undoubtedly cares for), he could be moved to act. In an article about embodiment, Doucet mentions some scenarios where male caregivers feel uneasy:

> Many fathers speak about how they initially have to watch their footing because there can be something potentially disturbing about their presence as opposed to mothers. This is most notably the case where fathers are caring for the children *of others* ... hosting girls' sleepover parties, as well as in fathers' observations of unknown men lingering in sites where children gather (parks, playgrounds, schoolyards). ("Estrogen Filled" 712)

Although my husband denies that he has ever been treated different because he is a SAHF, there may come a time when he is made more cognizant of the assumptions society makes about male caregivers or men who take care of young daughters. These assumptions and stereotypes, of course, are just that—and are disproportionately placed on fathers. For example, how often do you hear parents question whether their son should stay at a friend's house when only the mother is home and not the father? Yet, when a daughter is staying somewhere and only the father is home, some parents may question the safety of this situation. As a feminist, I see it as my challenge, over time, to help my husband and our entire family better understand injustices and their effects. In this way, I can engage in feminist mothering (I use this phrase in parallel with feminist fathering) so that my children can see what feminism can do in our society.

Conclusion

In closing, in this chapter I overviewed the story of my husband, a former member of the U.S. Air Force who now stays at home, as an example of a stay-at-home father. I discussed the history of fathering, stay-at-home fathers, as well as women breadwinners. I then articulated how stay-at-home fathers could be seen as performing in ways that are undoing gender. Finally, I argue that stay-at-home fathers, including my husband, are not necessarily feminist fathers, although they could be.

As I finish this chapter, many thoughts swim in my head. Primarily, I wonder if I made it seem as though fathers who are not feminists are bad fathers. Susan Bordo writes the following: "My father was not a feminist … [he] did not have enlightened ideas about men and women. But those conversations I saw him have with his granddaughter and that I know he had with me [where he talked with me like I mattered—that what I had to say was important] tell a different story" (29). I think her story gets at the crux of my concluding thoughts. A father (or husband) who is not a feminist can be a good parent. My husband works with our children, respects them, and encourages them. He is nurturing and loving, and he has much more patience than I do. In addition, my children have a mother who is more of an activist, who fights for justice, and who speaks (literally and figuratively) loudly. Perhaps, then, this goes back to the beginning of the chapter—my husband and I are different but often complement each other.

Finally, I am not sure, even if a SAHF were a feminist, that the stay-at-home situation necessarily aids feminist causes. As mentioned in this chapter, in some situations, having a SAHF may put more pressure on women. A female primary breadwinner who also engages in doing traditional mothering behaviours when she is not working is likely to feel overburdened. Thus, while a stay-at-home parent (a mother or a father) is a great option for families, perhaps there are larger feminist issues at play. Why in the U.S. is there a lack of public childcare? Why don't parents have more options regarding who stays at home and who works outside of the home? For example, I think my husband would appreciate working about ten to twenty hours every week as opposed to working his part-time job into my schedule, but childcare becomes a huge issue. Similarly, unpaid parental leave in the U.S. does not allow many parents the flexibility to stay at home after the birth of a child.

Why in the U.S. do we lack paid parental leave for both mothers and fathers? Doucet says that "Fathers face different choices in Sweden where the SAHD concept does not exist because family and labour market policies support varied combinations of paid work and care work, including long parental leaves, paternity leave, and high quality daycare ("Stay at Home" 11). Thus, societal changes can affect parents' ability to have choices in work as well as options for childcare.

The SAHF-breadwinner mother scenario definitely can provide some wonderful examples of undoing gender. My sons and daughter will grow up with differing expectations of feminine and masculine roles and behaviours. In fact, when I asked my sons (four and six) what is a good mommy and daddy; they listed similar qualities—moms and dads make dinner, love their children, do well at work, read to their children, play with them, and help them.[6] Thus, their ideas about the qualities of a good parent are already ungendered, which is quite a feat. At the same time, being a SAHF is not necessarily an act of feminism. A feminist father may work at ensuring his children are enlightened about injustices and inequalities—and will fight for a more just and equal world. However, not all SAHF are feminists. My intent is that this chapter prompts discussions and conversations about what inequalities in the SAHF situation still need to be addressed and what work needs still needs to be done. In the U.S., we are not yet in a position where parents have a lot of options when it comes to working outside the home and caregiving. I suspect many families do the best they can to make it work: to pay the bills, provide the best they can for their children, and find some sort of meaning in it all. As we stumble through different ways of doing and undoing gender, perhaps we also need to ask how can we undo some of the institutions that make some parents feel absent while others feel unfulfilled. In other words, we need to address how we can make both air bases and home bases fulfilling for all persons.

Endnotes

1. In *Parenting Together,* Diane Ehrensaft describes the 1950s nuclear family, in which the father was a breadwinner who "may have been expected to have only minimal involvement in the daily care of their young children—to be at most 'helpers' to their female partners" (4). She adds that women are expected to be "immersed"

in motherhood, whereas "for the man, it is just the opposite: He has to explain why it is that he *will* be involved in 'motherhood'" (27).

2. In *The Cultural Contradictions of Motherhood,* Sharon Hayes describes how stay-at-home mothers can sometimes be labeled as "lacking an identity apart from their kids" (136); as experiencing a "loss of self" (137).

3. In *Naturalistic Inquiry,* Yvonne Lincoln and Egon Guba argue that member checking, where the data collected from the members interviewed are verified, is "the most crucial technique for establishing credibility." They continue: "If the investigator is to be able to purport that his or her reconstructions are ... adequate representations of their own (and multiple) realities, it is essential that they be given the opportunity to react to them" (314).

4. In the book *On Men: Masculinity in Crisis,* Anthony Clare explains that "the whole issue of men—the point of them, their purpose, their value, their justification—is a matter of public debate. Serious commentators declare that men are redundant.... Throughout the world, developed and developing, antisocial behavior is essentially male" (3). Moreover, Clare says men are often "depressed, dependent, and in need of help" (3). He ends a chapter saying "But phallic man, authoritative, dominant, assertive-man in control of not only himself but of woman is starting to die, and now the question is whether a new man will emerge phoenix-like in his place or whether man himself will become largely redundant" (9).

5. According to the Association of American Universities, in 2015, the incidence of sexual assault for female undergraduate respondents was 23.1 percent. In addition, the Center of Disease Control's article titled "Preventing Sexual Violence," states "Nearly 1 in 5 women and 1 in 38 men have experienced completed or attempted rape."

6. I did not ask my daughter this question only because of her age (she is two years old).

Works Cited

Adams, Tony. E. et al. *Autoethnography.* Oxford, 2015.

Allen, Sarah, and Kerry Daly. "The Effects of Father Involvement: An Updated Research Summary of the Evidence." Centre for Families,

Work and Well-Being, University of Guelph. 2007, www.fira.ca/cms/documents/29/Effects_of_Father_Involvement.pdf. Accessed 10 Oct. 2017.

Anderson, Veanne N. "What's in a Label? Judgments of Feminist Men and Feminist Women." *Psychology of Women Quarterly*, vol. 33, no. 2, 2009, pp. 206-15.

Association of American Universities. "AAU Campus Climate Survey on Sexual Assault and Sexual Misconduct: Fact Sheet." 3, September 2015, www.aau.edu/sites/default/files/%40%20Files/Climate%20Survey/Fact%20Sheet%20for%20AAU%20Climate%20Survey%209-21-15_0.pdf. Accessed 20 October, 2018.

Bianchi, Suzanne M., et al. "Is Anyone Doing the Housework? Trends in the Gender Division of Household Labor." *Social Forces*, vol. 79, no. 1, Sept. 2000, pp. 191-234.

Bordo, Susan. "My Father the Feminist." *Men Doing Feminism*, edited by Tom Digby. Routledge, 1998, pp. 17-32.

Brittan, Arthur. "Masculnities and Masculinism." *The Masculinities Reader,* edited by Stephen M. Whitehead & Frank J. Barrett. Blackwell, 2001, pp. 51-55.

Centers of Disease Control. "Preventing Sexual Violence" 19, March 2019, www.cdc.gov/violenceprevention/sexualviolence/fastfact.html. Accessed 13 January, 2020.

Chesley, Noelle. "Stay-At-Home Fathers and Breadwinning Mothers: Gender, Couple Dynamics, and Social Change." *Gender & Society*, vol. 25, no. 5, Oct. 2011, pp. 642-64.

Chesley, Noelle. "What Does It Mean to Be a 'Breadwinner' Mother?" *Journal of Family Issues,* vol. 38, no. 18, 2017, pp. 2594-2619.

Chesley, Noelle, and Sarah Flood. "Signs of Change? At-Home and Breadwinner Parents, Housework and Child-Care Time." *Journal of Marriage & Family*, vol. 79, no. 2, Apr. 2017, pp. 511-34.

Clare, Anthony W. *On Men: Masculinity in Crisis.* Chatto & Windus, 2000.

Deutsch, Francine M. "Undoing Gender." *Gender & Society*, vol. 21, no. 1, Feb. 2007, pp. 106-127. EBSCO*host*, doi:10.1177/0891243206293577.

Doucet, Andrea. *Do Men Mother?: Fathering, Care, and Domestic Respons-ibility.* University of Toronto Press, Scholarly Publishing Division, 2006.

Doucet, Andrea. "'Estrogen-Filled Worlds': Fathers as Primary Care-givers and Embodiment." *Sociological Review,* vol. 54, no. 4, 2006, pp. 696-716.

Doucet, Andrea. "Is the Stay-At-Home Dad (SAHD) a Feminist Con-cept? A Genealogical, Relational, and Feminist Critique." *Sex Roles,* vol. 75, no. 1-2, July 2016, pp. 4-14.

Ehrensaft, Diane. *Parenting Together: Men and Women Sharing the Care of Their Children.* Collier Macmillan, 1987.

Ellis, Carolyn. "With Intimate Others Telling Secrets, Revealing Lives: Relational Ethics in Research." *Qualitative Inquiry,* vol. 13, no. 3, 2007, pp. 3-29.

Ellis, Carolyn, and Arthur P. Bochner. "Autoethnography, Personal Narrative, Reflexivity." *Handbook of Qualitative Research,* edited by Norman K. Denzin and Yvonna S. Lincoln. Sage, 2000, pp. 233-268.

Good, Glenn E., and Nancy B. Sherrod. "The Psychology of Men and Masculinity: Research Status and Future Directions." *The Psychology of Women and Gender,* edited by Rhoda K. Unger, Wiley and Sons, 2001, pp. 201-14.

Griswold, Robert L. *Fatherhood in America: A History.* BasicBooks, 1993.

Hays, Sharon. *The Cultural Contradictions of Motherhood.* Yale University Press, 1996.

Hochschild, Arlie Russell, and Anne Machung. *The Second Shift.* Penguin Books, 2003.

Holmgren, Linn Egeberg, and Jeff Hearn. "Framing 'Men in Fem-inism': Theoretical Locations, Local Contexts and Practical Passings in Men's Gender-Conscious Positionings on Gender Equality and Feminism." *Journal of Gender Studies,* vol. 18, no. 4, 2009, pp. 403-418.

Hopkins, Patrick D. "How Feminism made a Man out of Me: The Pro-per Subject of Feminism and the Problem of Men." *Men Doing Feminism,* edited by Tom Digby, Routledge, 1998, pp. 33-56.

Kahane, David. "Male Feminism as an Oxymoron." *Men Doing Feminism*, edited by Tom Digby, Routledge, 1998, pp. 213-35.

Kimmel, Michael S. "Masculinity as Homophobia: Fear, Shame, and Silence in the Construction of Gender Identity." *The Masculinities Reader*, edited by Stephen M. Whitehead and Frank J. Barrett. Blackwell, 2001, pp. 266-287.

Kimmel, Michael S "Who's Afraid of Men Doing Feminism?" *Men Doing Feminism*, edited by Tom Digby, Routledge, 1998, pp. 57-68.

Kramer, Karen Z., and Amit Kramer. "At-Home Father Families in the United States: Gender Ideology, Human Capital, and Unemployment." *Journal of Marriage & Family*, vol. 78, no. 5, Oct. 2016, pp. 1315-31.

Lamb, Michael E. "The History of Research on Father Involvement." *Marriage & Family Review*, vol. 29, no. 2/3, 23 May 2000, pp. 23-42.

Latshaw, Beth A. "From Mopping to Mowing." *Journal of Men's Studies*, vol. 23, no. 3, Oct. 2015, pp. 252–270.

Lincoln, Yvonne S., and Egon G. Guba. *Naturalist Inquiry.* Sage Publications, 1985.

Medved, Caryn E. "Constructing Breadwinning-Mother Identities: Moral, Personal, and Political Positioning." *Women's Studies Quarterly*, vol. 37, no. 3/4, Fall/Winter 2009, pp. 140-56. Medved, Caryn E. "The New Female Breadwinner: Discursively Doing and UnDoing Gender Relations." *Journal of Applied Communication Research*, vol. 44, no. 3, Aug. 2016, pp. 236-55. Meisenbach, Rebecca. "The Female Breadwinner: Phenomenological Experience and Gendered Identity in Work/Family Spaces." *Sex Roles*, vol. 62, no. 1-2, Jan. 2010, pp. 2-19.

Pew Research Center. "Growing Number of Dads Home with the Kids," *Pew Research Center: Social and Demographic Trends*, 5 June 2014, www.pewsocialtrends.org/2014/06/05/growing- number-of-dads-home-with-the-kids/. Accessed 17 Sept. 2017.

Poling, James Newton, et al. "Men Helping Men to Become Pro-Feminist." *Journal of Religion & Abuse*, vol. 4, no. 3, 2002, pp. 107-122.

Rochlen, Aaron B., et al. "Stay-At-Home Fathers' Reasons for Entering the Role and Stigma Experiences: A Preliminary Report." *Psychology of Men & Masculinity*, vol. 11, no. 4, Oct. 2010, pp. 279-85.

Smith, Jeremy Adam. *The Daddy Shift: How Stay-At-Home Dads, Bread-winning Moms, and Shared Parenting Are Transforming the American Family.* Beacon Press, 2009.

Solomon, Catherine Richards. "I Feel Like a Rock Star": Fatherhood for Stay-At-Home Fathers." *Fathering: A Journal of Theory, Research & Practice about Men as Fathers,* vol. 12, no. 1, Winter 2014, pp. 52-70.

United States. Census Bureau. "Facts-for-features: Father's Day: June 21, 2015" *United States Census Bureau Newsroom,* 12 June 12015, census.gov/newsroom/facts-for-features/2015/cbl5- ffl10.html. Accessed 5 September 2017.

United States Department of Labor. "Women in the Labor Force," www.dol.gov/wb/stats/stats_data.htm. Accessed 30 Aug. 2017.

United States Department of Labor. "American Time Use Survey Study." 27 June, 2017, www.bls.gov/news.release/atus.nr0.htm. Accessed 18 Aug. 2017.

West, Candace, and Don H. Zimmerman. "Doing Gender." *Gender & Society,* vol. 1, no. 2, June 1987, pp. 125-51.

Wood, Julia T. *Gendered Lives: Communication, Gender & Culture.* Cengage, 2015.

Chapter Ten

Father Figure

Lee Kahrs

Although I am my father's only daughter, he taught me how to be a man. A good man. As a child, I watched him treat my mother with a subtle reverence. He was not demonstrative, with any of us, but every so often he would sidle up behind my mother at the stove and hug her around the waist and say something silly in her ear, and she would smile and gently scold him with love.

My dad was very handy; he built a two-story addition on the house and did all the plumbing and electrical himself. All of our hot water taps drew cold water, and vice versa, and it was a running joke in our family.

He built two wooden sailboats in our basement—the first a twelve-foot single sail dinghy and the second an eighteen-foot racing sloop with a canvas deck and a jib. He built the steam boxes to bend the teak and mahogany trim pieces along the deck. It took him two years, and when the sloop was finished, we had to dismantle part of a stone wall outside the cellar door to get it out of the basement.

He worked hard as a high school social studies teacher, getting up at 5:30 a.m. each morning and driving forty-five minutes to the school just north of New York City. He loved to talk about history and current events, and the family Sunday morning routine was set early in my life: Catholic mass with my mother and brothers (my father was Lutheran and non-practicing) after which we would pick up the *New York Times* and a box of fresh donuts and head home. Entering the house, we could hear the strains of Bach on WQXR out of New York coming from the study. Everyone would take their section of the paper and a donut and retreat to a chair. I always took the book review and arts and leisure sections, my dad the front page, world, and business. He taught my

brothers and me to sail and about all things marine. He was not necessarily a patient man, and could often be short with us if we didn't move fast enough or made a mistake. The way we learned things from my dad was as quickly as possible and correctly the first time, but he took the time and we wanted to please him.

An ex-ski bum from the 1950s, dad also taught us to ski very early. I was about seven, and it was a sport we enjoyed together well into my adulthood.

My father would never describe himself as a feminist, but he was— my gender did not restrict me in his eyes. I came of age in the late 1970s and 1980s and was treated equally with my brothers, not differently. A tomboy early on, most activities I expressed an interest in doing were supported, whether it was throwing shot put and discus on the high school track team, learning to ride a motorcycle, or working on a horse farm through college.

Well, they supported me almost all of the time. I remember instances when my parents forbade me from doing something: wearing a t-shirt made out of the American flag for a high school trip to Spain, which they thought was disrespectful to our country, and taking a break from college to work on the horse farm fulltime. They were right on both counts.

Once I hit my teens, I was adamant about wearing masculine clothing and shunning such things as dresses, and makeup, and anything remotely feminine. It was not discussed, rather mutely accepted. But it was the early 1980s and I was not liberated enough to fight painful trips to Edgar's clothing shop to find a suitable dress for the annual spring chorale concert. Then I was the one mutely accepting, the dress collars irritating my neck and my large, wide feet pinched in pair of size ten women's heels.

Same Principles Apply

My parents ingrained the basic credos of life in all three of us kids: the value of hard work, honesty, and respect for ourselves and others. When I came out as a lesbian in 1986, my identity was built on those tenets of life. As I emerged as a butch lesbian attracted to femme women, my father's relationship towards and treatment of my mother was a strong model on which I built my own relationships with women.

My parents had a very traditional marriage in many ways. My mother was a working mother in the early 1960s, just as feminism was gaining

ground as a sociopolitical movement in America. She never read Betty Friedan or Gloria Steinem; she never followed Angela Davis, burned her bra, or marched for equal rights. In fact, if you asked her why never did those things, she would shake her head, cluck disapprovingly, and say she was too busy working, being married and raising three kids. She is also a committed Catholic and staunchly prolife.

What's notable is that although my mother was also a teacher, and then ran a successful childcare business for over twenty years, she was also a homemaker. She cooked dinner every night and kept the house clean, with the help of us kids, who had chores. I was in charge of dusting. She did all of the grocery shopping, but they both cooked, especially for the holidays. Sometimes my dad would discover a culinary challenge—like making homemade egg foo young—and every year as Christmas approached, he would declare, "We should make a Christmas goose, just like back in the days of Dickens and *A Christmas Carol!*" And we would vote him down.

But there were two other forces at work creating my parents' feminist perspective: my mother's ability to walk that line between independence, traditional marriage and career, and my father's acceptance and support of those choices.

My mom was raised by a mother, my Nana, who bore seven daughters and who became a single parent after the death of my grandfather when my mother was eighteen. Nana taught all of her girls to cook and clean and sew, but she also modelled strong female leadership, never yelled, and told her girls they could do anything they wanted in life.

My mom went on to marry a man who respected women and who was raised by a strong mother himself. My Oma (German for "grandmother") was a stern, practical, and hardworking woman with a head for business and a no-nonsense German disposition.

All Grown Up

My daughter Anna was nine when I met her and my future wife Susan. They were a set—Susan having adopted Anna—and I was thrilled to be in love and have a family of my own, something I had always wanted. Over time, just as the butch and femme roles in our marriage were clearly defined, so was my role as a father figure. Since I was more masculine in both disposition and bearing, it made sense. We never

even talked about it; it just happened organically. I remember the first Father's Day when they both surprised me with cards, real Father's Day cards, and the validation of my identity and my role in life enveloped me like a warm cocoon and I re-emerged.

I introduced my new family to camping and road trips. I played catch with Anna in the backyard after she joined a local softball team. I bought Anna her first bike—a purple Schwinn complete with a flowered basket on the front—and taught her to ride it.

I taught her how to fish, first for perch with worms, and then for bass with lures. I taught her how to swim in Lake Champlain and how to pull seaweed with her toes. I spent weeks trying to teach her how to drive a stick shift in my Dodge Dakota pickup truck; my intestines lurching as I sat in the passenger seat, fingers gripping the door as we sputtered up and down the local high school parking lot.

"That's it. Give it more gas," I would say as the truck was about to stall. And she would rev the engine and pop the clutch and the seatbelt would catch us in the throat as we both pitched forwards. She never quite got the hang of it.

Diagnosed with ADD and depression, Anna struggled through middle school and then high school. With Susan working nights as a nurse, I was in charge of getting our child out of bed and off to school each morning. Sometimes I was successful; sometimes I was not. We often faced off at the bus stop, with me holding a coat that she refused to wear in the dead of winter.

As Anna entered her teen years, Susan and I both lost a lot of sleep over her choices. She broke curfew constantly, partied, and had questionable friends; she would hang out at their homes with little, if any, supervision. There was the day she decided to skip school and walk to her friend's house a mile away. I called the school resource officer and had her picked up in a police cruiser. That scared her, thank God, and she never did it again.

We were able to just barely get her through high school, and she left home the minute she turned eighteen. Anna had been threatening to leave home since she was the eighth grade, the byproduct of rebellion and boredom. But as her eighteenth birthday loomed just after Thanksgiving, we knew it was going to become much more than a threat. For the month of November, Susan was in mourning. She knew it was coming, and it was her way of preparing herself. I, on the other hand,

was the soothsayer. "It's going to be okay," I'd say. "She'll always be our daughter, and she'll always have home to come back to."

That said, raising a child and then suddenly have her leave was a big adjustment. Our daughter was eighteen; it was adult time. It was what she wanted, and we couldn't legally stop her.

Anna always had her own way of doing things. She would half-listen to your more practical suggestions, nod, then do it her way. Yelling at her would get you nowhere except further away. Although I value her independence, her stridency, and her passion, it has taken me years to accept that she is who she is and will do what she wants, for that is how she learns. We had to trust that we raised her right and that she would go off into the world knowing right from wrong, the value of hard work, and the importance of honesty and accountability, like my parents had.

If I've learned anything about parenting a difficult child, it's that you have to let go, and that helped me tremendously during those years. It was much harder on Susan, who spent about a year suffering from empty nest syndrome, lost without the day-in, day-out routine of motherhood.

Nurture vs. Nature

I also learned that just because you are a feminist and a strong role model does not mean your children will follow suit.

All of Anna's life, she was told that she could do anything she put her mind to, could pursue any career, be her own person, and be independent and strong. What that looked like to us and what that meant to her were very different. But a year after she moved out of the house, Anna got pregnant, and we were going to be grandparents. We were not happy about it, but it was out of our control. Anna was thrilled.

There is another aspect of being adopted—bearing and birthing biological children is very important, as it feeds the intense desire for a blood-related family of one's own. As disappointed as we were that Anna was pregnant so young, we understood that need.

The one thing I could control was what I would be called by this child coming into the world, which became even more important once Emma was born. Acquaintances would say, "Hey, congratulations Grandma!" and I would feel my insides turn over. It felt wrong; it was not the correct name for me to be called, and that I started correcting people immediately.

"No, no. Not 'Grandma,'" I would say, a distinct edge in my voice.

"It's 'Poppy.' I am 'Poppy.'"

And that is who I am to Emma, and it is as natural as her blonde hair. There was a six-month period around age two when she was even mixing my pronouns, and I just took it in stride. It made sense, although I use "she" and "her."

Anna is a good mother. The feminist doctrine that she absorbed from our parenting is to be a working mother who does not need a man, or a woman, to be happy and successful in life, but becoming that mother took time, trial, and error. She had to learn by doing, so the lessons were hard. In talking to other parents, I learned a universal parenting lesson: whether they are naturally born or adopted, your children will make their own way and be their own people. All you can do is teach them the life lessons you believe in and hope for the best.

Father Figure

My wife and I split up after fifteen years together. Two days went by after Susan left before Anna and I could really talk. I called her with my heart in my throat. Adopted kids come with their own set of insecurities about who they are and what family is. A divorce can be even more traumatic for them than biological children, even when they hit adulthood.

Anna was twenty-three, but she was still my child and I needed to make sure she knew that.

She answered the phone.

"Hi, I'm just checking in," I said.

"O.K.," she replied. We were both fighting back tears.

I tried to clear the lump in my throat.

"I want you to know that not much is going to change," I said softly. "We are still a family. We will still have family dinners and birthdays and Christmases."

"O.K.," she said, crying.

"I will still tell you things you don't want to hear," I said. "I will still give you money for no reason."

She laughed, and I laughed, and that helped so much.

Last year on Father's Day, we all went out to dinner, and I got a card from Anna and Emma.

"Happy Father's Day to my ATM," it says on the front. Then, inside,

"By ATM, I mean 'Always There for Me.'" Underneath, she wrote, "Yay, a joke! Hee hee. Happy Father's Day to the #1 and only Lee/Poppy, we love you! Emma and Anna."

I cried again.

Fathering Committee

There are those in both the straight and the LGBTQ cultures who think that by living my life as a butch lesbian, I am merely modelling heterosexual male behavior. That is simplistic and insulting. This is who I am in my own skin—male-identified but not feeling as if I was born in the wrong body. That's the nature part.

The nurture side of my identity and my behaviour comes from not just my father's positive role modelling but also the influences I have cherry picked from my own culture. From "Father Knows Best" to Mike Brady to George Jetson, from Atticus Finch to Bob Cratchit, I mined and absorbed the cues from many different fathers during my early life. Blessed with a family unmarked by physical or emotional abuse, I only sought positivity. I drank it all in and waited patiently for a family where I could play my part.

My father can no longer sail or ski. He is eighty-four, and Parkinson's has taken what it wants from him. It has taken his balance and his strength. Late last year and in a matter of weeks, he moved from stage 3 firmly into stage 4. That's when Parkinson's started to take his memory and sometimes his speech. He is often unable to finish a sentence because he can't find the word that completes his thought, or he can't remember what he was saying. Some weeks he is lucid, and some weeks he is distant and quiet—his feet unsteady, his body bent, and his right arm shaking with a tremor.

On a good day, my dad can sit and recount the historical details of World War I, the Korean War, and the Tudors with ease. He still putters, still tends to the yard. When we go boating, I drive, and he sits in the passenger seat of our motorboat with the sun on his face and a slight smile on his lips. I still have him, and I still learn from him.

I fell in love with my wife Margaret last year. She has three sons—aged ten, nine, and seven—and it's like they were waiting for me. Our bond was immediate and profound. After a few months, they came up with a new name for me: Papito. My middle boy heard it in a song, told

the others, and it stuck. It means "Daddy" in Spanish.

My dad sees me and how I am with my sons, and I think he knows. If the goal was to raise strong, independent, and thoughtful children, my father did that, and now so am I. Despite the fact that my family has changed and grown, I know my mandate is to to be a good father figure to these boys, and I will always get cards on Father's Day.

Chapter Eleven

Observations and Ramblings of a Feminist Father

Stuart Leeks

Preface: I'm hugely grateful to my partner in life for her continued guidance and support on this journey. I wouldn't have come anywhere near as far without her.

When I was growing up, feminists always seemed to be talked about as women and often not in a favourable light. I never considered an association between myself and feminism.

A few years ago, I remember sitting in the shade of a tree with my wife and three young children on a sunny summer day at the local school fête—where my eldest was soon to start. We were all eating ice-cream, and there was nothing else particularly notable about the day. But it was on this day that I glanced over my shoulder and saw a tug-of-war competition going on. I turned back to my wife and continued talking. And then it hit me: it was boys vs. girls. So what? I can't begin to estimate how many times I'd seen competitions like that. But that day was different; that day it occurred to me to ask why.

Why set up the teams to pitch boys against girls? For a tug-of-war contest with young children, why pick the teams based on what they happen to have between their legs? Imagine if the teams were picked on the basis of skin colour; I'm fairly certain that the local newspapers would have picked up on this, and it would have caused a sensation. But divide teams based on gender and no one seems to question it.

That was the day that my perception of feminism started to change—I started to become a feminist.

A couple of months later, my son started at the school, and I discovered that as the children all arrive at school in the morning, they put their water bottles onto trays in the classroom. But the tray isn't big enough to fit all of the water bottles, so they have two trays. And, yep, you guessed it—they have a tray for boys and a tray for girls. Again, another example of segregation based on gender that went unnoticed.

As time marched on, previously hidden (from me at least) details kept appearing: the messages on children's t-shirts based on gender or the language that people unintentionally use towards children based on their gender ("that's a pretty hairband" vs. "wow, that's a cool dinosaur"). All of this sets the stage for girls to believe that they are supposed to look pretty and for boys to believe that they are strong and clever. In a children's clothing department store, you can always tell the pink girls' section from the boys' section, which has all manner of colours.

But as disturbing as these revelations were, the thing that disturbed me most was that I hadn't noticed them before. Prior to the tug-of-war realization, I would have firmly stated that I wasn't sexist, and I believed that. But now I was starting to see how much sexism exists in our culture and how much sexism I had been unknowingly immersed in it as I grew up. How could I, as a product of that sexist culture, stand up and say that I am not sexist?

It was a painful realization, but as a parent, I'm in a great position to turn that into a positive outcome: I can be a feminist father.

So what does being a feminist father mean to me? Initially, I was very focused on my daughter. I wanted to ensure that she has a positive self-image and to counter the sexist influences that would try to shape her. But feminism is bigger than that. It's not about being a feminist for my daughter. It's about being a feminist for my daughter, wife, sister, mother, sons, father, friends, colleagues, and people I don't know. I strongly believe that feminism is about making the world a better place for all of us. I don't mean this in an "All Lives Matter" kind of way but in the sense that we all benefit from feminism and have a part to play in working towards a more feminist future.

I'll confess that I had an initial rebellion against anything pink for my daughter. But I came to realize that it's not about stopping her from choosing pink; it's about making sure she feels that she has the freedom to choose the colour she wants rather than having to conform to a stereotype. Similarly, it's not about never telling her she's beautiful but

about helping her see that she is beautiful as well as strong, powerful, intelligent, and capable.

And being a feminist father is as much about how I parent my sons as it is about how I parent my daughter. They need to grow up with balanced gender views just as much as my daughter does. It's not just my daughter that needs to see herself as totally capable; my sons also need to have that balanced view of themselves as well as of women. My sons need to see women's strength, intelligence, and capability. And my sons need to see that they themselves are beautiful as well as strong, powerful, intelligent, and capable.

I also believe that being a feminist father is about how I represent my children to others. I work hard on the language I use, and I believe the time has come to stop making stereotyped comments like "oh that's just for boys" and start seeing each child as an individual. I want all my children, regardless of their gender, to grow up thinking that women can be astronauts, surgeons, mechanics, police officers, and scientists and that men can be teachers, nurses, secretaries, and stay-at-home parents.

It has been an interesting journey so far. I have discovered so much insidious sexism that I was previously oblivious to. Seeing and unpacking this sexism can be uncomfortable, but it is vital to support our children in developing their own awareness of it. And we can't do that unless we are prepared to open ourselves fully to this discomfort. But, in turn, through their explorations and enquiries, our children will help us to see that more clearly too, which will help to create a virtuous cycle of progress. I'll continue to follow people and organizations on Twitter that help me move forwards, such as The Everyday Sexism Project (https://everydaysexism.com/) and Let Toys Be Toys (http://www.lettoysbetoys.org.uk/). But most importantly, I look forwards to continuing this journey guided by the women in my life. We need to embrace the innate abilities and power in all of us, but, particularly, we need to listen to women as they tell us their truths. And when that feels uncomfortable, we need to sit with that and take a long hard look at ourselves.

Chapter Twelve

To My Son

Jed Scott

My son,

I became a father when you were born in June of 2006. Until then, my understanding of feminism was abstract: I believed in gender equality and opposed measures that undermined equality.

But in the wake of your birth, and the subsequent birth of your two younger brothers, I had to refine my definitions and be more intentional about living my beliefs.

I don't think we learn behaviour best by being told; it's better to see beliefs in action and slowly learn from them. I think you've done that. But you are at the cusp of puberty, when women change before your eyes from an alien species you're not very interested in to an alien species you're very interested in. So I think it's probably a good idea to put into the words the beliefs I've tried to live, along with some perspective on how I got them.

When I became a father, I became a fulltime father. Since I finished a graduate degree in studio jazz writing in 2003, I had been working a flexible schedule as a freelance composer, arranger, conductor, and private music instructor. In the three years that passed before you were born, I had developed a regular client base and had some successes, but it was still part time and so it made perfect sense for me to become your at-home parent. Your mother was and is a remarkable educator and conductor: she has taught hundreds and hundreds of students to sing in high school choir programs.

Nevertheless, it was challenging for me to be an at-home dad for reasons that relate to my evolving thinking about equality and feminism. I was embarking on a role that has been traditionally the exclusive realm

of mothers. I was feeding, changing, tucking in, teaching, and playing with you for eight to twelve hours a day as your mom went to work.

I grew up in Grosse Pointe, Michigan, the son of an orthopedic surgeon and a stay-at-home mom. Grosse Pointe will probably always be associated with WASP (white, Anglo-Saxon, and Protestant) privilege, and to be honest, that association is well deserved based on my experience. I lived six sidewalked, green-grassed, perfectly safe blocks from my elementary school, and the walk took me past beautiful, well-kept Victorian-style brick homes.

The truth is that even as I accepted the perks that came with growing up in immense privilege, I was uneasy with that privilege. Although I couldn't name it, I felt that opportunity was unevenly distributed and that I hadn't earned what I received. By middle school, certainly, I was aware that just a few blocks to the south of my school a boy exactly my age would be having a vastly different life experience, and he no more deserved his life than I deserved mine. I attended Grosse Pointe South—a palace of a school designed to recall Philadelphia's Independence Hall, complete with clock tower and sprawling grounds—while the parents of your aunt's best friend taught less than two miles away at a school with high dropout rates and metal detectors at the doors in the early 1990s.

But many classmates (though not my closest friends) appeared to settle easily and comfortably into their unearned elite status. It took me a long time to understand what made me chafe against this privilege. I'm a slow thinker.

Growing up an affluent WASP in Grosse Pointe, of course, wasn't the start of my privilege—or yours. Your grandfather's parents were both physicians, and on that side of your family, you have male ancestors who were civic and community leaders spanning hundreds of years, going back to the Mayflower and beyond to British royalty. We are descended from men who served as officers in every American war, from before the Revolutionary War to Vietnam.

It's fascinating to learn more about your family's history, and I spent many days poring over microfilm with your grandma in genealogical libraries. It's interesting to understand where you came from and how your genes came down from people who did amazing things in past

centuries. But the most fascinating part, I think, is to step back and understand how the unearned gifts you receive were collected over lifetimes. The men in our family amassed privilege for centuries, and we carry it, whether we asked for it or not.

I say men because one of the things we learn from studying family history is the systemic erasing of our female ancestors' stories. It's obvious and surprising to realize that of the people who came before you, exactly half of them were women—obvious because we all have two parents and surprising because we know so much less about those women. I can show you your ancestors' names in history books, on monuments as well as on deeds and road names. Your grandparents have hanging a vintage photo of our family's historic farm in Rhode Island along with the original English deed from 1742. But of all those names, we will never find the name of one of the women who came before you. Only the men.

Here is my first rule of being a male feminist: *Every person deserves equal respect and opportunities.*

Women haven't received equal respect in our own family history, although they inarguably deserved it. And historically, their opportunities for advancement, leadership, and creation have been stifled by legalized discrimination, societal norms, and family dynamics.

Your grandmother, my mother, is as strong as people come. Long before you were born, she came to be called The Queen by her circle of friends, and by the time you came into the picture, she had rejected any name from her grandchildren that didn't include Queen in it.

She isn't patrician or classist; she is down-to-earth as well as easy to talk to and trust. She has the ability to make fast friends, with the speed that comes from growing up an army brat on both sides of the Atlantic over the years spanning the very end of WWII, the Korean War, and the Vietnam War. She is opinionated, can be brash, but is deeply loving. She commands the room but enjoys nothing more than to feed the people she loves with the best food she can make. She was an independent, successful, strong woman in the 1960s and 1970s before she met your grandfather, and her stories from those days paint the picture of a woman who embodied feminism without ever mentioning it. It's funny that such a no-nonsense woman ended up with a nickname like The Queen, but

her authority is so complete and her earned respect so universal that it nonetheless fits.

Grandma Queen is the first strong woman I knew, and although she didn't have a career after I was born, there was no question that she ran the household and made it a happy home to grow up in. She was a stay-at-home mom by choice and by privilege, but she never regretted the choice and relished the opportunity to be an integral part of my school and home life and that of your aunt and uncles.

I never wondered whether men and women were equal because in my own life, they were. If anything, women were superior; she ran the home—my domain as a child—and Pop Pop deferred to her in most situations.

Not that that was necessarily a good thing, or an example I've chosen to emulate. Pop Pop's idea of deference tended towards an overly formalized, theatrical deference. He practiced long, low bows when she made a request, and for a while referred to Grandma Queen as SWMBO ("swimbo"), a reference to John Mortimer's Rumpole books, which stood for "She who must be obeyed." You probably won't be surprised that she didn't like this false honorific, and typically yelled back "Stop it!" when he brought out the name or the pantomime. Although it's gotten more subtle, Pop Pop still telegraphs a play-acted deference that has hard-to-parse layers. Does he really believe it? Is he just pretending? In my heart, I think that Pop Pop is a feminist, as he defines it, but it's not a way of practicing feminism that I ever wanted to echo.

What I learned from all this, and what I have tried to practice since I entered into marriage with your mom, is to toss any fakeness and replace it with real equality. That's what your mom deserves (as does your Grandma!), and that's how I try to behave. I trust her to make a decision when I'm not around, and she trusts me, too, but most often we both like to say that we understand the world by talking about it together. We make decisions together, and I never fake my respect for her opinion, nor does she fake hers. As much as possible (and it's almost always possible), we are equals in making decisions as parents.

I do a lot of different things for work: I compose and arrange music, teach, adjudicate, and more. But the most consistent work I've had for the past fifteen years has been conducting young men in extracurricular

a cappella choirs. For the last ten, I've directed the Aces, who are generally twelve to fourteen voices from grades nine to twelve. I say young men because it's the easiest first descriptor, but the truth is that for the last two or three years, I've almost always referred to them as a tenor/bass ensemble. As I've learned more about gender fluidity and inclusivity, I've updated my description and welcomed all who sing in that range, whatever their gender definition.

Why am I bringing up my work in this letter about my role as a feminist father? Because I think I first understood that role, and grew into it, while in a room of young male singers. It's been through teaching them that I've learned how to be a feminist man, how to lead from that place, and how to behave so others will internalize and emulate my perspective.

We don't often talk about gender roles or stereotyping in the Aces, but even so, I think understanding masculinity is one of the most important lessons I teach every year in the group. I would describe myself as a man who doesn't fit many of society's expectations about masculinity: I am not the primary breadwinner, I don't often raise my voice, I'm not autocratic, and I don't engage in stereotypical male behaviour (particularly including sports fandom, man-cave dwelling, etc.). My default is quiet; my default is respect. I think that being myself in relation to these young men offers them a chance to see an alternative to masculinity as exemplified by culture, coaches, and dads.

Mr. Rogers is the only cultural figure I can think of who is a good archetype for maleness as I try to practice it. He was gentle, soft spoken, and cared for all. And in *Won't You Be My Neighbor*, the wonderful recent documentary of his life, an entire segment was devoted to refuting the idea that he was gay. That's where we're at: our society still has trouble comprehending that a man can have these traits and not be gay. Of course, we've had plenty of gay young men in the Aces over the years, although many didn't come out until after high school. Some, I think, may never come out—our town is still pretty religiously conservative—but it's my hope and intention that they are able to be more of themselves because of their time in the Aces.

In the Aces, I'm also often resetting the gender roles my students have learned not just from society in general but from choir teachers in particular. One choir teacher many of my students have had before getting to high school likes to tell his students, "Women need to be loved;

men need to be respected." He has told students your age that a boy can't have long hair and "be a man." Male students sometimes arrive at the high school with a sense of superiority masquerading as respect. The things they learn in his classes about singing and musicianship are invaluable, but I think that part of my job in high school is to offer a different idea and help them deprogram these learned perspectives.

There's another piece to my role in the Aces, too—the piece that involves your mom. She's the director of choirs for the high school, so in many years, all of my students also sing in one of her choirs during the school day. They get to interact with both of us as leaders and really as surrogate parents in a choir program; we've really come to think of as a family.

In that context, some still apparently find it surprising to have your mom as the head of the program. She is literally my boss in the choir department—the buck stops with her. Of course, as I said, we understand the world by talking about it, so there's seldom a time that I'm not backing her up on a decision; nevertheless some students (and adults) take a while to understand who's in charge.

I can't tell you how many times in professional or social situations people assume that I'm the boss and mom is the assistant director. It happens when we're at music conferences, it happens at concerts and in student interactions, and it happens in social interactions. It even happens with principals and other school leaders: people who literally know who is in charge. They interact with me and your mom as if I'm in charge. The only answer is that it's because I'm a man.

Coming to understand this—and constantly deferring back to mom or correcting that mistaken assumption—has made me better understand the power I have, simply because I have a Y chromosome. I didn't ask for this power, and I certainly don't deserve it. (Your mom is way, way better at her job than I would be.) But I have it, and over these repeated interactions, I've had to acknowledge it and figure out what to do with it.

Here is my second rule of being a male feminist: *Acknowledge you have power you haven't earned.*

Just by being a man, you have power you haven't earned. Already, in middle school, you are being treated differently by adults. You are being groomed to possess this unearned power and so subtly that you aren't even aware of it. Become aware of it. See how boys are treated differently

than girls in our society and ask yourself is that because of something innate or because of something we've decided as a society.

Your mom and I care deeply about showing the equality that we feel both at home and at work. We might not talk regularly about feminism as a perspective in our day-to-day conversations with you and your brothers, but I think we demonstrate it in how we live our lives and in how we talk about so many issues from one day to the next.

I spent ten years of my life as a fulltime at-home dad, with a majority of the day-to-day responsibilities for raising and nurturing you and your brothers between your birth and the day your brother started fulltime kindergarten in 2016. Being at home while your mom was in the workplace, shining in her career and being our primary breadwinner, was, I think, a feminist act in the way we practiced it. Even today, at-home dads are a rarity.

I admit it hasn't always been easy to be a dad in a society accustomed to female homemakers. I remember getting funny looks at library story time when you were two, and even now, I don't feel as comfortable volunteering in the classroom as the stay-at-home moms of your class-mates do. I've never been a "Room Mom" at the elementary school, and when I have volunteered in various capacities, I've almost always been the only man in the room. I've felt always felt welcomed but held at a distant. When your elementary recently created a dads-only program called Watch DOGS. (Dads of Great Students), it didn't escape my attention that the way they were trying to get more dads involved didn't involve doing any of the typical school-assisting work that the parent-teacher organization was already doing. The school's proposal for getting more dads involved was just to have them helping out on the playground during recess.

I say all this not to complain but to call attention to how outside main-stream culture our choice has been. Indeed, I try to do as little com-plaining in this type of situation as possible. I understand that I am still cashing in on male privilege in these situations: I am being lauded just for showing up. I am the beneficiary of the low expectations our society holds for fathers. But complaining that the expectations aren't higher doesn't do anything to promote equality; it just lets me use my privilege to get on a soapbox. I am praised for being present at all, whereas I know your mom feels immense pressure to do her very demanding job as well

as she can while still making it to all of your school functions and being mom of the year, for which she gets nowhere near the praise I get for helping out on the playground once in a while.

How else do your mom and I live equality as parents? We do talk about it. We point out when inequality exists and ask lots of questions. You are old enough to notice that people defer to me, even though your mom is head of our choir program. So I ask, "Did you see that?" Noticing and discussing can be a powerful combination towards building a feminist mindset.

You probably heard us talking about a couple of weddings we recently attended; among the gems of anti-feminism jiu jitsu were these three quotes:

"When I met her [in high school] I told my wife, someday she'll make a great wife and mother. And probably other things, too."

"[To the couple] You'll correct each other when you're wrong. Well ... Jane, you can correct John. John, don't try to correct Jane."

"[In a toast] You'll soon learn that she will always get the last word in a discussion. With practice you can get the last two words, though ... as long as they're 'Yes, dear.'"

That's not feminism. It's portraying inequality as a virtue and jokingly reinforcing gender stereotypes rather than aiming for true equality. That's not the way your mom and I live our lives or our relationship. We trust each other to be honest. We trust each other to make good decisions, and neither of us is automatically right in any circumstance. So while I think your mom has the right idea more than I do, it's not because I'm henpecked or living in the 1950s. It's because she's smarter than me and often sees the world more clearly at a glance than I do.

Here's my third rule of being a male feminist: *As the recipient of unearned power, you must use it to exemplify equality and act out against instances of inequality.*

Your mom and I, I hope, are examples of equality to you and your brothers. I hope that I, especially, show you every day that I understand the many ways that I receive power I don't necessarily deserve and that I seek to correct that and redirect the power towards others who deserve it and do not receive it as automatically as I do.

The day after the 2016 presidential election, you wore a button with the Hillary Clinton slogan "Love Trumps Hate" into your fifth-grade classroom. It's one of the many reasons I love you. You knew that Trump supporters outnumbered Clinton supporters in your class two to one, but you had attended a rally for her, you believed in her message, and you expressed your disappointment by doubling down on your convictions.

Your convictions have developed because time and again we have talked openly about the issues of the day, and your mom and I have asked lots of questions of you and your brothers. Those questions, I think, have helped you shape your own outlook and reflect that outlook in your actions. "Why?" "Do you think that's right?" "Who is saying that?" Ask enough questions and you come to interesting answers.

Your ability to express your convictions and opinions has been tested by being the eldest of three brothers, especially by your youngest brother. He just turned seven and did so with a fancy tea party and dance party; he wore his fanciest party dress and received, among other things, a long pink wig and a spa and pedicure play set.

Genderfluid is the best word to describe him, and although he uses male pronouns, he constantly pushes the limits of gender identity, both at home and at school. He wore his first tutu at two, and by the end of first grade, he was regularly wearing dresses to school. While you were at Boy Scout Camp, he got his first pair of heels—pink patent leather with rose-gold sparkly bows. He is, in a word, fabulous.

It wasn't easy for you when you were both in elementary school together. I think you got more accusatory questions about his gender identity than he did, and your classmates were more persistent and cruel than his classmates. To your credit, you stood up, gave generous and supportive answers, and went to your (female and very supportive) principal when things got beyond your control. At his birthday tea party, you dressed in a white tuxedo jacket and helped serve the tea and cupcakes to the guests with your most formal manners.

Why am I writing about your relationship with your brother in a letter about feminism? Because your relationship with him, and his relationship with the world, deeply reflects your perspective on gender equality. Our society is fairly comfortable with girls who dress and

behave in a traditionally masculine way (the age-old word is "tomboy") but is distinctly uncomfortable with a boy adopting female behaviour. I think some piece of that discomfort is due to our culture considering female behaviour somehow submale.

That you have supported him on his journey towards himself shows that you don't define things in that hierarchical way. You believe in and understand equality, and your mind is open enough to accept that your brother's love of pink dresses and Barbie dolls is just a part of who he is.

<center>***</center>

1. Every person deserves equal respect and opportunities.

2. Acknowledge you have power you haven't earned.

3. As the recipient of unearned power, you must use it to exemplify equality and act out against instances of inequality.

You and I have received every bit of extra power available in the U.S. We are white, male, cisgender, middle class, well educated, with educated parents in a two-parent household. We have attended good schools with quality teachers and extra opportunities.

Being a feminist, then, means understanding that you and I didn't earn all of that power. I have more power than your mom, for no other reason than I have a Y chromosome. You have more power than your female classmates for the same reason. Start paying attention to how that power appears at school and in other situations. Are you getting extra opportunities? Extra praise from your teachers for less-than-stellar work? Even extra criticism can be a sign that you are innately viewed as having more worth.

There's not a lot you can do, yet you can gain knowledge. You can't speak out about unequal treatment in seventh-grade math class, but you can start to collect knowledge. You're old enough to open your eyes wider and recognize the truth. You're old enough to see and let what you see influence your perspective on the world.

And then, when the time comes, you're going to have to decide how to use your power. Are you going to accept it and use it to improve your own lot in life? Will you use your head start to get farther ahead of your peers? Of course, I don't want you to impede your own success; I want to see you shine to your full potential. But if you don't also use your power to lift up others and decrease the inequity of power, then you are

perpetuating a broken system that lifts you up at the expense of others.

"When you're accustomed to privilege, equality feels like oppression." That's a quote that has gained traction in the world recently, but it also rings true to me. You'll have to remember your privilege if you feel oppressed. When you don't get a scholarship because it's dedicated to only women, that isn't oppression: it's an organization striving for equality, but it feels like oppression to people like us, accustomed to privilege.

Son, you're already a feminist, although you don't really know it. You have strong views about equality, respect and love from the strong women in your life—from your mother and grandparents to the many wonderful woman teachers and principals who have helped shape you. You're already a feminist, even if when I asked you what feminism is, you said, "believing that women are inferior to men." You had mistakenly interpreted an -ism, like racism, as being bigoted against a group. We've got to work on definitions but not on worldviews.

Now is the time to start taking that worldview, defining it, and putting it to action in the world. You're old enough to forge your deeply held views into behaviours that can help to change the world. If you'll just use those three rules as a way to assess situations you're in and to help you decide the right course of action, you'll be on your way to a life well lived in pursuit of equality.

Love,
Dad

P.S. Just a few weeks after I finished writing this letter, your youngest sibling transitioned to her affirmed gender. That is its own story but a story that includes this: no one, absolutely no one, was more immediately committed to using new name and pronouns than you. You called others out when we slipped and showed nothing but support for your little sister. It gives me so much hope.

Afterword

Dan Friedman

"I set out to try to change the world, but I failed. So I decided to
scale back my efforts and only try to influence [my country], but I
failed there too. So I targeted the community in my hometown, but
achieved no greater success. Then I gave all my effort to changing
my own family, and failed with that as well. Finally, I decided to
change myself."

—Rabbi Yisrael Meir Kagan, The Chofetz Chaim (Seeker of Life),
1838-1933 (qtd. in Morinis 15)

"The personal is political."
—Second-wave feminist slogan

Recently, I had occasion to watch my wedding video from twenty
years ago, and I was surprised to notice that I did not like the
version of myself I saw on the screen. My reaction was: that guy
is too cocky, too self-assured, and too full of himself. I couldn't put my
finger on it, but there was something about the person I saw that made
my skin crawl.

Without a doubt, as the eldest son of a suburban middle-class Jewish
family, I was raised to believe in the centrality of my own subjectivity
and the importance of my own story. Growing up in the seventies, the
models I was given for success, even when they came from a slightly
left-of-centre position, all focused on autonomy: the artists, scientists,
and musicians I grew up admiring were successful largely because they
were autonomous, self-directed subjects in charge of their own lives.
Even my earliest encounter with feminism, the album Free To Be ... You

And Me, had as its underlying premise the quaintly second-wave idea that all we had to do to fix sexism was to let women be just as autonomous as men were. There was no analysis or criticism of the primacy granted to this autonomy; no voice questioned this idea or argued for the value or necessity of relationality. So much of my relationship to feminist fathering has been a decades-long struggle with these ideas.

I find myself, then, daunted by the task of creating an afterword that, somehow, takes the discrete offerings collected here and says something conclusive: certainty seems to be in direct contradiction to this project. Rather than portraying feminist fathering as singular or concrete, this book has considered the multifarious attitudes and actions that constitute it: distinct from the institution of patriarchal fatherhood, feminist fathering is as much about what it resists as what it is. For every action the feminist father in general can be shown to perform (many of the pieces in this collection include examples from the culture of what a feminist father does), there is something feminist fathers don't do (support or model misogyny, prescribe roles for daughters, and so on). If our aim becomes the establishment of a concrete, prescriptive set of feminist fathering dos and don'ts, I fear we will have missed a subtler point: What can masculinity learn from feminism to make itself less problematic? How can feminist fathers learn to occupy less space, and/ or to take up a feminist position more effectively? How can this afterword avoid the masculinist certainty that it aims to disrupt?

The themes and challenges above are resonant for me as an editor of this collection, but, of course, my connection to this topic precedes the present volume. I have been grappling with feminist fathering for sixteen years, since the spring day that brought the first of my four children into the world; the themes of this book are the themes of my fathering life. I have learned that feminist fatherhood requires me to maintain constant questioning and to avoid certainty. In that spirit, then, I do not aim to tie things up with a bow here; rather, I will explore some of the particular resonances and opportunities that feminist fathering has brought to me and that run through many of this book's contributions: disruption, discipline, debate, and devotion.

Kid 1. Disruption: *Free To Be... Dad*

Men are socialized to take a lot for granted and to ignore unseen and emotional labour (Hochschild and Machung xxiii). This socialization is the particular disservice that my upbringing did me in teaching me to be the centre of my own universe; family, religion, media, and school all offered the consistent message that I was an agent and an individual and, therefore, that I was essential. I was taught that everything around me was going to attempt to erode my own self and that only constant vigilance would allow for my survival.

So when I started out as a father, I experienced the disruption of a series of expectations about how my life was going to go. The thirty hours preceding the birth of my first child certainly ended to a lot of my (conscious or unconscious) notions of autonomy: my partner was in immense pain, and we were both exhausted. I experienced that moment that new fathers (and almost fathers) go through, when I realized *I'm incredibly tired and I can't do anything about it; and I can't even complain about it, because hey, I'm not the one in labour.* Here was a situation in which fighting against relationality and being vigilantly autonomous was not going to help. What this moment called for was being supportive, and as my beleaguered partner and I both found out, I had no idea how to do that.

New parenthood wasn't much better. With every new assault on my autonomy (time, sleep, and food), I became more upset and resentful. If there's one thing I learned from being a musician, it's that you get good at what you practice doing, and I spent at least the first dozen years of my life as a parent noticing and focusing on all the ways that parenting impinged upon my life—the lack of sleep, the lack of autonomy, the lack of spare time (Chandler 529). I missed many of the opportunities to be present that parenting had to offer. To be fair: I was raised to expect that this was what parenting would be like. I was raised to think about the ways that parenting would be an obstacle, a force to be kept at bay.

I may not have constructed the patriarchal context that bred me, but I do have a responsibility to recognize my social position and to take action. And I think what I don't like about the version of myself I saw on that video from twenty years ago is this: that guy still sees himself at the centre He hasn't learned yet that his life isn't all about him. Cue feminist fatherhood.

Kid 2. Discipline: What's a Dad to Do?

When you go to pick your kid up at daycare, often the teachers will greet you with a story about something interesting they did that day. On the particular day I'm thinking of, they came up to me as I entered the room and started praising my daughter, telling me how generous and selfless she was, telling me about how she had given so many toys to the other children. Eventually, I looked over and watched her in the corner playing all by herself, with a big pile of toys. Every time another kid would come over to her with a colourful or sophisticated toy, she would hand them one of the more boring toys from her pile; they, being toddlers, would grab the object just handed to them, drop the one they had been playing with, and walk away. My daughter would then collect the interesting toy. In this way, over time, she had collected all the most interesting toys in the room, all the while earning the praise and adulation of the teachers.

We all want to game the system: we have been raised, as good little capitalist entrepreneur-behavioural experiment subjects, to believe that if we can just figure out the rules and be good—that is, follow the rules—we will be rewarded. Even within the constrained universe of parenting babies and small children, we try to do this. We spend uncountable hours in pursuit of techniques: What is the right way to hold this baby so it will go back to sleep and leave me alone? What is the exactly correct quantity and combination of food this extremely picky toddler will be willing to eat right now so that they will not experience a blood sugar crash at the dinner party three hours from now and make a scene? For precisely how many minutes is it ethical for me to let my children sit in front of Netflix so that I can get this afterword written under deadline? Seeing our kids as systems we need to game puts ourselves back at the centre. You get good at what you practice doing, but this approach doesn't prepare you well for the subtler questions that arise:

- What's this weird rash that has appeared on my child's skin?

- What am I going to do when the teacher emails me to describe my kid's poor behaviour choices today at school?

- What is my teenager doing when they are out with those friends I don't know?

- Is my manipulative, toy-accumulating kid overly acquisitive? a sociopath? a genius?

Each of these has a quiet, second question tacked onto the end: Should I worry about this or not? And this is not a question that can be answered by figuring out the rules of a system. Suddenly, parenting is no longer a technique. It is an ache, a sliver, a disruption. Yet it is not only that.

Like parenthood, feminism is not a technique. As Nicole outlines in our introduction, and the diversity of pieces in this collection demonstrates, feminism is many things to many people; it has complex overlapping with numerous other progressive causes. As such, feminist fathering cannot be a technique with only one true way. As we have seen throughout this volume, there are as many different ways of being a feminist dad as there are of being a dad, which is to say, as many ways as there are dads. Perhaps what is central to the effort is the leaning into the ache, the resistance to technique.

We are not excused from thinking about the question any more than discovering those ambiguous parenting questions above excuses us from not thinking about them either. In fact, in a world where those hard parenting questions (and so many more) have traditionally been the purview of moms, just being a dad who chooses to think about the tough questions of parenting is a feminist move (Beck); it's an interrogation of the privilege that we have—as men who've been taught to take up the center of our own and our family's lives—of not thinking, not worrying, and not keeping these and so many other questions on our minds constantly.

Let's be clear: that's quite a low bar to set, and I certainly don't mean to imply that such a move is sufficient. But having the discipline to stay aware of our position relative to the story's centre (the story of our lives, our partner's life, and our family members' lives) is certainly a necessary starting point for feminist fathering. Arguably, this disruption of discipline, this rejection of the colonialist and neoliberal standard of citizenship in favour of an encumbered and engaged connection is both radical and necessary.

Kid 3. Debate: "The Possibility Inherent in Transgression"/"Actively Parenting against the Status Quo"

Funnily enough, it's the kid whose personality is probably most similar to mine that gives me the toughest time. And she is one tough cookie: her willingness to quietly (or, often as not, not so quietly) fiercely stand up for what she believes in is Herculean. I simultaneously admire and am frequently confounded by her unwavering and uncompromising commitment to the cause of the moment—be that cause gender advocacy and social justice, or the relative trade value of a late night snack, or a certain number of minutes of screen time. She is constantly pushing boundaries and testing every available limit, which I'm sure will make her a formidable activist, but for the moment, it frequently renders her simply impossible to be around.

Yet "impossible to be around" fails to capture it. At every moment, she sees, as Nicole's introduction has it, the possibility inherent in transgression—the possibility of a better way, a more just way of structuring her world and society. Sure, at 11:00 p.m. it's easy to dismiss her simultaneously punctilious and utopian vision of exactly what constitutes a fair bedtime—or, more likely, to desperately wish we could dismiss it, while instead becoming trapped within its labyrinthine twists and turns—realizing, only too late, that her commitment to a precise and just process is not in fact Herculean, it is, rather, terrifyingly *Sheherezadean,* each procedure (having a snack, reading a story, singing the preagreed upon portfolio of lullabies, *actually going up the stairs, please God)* endlessly opening out onto an expanding field of negotiated and renegotiated subprocedures that proliferate like some nightmarishly Deleuzian rhizome (Deleuze and Guattari 3), like the fragmented scene at the end of *The Matrix: Reloaded,* except it's a thousand and one eight-year-olds, each on their own little TV screen, each with their own slightly different, mutually exclusive conditions for going up those stairs, all of which must be satisfied in order to bring the whole mess to an end...

I may exaggerate slightly (come visit my house at 11:00 p.m. on a bad night and see for yourself); however, the insistence on questioning and the constant putting up for debate of every received status quo—from household responsibilities to family gender roles, to the very existence of a strict gender binary—will also serve the feminist fathering project (Doucet 213). In the face of mounting socially regressive, conservative,

transphobic, homophobic and misogynist pressures (to only name a few), we must not give up; we must not waver in our belief that even when the hour is late and we are all so very tired, a better way is possible. In this way, this child is not merely my tormenter but rather my teacher—a consistent force requiring me to be the best and most ethical, accountable, radical, and rigorous version of myself.

Kid 4. Devotion: Giving up the Centre, Recovering into Balance, and Finally Becoming Dad, Once and for All

> "Leaving ourselves alone ... entails, psychologically, re-owning those parts of ourselves that we've split-off or dissociated from and ... reconnecting with the whole of life. But leaving everything alone turns out not to be so easy."
>
> —Barry Magid (133)

Aikido is a Japanese martial art practised in pairs; it involves executing a series of choreographed movements designed to teach principles of balance, centering, and decentering. In the classic Western interpretation of this and similar arts like jujitsu, judo, and so on, the idea is, instead of fighting one's partner's intention, to go along with what they are doing, to reclaim the shared centre of gravity by yielding to an attack, and then to redirect the partner into a pin or a throw. There is also a whole series of graceful recovery movements in which participants train to absorb and return from being thrown; as the student progresses, they get better and better at recovering from being thrown harder and harder.

Being thrown was always my favourite part. I fell instantly in love with aikido when in 1993, at the age of nineteen, I caught sight of people practicing it through a doorway from across the street in downtown Ottawa. I remember experiencing a profound certainty that what I was seeing represented a social utopia, the ideal way for people to interact with and treat one another.[1] I read as much of the philosophical and the psycho-spiritual aikido literature as I could get my hands on, trained hard, and ended up as a junior teacher at an aikido school in Toronto— all the while struggling to balance a career in IT, support a partner with a tenure-track academic job, and raise three kids. Needless to say, there were a lot of heated discussions between my partner and me about

priorities, about evenings spent practicing, and weekend intensives. I was, in a way, still fending off fatherhood and responsibility, keeping it at bay by maintaining a strong, independent subjectivity.

Then, in late 2014, after a series of emergency retinal surgeries, I was told that being thrown around bodily at high velocity could potentially blind me. And so, after twenty years of avid practice, I had to give up something I had thought I would be devoted to for the rest of my life.

About a month later, our youngest daughter was born, and I was finally able to stop fighting against my life, yield, and let someone else occupy the centre.

In the psychology of addictions, there is the idea that abusers of addictive substances act as much to answer the question of whether or not they will relapse as they do to experience the high induced by the substance itself (Wilson and Dufrene 31); this tension can be just as anxiety provoking, or even more so, than other potential consequences of using. I remember clearly feeling at the moment of our youngest's birth that a great burden had lifted off my shoulders. It was as if a question that had been hanging over me, that I didn't even realize I'd been resisting for years—would I or would I not, like my own father, be the father of four children?—had finally been answered definitively. I was finally free to be present to the reality of my own life, as it is, and not the fortress -life I had been constructing and defending for so long.

Despite her feistiness, our daughter has folded herself into our family's life seamlessly, and, somehow, it feels like a little less work than her predecessors were. In aikido practice, we used to say "at least fifty percent of the resistance you feel is your own," and I think in her case, this rings true. I chalk up most of the ease with which it feels like she navigates her life to my own change in emotional posture.

Making the choice to be present and to deliberately enter into relationality—with my partner, my kids, my community—has freed me to encounter and inhabit the relational, liminal subjectivity of parenting. I think it has actually saved my life, and I almost missed it. I had to get all the way to kid number four (and almost go blind) before I realized that this was the opportunity I was passing up. I realized that parenting didn't have to be a problem and that it was simply one of the available choices for how my life was going to go. Something snapped into place; my feelings about being a parent profoundly changed. As my partner likes to say, now the kids were finally all here.

So now, feminist fatherhood is just about doing whatever it is we do on a daily basis. The big decisions of parenting are put to rest for me, and feminist fatherhood is about a million acts of daily living.

In offering these snapshots and thoughts about my own life, I do not mean to suggest that my experiences are emblematic of feminist fatherhood, nor do I suggest, for even a second, that the disruption and wrangling that I've documented here are over and that my family now lives in some utopic, rainbow-filled postfeminist wonderland of gender equality. To be sure, in the face of increasingly problematic cultural pressure and technological distraction, I have to remake that choice to enter into presence and parenting every day. Some days I do better than others. But when I cast a lens at my own experiences, I can see many of the tensions and possibilities that are present throughout this book and throughout the bigger context of feminist fatherhood: the awkward stepping in and out of privilege and oppression, as well as the competing impulses of, to paraphrase my people, being a Man vs. being a *Mensch*. What I can say with certainty is that the conversation continues. This book has sought to participate in that ongoing dialogue and to contribute to the landscape of feminist fathering as a set of lived practices, theoretical conversations, and loving interventions, which witnesses all the enormous and miniscule details that comprise the term.

Endnotes

1. I've since learned of other people having had a similar first exposure to aikido, Terry Dobson perhaps most famously (Dobson 5).

Works Cited

Beck, Julie. "The Concept Creep of Emotional Labour." *The Atlantic,* Nov 26 Nov., 2018, www.theatlantic.com/family/archive/2018/11/arlie-hochschild-housework-isnt-emotional-labor/576637/. Accessed 12 Jan. 2020.

Chandler, Mielle. "Emancipated Subjectivities and the Subjugation of Mothering Practices." *Maternal Theory: Essential Readings*, edited by Andrea O'Reilly, Demeter Press, 2007, pp. 529-541.

Deleuze, Gilles, and Félix Guattari, *A Thousand Plateaus: Capitalism and Schizophrenia,* Translated by Brian Massumi, University of Minnesota Press, 1987.

Dobson, Terry. *It's A Lot like Dancing: An Aikido Journey.* Frog, Ltd., 1993.

Doucet, Andrea. *Do Men Mother?* University of Toronto Press, 2006.

Hochschild, Arlie, and Anne Machung. *The Second Shift.* Penguin Books, 2003.

Magid, Barry. *Ending the Pursuit of Happiness: A Zen Guide.* Wisdom Publications, 2008.

Morinis, Alan. *Everyday Holiness: The Jewish Spiritual Path of Mussar.* Trumpeter Books, 2008.

Wilson, Kelly G., and Troy Dufrene, *Things Might Go Terribly, Horribly Wrong: A Guide To Life Liberated from Anxiety.* New Harbinger Publications, 2010.

Notes on Contributors

Bruna Alvarez received her MA in social anthropology in 2012 and PhD in 2017; she was part of the AFIN Research Group at the *Universitat Autònoma de Barcelona* (AFIN-UAB). Her research interests have revolved around motherhood, reproduction, work-life balance, gender equity in the home, reproductive decisions, and parents' reasons for having children. Currently, she is a postdoctoral researcher in the AFIN-UAB doing research with recipients of gamete donation in assisted reproductive technology, and is a fertility counsellor in Barcelona (Spain), with special attention to international patients.

Katie Barnett is a lecturer in film studies at the University of Chester, U.K. Her research interests are broadly centred around representations of gender and family in American cinema and television, with a particular focus on images of masculinity and fatherhood. She has previously published work on the construction of fatherhood in the films of Robin Williams, representations of death and boyhood in Hollywood, and cult television practices in *Freaks and Geeks*. Katie is currently completing a monograph examining images of fatherhood in 1990s Hollywood.

Marina Bettaglio is an associate professor in the Department of Hispanic and Italian Studies at the University of Victoria (Canada), where she teaches in both programs. She holds a PhD in Hispanic studies from SUNY Buffalo, an MA in comparative cultural studies from Ohio State University, and a *laurea* from the University of Genoa (Italy). A cultural comparativist, she focuses on contemporary Spanish and Italian cultural studies with a gender perspective. She has written extensively in the fields of mothering, gender, and media studies. Her recent publications include a co-edited volume on the representation of gender-based violence in contemporary Italian society and several

articles that analyze the discursive construction of the maternal figure in a variety of fiction and nonfiction texts. She has written on high and popular culture, on canonical authors such as Lope de Vega, Pirandello and Montale, and on contemporary Spanish, Latin American, and Italian authors, journalists, cultural commentators, and bloggers.

Ginger Bihn-Coss is an assistant professor in the School of Communication Studies at Kent State University, Tuscarawas. Her primary research areas include gender and communication, health communication, and organizational communication. She is especially interested in examining how disenfranchisement, power, and resistance affect health decision making. She is passionate about her teaching as well as equal rights, community involvement, and how communication can be used to empower people. She is married to her husband, Eric, and has four children.

Nancy Bressler, PhD, is an assistant professor of communication at West Virginia Wesleyan College. Her research focuses on pedagogical advancements, specifically the development of students' media literacy skills, and how instructors can incorporate media activities into the classroom. She has published this research in the *Journal of Communication*, the *Speech & Theatre Association of North Dakota*, and *Teaching from the Heart: Critical Communication Pedagogy in the Communication Classroom*. In addition, her media studies and critical and cultural research examines how media representations influence and contribute to American identities, cultural norms and values, as well as social perceptions.

Andrea Doucet is the Canada research chair in gender, work, and care and is a professor of sociology and women's & gender studies at Brock University. Her book *Do Men Mother?* (2006, 2nd edition, 2018) was awarded the 2007 John Porter Tradition of Excellence Book Award from the Canadian Sociology Association. She is also co-author of two editions of the book *Gender Relations in Canada: Intersectionalities and Social Change* (2008, 2017) and a forthcoming edited collection titled *Lorraine Code: Thinking Responsibly, Thinking Ecologically*. She is a proud parent of three adult (feminist) daughters.

Steven Farough is an associate professor of sociology at Assumption College in Worcester, MA. He does research on stay-at-home fathers, masculinities and post-civil rights racial inequality in the United States.

Dan Friedman studied music at York University and got interested in feminism while learning about cultural theory from Ioan Davies in graduate school. He lives in Toronto with his partner and four mostly delightful children, splitting his remaining time (such as it is) between a web consulting business, singing folk music, and Tai Chi.

Lee Kahrs is the managing editor of *The Other Paper, Shelburne News,* and *The Citizen*, three weekly community newspapers in Chittenden County, Vermont. She is a July 2018 graduate of the University of Southern Maine's Stonecoast MFA program, majoring in creative non-fiction. Lee's essays have appeared in *Idol Talk: Women Writers on the Teenage Infatuations That Changed Their Lives* and the July 2018 issue of *The Stonecoast Review.* She has completed a collection of essays detailing her life as a 9/11 refugee and her move to domestic life in Vermont. She is also working on a TV show and a nonfiction book about the dearth of butch lesbian characters in modern literature, film, and television.

Jeff Karem is a professor and department chair of English at Cleveland State University. His research and teaching focus on twentieth-century American literature, with an emphasis on regional and ethnic literatures throughout the Americas. His work examines how what we define as "American literature" has changed over time, and he aims to expand our understanding of the field beyond national boundaries in favour of an international approach to the subject. Karem has published articles on African American literature, Native American literature, and literatures of the Caribbean and Latin America. Karem is the author of two books: *The Romance of Authenticity: The Cultural Politics of Regional and Ethnic Literatures* (University of Virginia Press, 2004) and *The Purloined Islands: Caribbean-U.S. Cross-Currents in Literature and Culture* (University of Virginia Press, 2011).

Donna J. Gelagotis Lee is the author of two award-winning collections: *Intersection on Neptune* (The Poetry Press of Press Americana, 2019), winner of the Prize Americana for Poetry 2018; and *On the Altar of Greece* (Gival Press, 2006), winner of the 2005 Gival Press Poetry Award and recipient of a 2007 Eric Hoffer Book Award: Notable for Art Category. Her poetry has appeared in publications internationally, including *Atlantis: A Women's Studies Journal, Descant, Feminist Studies, Mothers and Sons: Centring Mother Knowledge* (Demeter Press, 2016), and *Vallum: contemporary poetry.*

Stuart Leeks is a socially awkward father to three children, proud husband to Emilie (all-round amazing person and parenting coach at www.journeys-in-parenting.com), geek for fun and profit, home-educator, introvert, wannabe guitarist and ukulele player, and sexist feminist. He can be found on twitter @jstsmblk and blogs at www.justsomebloke.com/blog. He/him.

Debra Michals is an assistant professor and director of women's and gender studies at Merrimack College and a stepmother to two young women, now both in their early twenties. As a feminist historian and former journalist, she is drawn to research that focuses on the links between popular culture and social change, particularly the spreading of feminist ideals in mainstream media. She is currently completing a social history of women's entrepreneurship since World War II, which looks at the impact of the changing social landscape on women's choices, opportunities, and obstacles, and the discourse on family that was often a factor in their decisions to start businesses. Future work will also explore the links between activism and enterprise. Dr. Michals also served on the Scholar Group advising the Congressional Commission for an American Museum of Women's History.

Jed Scott is an active freelance arranger, composer, and conductor, with specialties in vocal jazz, contemporary *a cappella*, and traditional choral music. He has multiple published works with leading publishers, and he founded and runs the Michigan Choral Commission Consortium, which is dedicated to facilitating the creation of new choral music commissioned for Michigan choirs. Jed is an adjunct faculty member at Grand Rapids Community College and directs the Rockford Aces, an extracurricular TTBB choir at Rockford High School. He is a lifelong resident of Michigan and currently lives in Rockford with his brilliant wife, Mandy, and their three children, Owen, Julian, and Daniella. He is blessed to spend his days with them and his mornings and evenings working to create music. Jed blogs daily about creativity, choral music, and education at www.jedscott.com.

Nicole Willey is a professor of English at Kent State University Tuscarawas, where she teaches a variety of literature and writing courses and serves as mentoring program coordinator for KSU Tuscarawas. Her research interests include mothering, masculinities, memoir, pedagogy, mentoring, nineteenth-century American literature,

and slave narratives. She has authored *Creating a New Ideal of Masculinity for American Men: The Achievement of Sentimental Women Writers in the Mid-Nineteenth Century* and has co-edited the collection *Motherhood Memoirs: Mothers Creating/Writing Lives*. She lives in New Philadelphia, Ohio, with her husband and two sons.

Deepest appreciation to
Demeter's monthly Donors

DEMETER

Daughters
Naomi McPherson
Linda Hunter
Muna Saleh
Summer Cunningham
Rebecca Bromwich
Tatjana Takseva
Kerri Kearney
Debbie Byrd
Laurie Kruk
Fionna Green
Tanya Cassidy
Vicki Noble
Bridget Boland

Sisters
Kirsten Goa
Amber Kinser
Nicole Willey
Regina Edwards